EL GRECO TO MURILLO

EL GRECO

Spanish Painting in the

TO MURILLO

Golden Age, 1556-1700

NINA AYALA MALLORY

 Icon Editions

An Imprint of HarperCollins*Publishers*

FIRST EDITION

Designed by Cassandra J. Pappas

Library of Congress Cataloging-in-Publication Data
Mallory, Nina A.
 El Greco to Murillo : Spanish painting in the Golden Age,
1556–1700 / Nina A. Mallory. — 1st ed.
 p. cm. — (Icon editions)
 Includes bibliographical references.
 ISBN 0-06-435531-4 — ISBN 0-06-430195-8 (pbk.)
 1. Painting, Spanish. 2. Painting—16th century—Spain.
3. Painting, Modern—17th–18th centuries—Spain. I. Title.
ND805.M35 1990
759.6'09'032—dc20 89-45685

90 91 92 93 94 CC/MPC 10 9 8 7 6 5 4 3 2 1

CONTENTS

LIST OF ILLUSTRATIONS

FOREWORD

Spanish art, like many other aspects of Spanish culture, is considerably less familiar to the English-speaking world than the art of Holland, Italy, or France. That is not to say that the ranking painters of the Spanish school—El Greco, Ribera, Zurbarán, Velázquez, or Murillo—have not been well studied; the scholarly literature in English devoted to them, especially in recent years, is substantial in every sense. Nonetheless, a great deal of Spanish art of the hundred and forty years in which these artists flourished, a period that can justly be called the Golden Age of Spanish painting, still remains little known outside of Spain. With one exception, even the acquaintance with the major figures of this period, and the appreciation of their art, is a phenomenon of fairly recent vintage, going back only to the mid-nineteenth century. The exception is the Sevillian painter Murillo (1617–1682), whose pictures were bought and valued outside of Spain in his own time, and whose fame climbed to ever greater heights throughout the eighteenth century; his works were taken abroad in such large numbers—particularly by English and French collectors—that a royal decree had to be passed in 1779 to put a stop to further exports. Until well into the nineteenth century, Murillo remained the best known and most admired seventeenth-century Spanish artist.

A broader interest in Spanish art began to emerge only in the early nineteenth century, as a result of the Napoleonic occupation of Spain during the Peninsular War (1808–14) and the attend-

ant wholesale transport of the plundered art treasures to France. The Secularization Act of 1835, which gave rise to a major dispersal of the works of art that had belonged to the disestablished convents and monasteries of Spain, also enriched both private and public collections of Spanish art, at home and abroad. With the wide exposure Spanish painting received from 1838 to 1848 in the Galerie Espagnole of the Louvre, which exhibited Louis-Philippe's large collection of Spanish pictures, the work of the relevant figures of the Golden Age began to attract the admiration of the most important French artists of the time, and even to attain some popularity with the public at large. It was at this point that forgotten figures such as Zurbarán were rediscovered, and that Velázquez began to occupy the eminent position in the history of art that he has held since.

The Romantic image of Spanish culture and its special national traits, forged primarily in France and England in the mid-nineteenth century, has colored the view of Spanish painting for generations of art lovers. This Romantic view focused on those features of Spanish art that appeared most foreign, and ignored those it shared with the art of Italy or Flanders; austerity, uncompromising realism, and religious intensity were taken as the principal measure of what was "authentic" Spanish art. This image of Spain consigned artists of extraordinary quality—and Spanish painting of the second half of the seventeenth century altogether—to a well-populated limbo of uncharacteristic Spanish art. Murillo's continued fame from his own day through half of the nineteenth century kept him from suffering the same neglect as his contemporaries, but after the mid-century it was primarily the pictures of his ragged street urchins that validated his identity as a Spanish artist.

While our understanding of seventeenth-century Dutch painting is grounded on an awareness of the breadth and multiplicity of all the artistic options present in that country during that period, our vision of Spanish painting has depended too exclusively on a limited set of options, which have come to stand for the whole. One of the objectives of this book is to present to the English-language reader a more complete and balanced picture of Spanish painting under the Hapsburgs, from 1556 to 1700, expanding the traditional perceptions of what constitutes its character.

In the last fifteen years there has been a notable increase in English-language publications about Spanish art. Important monographic studies and exhibition catalogues devoted to some of the major artists of this period have not only illuminated the art of El Greco, Ribera, Zurbarán, and Velázquez but also brought it to public attention. At present, however, there is still no work in English that deals satisfactorily with the period as a whole on a level appropriate both to the general reader interested in art and to the student of art history; the art of Spain in its Golden Age is covered in summary fashion almost exclusively in textbooks that aim to serve college-level courses in European Baroque art. The only book now available in English that is entirely dedicated to the subject of Spanish art and includes the period in question is the volume by George Kubler and Martin Soria in the Pelican History of Art series, *Art and Architecture in Spain and Portugal and Their American Dominions: 1500 to 1800*, a work that covers all three visual arts and that, as its title indicates, ranges over a considerably broader geographic area and period of time. It is also thirty years old and cannot reflect the results of more recent scholarship in this area. The present volume is intended to fill that gap and to give Spanish painting the greater exposure it merits.

Within the field of Spanish art, much important work has been devoted in recent years to expanding the possible points of view from which the individual work of art or the entire oeuvre of an artist can be interpreted. Iconography has been given a more inclusive scope, with stress on the ideological uses of art, and a great deal of attention has been focused on the role played by private and public patronage in the conception and outcome of any artistic enterprise. The documentary investigation of the important private collections of this period, as it reveals the tastes of the moneyed classes who purchased paintings on a large scale, and the availability, as well as the desirability, of different types of works during this time span, has thrown light on still another facet of the relationship of art to its social environment. The understanding of Spanish painting has been much enriched by the new insights into the process of creation provided by these various avenues of inquiry.

The survey of Spanish painting presented here focuses on the most significant artists of the Golden Age who worked in its

two principal artistic centers—the court in Madrid and the great commercial metropolis of Seville—within an overall framework that traces in a chronological sequence the development of this art during that hundred-and-forty-year period. The presentation of each artist attempts to bring out the singularity of his artistic expression, the relationship of his work to the painting of other schools, and the ways in which his art responded to the specific cultural, religious, and political medium of Spain. The emphasis has been placed on the works themselves, and on the artistic vision that they embody, rather than on their social or political functions. But although concern with matters of style, expression, and technique has been primary, extra-artistic factors that affected the course of Spanish painting and the production of its individual practitioners have always remained in sight as part of the infrastructure upon which the art of this period was built.

The long period of Hapsburg rule in Spain, from the reign of Philip II (1556–1598) to that of Charles II (1665–1700), was unquestionably one of the most brilliant epochs for Spanish arts and letters. Fray Luis de León (1527–1591), Miguel de Cervantes (1547–1616), Luis de Góngora (1561–1627), Lope de Vega (1562–1635), Francisco de Quevedo (1580–1645), Tirso de Molina (1584?–1648), and Pedro Calderón de la Barca (1600–1681)—the greatest figures in Classical Spanish literature—all flowered at this time, and Spanish painting also reached then its highest plateau; the genius of El Greco, Ribera, and Velázquez was not equaled by later Spanish artists until Goya's day.

Paradoxically, this was also the period of Spain's decline as a world power; from the position of political dominance and wealth that it had held under Emperor Charles V, it slid into an economic and political decline, which by the middle of the seventeenth century had become precipitous. By 1700, at the death of the last Hapsburg king, the great imperial power had become just a bone of contention between Austria and France, and would soon be absorbed into the sphere of influence of the Sun King by the establishment of the Bourbon dynasty on the Spanish throne. Its first monarch, Philip V, grandson of Louis XIV, brought with him to Spain French culture and French tastes, which soon became those of his court. It is only at this point that a significant decline in the caliber of Spanish artistic and literary output begins.

The definition of the temporal boundaries of what is

termed Spain's "Golden Age," in reference to its preeminence as a world power, has varied widely, but in art these boundaries have generally been understood to extend to the death of Velázquez in 1660. The political destiny of Hapsburg Spain had already been sealed by that of Philip IV in 1665 and the subsequent accession to the throne of the sickly and apathetic Charles. The death of the latter, thirty-five years later, only made Spain's political and economic collapse official. The art of painting, however, continued to thrive long past those dates; not only did Murillo live and work for two more decades, but there were also artists of great stature working at the court throughout those years. It was only after the death of Claudio Coello in 1693 that Spanish painting entered a fallow period, which would last until the arrival at the court of Francisco Goya (1746–1828) almost a hundred years later.

🕮 Spanish Painting in the Second Half of the Sixteenth Century

Juan Fernández de Navarrete, Alonso Sánchez Coello, Juan Pantoja de la Cruz

On August 10 of 1557, the feast day of Saint Lawrence, the armies of Philip II of Spain scored a major victory against the French at the Battle of Saint-Quentin, and the king vowed to erect a great monastery dedicated to that saint in thanks for his protection. In 1563, in compliance with that vow, he set the foundation stone for the royal monastery of San Lorenzo de El Escorial in the mountains of the Guadarrama, the immense, stark edifice that so fittingly stands as a symbol of his reign.

The task of designing the enormous structure had been given to Juan Bautista de Toledo, and the first building campaign proceeded under his direction. After his death in 1567, the work was taken over by Juan de Herrera (c. 1530–1597), and was completed in 1582 according to his design.

Philip's intentions in building El Escorial had been to gather under one roof a Hieronymite monastery, a palace to house him and his court, and a great church with a mausoleum worthy of receiving the remains of his father, Emperor Charles V. The building and decoration of the palace-monastery were to be the largest artistic project undertaken in Spain during the sixteenth century, and the execution of its vast decorative program brought together some of the best Spanish painters of the time.

By 1575, work on the structure had advanced sufficiently

for the pictorial decoration to begin on an appropriately grand scale. Philip II, who had inherited his father's taste for Italian painting, summoned for the task a group of Italian artists who were already in Spain and were expert fresco painters. Between 1583 and 1586, a second group of Italians, of greater renown than the first, was imported from Italy to fresco the walls of the large cloister and the vaults of the basilica, as well as to paint the major altar-pieces intended for the latter. Among this second group of artists were Federico Zuccaro, Luca Cambiaso, and Pellegrino Tibaldi— that is, the cream of central Italian painting at the time. But although these artists dominated the execution of the decorative program during the entire course of the project, Spanish painters also participated in the enterprise from the beginning, and many of their works can now be seen alongside those of their Italian colleagues.

JUAN FERNÁNDEZ DE NAVARRETE (1526–1579)

Among the few Spanish artists called by Philip II to work in El Escorial was Juan Fernández de Navarrete, nicknamed El Mudo (The Mute), a painter who had received at least part of his artistic training in Italy. At the beginning of 1568, probably the year that he arrived in Madrid from his stay abroad, Philip II named him Painter to the King, and Navarrete started to work immediately on some pictures destined for the monastery.

According to Father Sigüenza's report in his *Historia de la órden de San Jerónimo* (Madrid, 1605), Navarrete had secured this appointment by presenting Philip with the *Baptism of Christ* (Madrid, Museo del Prado), a picture in which the Florentine Mannerist side of his education prevails, particularly in echoes of the work of Taddeo Zuccaro (1529–1566). In his work for El Escorial, on the other hand, Navarrete's pictorial style shows a blend of Florentine and Venetian inspiration, with stress on the latter; his paintings there attempt a synthesis of Michelangelesque form and Venetian color and chiaroscuro.

The first important works executed by Navarrete in El Escorial were four large canvases depicting the Assumption of the Virgin and scenes from the lives of three saints, painted between 1569 and 1571. These pictures were done to decorate the monas-

tery's temporary sacristy during the building of the basilica, and were later placed in the upper cloister. The most impressive of them is the *Beheading of Saint James* (1571) [1], a work that is clearly influenced by Venetian painting—particularly Tintoretto's—in color and composition. The expressive naturalism of Navarrete's rendering of the saint's face at the moment of death, however, is a very personal feature, and it enhances the emotive content of the scene well beyond what the dramatic but rhetorical gestures of the saint and his executioner can convey.

These canvases were followed by four more, painted in 1571–75 and also placed later in the upper cloister. Among them

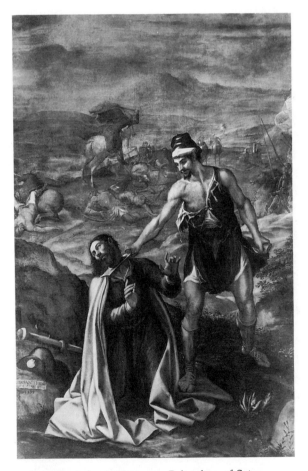

1. *Juan Fernández de Navarrete:* Beheading of Saint James, *El Escorial, Monastery of San Lorenzo*

was a night *Nativity* (1575), still in El Escorial, which is even more in line with contemporary Venetian painting—again Tintoretto, the Bassanos, and the late Titian—in its striking chiaroscuro and rich luminary effects.

In 1576, Navarrete started to paint an extensive series of altarpieces depicting pairs of saints, to be placed over the numerous altars housed by the basilica. By the time he died, three years later, he had already completed eight of them, representing the twelve apostles and the four evangelists. These altar paintings show powerfully characterized, monumental figures, of which his *Saint James the Major and Saint Andrew* [2] is a good example. This picture and its companions also give us a clear measure of his talent; in both style and technique, Navarrete stands out as the most progressive and accomplished of the Spanish painters working in El Escorial.

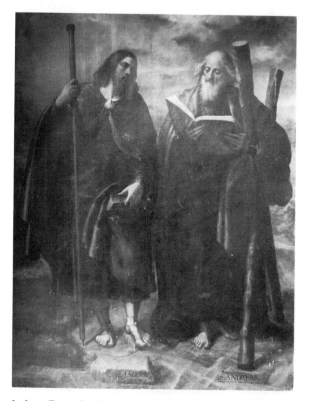

2. *Juan Fernández de Navarrete:* Saint James the Major and Saint Andrew, *El Escorial, Basilica*

ALONSO SÁNCHEZ COELLO (C. 1531/32–1588)

Apart from Navarrete, the only Spanish painter of real distinction to work in El Escorial was Alonso Sánchez Coello, better known for his portraits than for his religious paintings.

Sánchez Coello was born in Benifayó (Valencia), but while he was still a child, his parents moved to Portugal, where his grandfather lived. After finishing his apprenticeship in Lisbon, he went to Flanders to perfect his painting skills with Anthonis Mor (c. 1517/20–1576), painter to Emperor Charles V. Mor had gone to Lisbon in 1550 to portray the king of Portugal and the royal family, and Sánchez Coello probably left with him when the Flemish painter returned to Brussels. He remained with Mor from 1550 to 1554, and then returned to Spain to settle at the court, where he was immediately named Painter to the King.

It is to portraiture that Sánchez Coello owes his well-deserved fame, for in this field he is as eminent as such contemporary Flemish painters as Frans Floris (c. 1518–1570) and Frans Pourbus (1545–1581), and outstrips by far the more famous Frans Pourbus the Younger (1569–1622), whose success throughout Europe as court painter was eclipsed only by Rubens's emergence in that field during the first decade of the seventeenth century.

An important function of Sánchez Coello's post as Painter to the King was to portray him periodically for various purposes, but although some of his portraits of Philip II are known through seventeenth-century descriptions, not a single unquestioned likeness of the king is extant today. On the other hand, several portraits of the rest of the royal family painted throughout the artist's career, including the superb likeness of the ill-fated Don Carlos, of 1564 [3], have come down to us. From them one may glean his approach to courtly portraiture and its evolution.

Among the early portraits, that of the king's sister, *Margaret of Parma* [4], painted c. 1555, stands out as one of the artist's most attractive works. Apart from its technical brilliance and the ornamental quality Sánchez Coello imparts to the rendering of Margaret's apparel, it also captures vividly the sensuous character of this woman's beauty. Her portrait is also interesting because of the symbolic device introduced by the artist to express a specific aspect of the sitter; Margaret of Parma, then Governor of the

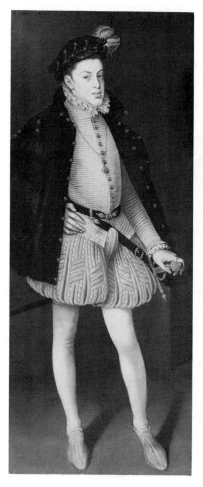

3. *Alonso Sánchez Coello:* Infante Don Carlos, *Vienna, Kunsthistorisches Museum*

4. *Alonso Sánchez Coello:* Margaret of Parma, *Brussels, Musées Royaux des Beaux-Arts*

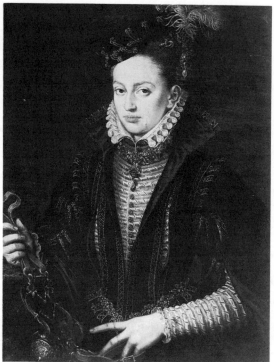

Netherlands, is shown holding an elaborate bridle, a common symbol of restraint and of the virtue of temperance, attributes of good government.

In the portrait of Philip II's favorite daughter, the *Infanta Isabel Clara Eugenia,* at the age of twelve or thirteen [5], the elegance of the child and her imperious look (even though overlaid by good humor) leave no doubt about her station in life. In this later picture, dated 1579, the garments of the sitter do not have the ornamental value given to those in Margaret of Parma's portrait or in the portrait of Philip II's third wife, Isabel of Valois (Vienna, Kunsthistorisches Museum), painted slightly later, c.

1560. In those earlier pictures, the visual attraction of the costumes does not displace the viewer's attention from the likeness to the apparel of its wearer, because the sitters' faces are vividly characterized and retain their primacy. In the portrait of Isabel Clara, instead, the rich dress is deliberately subordinated to the Infanta's face; it is still described in detail, but it is given less life and substance.

In the portrait of *Infante Don Diego* [6], dated 1577, Sánchez Coello elaborates more than usual the figure's setting, which usually is a neutral ground. Here, the boy stands in a defined environment: the corner of a room with a door that opens out on a balcony. But although Don Diego's setting is fully described, his lighted figure is still silhouetted against a dark background, as in most other portraits by the artist. In this likeness, Sánchez Coello presents us the prince—who was no more than two years old at the time—in his role as heir to the Spanish throne. Don Diego is depicted holding a spear in his right hand and the reins of a toy

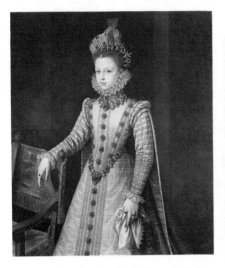

5. *Alonso Sánchez Coello:* Infanta Isabel Clara Eugenia, *Madrid, Museo del Prado*

6. *Alonso Sánchez Coello:* Infante Don Diego, *England, private collection*

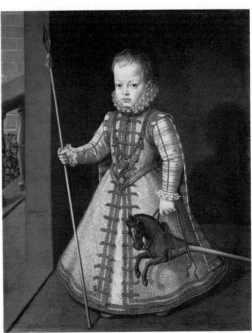

horse in the left, in a probably deliberate recall of Titian's eques-
trian portrait of the prince's grandfather, Emperor Charles V
(Madrid, Museo del Prado).

In the two later works, Sánchez Coello stylizes the render-
ing of the model's costume, giving it less three-dimensionality and
less-defined textural qualities. The garments become primarily a
symbol of status and are less appealing formally, receding in picto-
rial importance in relation to the head. The somewhat earlier
portrait of Philip II's fourth wife, *Queen Ana of Austria* (Vienna,
Kunsthistorisches Museum), dated 1571, maintains a measured
balance between pattern and volume, between the dominance of
the head and the symbolic and illustrative functions of the gar-
ments. If the portrait of Margaret of Parma is one of Sánchez
Coello's warmer and more expressive likenesses, that of Queen
Ana is certainly the most regal.

In his undisputed portraits of the royal family and of other
personages outside the Hapsburg dynasty, Sánchez Coello com-
bined the technical perfection and minuteness of detail of the
Flemish school, with an observation of the human side of his
sitters that transcends the sober appearance and reserved manner
imposed by the rigid etiquette of the Spanish court. His courtly
portraits do not always attain the psychological penetration of
Anthonis Mor's, but they embody perfectly, instead, the ideal of
composure and dignity that would remain valid in Spanish portrai-
ture until the end of the seventeenth century.

After Navarrete's death in 1579, the execution of the re-
maining altarpieces of the basilica of El Escorial originally assigned
to him were distributed between Sánchez Coello, Luis de Carvajal,
and Diego Ampuera de Urbina, who painted them between 1580
and 1587. Sánchez Coello's eight canvases were executed between
1580 and 1582. These altarpieces attest to the perfection of his
Netherlandish technique, comparable to that of the best Flemish
masters of his time. He also shared with some of these, such as
Frans Floris and Marten de Vos, an Italianizing idealism and their
admiration for Venetian coloring. Side by side with clearly ideal-
ized portrayals, as appear in *Saint Jerome and Saint Augustine* [7],
however, he painted heads which are obviously studied from life,
and are as finely characterized as any of his court portraits.

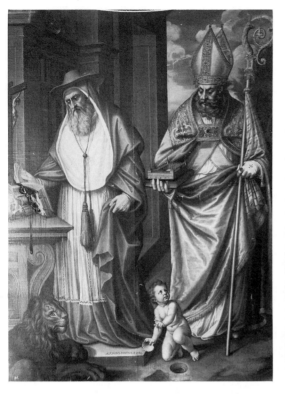

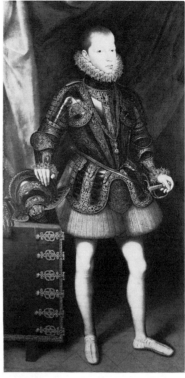

7. *Alonso Sánchez Coello:* Saint Jerome and Saint Augustine, *El Escorial, Basilica*

8. *Juan Pantoja de la Cruz:* Infante Don Felipe in Armor, *Vienna, Kunsthistorisches Museum*

JUAN PANTOJA DE LA CRUZ (1549/53–1608)

After Sánchez Coello's death, his successor in the field of courtly portraiture was his faithful pupil Juan Pantoja de la Cruz, who continued developing his master's models without, however, attaining his pictorial quality or his ability to give life to his sitters.

No paintings can be attributed with certainty to Pantoja before Sánchez Coello's death in 1588. His earliest datable and dated works are from c. 1590/92 and 1593, when Pantoja was about forty years old and his style was already formed. Characteristic of this period is the portrait of *Infante Don Felipe in Armor,* of c. 1592 [8], whose compositional prototype was first established in Spain by Titian's *Philip II in Armor* (Madrid, Museo del Prado), of c. 1559. In its style and technique, Pantoja's *Infante* remains quite

close to Sánchez Coello, and the modeling of the forms and relative suppleness of the pose still recall his master's portraits.

With the passage of time, Pantoja's work became harder and less expressive, so much so in his later portraits that the persons portrayed are almost exclusively defined by the richness of the costumes and the formality of the poses. In most of his portraits, the details of costume prevail visually over the description of the individual, and this dominance of pattern, together with the stylization of the model's features and the impassivity of their expressions, results in a flattening out of the image of the sitter, both literally and psychologically. Only exceptionally does the personality of the sitter emerge over the complex pattern of lace, embroidery, and jewels that makes up the figure. Such is the case of the 1599 portrait of Isabel Clara Eugenia at the age of thirty-three, whose lively character was also captured at various times in her life by Sánchez Coello and Rubens.

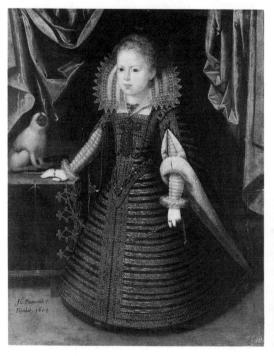

9. *Juan Pantoja de la Cruz:* Infanta Ana of Austria, *Vienna, Kunsthistorisches Museum*

10. *Juan Pantoja de la Cruz:* Fray Hernando de Rojas, *Madrid, Duquesa de Valencia Collection*

Pantoja's production over the last eight years of his life was considerable; it is known that he painted dozens of portraits of the royal family, plus many more of important personalities in Philip III's court. Among the most successful of his royal portraits is the *Infanta Ana of Austria*, of 1604 [9], in which the hardness of Pantoja's style and his emphasis on the ornamental design of the costume are softened by the girl's pretty face and the presence of a small monkey, which she holds by a fine chain.

In Pantoja's portraits of less exalted sitters, such as that of the Augustinian friar Hernando de Rojas, rector of the College of Doña María de Aragón [10], we discover an unsuspected physical and psychological realism and a softer technique. In this likeness, in contrast with the court portraits, it is the head that receives all of the artist's and the viewer's attention.

Although the greatest part of Pantoja's production consisted of portrait paintings, he also executed religious works in a Late Mannerist style in which contrasts of light and dark played an important role. This chiaroscuro, even though contemporary with Caravaggio's, cannot be associated with the work of the Italian master, and relates, rather, to Venetian and Lombard painting of the late sixteenth century, also part of Caravaggio's background. Pantoja's religious works, of which the *Birth of the Virgin* of 1603 (Madrid, Museo del Prado) may serve as an example, reveal a solid artistic training, but we know nothing about where or with whom he obtained it. Since our information about Pantoja's life goes back only to 1585, the year of his marriage, it is tempting to assume that his style was formed in northern Italy during the preceding years.

There is an interesting facet of his art, still-life painting, which we know only thanks to a preserved inventory of his possessions. Unfortunately, either none of his still lifes has survived or they have not been recognized as his work. Since these pictures are described in the inventory as "Italian still lifes," it has been suggested that they may have reflected those of the Cremonese Vincenzo Campi (c. 1530/5–1591). This would fit in with a possible stay in Italy and a firsthand knowledge of Lombard painting. The still lifes mentioned in the document, probably not the only ones he executed, were painted in 1592, which would put them among the first works of this genre in Spanish painting.

🝔 El Greco (1541-1614)

The only Spanish painter of the sixteenth century to enjoy today universal fame is El Greco, who, as his name suggests, was not a native of Spain. Moreover, his style had been formed in Italy before he settled in Toledo at the age of thirty-six, and it was totally foreign to the local artistic tradition. Nonetheless, El Greco can rightfully be regarded as one of the foremost painters of his adopted country, because it was in Toledo where he reached artistic maturity, and where he painted the works that would give him the high repute he enjoyed then and again enjoys now. His successful career and the manner in which his style developed were also inextricably bound to the patronage he would find in that Spanish city, and to the isolation from contemporary Italian art in which he worked there.

Born Doménikos Theotokópoulos in Candia, capital of Crete, in 1541, his first artistic formation took place within the tradition of Byzantine art, which was still current on his native island. Of the works he may have executed in a late Byzantine style, however, none has been recognized, although in 1566 he is mentioned as a master painter in Candia. Not long after that date, in 1568, El Greco's presence is already recorded in Venice, under whose political hegemony Crete was at that time. In the three and a half years of his residence there, El Greco would undergo a very different artistic education, which transformed him into a painter of the Venetian school.

Although some years later the miniaturist Giulio Clovio

referred to him as a "disciple of Titian," such a relationship is not factually documented and is quite improbable; El Greco's Venetian works are as close or closer to the paintings of Tintoretto than to Titian's, of whom he was a disciple only in generic terms. The pictures of this period, of small format and painted in tempera on panel [11], reveal his beginnings as an icon painter, but they also show his absorption of the new Italian style that had been shaped in Venice at this particularly fortunate moment, when not only Titian and Tintoretto but also Veronese and the Bassanos were active.

In 1570, already in possession of the painterly technique and rich coloring of the Venetian school, El Greco went to Rome to gain command of the human figure. There he established contact with Giulio Clovio, the artist responsible for the Michelangelesque illuminations of the *Farnese Book of Hours,* who became his protector. The few paintings of this period by El Greco that have come down to us show the increasing incorporation into his Venetian style of the artistic models of Renaissance painting in Rome.

Although El Greco entered the Farnese circle through his friend Clovio, his artistic career did not develop in a satisfactory manner, so in 1576 he decided to leave Rome in search of better

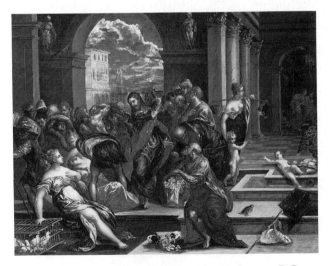

11. El Greco: Purification of the Temple, *Washington, D.C., National Gallery of Art*

opportunities elsewhere. His choice of Spain as the most promising destination to reward his ambition is not surprising, for Philip II, a great lover of Titian's painting and the richest sovereign in Europe, had already undertaken the pictorial decoration of El Escorial, for which he needed the collaboration of the best available artists. As has already been noted, the king turned his eyes to Italy as the prime source of painters for this enterprise, and El Greco, as a painter of the Italian school, could therefore expect a warm welcome from the king. This was not to be, however, and it was only in 1580 that El Greco was able, at long last, to obtain a royal commission for an altarpiece in El Escorial.

Although it is likely that on arriving in Spain El Greco may have gone to Madrid, where the court was then in residence, the earliest notice we have of him is in July 1577, when he was already at work on one of his two first important commissions in Toledo. This was the large *Disrobing of Christ*—a very infrequent subject among the images of the life and passion of Christ [12]—which he painted for the sacristy of its cathedral.

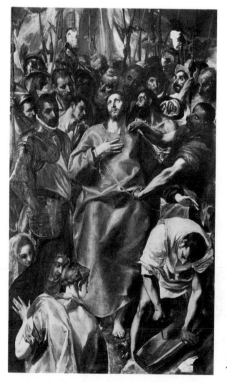

12. *El Greco:* Disrobing of Christ, *Toledo, Cathedral*

Even though the rich and brilliant color of the *Disrobing*, and the daring brushwork with which the heads around Christ are defined are strictly Venetian in origin, the composition also reflects central Italian Mannerist painting in its compression of space and strong verticalism. As in Mannerist paintings, there is a similar density of figures on the picture plane, and a centripetal pressure of their forms toward the edges of the composition. The emotional expressiveness, the passionate force of the image, however, are El Greco's own, and they must have had a powerful impact within the mediocre artistic environment of Toledo at the time.

This splendid picture, in which El Greco's unmistakable artistic personality is already revealed, was the object of the first of many disputes concerning payment for his works that the artist was to have throughout his career, but it also established immediately his reputation as the most outstanding painter in Toledo.

At the same time that El Greco worked on the *Disrobing of Christ*, which he would finish in 1579, he was also painting the pictures for the high altar of the church of Santo Domingo el Antiguo, and the altarpieces for its two side altars. This had been the project that had actually taken him to Toledo, since the commission stipulated that the artist had to reside in that city during its execution.

The iconography of the main altarpiece was designed to express the devotion to the Virgin Mary of the deceased donor, Doña María de Silva, and her faith in man's redemption through the blood of Christ. The *Assumption of the Virgin* [13], in which she is represented as the Immaculate, was its central picture, and the *Holy Trinity*, depicted as the Throne of Mercy [14], was placed above it, in the second story of the retable. The *Sudarium*, Veronica's veil with the imprint of Christ's face, was in a cartouche above the *Assumption*, and at either side of the latter stood the two Saints John (the only pictures still in situ), both frequently associated with the Virgin. Above them were represented Saint Benedict and Saint Bernard, saints who were de rigueur in a convent of Bernardine nuns, one as the founder of the Benedictine order, and the other as founder of its offshoot, the Bernardine order. Most of these paintings are now dispersed among various collections, and one of them has been lost. For the lateral altars

of the church, El Greco painted a *Nativity* and a *Resurrection* (in situ).

The two principal pictures in this group of paintings, the *Assumption of the Virgin* and the *Holy Trinity*, are even more representative than the *Disrobing* of El Greco's new manner, with its blend of Venetian colorism and references to the art of Rome. The composition of the *Trinity*, in which Christ and God the Father are presented in a pietà configuration, is based in general terms on the Dürer woodcut of 1511 of the same subject, but Christ's body is of clear Michelangelesque descent. Although we know that El Greco was critical of Michelangelo's painting, we also know that he admired this artist as a great master of *disegno*, and in this case the pose and physical structure of Christ (clearly sculpturesque) make direct reference to several figures by the Florentine master.

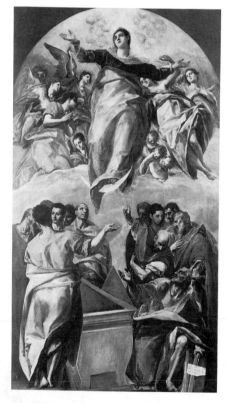

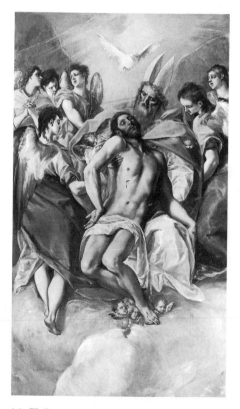

13. El Greco: Assumption of the Virgin, *Art Institute of Chicago*

14. El Greco: Holy Trinity, Madrid, Museo del Prado

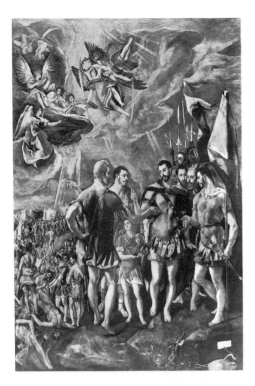

15. *El Greco:* Martyrdom of Saint Maurice and the Theban Legion, *El Escorial, New Museums*

Such formal references in both paintings, however, do not make them as a whole less expressive of El Greco's own personality. In the *Trinity,* among other things, we can already see the purplish reds and acid olive-greens that are so characteristic of his palette. In the *Assumption,* the draperies that envelop the Virgin, the angels, and the apostles obscure and flatten out their bodies, and the juxtaposition of the figures denies the existence of space between them, features also distinctive of his style.

In both the Disrobing of Christ and the *Assumption,* there are heads which are obviously individualized portraits, sprinkled among the idealized heads of most of the figures. In the latter, besides the heads of some of the apostles that are obviously taken from the model, there is a portrait of a small child on the left looking straight at the viewer which it is tempting to imagine as that of his son Jorge Manuel, born in Toledo in 1578 from El Greco's union to Doña Jerónima de las Cuevas.

The royal commission that El Greco had hoped to receive from Philip II when he went to Spain came at last in 1580. It was for a large picture, the Martyrdom of Saint Maurice and the Theban Legion [15], to be placed on one of the more important altars of

the church of El Escorial, as a pendant to the *Martyrdom of Saint Ursula,* painted earlier by Luca Cambiaso. El Greco's extraordinary picture is still in El Escorial, but not in the place for which it was originally intended. Philip II did not regard it as acceptable, and had another one of the same subject painted in 1584 by Romolo Cincinnato, one of the Italian painters then in residence at El Escorial.

The rejection of this picture by as fine a connoisseur of art as Philip II is difficult to understand from a modern point of view, and has been frequently attributed to the lack of decorum—of propriety, in religious terms—in El Greco's interpretation of the subject. This impropriety would presumably be his displacement of the decollation of the martyrs to the middle ground, in order to concentrate attention instead on the elegant figures of the saint and his companions, engaged in expressive discussion in the foreground. The painting by Cincinnato commissioned to replace it, however, is no less Mannerist in its emphasis on the balletic stances of the foreground figures; the composition of the scene and the poses of the principal actors in the two works are, in fact, very similar. To this one should add that El Greco's approach, stressing the Christian virtues of meekness and steadfastness in the soldiers, and not their bloody punishment, is perfectly orthodox. It is a great deal more likely that what Philip II found objectionable in this picture was El Greco's style, and not his interpretation of the subject matter, for the latter aspect could have been controlled in subsequent works, while the former belonged to the essence of the painter's art, and was ineradicable. The direction in which Philip II's taste in painting lay can be gauged by his passion for the art of Titian—an art of natural colors and normative forms—and the *Martyrdom of Saint Maurice* is already very far removed from that Renaissance canon. El Greco did not receive any other commissions from the king.

After this failure in his expectations of success at court, El Greco settled definitively in Toledo, where his reputation was firmly established, and there he would remain for the rest of his life.

The most famous of El Greco's works is probably the *Burial of the Count of Orgaz* [16], painted in 1586–88. This great picture

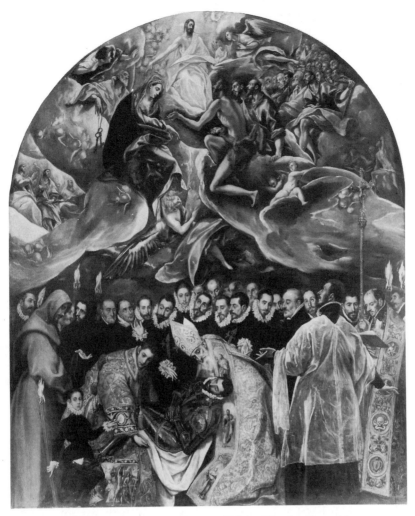

16. *El Greco:* Burial of the Count of Orgaz, *Toledo, Church of Santo Tomé*

was executed for a rather modest location, the church of Santo
Tomé in Toledo, for which it was commissioned by its parish's
priest. The painting was to honor the memory of Don Gonzalo de
Ruiz, Lord of Orgaz (d. 1323), the long-dead benefactor of Santo
Tomé, whose generosity had also extended to the Augustinians of
San Esteban. According to a local tradition, on the day of the
funeral of that pious gentleman, Saint Augustine and Saint Ste-
phen had miraculously descended to earth to give him burial, and
that is the scene that El Greco was to paint, adhering to a brief
but detailed description that was part of the contract for the work.

The central image of the *Burial of the Count of Orgaz* shows
the two saints, dressed in rich dalmatics and capes, at the very

moment that they lower into his tomb the body of the count, dressed in damascened armor. The foreground space where they stand is shared by Saint Francis, who watches the descent; a child (undoubtedly Jorge Manuel at the age of eight), who looks at us and points toward the count; and the assisting priest in white alb, who points out the miraculous event and looks up in wonder toward the heavenly glory, where an angel carries aloft the soul of the count. The religious content of the picture is expressed in this counterpoint of glances and hand gestures: the generous Lord of Orgaz was worthy of the miraculous apparition of the two saints, and of eternal life, for his renowned charity (the Franciscan represents the oldest mendicant order); the assisting priest brings this lesson to our attention, and the child points to the count as a model of conduct.

After the advent of Protestantism, the Catholic Church placed great stress on the value of good works—particularly the exercise of charity—as an instrument of salvation, reaffirming the doctrine of free will that had been rejected by the Protestants. The efficacy of saints as intercessors for man before God, a doctrine also impugned by the Reformation, is prominently advertised in the glory that crowns the scene, where the Virgin and Saint John the Baptist plead for the count's soul.

In the middle ground, El Greco painted a gallery of portraits of Toledan gentlemen dressed in the Spanish fashion of the period, their black garments bringing out the brilliant color of the figures in the foreground. Among these men is Antonio Covarrubias, the distinguished scholar and friend of El Greco who would be portrayed again by him some years later. The figure directly above the head of Saint Stephen, the only one besides the child to look at the spectator, has been identified as El Greco himself, but this identification does not have a solid basis.

In the *Burial*, El Greco uses two different modes to represent the divine and the human spheres, and the glory makes clear that his antinaturalist style had been fully developed by this date. Although in the earthly realm his figures have somewhat elongated proportions, and the spatial construction of the group denies them volume and breathing space, they still retain sufficient mass to be read as men of flesh and blood, and, more important still to their appearance of reality, their garments are painted in the best Vene-

tian illusionistic technique. In the glory, on the other hand, the tendencies toward his own, idiosyncratic brand of Mannerism, which were beginning to emerge in the *Disrobing of Christ* and the retable for Santo Domingo, and were even more apparent in the *Martyrdom of Saint Maurice*, reach a critical point. The figures in this half of the picture, of which Saint John the Baptist is the most notable example, have extremely attenuated proportions, and the representation of mass and spatial intervals prevents any rational reading of their space, since the indications of distance and the placement of figures are either ambiguous or downright contradictory. The clouds here already have that protoplasmic appearance that is a distinctive feature of El Greco's late paintings, and all surfaces, be they flesh, cloth, or clouds, seem to share an identical texture and consistency.

In the *Crucifixion with Two Donors* (Paris, Musée du Louvre), a picture that belongs to this same period (c. 1585–90), the stylistic break between the human and the divine spheres is also evident. As in the *Burial*, El Greco creates in the *Crucifixion* a marked contrast between the realism of the portraits of the unidentified donors and the idealized figure of Christ, in whom no trace of suffering can be seen. This contrast, in conjunction with the absence of the landscape usual in his Crucifixions, stresses the devotional, rather than illustrative, character of the work.

Among the most frequently repeated devotional images painted by El Greco are those of saints presented in attitudes of contrition or spiritual meditation; the Repentant Magdalen, Saint Peter in Tears, the Penitent Saint Jerome, Saint Dominic in Prayer, Saint Francis in Meditation are reprised time and time again. Most of these images were subjects of El Greco's own creation, inventions that would be later perpetuated in the work of seventeenth-century Spanish painters. That is the case of his image of Saint Dominic in Prayer and, above all, of his different versions of Saint Francis in Meditation.

Until this time, the most frequent depiction of Saint Francis had been that of the saint receiving the stigmata, a subject that El Greco also interpreted. To the existing repertoire of images of Saint Francis, El Greco now added a type that had been previously associated only with hermitical saints, such as Jerome or the Magdalen: Saint Francis in contemplative prayer before a crucifix and

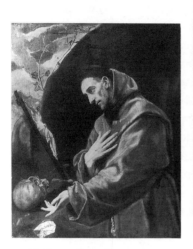

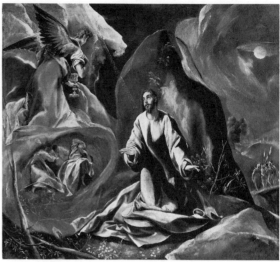

17. *El Greco:* Saint Francis in Meditation, *Barcelona, Torelló Collection*

18. *El Greco:* Agony in the Garden, *Toledo (Ohio) Museum of Art*

a skull, or simply before a skull. In the two principal versions of this subject, the saint appears on his knees, in full length (San Francisco, M. H. de Young Memorial Museum), or standing, in half length [17].

The emphasis on meditation about the impermanence and vanity of life is characteristic of the Counter-Reformatory spirit that imbues religious thought in the latter part of the sixteenth century and the early part of the seventeenth, and it is particularly strong in Spain. El Greco's new images of Saint Francis meditating on death responded to this emphasis, and became the prototypes of those painted in the seventeenth century, most prominently Zurbarán's.

El Greco also painted numerous versions of a subject for which there was a longstanding tradition in Venetian painting, Christ Bearing the Cross, presented as a devotional image, isolated from its narrative context. This subject is given two different forms, but both emphasize Christ's facial expression. In the pictures of larger format, such as the one in New York, Metropolitan Museum of Art, Lehman Collection, of c. 1585–90, Christ appears in half length, almost frontally, and his look conveys resignation and a noble serenity; the suffering man, in communion with the

Father, rises to his divine nature. In the version in which Christ appears *en buste* (e.g., New York, Oscar B. Cintas Foundation), of c. 1590–95, on the other hand, the pathetic factor predominates. Here, the close-up view of the face and the movement and inclination of the head reinforce the image's emotional note.

Almost all of El Greco's narrative paintings depict episodes of the lives of Christ and the Virgin, and he takes up the same subjects, in similar but varied compositions, throughout the entire course of his artistic career. Of the episodes he depicted repeatedly, the *Agony in the Garden* of c. 1590–95 [18] is perhaps the most original. Although the episode of the *Agony in the Garden* had been painted numerous times by other artists—particularly by masters of the Venetian school, such as Bellini, Titian, and Tintoretto—it had never been given such an electrifying rendition. In this composition, unprecedented in Spain or Italy by its expressive force, El Greco utilized the supernatural and emotive elements inherent in the subject to create an image of great spiritual intensity.

Part of the effect of this picture is due to the illumination and coloring that El Greco uses here: a sharp and cold light that bleaches out at the highlights the brilliant reds and blues of Christ's robes. But the impact of the *Agony in the Garden* is also due to El Greco's decidedly abstract rendering of the natural forms of which it is composed. To a greater degree than in other pictures, spatial definition is deliberately ambiguous, and both the figures and the features of the landscape are flattened into sharply contoured, overlapping planes forming a disconcertingly two-dimensional pattern. The piece of sky whose moon sheds light on the approaching soldiers led by Judas, for instance, is superimposed on the rock that frames Christ, bringing those distant figures to the same foreground plane occupied by the protagonist of the drama. Perhaps the most unusual passage of this composition in this respect is the "uterine" cavity that encloses the three sleeping apostles within the cloud on which the angel kneels. El Greco plays here with a spatial equivocation that brings the apostles very close to Christ but, by confining them to what appears to be a closed capsule, also removes them infinitely far from him.

The subject of the *Purification of the Temple* of c. 1568–70 [11], one of the first pictures in which El Greco employed his new Italian manner, was taken up again at other stages of his evolution

as an artist, and this circumstance gives us an excellent view of the transformation of his style through five decades.

Before leaving Italy for Spain in 1577, El Greco had painted a new version (Minneapolis, Institute of Art), in which the composition was clarified and the plastic definition of the figures handled with greater refinement and sureness, developments accounted for by his Roman experience. About 1600, El Greco created yet another version of the *Purification of the Temple* [19], in which the figures occupy greater space in the canvas, both in width and in height, and present a more compact and unified arrangement. Here, the conflation of the different planes where the figures stand organizes their agitated movements into a compact mass of silhouettes that interlock like the pieces of a puzzle. The woman in the foreground in the earlier pictures (an ornamental *repoussoir* figure evocative of similar ones in Titian and Tintoretto) is substituted by a man bending down, locked instead into the overall pattern. In one of the many instances of self-quotation that appear in El Greco's paintings, the bending man reproduces in reverse the executioner in the foreground of the *Disrobing of Christ* [12].

Although the largest number of El Greco's works were painted for a circle of learned and influential patrons in Toledo itself, during the 1590s he also received important commissions from outside the local sphere. One of the largest enterprises of this period was the painting of the principal retable for the church of an Augustinian seminary in Madrid, the College of Nuestra Señora de la Encarnación, better known as of Doña María de Aragón, the name of its founder. Since the executor of Doña María's will, with whose bequest the church was to be finished, had lived in Toledo for some time, it is possible that it was he who thought of entrusting El Greco with the commission. The contract for the work was signed in December of 1596, and the retable, which was made up of several paintings of great size, was delivered in July of 1600.

Only three paintings, the *Adoration of the Shepherds* (Bucharest, Romanian National Museum), the *Annunciation* [20], and the *Baptism of Christ* (Madrid, Museo del Prado), have been unanimously connected to this commission, but some reconstructions of the original ensemble would also include three more pictures on

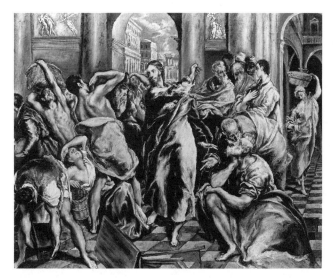

19. *El Greco:* Purification of the Temple, *New York, Frick Collection*

a second story: a *Crucifixion,* a *Resurrection,* and a *Pentecost* (all three in the Museo del Prado). This reconstruction corresponds to the most common configuration of Spanish retables of this period, a fact that recommends its plausibility.

The *Annunciation* for the College of Doña María de Aragón is also a good example with which to gauge the distance traveled by El Greco from his early days in Venice to this moment, when the painter was at the zenith of his career. The little panel of this subject painted before 1570 (Madrid, Museo del Prado), with its deep architectural setting, fits perfectly within the framework of the Venetian school, as does also a larger canvas, with more solid figures and rational space, painted when El Greco was already in Rome (Lugano, Thyssen-Bornemisza Collection). In the great canvas painted for Madrid, we find instead all the stylistic traits of El Greco's later work observed in some of his previous pictures: conflation of the various planes in depth into a single foreground plane; compression of the volumes as in a relief; abstract handling of surfaces and textures of figures and objects; great attenuation of the figures; and a brilliant, cold light playing over the yellowish greens, purplish reds, and leaden blues of their garments. The expressive intensity and the supernatural character of the scene have increased tenfold with respect to the earlier pictures. The Incarnation here has a cataclysmic force; all the ele-

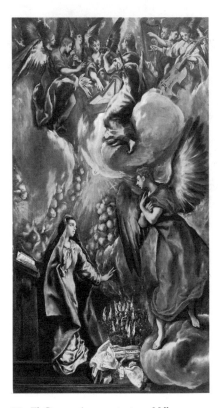

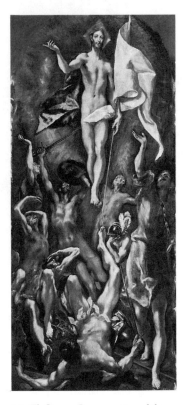

20. *El Greco:* Annunciation, Villanueva y Geltrú, *Museo Balager*

21. *El Greco:* Resurrection, Madrid, *Museo del Prado*

ments that make up the picture appear to be in a state of flux, swept up in a dizzying whorl whose epicenter is the dove of the Holy Spirit.

This *Annunciation* contains an unusual iconographic element, a burning bush seen behind the Virgin's sewing basket. This burning bush is a reference to the one that appeared when Moses met with God at Mount Horeb, which burned with fire but was not consumed (Exodus 3:2–4). The Virgin, like Moses, also received the visit of an angel as the messenger of the Lord, but God now descended to establish the era of Grace, superceding that of Law. The image of the burning bush is also a metaphor for the inviolate virginity of Mary, even at the moment of Christ's conception.

There is a small version of this *Annunciation* by El Greco's hand whose function has been debated; did it serve as a *bozzetto,*

done prior to the execution of the large canvas, or was it a *ricordo*, a replica at a small scale made to preserve a record of the larger work? There are many such small versions of El Greco's large paintings (some of them by his workshop), and Francisco Pacheco mentions in his *Arte de la pintura* (Seville, 1649) that when he visited El Greco in Toledo, the artist had shown him a large room full of "little sketches" of all the works he had executed throughout his life. It is most likely that pictures such as the small version of the *Annunciation* were done as replicas of the large paintings, which in many instances they reproduced in great detail. Since El Greco often had copies of his pictures executed by workshop assistants, these *ricordi* would have been indispensable for the task.

The *Baptism of Christ* (Madrid, Museo del Prado) is a work similar to the *Annunciation* in dramatic intensity. The mystery of the descent of the Holy Spirit, at the moment when the water poured by Saint John touches Christ's head, is rendered by the artist in forms that express its spiritual essence—redemption through grace—in vivid visual terms. The path of light that connects God the Father and the half-kneeling Christ resembles that of a lightning bolt, whose discharge galvanizes the cherubim of the glory. It also contributes to create the effect of instantaneity in the union of the heavenly and earthly spheres at the moment of the baptism.

The size differences among all figures, both on earth and above, is so extreme in the *Baptism* that it produces an almost unbearable visual tension in the spatial reading of the picture, contributing to the mystical character given to the depiction of the event.

The *Resurrection* that probably formed part of the retable of Doña María de Aragón [21] is as extraordinary a composition as the previous two paintings. The traditional sarcophagus or wall tomb, never absent in representations of this subject, is replaced by the bodies of the soldiers that guard it, whose mass fills up without a gap the lower half of the picture. The upper half is almost completely taken up by Christ, flanked by his red mantle and white standard, and surrounded by a luminous aura. Christ appears here suspended in midair, erect and immobile, while the soldiers gesture and topple over with uncontrolled movements, as if overwhelmed by an explosion. El Greco's compression of picto-

rial space here reaches its furthest limit; perspectival space disappears almost completely. Throughout the composition, El Greco manipulates the contours of figures in different planes so that they fit one inside the other, interlocking on the picture plane. Even the exaggerated foreshortening of the fallen soldiers in the foreground functions two-dimensionally. The pose of the figure in the center is of Venetian origin (it is particularly reminiscent of Tintoretto), but it also abounds in Roman Mannerist painting. In the Italian models, however, it is not used in combination with the unspatial meshing of figures on one plane that exists here, and which fights against and destroys the illusion of perspective recession that such foreshortening promotes.

To this same period of artistic activity belong three altarpieces painted by El Greco between 1597 and 1599 for the Chapel of San José in Toledo. The large picture over the central altar represents Saint Joseph with the Christ Child (in situ) and above it is a Coronation of the Virgin, a dense composition in line with the paintings done for Madrid.

The devotion for Saint Joseph is a phenomenon of the Counter-Reformation, and it was particularly strong in Spain, where it was promoted by Saint Teresa of Avila, Saint Peter of Alcántara, and the Jesuit Order. Together with this new devotion, a change in the manner of representing the saint took place: the traditional image of a man of advanced years was replaced by that of a man in the flower of his life, thirty to forty years old. Saint Joseph was presented as the protector of Christ during his infancy and as an example of paternal devotion, at times assuming the role occupied exclusively by the Virgin in earlier works. El Greco's painting stresses the emotive relationship between Joseph and the Child, who throws his arms around the saint and casts a shy glance toward the viewer; Saint Joseph, in turn, caresses the Child with a protective gesture, while looking down at him with great tenderness. The angels flying above Saint Joseph's head carry white lilies, the attribute of purity, and garlands of roses and laurel leaves, symbols of love and triumph. After El Greco, Zurbarán and Murillo would be the painters to represent most successfully the ideal of physical vigor, virtue, and paternal love that characterizes this new image of the patriarch.

The *Saint Martin and the Beggar* [22], which was placed over

one of the side altars of the Chapel of San José, is one of El Greco's best-known pictures, and must also have been much admired in his day, for there are several copies of it. The saint appears on horseback, dividing his cloak in half to share it with the naked beggar, an action that testifies both to his charity and to his prudence.

The principal reason for the choice of the episode of Saint Martin and the beggar for one of the altars in this chapel was that he was the namesake and patron saint of its founder, Martín Ramírez. The choice was also apposite because the saint's action illustrated a work of charity, a virtue for which the founder was well known. Apart from these personal reasons, the theme of charity was the subject of many Spanish pictures from the end of the sixteenth to the middle of the seventeenth century, and this is related to the purposes of the Counter-Reformation. After the Council of Trent, the virtue of charity came to occupy a central position in the church's thinking about salvation. In contrast to Protestantism, which valued little what man could do himself to achieve his salvation, the Catholic Church exalted the efficacy of good works and, first among them, the exercise of charity.

El Greco presents his Saint Martin, who lived during the

22. *El Greco:* Saint Martin and the Beggar, *Washington, D.C., National Gallery of Art*

fourth century of the Christian era, in the damascened armor of his own day, bringing the event to the present and suggesting the timelessness of its message, as he had done in the *Burial of the Count of Orgaz*.

In these two pictures for San José, El Greco painted two views of Toledo beyond the figures of Saint Martin and of Saint Joseph. In that of *Saint Martin*, more rural in character, the bridge of Alcántara is highlighted; in that of *Saint Joseph*, which shows all of the city except what is covered by the figures, we can see the same topographical elements that are present in El Greco's famous *View of Toledo* [23].

The *View of Toledo* is one of the most amazing landscapes ever painted, and its singularity has stimulated a number of critical interpretations that attempt to explain its meaning. Its unusual and highly dramatic appearance, however, is formally and expressively consistent with El Greco's religious works. The extraordinary sky, which contributes in great measure to the cataclysmic quality of the landscape, is very similar to those that can be seen in many of his religious works, and the violence with which the landscape itself seems rent is a result of his compositional methods. The way in which the painter disposed the various land masses and

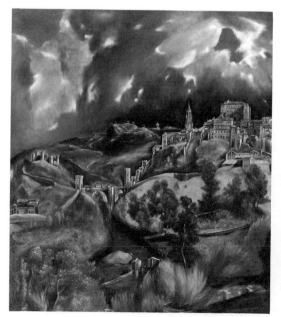

23. *El Greco:* View of Toledo, *New York, Metropolitan Museum of Art*

24. *El Greco:* Saint Jerome as a Cardinal, *New York, Frick Collection*

accidents of the terrain is essentially like his method of composing the group of figures in the *Resurrection* [21], and it creates a formidable tension between the silhouettes on the picture plane and the three-dimensional volumes and space that are implicit in such a view. The use of the cold greens and leaden blues typical of his palette also accentuates the distinctiveness of the *View of Toledo*, and contributes to the transcendental aura that attaches to this painting.

Unlike the *View and Map of Toledo* (Toledo, Museo del Greco), of c. 1608–14, both cartographically correct and more clearly emblematic in intention, this *View of Toledo* does not present a realistic panorama of the city and its environs as seen from a particular point of view. It displays instead all of its most notable monuments—primarily the Alcázar, the cathedral, and the Roman bridge of Alcántara—in a single image that highlights the past and present grandeur of El Greco's adopted city. His painting, more subtly than the ostensibly emblematic city views of the sixteenth century, is a brilliant and proud symbol of Toledo.

Saint Jerome as a Cardinal [24], also a work of this period, introduces a novel format for the rendering of a very common subject in Christian art, that of Saint Jerome as translator of the Bible. Since the Middle Ages, the saint had been represented as a scholar working in a study amidst his books or, alternatively, as a half-naked penitent hermit in the desert, accompanied by the lion from whose paw he had removed a thorn. Occasionally, these two views of the saint were blended by incorporating the books into the desert setting or, more frequently, by introducing the lion into the study. El Greco presents him for the first time in the form of a half-length portrait of a cardinal.

Saint Jerome is shown seated behind a table on which lies an open book, his hands resting on its pages and his thumb marking the place of the marginal note he was studying. In this simple image, El Greco expresses the two aspects of the saint, the ascetic, which is denoted by his uncut beard, emaciated face, and severe mien, and the intellectual, suggested by the nature of his activity and the faraway glance that he casts on the intruder, on our side of the picture plane, who has interrupted his reading.

The portrait formula that El Greco employs in this effigy of Saint Jerome had appeared in both Northern (Flemish and

German) and Italian portraiture in the sixteenth century; a figure in half length behind a table or parapet appears captured in the midst of a momentary gesture, as if the irruption of the viewer before the subject had distracted him from his customary activities. Portraits of this type were most probably known by El Greco; his genius is manifested in his application of this convention to the representation of a saint in order to bring him close to the observer, with whom he now shares a common space and time.

This portraitlike interpretation of Saint Jerome is also found in the apostle pictures painted by El Greco from about 1585 to the end of his life [25]. These half length figures originally were part of a series that depicted in separate images the twelve apostles and the Savior, six apostles flanking Christ at either side, possibly all aligned on the same wall, or else with the apostles on two walls facing each other and Christ on the end wall. These *Apostolados* are an iconographic novelty in religious art which appears during the Counter-Reformation, and El Greco is the artist who sets the pattern for such series and popularizes them in Spain. Following his example, Rubens would paint an apostle series for the Duke of Lerma c. 1610–12, and Ribera would execute several of them about the middle of the seventeenth century.

The novelty of El Greco's *Apostolados* is not so much the idea of showing Christ flanked by the twelve apostles, but of

25. *El Greco:* Saint Thomas, *Toledo, Museo del Greco*

presenting the latter in the guise of portraits, individualizing each of them in their physical appearance and personality, and giving them in this way some degree of contemporaneity. (Their portrait-like character is in part responsible for one of the many absurd ideas that El Greco's paintings have inspired in the layman: that these saints were likenesses of the inmates of a local insane asylum.) Christ, more idealized, is shown with his right hand raised in a gesture of blessing and his left resting on the orb of the world, as a Salvator Mundi, a type popular since the beginning of the sixteenth century.

The paintings executed by El Greco between 1603 and 1605 for the church of the Hospital de la Caridad in the town of Illescas are very well documented, and many details are known about the commission. Most of them are of an unpleasant sort, revolving on the patrons' dissatisfaction with the *Madonna of Mercy*, and the controversy between the artist and the hospital over the size of the payment he was to receive for his work. Such disputes were quite frequent throughout El Greco's artistic career in Toledo, since the sums at which his works were appraised when finished were always smaller than what El Greco judged appropriate. In Spain, unlike in Italy or Flanders, contracts drawn up for the execution of artistic works did not fix a sum concerted beforehand between the artist and the patron as payment for them; instead, the paintings were appraised at the termination of the work by a commission formed by painters or other qualified experts, named by the artist and the patron to represent their respective interests. The consequence of this practice, which placed the artist at a disadvantage, was that El Greco was never satisfied with the amounts set by these appraisals, and on various occasions tried to obtain a better fee by taking legal action, a course that never achieved the desired result. In this case, to make matters worse, the appraisers had been named exclusively by the hospital.

The four paintings for Illescas—a locality halfway between Madrid and Toledo—are among the painter's most unusual creations. Although they are still at the Hospital de la Caridad, their present location is not the original one, and what their original placement may have been is still a matter of dispute. The pictures are the *Madonna of Mercy;* the *Coronation of the Virgin,* of oval shape; and the *Annunciation* and the *Nativity,* both tondos. In all

of them, but particularly in the last three, El Greco made use of the *di sotto in sù* (worm's-eye view) perspective frequent in Venetian painting, which makes it likely that the *Madonna of Mercy* was set in the attic of the high altar retable, and the other three placed in the center of the presbytery's vault and in the arches of its side walls. The compositions are also adapted to the circular shape of the canvases, so that they have the effect of images reflected in convex mirrors.

In the *Nativity* [26], the assumed vantage point of the viewer, from which the head of the ox occupies the foreground, is also a singular feature. To the unusual format and perspective of this picture, El Greco adds an intense chiaroscuro; the body of the Child, revealed by Mary, is the luminous center of the nocturnal scene. In spite of the dramatic quality which these devices give to the picture, the *Nativity* presents an essentially poetic vision of great tenderness: Mary and Joseph's adoration of the Child in the intimacy of the manger.

El Greco's technique in these works is astonishingly free; in the *Coronation*, where the principal figures are enveloped by a whirlwind of clouds and cherubs, these are executed with such a loose and open brushwork that seen from close up their forms are almost undecipherable.

There is also another painting by El Greco in a side altar of the church in Illescas, a full-length *Saint Ildefonso Writing* [27], almost certainly painted before the pictures for the presbytery, since it is not likely that after the difficulties the painter had gone

26. *El Greco:* Nativity, *Illescas, Hospital de la Caridad*

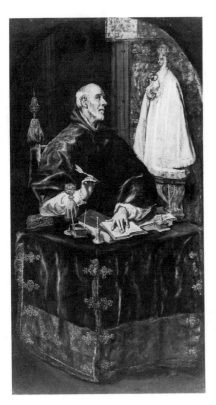

27. *El Greco:* Saint Ildefonso Writing,
Illescas, Hospital de la Caridad

through with the appraisal of the latter he would have undertaken
to paint still another picture for the hospital.

Saint Ildefonso, seventh-century bishop and patron saint
of Toledo and, according to tradition, founder of the convent at
Illescas as well, is most frequently represented at the moment of
the miraculous imposition of a chasuble by the Virgin herself, the
reward for his writings in defense of her perpetual virginity. Here,
instead, El Greco represents him at work on a text, sitting at a desk
in his oratory, where an image of the Virgin of Charity (a carved
figure in the Hospital of Illescas) can be seen in the background.
The iconography of El Greco's picture, in which the saint holds
his pen poised in midair and glances upward, as if he were receiv-
ing inspiration from above, derives formally from images of the
evangelists that go back as far as Byzantine manuscripts, and is
perhaps compounded with medieval and Renaissance depictions
of Saint Jerome in his study. Here it serves to stress the merit of
Saint Ildefonso's theological work more than its reward, present-
ing him as a model of erudition at the service of faith.

El Greco's *Saint Ildefonso* at Illescas, like his half-length

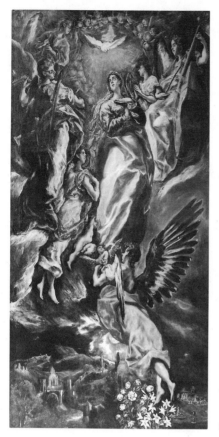

28. *El Greco:* Assumption of the Virgin, *Toledo, Museo de Santa Cruz*

Saint Jerome [24], suggests a portrait likeness, and would serve as an inspiration to many a Spanish seventeenth-century painter in the depiction of erudite holy men [99].

The decoration of the Oballe chapel in the church of San Vicente in Toledo, initially meant to consist of frescoes by a little-known painter, was eventually undertaken by El Greco c. 1607–13; for it he was to paint one of the most beautiful works of his last years: the *Assumption of the Virgin* now in the Museo de Santa Cruz [28].

The identification of this painting as an Assumption has been questioned, due to the presence in the landscape (again a view of Toledo) of the traditional Marian symbols of the Immaculate Conception. El Greco's image, however, with the ascending Virgin raising her eyes toward the Holy Spirit, and roses and lilies falling to fill her grave below, is perfectly suitable for an Assump-

tion; his *Assumption* for Santo Domingo [13] also includes a standard feature in all Immaculate Conceptions, the crescent moon at the Virgin's feet.

A comparison between this late *Assumption* and that for Santo Domingo, painted thirty years earlier, makes clear what aspects of El Greco's painting remained constant throughout this span of time, and what changes took place as the result of his artistic evolution.

Venetian coloring, to which are added the yellowish greens and grayish blues favored by the central Italian Mannerist painters, is one of the constants in the artist's work, even though here it appears in a context of greater light-and-dark contrasts. The compression of the space, already visible in the *Assumption* of 1577, is also an integral part of El Greco's way of composing, but in the later work it has increased considerably. The elongation of the figures' proportions, present to some extent in the early altarpiece, goes well beyond the limits of the possible in the late *Assumption*. The figures' bodies in the latter, besides, are dematerialized in comparison to the early picture; their arbitrary and apparently malleable shapes can barely be guessed under their robes. What has disappeared altogether in this late painting is El Greco's references to Italian Renaissance art, such as the echo of Michelangelo's Saint Bartholomew from the *Last Judgment*, evident in the apostle on the right of El Greco's first *Assumption*. When artistic quotations appear in El Greco's late works, the sources are his own paintings.

If Santo Domingo's *Assumption* already reveals El Greco's artistic personality, his style is nonetheless still within the aesthetic boundaries of Renaissance art as expressed by the sixteenth-century theoreticians. In the San Vicente *Assumption*, on the other hand, El Greco carried to its ultimate limits the antinaturalism that characterized his painting in Toledo from the beginning, attaining a degree of abstraction in the treatment of his visual material that disconnects it decidedly from earthly reality. This abstraction is not just the result of a cerebral, aesthetic purpose coldly pursued; it is also charged with intense emotion. In El Greco's late works, matter appears to have been transmuted into pure spirit.

Probably the most obvious characteristic of El Greco's art is indeed its spirituality, and it is tied to the progressive movement

in his work away from any reference to nature. This approach toward representation, most marked in the pictures painted in the first two decades of the seventeenth century, separates it radically from the new artistic movements that had been formulated in Italy already by the last decade of the sixteenth. If one compares his *Assumption* of c. 1607–13 with the painting of the same subject by Annibale Carracci in Santa Maria del Popolo, Rome, of 1601, or with the *Death of the Virgin* by Caravaggio (Paris, Musée du Louvre), of 1604/5, both painted in Rome, it is clear that they belong to a different world from El Greco's; the two opposite poles of Italian Early Baroque art embodied in Annibale's and Caravaggio's works are closer to each other than to El Greco's picture. In Italy, artistic thinking and practice had been revitalized by a return to the study of nature and of Classical art; the art of El Greco is that of a painter of genius working in isolation, away from the progressive currents of Italy's artistic centers, and developing his Mannerist style to a level of idiosyncrasy unthinkable elsewhere.

If El Greco was able to develop his unique style, it was partly because there was no school of painting in Toledo when he arrived there that offered a valid alternative, nor painters of high enough caliber who could give him competition. To this must be added that in Toledo, the most important stronghold of the Spanish Church, he was able to find an audience consisting to a large extent of prelates and administrators of religious institutions, who were men of refined tastes and appreciated the quality of his art. Most important, they also found their requirements for decorum and spirituality in the presentation of sacred subjects well served; for though the formal vocabulary of El Greco was idiosyncratic, the doctrinal content of his canvases was always strictly orthodox.

El Greco's last version of the *Purification of the Temple* [29], a work painted near the end of his career (c. 1610–14), also makes a vivid contrast with his earliest picture of the Purification, painted in the Venetian mode a little before 1570 [11], and with that of c. 1575 (Minneapolis, Institute of Art), which followed it. His last essay on the subject, on the other hand, is very close to the *Purification* painted about 1600 [19] in the handling of the mass of figures surrounding Christ. Only on the left does El Greco add two figures (perplexingly small) which were not present in any of

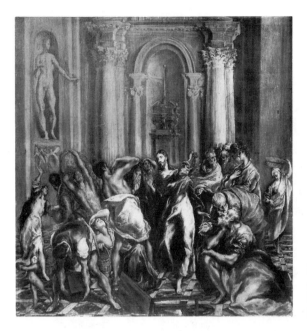

29. *El Greco:* Purifi-
cation of the Temple,
*Madrid, Church of San
Ginés*

the earlier versions. The most notable differences between this
painting and the previous version are the almost square propor-
tions of its composition and the design of the temple's architec-
ture, which is simpler (except for the floor pattern) but also more
important visually.

In this *Purification,* the figures come up only to half the
height of the picture; the rest is filled by the Classical architecture
of the temple, whose center is the golden ark set up in an imposing
niche. The central axes of the ark and the triumphal arch that
frames it are aligned with the figure of Christ, all slightly to the
right of the picture's center. Balancing this displacement to the
right of the spiritual center of the composition, El Greco painted
on the left a statue of a male nude set in a niche, with a relief below
it. The latter is clearly an Expulsion from Paradise, a scene appro-
priate to the central theme of the picture and one that, together
with a Sacrifice of Isaac as prefiguration of the sacrifice of Christ,
had already been introduced into the c. 1600 version. The male
nude is more difficult to place iconographically, since it lacks any
attribute that might identify it. If it is Adam, the only likely nude
in the context of the temple, the reason for his prominence here
is not apparent. Only the pose of spiritual devotion directed to-
ward the ark might give a clue, but it is not sufficient to decipher
the identity or purpose of the figure.

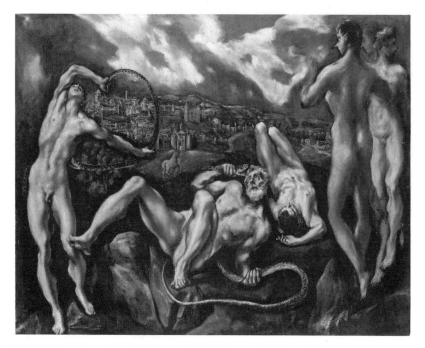

30. *El Greco:* Laocoön, *Washington, D.C., National Gallery of Art*

The position occupied by the *Laocoön* [30] in El Greco's oeuvre is unique, since it is the only known picture with a pagan subject to have been painted by him; its expressive and pictorial power ranks it among his greatest works.

The episode of the Trojan War depicted here had entered the artistic consciousness of the sixteenth century with the discovery in Rome in 1506 of the Roman-Hellenistic marble group that is at present in the Vatican. The Laocoön's importance for sixteenth- and seventeenth-century art, however, lies in its formal and expressive qualities rather than in its subject matter. Since this is, in fact, a scene altogether rarely represented, and totally unexpected as a subject for El Greco, various theories have been put forth to explain the reason for its choice, none of them totally convincing. The content of the scene as represented by El Greco, who had not finished painting it when death overtook him, also lends itself to speculation about its meaning. Besides the priest Laocoön and his two sons attacked by snakes, the picture includes two more figures, which, being unfinished and full of *pentimenti,* are difficult to identify. It also has a recognizable view of Toledo

in the background, which stands in for Troy, and although the depiction of Toledo in the *Laocoön*'s setting may be explained as similar to its presence in the background of many religious works by the artist, it is also possible that it is a pertinent reference to an old tradition, according to which Toledo had been founded by descendants of the Trojans. The presence of the two standing figures on the right is more puzzling, and suggests that the myth was not painted simply in order to illustrate a dramatic episode in a pagan legend, interesting on its own, but rather to point to a meaning that transcends it. What that further layer of meaning may have been, however, will probably remain a mystery as long as the identity of those figures, key to its interpretation, is not satisfactorily elucidated.

One of El Greco's last works was the *Adoration of the Shepherds* [31], destined for his family chapel in Santo Domingo el Antiguo. As in the *Adoration* painted for his first commission in the same church (and in at least one more later version), the event

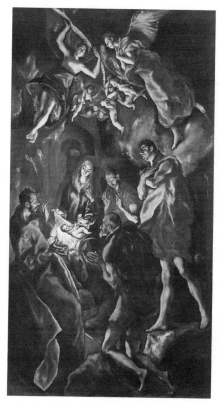

31. El Greco: Adoration of the Shepherds, Madrid, Museo del Prado

is depicted as a night scene, and El Greco makes use of a highly dramatic, intense chiaroscuro. The picture, however, is also a brilliantly colored piece, in which the artist gives an extraordinary virtuoso performance of pictorial skill. Venetian technique is here taken to lengths that probably would have horrified Titian; El Greco's expressionistic handling of paint is comparable only to that of works painted in the late nineteenth century or in our own.

Although El Greco is primarily known for his religious pictures, he was also a consummate portrait painter, and has left us a full gallery of images of distinguished men who lived in the Toledo of his day.

The first of his portraits to have come down to us, and perhaps the first one he painted, is Giulio Clovio's, done in Rome c. 1570–72. Its format and composition reflect Venetian models, and its iconography parallels that of many sixteenth-century portraits on both sides of the Alps, with the sitter presented in a context that reveals his occupation or interests. Here, Clovio is depicted pointing to a page in the manuscript *Book of Hours* that he had illuminated in 1546 for Alessandro Farnese. We may assume it was a good likeness, and there is nothing to separate it from contemporary portraits by other artists.

32. *El Greco:* Vincenzo Anastagi, *New York, Frick Collection*

The full-length, life-size portrait of Vincenzo Anastagi [32], on the other hand, is a more distinctive work, where El Greco's personality is already discernible. It has been variously dated between 1568, at the beginning of his stay in Italy, and 1577, the year of his arrival in Toledo. It most probably belongs to the last years of his Italian sojourn, since it is known that Anastagi was in Rome in 1575, and the style of the painting, closer to that of El Greco's work in Toledo than to the style of the *Giulio Clovio,* also suggests a date c. 1575/76.

The portrait of Anastagi is a very striking painting, among other things for El Greco's distinctive use of color: an unexpected combination of a dark yellowish green for the breeches with a pale grayish rose for the wall to set it off. The spatial relationship of the figure and its surroundings already manifests the ambiguity that would become so pronounced in his later work. Although El Greco places the subject in a defined architectural setting that includes the junction of the wall and ground planes, a window with open shutters, and a dark red hanging drape, the figure and the helmet lying on the ground do not have a well-defined location in that setting, since the floor beneath them appears to rise vertically. The interlocking on the picture plane of the contours of the various elements that make up the composition also impedes a clear reading of their placement in space.

One of El Greco's most famous portraits, known as the *Gentleman with His Hand on His Breast* (Madrid, Museo del Prado), is a good example of the portraits done in his early years in Toledo, c. 1577–79. It has the same solidity and realism as the likeness of Vincenzo Anastagi, but the subject's proportions are already somewhat elongated, a stylization absent from the earlier work. The figure also lacks a specific environment; it is set instead against a neutral, brownish background, a common feature of El Greco's portraits from this moment on.

The frontal pose of the subject, with his right hand pressed against his breast in a gesture of allegiance, and the prominently displayed Toledan sword suggest that the painting may have been commissioned to commemorate this gentleman's swearing-in ceremony into a knightly order. El Greco's image of this unknown young man, of proud mien and ascetic beauty, dressed with the sober elegance of Philip II's courtiers, has become the personifica-

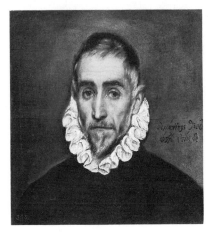

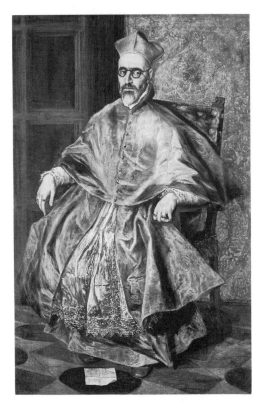

33. *El Greco:* Elderly Gentleman,
Madrid, Museo del Prado

34. *El Greco:* Portrait of a Cardinal,
New York, Metropolitan Museum of Art

tion of the Spanish *hidalgo* in the eyes of generations of modern viewers.

A small portrait, the *Elderly Gentleman* [33], painted probably during the same period in which El Greco was working on the *Burial of the Count of Orgaz,* c. 1586–88, is executed with greater freedom and expressiveness than his earlier likenesses, and is also one of his subtlest characterizations. The luminous, somewhat sad gray eyes, and the kindly and spiritual expression of the unknown gentleman make him one of the most attractive characters painted by El Greco.

Antonio de Covarrubias, portrayed by El Greco c. 1600, was one of the most distinguished personalities of his time in Toledo and had been the painter's friend probably since his earliest days in Spain. It was within the intellectual circle headed by this illustrious canon that El Greco found his place shortly after his arrival, and where he would meet many of his patrons and protectors. The refined physiognomy of Covarrubias, seen almost

in profile, had made an earlier appearance among the gentlemen surrounding the central group in the *Burial of the Count of Orgaz* [16], twelve or more years earlier. In the later portrait, El Greco also captured with great delicacy the personality of this cultivated and erudite jurist, whose face expresses complete serenity.

The most important of El Greco's portraits, because of its novel format, size, and the superb artistry with which it is painted, is unquestionably the large *Portrait of a Cardinal* [34], datable to c. 1600 or shortly after.

The format of this picture, in which the subject is portrayed seated in an armchair, full length and life size, is extremely rare in the sixteenth century, not just in Spain but anywhere else. The traditional format for portraits of popes or other highly placed dignitaries of the church had been established by Raphael at the beginning of the century with his portrait of Pope Julius II (London, National Gallery), which presented him in three-quarter length against a simple and uniform background. This formula would be endlessly repeated by later artists. The only antecedents for the seated full-length figure that El Greco might have known, although it is not likely he did, are two paintings by Titian: the 1546 *Paul III and His Nephews* (Museo e Gallerie Nazionale di Capodimonte), which, being a group portrait, cannot really be said to be a close prototype for El Greco's *Cardinal*, and the 1548 *Emperor Charles V Seated* (Munich, Alte Pinakothek), with which it shares a greater resemblance, but which does not represent an ecclesiastic. The only portrait that is at all comparable to El Greco's and dates from early in the seventeenth century is Paul V's (Rome, Palazzo Borghese), painted c. 1605–9 and attributed to Caravaggio, but this is a picture that El Greco could not have known, even if it had predated his *Cardinal*.

El Greco's *Portrait of a Cardinal* is also fascinating for the magnetism that the artist's interpretation of his sitter exercises upon the viewer. The energy generated by El Greco's technique in his depiction of the prelate's red robes and the tension of the cardinal's left hand, which grips the armrest like a claw, invite an initial reading of his personality as comparably intense, almost frightening. Under closer scrutiny, however, the cardinal's elegantly relaxed right hand and his facial expression reveal a softness and delicacy that contradict that first impression, and his sidelong

glance behind the black-rimmed eyeglasses is more that of a thoughtful, bookish man than of a man to be feared. The sitter has long been identified with the Great Inquisitor, Cardinal Fernando Niño de Guevara, but a recent study proposes a more plausible identity, that of Cardinal Bernardo de Sandoval y Rojas, well known for his love of learning and his patronage of the arts. Sandoval was made cardinal and raised to the archiepiscopal see of Toledo in 1599. If this is indeed his portrait, El Greco probably painted it soon after that date.

Another large portrait of haunting beauty is Fray Hortensio Félix Paravicino's (1580–1633) [35], painted about 1609. The young Trinitarian friar, a great orator and a distinguished poet, wrote on four different occasions sonnets in honor of El Greco, and in one of them he praises this likeness with verses that end in these lines: "... for even my soul ... in spite of twenty-nine years of acquaintance, doubts which is the body that it should inhabit, perplexed between your hand, and that of God."

Fray Hortensio is portrayed frontally, with a slight turn of the head and a similarly slight displacement of the composition's visual axis toward the left. The marked tilt of the upper edge of the chair's back and the convergence of its vertical lines avoid a parallelism between the rectangle of the chair and that of the canvas, and help to create a dynamic image. Instead of the cardinal's reserve, both sensibility and openness of heart can be read on Paravicino's countenance. In contrast to the coloristic intensity of the previous portrait, here only the red of the friar's lips and the blue and red of the crosses on his habit introduce small notes of color among the blacks, grays, and whites that make up the painting.

The approach to the handling of space that we have observed in El Greco's religious works can also be seen in these two portraits, in spite of the compulsion toward naturalism inherent in this genre. In the picture of the cardinal, even though the chair is set at an oblique angle and the pose of the seated figure requires a projection of the lap to a plane closer to the viewer than that of the torso, El Greco manages to hamper to a great extent the reading of the image in three dimensions. In that of Fray Hortensio, the compression of both figure and chair onto the picture plane is more marked, but in neither portrait does the game played

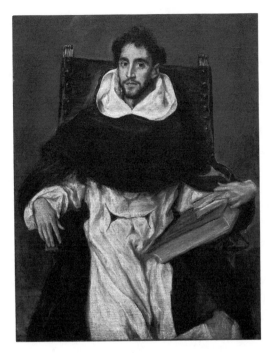

35. *El Greco:* Fray Hort-
ensio Félix Paravicino, *Bos-
ton, Museum of Fine Arts*

by the artist with our perception of volume impair that of the
human reality of the two men.

The portrait generally identified as a likeness of the lawyer
Jerónimo de Cevallos (Madrid, Museo del Prado), who lived in
Toledo from c. 1600 until his death sometime after 1623, is one
of the simplest and yet most original of El Greco's late works in
this genre. Within the limits set by portraiture, its freedom of
execution may be compared to that of the *Adoration of the Shepherds*
painted for his family chapel [31]. In this likeness, the artist utilizes
the reddish color of the priming as one more ingredient in the
creation of an illusionistic image, giving to it almost the same value
as to his brushstrokes. The irregularity with which El Greco paints
Cevallos's features approximates the distortions that the artist
introduces in the description of his invented figures, but here,
while giving a special animation and expressiveness to the sitter's
physiognomy, it remains within the bounds of what the eye can
accept as possible.

The remarkable portrait of an unidentified scholar at his
desk [36], datable about 1610–14, is among El Greco's last works.
The identity of the sitter remains in doubt, but he has been

tentatively identified as the Italian historian Giacomo Bosio, author of several books on the Order of Malta, and as Dr. Francisco de Pisa, the erudite chaplain of the Convent of Las Benitas in Toledo, who is known to have been portrayed by El Greco. As in the portrait of Jerónimo de Cevallos, whose freedom of execution it shares, the sitter's bust is massive but even more imposing, since the figure is shown at half length. The format of this painting is the same that El Greco had used for the *Saint Jerome* some years earlier, but here the subject looks straight out at the viewer, even though his cold glance and severe expression establish a respectful distance between the two.

Through references made by Francisco Pacheco and by Jorge Manuel Theotokópoulos, respectively, it is known that El Greco wrote (at least in rough form) a treatise on painting and another on architecture, which were never published. Neither manuscript is extant, but his ideas on art have come down to us, at least partially, through his marginal annotations on his copies of Vasari's *Lives of the Painters* and of Vitruvius' *Ten Books on Architecture,* in the Venetian edition of Daniele Barbaro. As one might predict, his aesthetic ideas reflect Mannerist art theory in the importance given to *grazia,* virtuosity, and artistic intuition,

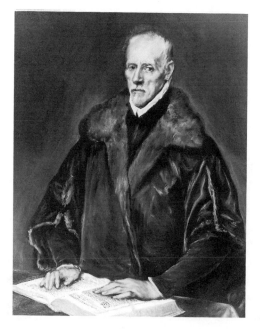

36. El Greco: Portrait of a Man, *Fort Worth, Kimbell Art Museum*

but he also assigns great importance to color, and regards as ideal a synthesis of Venetian *colore* and Florentine-Roman *disegno*.

Although El Greco's painting has been most frequently interpreted as an expression of the mysticism of his times, it also reflects the intellectual, thoughtful nature of the artist. The size and content of his library, and his wish to formulate his aesthetic ideas in theoretical treatises attest to this, but this aspect of his artistic personality can be deduced as well from the theological rigor of his works, which express and uphold the Counter-Reformatory ideas prevalent in Toledo at this time.

At his death in 1614, El Greco's art was perpetuated for some time in the work of his son Jorge Manuel (1578–1631), who had been his principal assistant in the last two decades of his life. He left only one distinguished pupil, the painter Luis Tristán, whose work, however, falls within the movement toward realism that marks the first phase of the Baroque in Spain.

🎔 Early Baroque Painting in Seville

The Painters of the First Third of the Seventeenth Century:
Francisco Pacheco, Juan de las Roelas, Francisco de Her-
rera the Elder

FRANCISCO PACHECO (1564–1644)

Francisco Pacheco's significance in the history of Spanish art goes
well beyond his merits as a painter; his artistic production is only
of modest quality in relation to that of Roelas or Herrera, who
were active in Seville at the same time. His importance rests pri-
marily on his authorship of the *Arte de la pintura* (The Art of
Painting), the richest source for the knowledge of the practice and
theory of art in Spain in the early Baroque period, which was
published posthumously in Seville in 1649. His second claim to
fame, as he himself makes clear in his treatise, is having been
Velázquez's teacher.

Pacheco was born in Sanlúcar de Barrameda in 1564, and
his artistic apprenticeship took place first in Seville, in the work-
shop of a painter about whom nothing is known, and later in
Flanders, where he studied with a local artist during a brief stay
in Ghent. But it was his residence in the house of a homonymous
uncle, canon of the cathedral of Seville, that determined the
course that Pacheco's life was to take. The elder Pacheco was a
poet and a serious Classical scholar, and in the literary and intel-
lectual circles in which he moved, young Pacheco's education was
enriched by knowledge of a sort that seventeenth-century painters
seldom acquired. Through his frequent association with the Je-
suits, he also gained a familiarity with theological matters that was

important for his ideas on iconography (Pacheco became an officer of the Holy Inquisition, and was named its censor of sacred paintings in 1618). It was this humanistic and theological culture that would serve as a base for his writings on art.

Pacheco's painting no longer follows the artistic canons of Mannerism, but in spite of all his theoretical support of the merits of naturalism in the *Arte de la pintura,* his works are very far from putting it into practice. His execution is dry, and his forms hard and stilted, and the presentation of the subject is usually staid and inexpressive. In their theologically correct representation of religious subjects, and absence of anything that might distract the viewer from their spiritual content, his pictures conform closely to the dictates of the Council of Trent (1544–63) concerning sacred art, but at a time when such a strict interpretation of those tenets had already been transcended by most religious painting.

Typical of Pacheco's style are the *Christ on the Cross* (Granada, Fundación Rodríguez Acosta), of 1614, and the *Immaculate Conception with Miguel Cid* (c. 1621), in the cathedral of Seville [37], subjects whose iconography he describes and explicates in detail in his treatise. The two pictures adhere faithfully to his own dictates: his Christ is crucified with four nails instead of three, a point stressed in the *Arte de la pintura,* and his representation of the Immaculate Virgin also follows his written prescriptions almost to the letter. As a measure of the impact of Pacheco's writings on Spanish seventeenth-century art, it should be noted that the four-nail version of the Crucifixion would be perpetuated in later images of Christ painted by Sevillian artists up until Murillo's day, when the Crucifixion is again represented with three nails.

Although Pacheco made several trips that took him away from Seville—the early one to Flanders and two much later ones to Castile—his work does not seem to have been influenced by the paintings he saw in the places he visited. In his first trip to Castile, in 1611, he went to Toledo to see El Greco, whose art was then in its final stylistic phase, but if he gathered from him some of his theoretical ideas on art, nothing of his style, coloring, or painting technique made a dent in Pacheco's own painting. Twelve years later, in 1623, he traveled again to Madrid, accompanying the young Velázquez—now his son-in-law and an independent mas-

37. *Francisco Pacheco:* Immaculate Conception with Miguel Cid, *Seville, Cathedral*

ter—and remained there for almost two years. At this date Pacheco was almost sixty years old, and expectably remained impervious to the various stylistic modes of contemporary painting, which at this moment were decidedly naturalistic. To the end of his life, he would remain faithful to a style that rejected Mannerism but did not yet embrace the Baroque naturalism that dominated Spanish painting of the first third of the seventeenth century.

JUAN DE LAS ROELAS (C. 1558/60–1625)

Of Pacheco's contemporaries, the painter of greatest artistic stature in Seville during the first quarter of the seventeenth century is without doubt Juan de las Roelas, born about 1558/60. The first notice we have of Roelas, in 1598, locates him in Valladolid, where he may have been born and where he was by then practicing his art. It was also there that he was ordained as a priest sometime before 1603, the year in which he obtained a prebend in the Sevillian village of Olivares. He would reside in Olivares and in Seville, mostly in the latter, from 1603 to 1625, the year of his death, with a hiatus of at least two years spent in Madrid between 1614 and 1621.

Roelas's style, such as we see it in his *Santiago at the Battle of Clavijo* [38], of 1609; the *Transit of Saint Isidore* (Seville, San Isidoro), painted in 1613; and in the *Martyrdom of Saint Andrew* [39], somewhat earlier in date, has no immediate precedents in Castilian or Andalusian painting of the late sixteenth century, but it is also difficult to determine just what foreign influences may have shaped it. Venetian painting has always been pointed to as a source for his style, particularly the art of Veronese and Bassano, but his compositions and his physical types have little to do with these two painters. The common ground shared by Roelas's work and Venetian painting is primarily the emphasis on color and a loose, painterly technique, but this is true only in a most general way. If Italian antecedents for his style are sought, other names come to mind more readily. In the soft contours of the figures, the use of *sfumato,* and the sweetness of physiognomy, Roelas's pic-

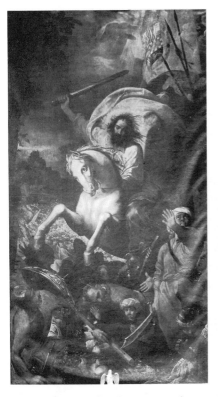

38. *Juan de las Roelas:* Santiago at the Battle of Clavijo, *Seville, Cathedral*

39. *Juan de las Roelas:* Martyrdom of Saint Andrew, *Seville, Museo Provincial de Bellas Artes*

tures come closer to Correggio and Lorenzo Lotto, sharing also with the latter a somewhat dissonant coloring. His compositions, in which the figures are compressed onto the picture plane, are anything but Venetian, following instead a common Mannerist format from which he never departed completely. Given the meager biographical data we have, it would appear that Roelas's style was formed in Valladolid in contact with the paintings of the various Italian and Northern schools in the royal collection, from which he must have drawn the materials with which to fashion his art.

The expressive vitality and the painterliness of Roelas's works would play an important role in the development of later generations of Sevillian artists, such as Murillo, and break ground for the Late Baroque style of Herrera the Younger and Valdés Leal.

FRANCISCO DE HERRERA THE ELDER (C. 1589/91-1654/57)

The work of Herrera the Elder, born only ten years before Zurbarán and Velázquez, and an exact contemporary of Ribera, does not fit fully into the movement toward Baroque naturalism that these artists were practicing by the second decade of the seventeenth century. His painting remains for the most part stylistically antiquated, attached to forms that were no longer current in the quarter century before his death. Nonetheless, his role within Seville's artistic environment is far from negligible, for his technique (the only genuinely modern element of his work) would serve as a model to a younger generation of painters: Murillo, Valdés Leal, and his own son, Herrera the Younger.

Herrera's early pictures, those that he executed between 1614 and 1627, do not depart from the compositional and typological patterns of Italian Mannerism that had already been absorbed by Spanish artists. In their rich color and loose brushwork, however, the later paintings of this period, such as the *Triumph of Saint Hermenegild*, of c. 1620 [40], come close to those of Roelas.

In the pictures of the series on the life of Saint Bonaventure, done in 1628 for the church of the College of Saint Bonaventure in Seville [41], Herrera developed a more realistic mode, both in terms of figure types and spatial construction. Most striking

40. *Francisco de Herrera the Elder:* Triumph of Saint Hermenegild, *Seville, Museo Provincial de Bellas Artes*

41. *Francisco de Herrera the Elder:* Saint Bonaventure Professing the Franciscan Order, *Madrid, Museo del Prado*

here is his individualization of the characters that appear in the various episodes, which are portraitlike, a feature that would be emulated by Zurbarán in the canvases that he contributed to the same series in 1629. In these paintings Herrera also uses a very personal technique, in which impasted dabs of paint give great animation to the picture's surface.

Very few securely datable works painted by Herrera in the following ten years are known, but two of his most impressive pictures date from 1639: an enormous *Saint Basil,* now in the Museum of Fine Arts of Seville, and the Louvre's *Saint Basil Dictating His Rule,* painted for his college and convent. The powerful handling of light in both pictures is a precedent for the dramatic chiaroscuro of the following generation of Sevillian painters, and the looseness of the brushwork, which at times borders on violence, prepares the way for Valdés Leal's and Herrera the Younger's technique. In the first, the mass and movement of the figures approach the vigor of contemporary Italian Baroque painting, as does the diagonal arrangement that connects Christ to the

saint, but in the second, the spatial composition remains bound to a Mannerist compression of the figures toward the picture plane, and their organization in superimposed strata.

In the canvases of the 1640s (Herrera's last dated work was signed in 1648), there is a change of course toward a more serene, idealizing style, and a sweeter and softer emotional tone, clearly visible in two works of widely different subjects: *Saint Joseph with the Christ Child*, of c. 1645 [42], and the *Miracle of the Bread and the Fishes* (Madrid, Archbishop's Palace), of 1647. The first is uncannily Murillesque for its date, both in sentiment and physical types (a signed and dated version of 1643 in the Fundación Lázaro Galdiano, Madrid, is closer to his previous work in figure types and technique), and the second is so near to Murillo's sensibility that the younger artist followed its composition quite closely in his large canvas of the same subject in La Caridad, painted twenty years later.

Herrera left Seville for Madrid in 1650, but there is no extant work known to have been painted at the court. He died there a few years later, probably in 1656, as Palomino's *Lives* reports.

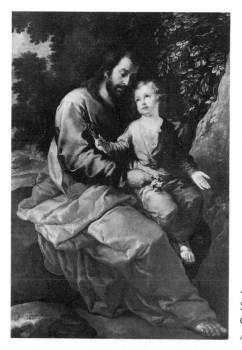

42. Francisco de Herrera the Elder: Saint Joseph with the Christ Child, *Budapest, Museum of Fine Arts*

☸ Early Baroque Painting in Castile

The Painters of the First Third of the Century: Luis Tristán, Juan Sánchez Cotán, Pedro Orrente, Juan Bautista Mayno, Vicencio Carducho, and Juan van der Hamen; Francisco Ribalta in Valencia

LUIS TRISTÁN (C. 1585–1624)

Luis Tristán, born in the province of Toledo about 1585, is the only pupil of El Greco who developed his own artistic personality and distinguished himself as a painter. His pupil-master relationship with El Greco is visible only in his depiction of a few specific subjects, for which he adapted the older artist's formal schemes, a practice he would continue to the end of his short life.

Tristán was an apprentice in El Greco's studio between 1603 and 1606, and he is known to have spent some time in Italy during Pope Paul V's reign (1605–21). It is likely that this stay took place between 1607, when he was no longer with El Greco, and 1613, the year he was commissioned to do a large canvas of the Last Supper for the Convent of La Sisla, outside Toledo. After 1613, his residence in that city was uninterrupted until his death in 1624.

The first decade of the seventeenth century in Italy was the moment of Caravaggio's apogee, when his realism and tenebrism reached the peak of critical esteem, and there is no doubt that Caravaggism, so contrary to the training in El Greco's very personal brand of Mannerism that he had received, was decisive for Tristán's art.

No works datable before 1616 are known, but it is proba-

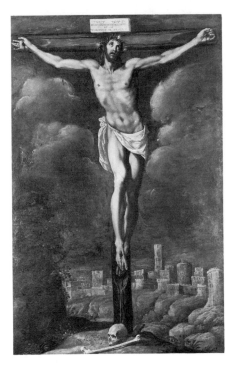

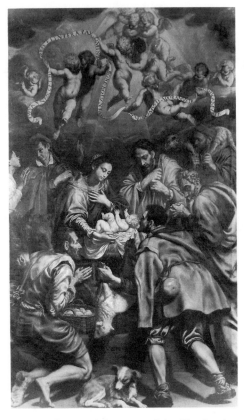

43. *Luis Tristán:* Crucifixion, *Toledo, Museo de Santa Cruz*

44. *Luis Tristán:* Adoration of the Shepherds, *Church of Yepes (Toledo)*

ble that the *Crucifixion* [43] painted for the Hospital of La Misericordia in Toledo belongs to the period immediately after his return to Spain. This *Crucifixion* echoes, in the composition of the figure, those painted by El Greco, but it also reveals Tristán's study of Michelangelo and the naturalism absorbed in Rome. Comparing it with any of the Crucifixions painted by his master, the viewer is struck more by the differences that separate them than by the traits they have in common. In contrast to the stylized, ethereal Christs painted by El Greco, Tristán reflects in his description of Christ's body a Michelangelesque idealization modified by the truthful representation of its anatomical details. The Cross is also described in very specific, naturalistic terms, and the quality of the wood and the way in which it has been roughly hewn catch the beholder's attention and contribute to lend credibility to the event depicted.

The *Adoration of the Shepherds* [44], painted in 1616 as part

of the high altar retable of the church of Yepes (Toledo), offers a
marked contrast to any of the versions of this subject painted by
El Greco. The religious meaning of the scene is apparent only in
the presence of the cherubs that fly overhead holding ribbons with
an appropriate text, and even these are shown as rather substantial
creatures. All the other characters in the painting are common
types dressed in contemporary clothes, with an emphasis in their
portrayal on naturalistic touches. The shepherd on the left, for
instance, presents the very dirty soles of his feet to the beholder,
a frequent detail in Caravaggist works.

Although the group is quite compact, each figure's volume
is well defined, and their solid forms have an almost tactile pres-
ence. The light is used exclusively to model those forms, not to
suggest the supernatural aspect of the scene. In this, Tristán de-
parts not only from El Greco but also from Caravaggio; this aban-
donment of light's potential for mystery, however, also occurs in
the work of most of the latter's Italian and Northern followers.

Apart from the six scenes of the life of Christ that occupy
the bottom three of the huge four-story retable at Yepes, the
ensemble includes eight figures of saints in bust or half-length
views. Among them are the beautiful *Saint Monica* [45] and *Saint
Mary Magdalen* (Madrid, Museo del Prado), where Tristán con-
trasts old age and youth, introspection and longing. Both in the
Saint Monica and in the *Adoration of the Shepherds*, the type of
realism achieved, the way the canvas is painted, and even the
physical types of the figures are reminiscent of the Italian Caravag-

45. Luis Tristán: Saint Monica,
Madrid, Museo del Prado

gist Orazio Borgianni (c. 1578–1616). This Roman painter spent some time in Spain—perhaps on two occasions but in any case on one—between 1604 and 1607, and he was one of the first artists to introduce the new naturalistic style into Castile.

In the *Saint Peter of Alcántara* [46], now in the Prado, the harsh realism with which the ascetic saint is interpreted is combined with an almost fierce expressiveness; his physical person is brought close to the viewer, and the viewer's heart is touched by the intensity of the saint's devotion. Iconographically, Tristán continues the type invented by El Greco for Saint Francis [17], but the still life of books, inkwell, and skull, as well as the flowers in the foreground, has a visual importance here that would seem out of place in El Greco's paintings.

The various portrayals of rude saints painted in this vein by Tristán are among his most successful pictures, both in artistic and religious terms. In these images, Tristán strives for verisimili-

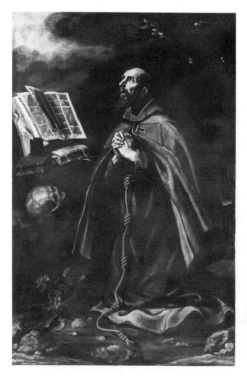

46. *Luis Tristán:* Saint Peter of Alcántara, *Madrid, Museo del Prado*

47. *Luis Tristán:* Saint Louis of France Distributing Alms, *Paris, Musée du Louvre*

48. *Luis Tristán:* Holy Trinity, *Seville, Cathedral*

tude and a strong and simple expression of faith, so that the pictures act as convincing stimuli to devotion, fulfilling the most important requisite for religious art in Spain at the time. The realism and expressiveness of Tristán's devotional images are not features exclusive to his work, however, but appear in religious art of this period in general.

One of Tristán's most important pictures is the large *Saint Louis of France Distributing Alms* [47], of 1620, in which he uses all the elements of Caravaggist painting to great effect. The strongly illuminated figures are set before an impenetrably dark background, and their volume is boldly defined by the chiaroscuro that models them. The poor cripples who approach the king seem drawn from nature, and once again the dirty soles of their feet are thrust into the foreground. Saint Louis is not idealized either, but he is monumentalized by his towering proportions and by his isolation.

A subject in which Tristán recasts one of El Greco's compositions at a late date in his career is the *Holy Trinity,* which he painted in several slightly different versions, the one illustrated here [48] dating to 1624. But although the disposition of the figures of Christ and God the Father harks back to El Greco's *Holy*

Trinity for Santo Domingo [14], the pictorial treatment is totally foreign to that of the master. The description of the body of Christ, large and muscular, makes us feel his inert mass, and his pose is not conceived in terms of grace, as El Greco's is; what in El Greco was a sinuous and languorous movement is here an angular and heavy physical collapse. God the Father also departs from El Greco's idealizing canons, and is presented instead as a weathered old man with a thoroughly human expression of sorrow.

An artist whose religious images are cast in a realist vein may well be expected to flourish as a portrait painter, but only a few portraits have been firmly attributed to Tristán. Those few, such as the *Portrait of a Gentleman*, now in the Prado, confirm that his aptitudes in this field were considerable. The format of this picture, a reduced bust which is set before a tan background, is much like that of many of El Greco's portraits, but its facture is more impasted than in El Greco's prototypes, and the expression of the sitter, in which a hint of a smile can be seen, is more open and lively.

The vigor and emotional impact of Tristán's painting raise him well above all his contemporaries in Toledo, with the exception of Juan Bautista Mayno and Pedro Orrente. After Mayno's departure for the court c. 1620, Tristán's death in 1624, and Orrente's final parting with the city in 1632, Toledo would never again recover its importance as a major artistic center, a position it had held since the turn of the century.

JUAN SÁNCHEZ COTÁN (1560–1627)

Sánchez Cotán is one of those paradoxical artists who appear once in a while in the history of art; he is a magnificent painter in one genre—in his case, that of still life—but only a mediocre painter in all others. Had his few early still lifes not been preserved, his religious scenes, to which he devoted most of his career, would certainly not have gained him the artistic reputation he now has.

Born in 1560 in Orgaz, a town near Toledo, he was educated as an artist by Blas de Prado (c. 1545–1599), at the time one of the best painters in Toledo. His apprenticeship with Prado is significant, because this artist was noted for his still lifes (a new

genre in Spain), and may have inspired Sánchez Cotán to follow in his footsteps. No signed still life by Blas de Prado is known, and only a couple of very delicate small pieces have been tentatively attributed to him, so nothing more than a generic influence on Cotán may be posited.

Of Sánchez Cotán's early work almost nothing has been identified; the first still lifes of which we have notice date shortly before 1603, when he decided to enter the Carthusian order. That year he made his will in Toledo and an inventory of his possessions, through which some of his extant still lifes have been recognized. From this inventory we also learn that he had painted numerous religious works and portraits, although only one of the latter has come down to us, the unusual *Brígida del Río, the Bearded Woman from Peñaranda* (Madrid, Museo del Prado), dated 1590. Most of his known still lifes were painted in the years just before his departure for Granada in 1604, but he must have painted others as well after donning the Carthusian habit in that city.

All of Sánchez Cotán's still lifes [49, 50, 51] present ordinary edibles in the framework of a square opening in a stone wall, perhaps an opening used as a cooler for provisions or simply a kitchen window. Whatever the case, the arrangement of the fruits and vegetables does not suggest a practical purpose but seems, instead, a calculated arrangement of natural objects to explore their pictorial possibilities. Within this compositional formula, Sánchez Cotán varies the kind, placement, and number of objects in each still life, filling to a lesser or greater degree the black space of the opening against which they are silhouetted. The same objects—vegetables, fruits, and fowl—appear in more than one composition in different combinations.

The textures, colors, and volumes of the foods in these pictures are studied with minute attention, and the resulting illusion of reality is enhanced by the strong lighting that models them. Also contributing to the effect of palpability of the foods portrayed is their frequent extension beyond the limits of the opening toward the viewer, as if they were breaking through the picture plane.

This emphatic realism, the strong chiaroscuro contrasts, and the illusionistic projection of objects that seem to invade our space cannot be found together in Spain, Italy, or Flanders any

49. *Juan Sánchez Cotán: Still Life with Game Fowl, Vegetables, and Fruits, Madrid, private collection*

earlier than the years in which Sánchez Cotán painted these pieces. Their descriptive precision does have an antecedent in Flemish art of the fifteenth and sixteenth centuries and in Caravaggio's early genre pictures, but in those works it is not combined with a dramatic use of chiaroscuro, which appears only in the context of Caravaggio's religious work after 1600. The device of having objects project beyond the surface on which they rest was used by Caravaggio as well, but Sánchez Cotán could hardly have seen the paintings in which it first appears, since the earliest of them is probably Caravaggio's *Supper at Emmaus* (London, National Gallery), painted about 1600. Lacking any evidence to the contrary, one may conclude that the still lifes of Sánchez Cotán are works of great originality, besides being outstanding pictures.

Among the paintings which contain a greater number of objects, the *Still Life with Game Fowl, Vegetables, and Fruits* [49], of 1602, and the *Still Life with Fruits and Vegetables* (Madrid, J. L. Várez Fisa Collection), perhaps a little earlier, are the most attractive ones. Although the foods fill the area of the opening almost completely, the objects are arranged so that they fit the enclosure very comfortably, each with its own space and none subordinated to another. Each object by itself commands our attention, and the whole seems to have the inevitability of a theorem.

The geometric aspect of Sánchez Cotán's compositions is most prominent in the two works that are probably also his best, the *Still Life with Quince, Cabbage, Melon and Cucumber* [50] and the *Still Life with Cardoon and Parsnips* [51]. In the first, the fruits and

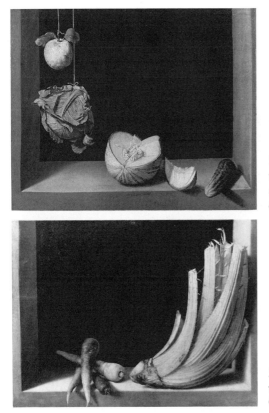

50. Juan Sánchez Cotán: Still Life with Quince, Cabbage, Melon, and Cucumber, San Diego Museum of Art

51. Juan Sánchez Cotán: Still Life with Cardoon and Parsnips, Granada, Museo de Bellas Artes

vegetables, suspended from fine strings and resting on the window-sill, are held in place by a subtle but unbreakable bond, the parabolic curve that organizes them into a composition. In the *Cardoon and Parsnips* the still-life elements are reduced to the absolute minimum, but with a sense for form, placement, and color that makes this an extraordinary picture. It is not surprising that these works have been interpreted in religious terms; their ascetic simplicity imparts to them an aura of transcendence.

Sánchez Cotán's religious works are well represented in the Cartuja of Granada, and in the city's Provincial Museum. His style in these pictures is a variation on the idealizing manner of the paintings that decorate the monastery of El Escorial, and it is only in details such as the bread and cheese in the *Rest on the Flight into Egypt* (Granada, Cartuja), where one may see his bent for realism. In the picture of the apostles Saint Peter and Saint Paul [52], in the same convent, the artist's interest in pictorial illusion is also reflected by the trompe l'oeil architectural frame surrounding the painting. Another example of this type of illusionism is the Cross

that he painted on the wall of the refectory of the Cartuja, also
done so as to simulate an actual three-dimensional cross.

 Sánchez Cotán died in the Cartuja of Granada in 1627,
having left his mark on Spanish painting through the few still lifes
he painted about the age of forty, halfway through a career that
was otherwise modest. It is as the creator of a distinctively Spanish
type and format of still life, which would be widely imitated, that
Cotán's stature as an artist will always be gauged.

Among the artistic descendants of Sánchez Cotán, the painter
who comes closest to him in the content and format of his still lifes
is Alejandro de Loarte (c. 1595/99–1626), over twenty years his
junior. As in the case of Sánchez Cotán, the largest portion of his
production consisted of religious paintings and portraits, but his
posthumous fame is based on the still lifes he painted during a
short period at the end of his life, from 1623 to 1626. In spite of
the brevity of his activity in this genre, his repertoire is broader
than what we know of Cotán's, probably because by the 1620s still
lifes had become fashionable, particularly at the court.

 Loarte worked all or most of his life in Toledo, and his

paintings leave no doubt that he knew Sánchez Cotán's works firsthand [53]. His compositions, however, are generally fuller, and the edibles are distributed symmetrically to each side of a central axis, an arrangement that lends them some monumentality. This placement of the foods, in spite of the naturalism of Loarte's subject and style, also emphasizes the artifice of the picture, albeit not as subtly as in Cotán's works. Even in those pictures where Loarte comes closest to Cotán, his technique is not as refined and exact in the reproduction of his subject as is the latter's; his brushwork is more visible and his color less transparent.

The best-known work by Loarte, and his most notable one, is the *Poultry Vendor* [54], which exists in two versions. Much larger in size than the straightforward still lifes, it is close in type to sixteenth-century Flemish or North Italian still lifes with figures, such as those of Pieter Aertsen, Bartolommeo Passarotti, or Vincenzo Campi. Besides the poultry vendor and her client, Loartes's market scene includes a view of distant buildings seen through the openings between the two figures and the hanging birds. Although the scene represents a transaction in progress, the figures share the dead fowl's immobility; Loarte's figure style is similar to that of Tristán, who was his contemporary and also worked in Toledo, but his characters lack the expressiveness of the latter's.

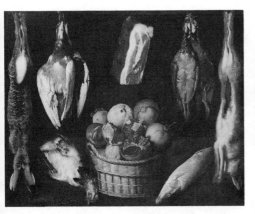

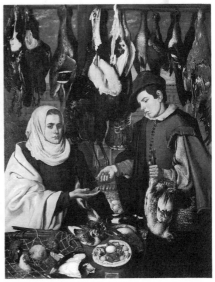

53. *Alejandro de Loarte:* Still Life with Game and Fruit, *Madrid, Fundación Santamarca*

54. *Alejandro de Loarte:* Poultry Vendor, *Madrid, private collection*

PEDRO ORRENTE (1580–1645)

Pedro Orrente was probably born in Murcia in 1580, but it is most likely that his apprenticeship took place in Toledo, where he was already living by 1600. A few years later, sometime between 1604 and 1612, when he is not recorded in Spain, he may have gone to Italy, where he is believed to have broadened his artistic education in the studio of Leandro Bassano (1557–1622). Orrente's artistic activity during a large portion of his career, from 1612 to 1632, was divided between Toledo, Murcia, and Valencia, with stays of long duration in the first of these cities. In 1632 he settled in his native Murcia for some time, but in 1638 he is recorded again in Valencia, where he would remain until his death in 1645.

Although Orrente's firsthand experience of contemporary Venetian painting is not documented, there is no doubt that the art of the Bassanos was very important in the formation of his style. His best-known works are those in which the Bassano influence is strongest—that is, pictures of biblical subjects of the Old or New Testament in which people and animals, often at a small scale, appear in rustic settings. *Laban Comes to Jacob at the Well* [55] is a typical example of such pictures, which were often part of a series illustrating a biblical narrative, in this case the story of

55. *Pedro Orrente:* Laban Comes to Jacob at the Well, *Madrid, Museo del Prado*

56. *Pedro Orrente:* Adoration of the Shep-
herds, *Toledo, Cathedral, Sacristy*

57. *Pedro Orrente:* Martyrdom of Saint
Sebastian, *Valencia, Cathedral*

Jacob. A particularly fine painting, in which the figures occupy a
larger area of the canvas, is *Jacob Laying the Peeled Rods Before
Laban's Flock* (Raleigh, North Carolina Museum of Art).

In the altarpieces Orrente painted in Toledo, such as the
undated *Adoration of the Shepherds* [56], the Venetian element in
his art is also strong, but here his painting also has a close relation-
ship to Tristán's work, with which it shares the vigorous realism
characteristic of the early phase of the Baroque in Spain. That
realism is much in evidence in Orrente's first known signed work,
the *Miracle of Saint Leocadia,* a large painting commissioned by
Cardinal Sandoval y Rojas for the cathedral of Toledo and exe-
cuted in 1617. The composition and the worm's-eye view are
clearly related to Veronese's paintings, but the figures seem in-
dividualized likenesses and have a characteristic tactile solidity.

The *Martyrdom of Saint Sebastian* in Valencia's cathedral
[57], one of Orrente's best works, is probably of similar date, about
1615/18. It was originally the central picture of a retable commis-

sioned for the chapel of the Covarrubias family, of which the three predellas and the crowning picture have been lost.

In the *Martyrdom,* the physical types of the saint and the angels, the details of flowers and armor in the foreground, and the treatment of the landscape and background figures are conceived and executed with the blend of Castilian realism and Venetian style—particularly Bassano's and Tintoretto's—that distinguishes all of Orrente's work. The pose of Saint Sebastian itself, however, is so particularly elegant that it has suggested to some scholars that the artist may have been inspired by a Mannerist print or by a print after Guido Reni's *Samson* (Bologna, Pinacoteca), a work painted c. 1615–20. Although this is very possibly the case, the borrowing is very well integrated into the new composition, and the treatment of the subject, the coloring, and the execution are characteristically Orrente's. In any case, the practice of using a print as the basis for a pose or an entire composition was very common in Spain at the time, and painters as important as Zurbarán, Alonso Cano, Velázquez, and Murillo felt no qualms about borrowings of this sort.

Orrente's works are very seldom signed, and dates for his pictures are even scarcer, but the few signed and datable paintings done c. 1615–19, when he was in his thirties, already show the characteristics that would remain constant in his art throughout his career. The evolution of his style beyond that period, however, has not been properly studied yet.

JUAN BAUTISTA MAYNO (1578–1641)

Of the painters who worked in Toledo in the first third of the seventeenth century, the most distinguished is undoubtedly Juan Bautista Mayno. He was the son of a Milanese gentleman and a Hispano-Portuguese lady, the Marquesa de Figueredo, who were established at the court of the Princess of Eboli in Pastrana, where he was born. His family ties led him to an Italian artistic education, in which the knowledge of Milanese art (most importantly Savoldo's work) was combined with that of the painters active in Rome (both in the Carracci and Caravaggio circles). By the time he is recorded working in Toledo, in 1611, his own style was already fully developed.

One of his most important works, the retable for the high altar of the church of San Pedro Mártir in Toledo, was executed in 1612–13, the year he professed as a friar in that Dominican convent. The large canvases which made up the now dismembered altarpiece represent the four Christian feasts: the Adoration of the Shepherds, the Adoration of the Magi, the Resurrection, and the Pentecost. Important prototypes for three of those subjects had been painted by El Greco, who was still alive and working in Toledo at the time; Mayno, however, struck out on his own, and devised for them naturalistic interpretations of great individuality.

The *Adoration of the Shepherds* [58] is a composition ruled by a careful geometric scheme, which organizes the naturalistic elements into a perfectly balanced and harmonious ensemble. Memories of Caravaggio are apparent in the types and poses of the angels—who might be ordinary shepherd boys that had sprouted wings—and in the half-nude shepherd in the foreground, but the clear light, the bright colors, and the glowing flesh of the figures bring to mind Orazio Gentileschi (1562–1639) as well. The lyrical tone of the scene is also reminiscent of Gentileschi's paintings; the moment of devotion depicted in the *Adoration* is permeated by melancholy as well as joy, a mood that is projected by the figures closest to the viewer, the flute-playing child and the shepherd who holds the bound lamb, evocative of the Agnus Dei.

The *Adoration of the Magi* (Madrid, Museo del Prado) is even more brilliant in color and light, for Mayno's naturalism is independent from the tenebrism that characterized the work of the other painters who worked in Toledo. Mayno's painting technique creates an illusion of the reality of all that he describes with great precision and subtlety, from the brocade of Melchior's mantle and the gold vessel with his offering, to the tender flesh of the infant, modeled by reflected light in Gentileschi's manner. The scene of the Adoration is pared down to its barest essentials by the reduction of the setting and of the number of figures involved, limited here to the six principals, and only a black boy and an elegant young man as the Magi's retinue. The composition of the *Adoration of the Magi* is very compact, and the figures are pulled together by a pinwheel arrangement, features that make it quite different from the previous painting, where they are aligned in parallel planes within a more ample and open space.

The *Resurrection* is the least satisfactory of the group, for though the soldier's figures are splendid, the realism of Christ's figure in combination with a Mannerist pose is frankly disconcerting. The *Pentecost* [59] is the most compact composition of all, and the definition of the space is almost exclusively entrusted to the bulk and placement of the figures. Counter to the symmetry that usually prevails in the representation of this subject, Mayno arranged his figures again in crossed diagonals, and placed the Virgin at the extreme left of the group, while retaining the central placement of the Holy Spirit. The twelve apostles and the Magdalen are all fully individualized characters, but notable among them is the bespectacled Saint Luke, who appears recording the event (Acts 2:1–4), pen and inkwell in hand.

Probably in connection with the painting of this retable, Mayno was also commissioned a series of frescoes for the presby-

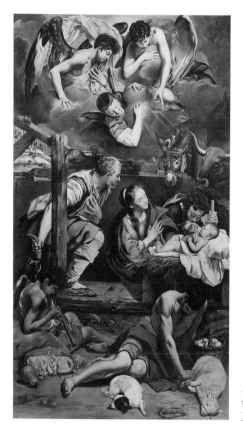

58. *Juan Bautista Mayno:* Adoration of the Shepherds, *Madrid, Museo del Prado*

tery and choir of the church at Yepes, where he shows his mastery of this medium. In them, he was able to incorporate successfully in fresco painting the firm modeling of his oils and his interest in subtle light effects.

About 1620, Mayno left Toledo to establish himself in Madrid, where he readily gained access to the court and was named drawing master of the future Philip IV. There he would remain until his death in 1642.

In 1634, Mayno was among the painters selected to participate in the decoration of the Salón de Reinos (Hall of Realms) in the Buen Retiro, the new palace built by the initiative of the Count-Duke of Olivares, Philip IV's prime minister, as a royal residence worthy of the glory of the Spanish monarchy under King Philip. A series of twelve monumental pictures, commemorating as many battles recently won by the Spanish armies over its many

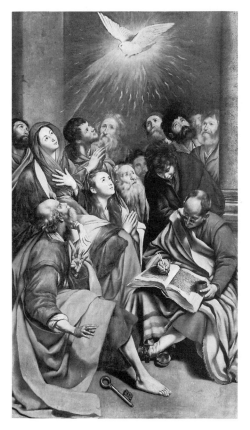

59. *Juan Bautista Mayno:* Pentecost, *Madrid, Museo del Prado*

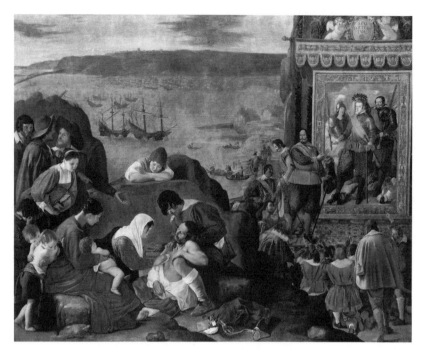

60. *Juan Bautista Mayno:* Recovery of Bahia, *Madrid, Museo del Prado*

enemies, was to be the principal element of the decoration, and the most important painters in the court had been summoned to execute one or more of the large canvases. Mayno's share was the painting of the recovery from the Dutch in 1625 of the Brazilian port of Bahia, accomplished under the command of Don Fadrique de Toledo. Apart from Velázquez's *Surrender of Breda* [131], Mayno's picture is the most distinguished of the series, which includes paintings by Zurbarán, Jusepe Leonardo, Antonio de Pereda, Eugenio Cajés, Vicencio Carducho, and Félix Castelo.

The *Recovery of Bahia* [60], painted in 1635, is a work of extraordinary pictorial beauty, luminous and delicately colored, but it is also distinctive by the originality of its content, which differs from that of any of the other scenes in the Hall of Realms by its emphasis on the human toll taken by war. The composition is divided into three distinct planes, rather than the two marked by the rest of the pictures in the series, and the foreground is not occupied by the victorious general, as it is in those, but peopled instead by a group of soldiers, women, and children who express the pathetic side of military contests, not their heroic and glorious aspects.

In the main group of this foreground plane, Mayno repre-
sented a wounded soldier receiving the ministrations of a charita-
ble woman and the comfort of a companion at arms; to the side
is a woman with three children, also an image of charity, and still
another approaches them with a bundle of clothes. The scene is
observed and commented on by a boy and three men. The victori-
ous commander, Don Fadrique, occupies the middle ground, and
is shown standing on a platform covered by a canopy, under which
an allegorical tapestry is displayed. In this tapestry, Minerva and
the Count-Duke of Olivares are represented crowning Philip IV
with laurels, while the king raises a palm frond in his right hand,
emblem of victory, and crushes underfoot personifications of her-
esy, envy, and treachery. Don Fadrique points to the image of the
king, while the defeated soldiers kneel to render him homage. The
background is occupied by the bay and the Spanish fleet.

Apart from religious or historical paintings, Mayno's
oeuvre also includes some portraits, which show his naturalistic
style put to good use. Even though, according to a contemporary
report, he painted many portraits because he knew how to im-
prove discreetly on his sitters' appearance, this does not seem to
be the case in the half-length *Portrait of a Gentleman*, of c. 1610/12,
or in the bust *Portrait of a Dominican Monk* [61], of c. 1635, done
with the same objectivity we see in the best Dutch portraits of the
period.

Mayno's known works are few, but those that have come
down to us documented or have been identified as his are all of
the highest quality. Perhaps this high index of quality is the reason

61. *Juan Bautista Mayno:* Portrait of a Dominican
Monk, *Oxford, Ashmolean Museum*

for the unusual paucity of works from a painter who was much admired in his own day and who lived to the age of sixty-three. It suggests that he probably did not make much use of assistants, and that he devoted great care to the painting of his pictures; their polished technique and his attention to detail must have also demanded a slow execution.

VICENCIO CARDUCHO (1576–1638)

Vicencio Carducho was the most active painter of his generation, important not only for his very extensive production, distributed all over Spain, but also for having written the most relevant theoretical treatise on art of the seventeenth century to be published in Spain, the *Diálogos de la pintura, su defensa, orígen, esencia, definición, modos y diferencias*, printed in Madrid in 1633.

Carducho was born in Florence, but he arrived in Spain at the age of nine, in 1585, accompanying his brother Bartolomé (c. 1560–1608), who had been invited by Philip II to participate in the decoration of El Escorial. Bartolomé spent some years there, painting under the direction of Federico Zuccaro, but when the latter returned to Italy, he remained in Spain, where he continued to reside as Painter to the King for the rest of his life. Vicencio, who eventually participated in his brother's decorative projects for the royal palaces, was in turn named Painter to the King in 1609, and soon started to receive prestigious and sizable commissions, among them the retable for the church of the Convent of La Encarnación in Madrid, of 1614–16 (in situ), and the decoration of the Sagrario of the cathedral of Toledo, of the same years, commissioned jointly from Carducho and Eugenio Cajés (1576–1634), the son of another Italian artist who had settled in Spain.

Although Carducho became the painter of religious works most in demand in Madrid, after Velázquez settled at the court in 1623, his position as Painter to the King must have been seriously diminished. The only major works he painted for Philip IV after that date are the three battle pictures for the Hall of Realms in the Buen Retiro (now in the Prado), executed in 1634, a project in which not only his fellow painters to the king participated, but the young José Leonardo (c. 1601–1656) and the novice Pereda as well.

In 1626, Carducho received what is perhaps his most im-

portant commission: the execution of a large series of stories of the Carthusian order for the cloister of the Monastery of El Paular de Segovia [62]. The cycle consisted of fifty-four episodes in the life of Saint Bruno and other venerable Carthusians, and was finished in the brief space of six years, being set in place in 1632. Since many of the commissions received by Carducho consisted of several, sometimes numerous, pictures, he must have headed a large workshop to produce them; to fully appreciate this cycle, therefore, one must also look at the oil sketches he painted in preparation for the large canvases, since in the latter his assistants must have done a great share of the work. His facility as a painter, which is not as evident in the finished pictures, stands out in these sketches [63], but both small- and large-scale works attest to the dramatic quality of his compositions and to his prolific imagination, tested by the great variety of scenes contained in the cycle.

Carducho's art throughout his career remained attached to the Renaissance-Mannerist tradition of idealization attendant to his Florentine origins. His ideas on art, as expressed in his treatise, also adhere to the doctrine of idealization prevalent in Italian artistic theory since the sixteenth century, and are similar

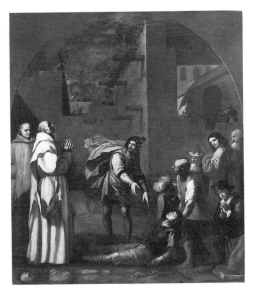

62. Vicencio Carducho: Don Bosson, General of the Order, Revives a Dead Mason, *Madrid, Museo del Prado*

63. Vicencio Carducho: The Dream of St. Hugh(?), *Edinburgh, National Galleries of Scotland*

to those of contemporary Italian theorists, some of whose works are actually later than Carducho's. The fundamental principle of his thinking is not a simple rejection of Caravaggesque realism, but the priority and importance given to the painter's assimilation of the tenets of artistic theory, without which the simple observation of nature would be deleterious to his art. Carducho's painting is in accord with his theoretical principles, for although the naturalism that distinguishes this period of Spanish painting is not totally absent from it, it is the least emphasized of its traits.

JUAN VAN DER HAMEN (1596–1631)

Born in Madrid in 1596 from a Flemish father and a half-Flemish mother, Juan van der Hamen was raised in an unusual social setting for a painter of that period; his parents were wealthy and of noble blood, and his family (particularly his brother Lorenzo) moved in an intellectual circle that included such eminent writers as Lope de Vega and Quevedo. About his artistic education nothing is known, but it must have been over by 1615, the year he married. The first notice we have of his activity as a painter dates to 1619, and concerns a still life of game and fruit done for the palace of El Pardo, the sort of work for which he is now best known.

The Pardo's still life has not been identified, and therefore we are ignorant of its composition, but other early paintings by Van der Hamen (and later ones throughout his life) continue and develop the type created by Sánchez Cotán in Toledo. Besides looking at Spanish models, however, he also turned for inspiration to Flemish and Dutch ones, such as the paintings of Clara Peters, Floris van Dijck, and Frans Snyders, and at times his work mixes both traditions.

The type of still life that is most commonly identified with Van der Hamen is well represented by the superb *Still Life with Sweets and Glassware* of 1622 [64], where sweets, fine glassware, earthenware, and porcelain pieces are simply aligned on a narrow stone lintel and set off by a black background. These objects are painted in painstaking detail, so that each one individually, rather than the composition as a whole, claims the viewer's attention.

Also very typical of Van der Hamen's work is the *Still Life*

64. Juan van der Hamen: Still Life with Sweets and Glassware, *Madrid, Museo del Prado*

65. Juan van der Hamen: Still Life with Fruit Bowl and Sweets, *Madrid, Banco de España*

with Fruit Bowl and Sweets of 1627 [65], where he uses a monumental green Venetian glass bowl with an ormolu mount, a receptacle that appears in many of his pictures from 1623 on. Here, a rectangular stone opening in the manner of Sánchez Cotán frames a symmetrical composition in which the fruit bowl is flanked by two identical stemmed glass plates holding biscuits and candied fruit. Also following Cotán's example, the artist has projected some sweets forward from the lintel, whose chipped edge adds to the trompe l'oeil effect of this device.

The compositional format illustrated by the *Still Life with Sweets and Pottery* of 1627 [66], in which the objects are arranged on a stepped stone parapet and a lower plinth which projects toward the viewer, appears for the first time in 1626 in Van der Hamen's work. This distinctive type of composition, where the structure on which the objects rest is asymmetrical and involves greater depth, is often repeated with variations in the latter part

66. *Juan van der Hamen:* Still Life with Sweets and Pottery, *Washington, D.C., National Gallery of Art*

of his career, although he does not renounce altogether the symmetrical type of the *Still Life with Fruit Bowl and Sweets.* As is also the case for the symmetrical pictures, the stepped compositions were sometimes done as pairs, and then symmetry was observed in their joint designs.

In the still lifes painted in the last years of Van der Hamen's life, the dimensions of the pictures increase and the objects acquire a greater monumentality. In the asymmetrical compositions, in addition, a greater quantity of objects goes along with the additional stone surfaces and larger size of the pictures. This expansion in the dimensions and number of objects represented, together with the play of horizontal and vertical planes, gives these pictures an exceptional formal richness. When compared to Sánchez Cotán's still lifes, these larger works by Van der Hamen appear complex and luxurious, but even they have a starkness and severity that singles them out as products of the Spanish school.

Although Van der Hamen also did portraits and history paintings, little evidence of this activity remains today. The only known examples of religious art that have come down to us are some pictures in the church of La Encarnación, in Madrid, but there are also two paintings in which flowers and fruits are combined with figures in allegorical compositions on the theme of love: the *Offering to Flora,* of 1627 (Madrid, Museo del Prado), and *Pomona and Vertumnus,* of 1626 (Madrid, Banco de España).

Very few of his portraits have been identified either, although they were an important part of his output, and were so

regarded by the literary figures of his time.* One of those that have survived, however, is of special interest because of its subject. The *Portrait of a Dwarf* [67], datable about 1625, depicts a man dressed with great elegance, bearing the attributes of nobility and power: a sword and a general's baton. In spite of this, and of his haughty demeanor, it is very likely that the person portrayed was one of the dwarfs that were ubiquitous presences in all the courts of Europe at this time. This picture, which was discovered and attributed not too long ago, is remarkable for its descriptive realism—still rare in courtly portraits of this period excepting those by Velázquez—and for being one of the few precedents for the latter's portraits of court jesters.

67. *Juan van der Hamen:* Portrait of a Dwarf, *Madrid, Museo del Prado*

Although dwarfs, fools, and jesters appear in Spanish painting of the sixteenth century, it is primarily in the context of their masters' portraits, to whom they serve as ornaments; the exceptions to this being two portraits of jesters, painted by Anthonis Mor (Madrid, Museo del Prado). Until Velázquez produced his extraordinary series of portraits of Philip IV's dwarfs and fools as individual human beings, rather than as appendages to the royal

*Juan van der Hamen is the Spanish painter who received the greatest amount of literary praise in his day; he is mentioned in Pacheco's *Arte de la pintura,* in Juan Pérez de Montalbán's *Para todos* (an index of Madrid's intellectuals), and in two sonnets by Lope de Vega.

person, Van der Hamen was the only painter after Mor to portray one of these characters as a figure interesting on its own.

The last dated works of Van der Hamen belong to 1627, but one may assume that he went on painting until 1631, the year of his untimely death at the age of thirty-five. His ambition as a painter was probably directed toward history painting, always more highly regarded than any other genre, but during his lifetime he was more successful and earned greater renown as a painter of still lifes, and it is for them that his work is still highly esteemed today.

FRANCISCO RIBALTA (1565-1628)

Although Francisco Ribalta's artistic maturity was spent mostly in Valencia, his work should be considered within the sphere of painting in Castile, because it was in Madrid and in El Escorial that his art was formed. Born in Solsona (Lérida) in 1565, Ribalta left Catalonia for the court shortly after the death of his parents, and his first known work, the *Crucifixion of Christ* (Leningrad, Hermitage), was signed in Madrid in 1582. Most probably he received the better part of his training at the court, since his style during the years he worked in Madrid, and during the early part of his residence in Valencia, is decidedly Mannerist and clearly inspired by the Italian painters who worked at El Escorial: Zuccaro, Cambiaso, and Tibaldi. Navarrete's influence is apparent in Ribalta's interest in a chiaroscuro of Venetian origin, but it was his direct contact with Italian models studied in the royal collection—the canvases of Titian and Sebastiano del Piombo in particular—that most clearly influenced his works. In those painted after he settled in Valencia, during the first two decades of the seventeenth century, this assimilation of the pictures to which he had had access in the court of Philip II was translated into an ecclecticism in which copies and adaptations of figures and compositions drawn from the works of those painters abound, mixed with a new repertoire of models drawn from the most important Valencian painters of the sixteenth century, Vicente Masip (c. 1475–before 1550) and his son Juan de Juanes (1523?–1579).

Ribalta must have gone to Valencia sometime between 1597, when his son Juan (who would become his best assistant and

68. *Francisco Ribalta:* Saint James the
Major, *Algemesí (Valencia), Parish
Church*

collaborator) was born in Madrid, and 1599, when the artist is
already recorded in the Mediterranean port. It is likely that this
move was motivated by the prospect of finding better opportuni-
ties of employment there, since Archbishop Juan de Ribera had
undertaken at this time the decoration of the College of Corpus
Christi, in which Ribalta would later work. The remainder of his
life would be spent in Valencia, where he died in 1628.

The paintings that Ribalta executed in 1603 for the parish
church of Algemesí, dedicated to Saint James the Major [68], and
the pictures painted for the College of Corpus Christi from 1604
to 1610 show him in possession of an elegant style, still decidedly
Mannerist, in which the influence of the Escurial painters and
quotations from artists he admired are still quite evident. It is only
about 1618–20 that Ribalta's work begins to show the naturalism
that marks the early phase of Spanish Baroque painting. It is not
impossible that this shift in direction may have resulted in part
from Orrente's arrival in Valencia, where he painted the *Martyr-
dom of Saint Sebastian* for the cathedral c. 1615–18 [57]. This new
naturalism, which Ribalta developed within his own personal style,
would endure to the end of his life.

To this short period of artistic maturity belong his most famous and original works, among which the *Saint Francis Visited by the Lamb*, of 1618/20 (Madrid, Museo del Prado), is probably one of the earliest. In this painting, the foreground elements— Saint Francis and the lamb, the cot and its blanket—are interpreted in his new naturalistic mode, but the consoling angel is still an entirely Mannerist creation in physiognomy and pose. The detailed, realistic description of all that surrounds the saint is in vivid contrast to the angel's idealization, something that does not happen in the religious paintings of Tristán, Mayno, or Orrente, in which all the characters, their garments, and their environment are conceived in one key.

In the *Saint Francis Embracing the Crucified Christ* [69], of c. 1621–22, Ribalta abandons the last vestiges of Mannerism in his art. The picture presents the saint in an allegorical scene that

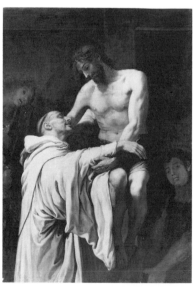

69. *Francisco Ribalta:* Saint Francis Embracing the Crucified Christ, *Valencia, Museum of Art*

70. *Francisco Ribalta:* Saint Bernard with the Crucified Christ, *Madrid, Museo del Prado*

expresses his renunciation of the world to embrace poverty and the way of Christ. Saint Francis has under his feet a crowned leopard, symbol of vanquished worldly glories and the seven deadly sins, on which he raises himself to reach Christ. Christ, in turn, lowers one arm from the Cross to place his crown of thorns on the saint's brow, while an angel brings Christ a crown of flowers. All the figures here are sturdy and solid, with a minimum of idealization, and the depiction of their feelings is subtler and less stereotyped than in *Saint Francis Visited by the Lamb*. The spiritual resonance of the scene is deeper; the angel's pathos and the simple tenderness of Saint Francis are completely convincing.

Mystical visions in which the saints are in direct contact with the divinity are very frequent in seventeenth-century art, and one of the most famous and successful paintings by Ribalta, *Saint Bernard with the Crucified Christ* [70], of c. 1621–22, shows precisely such a miracle.

This picture has a simpler composition than that of Saint Francis, and the two principal figures fill almost the entire canvas, the head of an angel barely visible in the dark background. Here, Christ detaches both arms from the Cross to embrace Bernard, whose ecstasy is not only revealed by his closed eyes and beatific smile, but also by the lassitude of his right arm and head, which depend on Christ's arms for support. The realistic presentation of Saint Bernard, a figure with very Mediterranean features, and of his habit, whose soft folds are studied from nature, is radically different from Ribalta's interpretation of figures and garments in the pictures of the period 1600–1615.

Francisco Ribalta's most distinguished collaborator was his own son, Juan Ribalta, who assisted him in the works painted in the years of his artistic prime, and who also worked independently from 1615 on. Juan died only a few months after his father, also in 1628.

🦠 *Jusepe de Ribera* (1591-1652)

Ribera was born in Játiva (Valencia) in 1591, and nothing is known about his youth and artistic training until 1615, when his presence is documented in Rome. It has often been said, although without any real evidence, that he was Ribalta's pupil in Valencia, and it is quite possible that such was the case, since Ribalta was then the most prestigious painter in that city and was head of a large workshop. Stylistically, however, there is no visible influence of Ribalta's art on Ribera's but rather perhaps the opposite, for the tenebrist and realist manner of the older artist does not begin to emerge until c. 1618–20, well after Ribera's putative apprenticeship.

Although it is not documented, Ribera's departure for Italy is likely to have taken place in the years between 1607 and 1611, when the painter was between sixteen and twenty years old. If his port of entry was Naples, Caravaggio's prestige there and the impact of his style were then at their peak, since the artist had spent some time in this city in 1606 and 1607. At this date, Caravaggist painting also prospered in Rome among Italian and foreign painters residing there, and this was still true in 1615, when we know for certain that Ribera was living on Rome's Via Margutta, a street long favored by artists.

The first work executed by Ribera in Rome of which we have notice, and which must date from about 1615, is a group of half-length figures representing the five senses, a popular subject in painting since the sixteenth century. Only four of the original paintings have been located—the senses of sight, touch, taste, and smell—but copies of all were made in their own day, and the

appearance of the sense of hearing is known through several of them.

The most engaging of these pictures is *The Sense of Taste* [71], in which we see a heavy and obviously uncouth man enjoying a modest meal and addressing a toast to the observer. The compositional format of this picture, with a half-length figure sitting behind a table, appears as early as the fifteenth century in Flemish painting; it is common in the next century in Northern art, and is used in Italy at the end of the sixteenth century, by Passerotti and Annibale Carracci in Bologna, and by Caravaggio in Rome. What is original about Ribera's use of this format is applying it to the representation of the senses. While traditionally this subject had been illustrated in the form of allegorical scenes with countless objects and figures appropriate to each sense—a type that continued to be preferred well into the seventeenth century—Ribera conceived the illustration of the senses as simple genre scenes rendered in a naturalistic vein.

In *The Sense of Taste*, one may find most of the characteristics that are associated with Ribera's painting: a tactile realism in the depiction of volumes and surfaces, an intense chiaroscuro, and great gestural expressiveness. But his painting technique, in which the brushwork is smooth and even, still lacks the liveliness and variation in density that he would soon develop.

71. *Jusepe de Ribera:* The Sense of Taste, *Hartford, Wadsworth Atheneum*

Thinking perhaps that in the Kingdom of Naples, then part of the Spanish imperial domain, his talent would bring him more success than he would be able to attain in Rome, Ribera took himself to the capital of that viceroyalty in 1616. His decision was probably the right one, since the Roman artistic scene was beginning to be increasingly controlled in those years by the Bolognese school and its brand of Baroque Classicism, something that did not augur too bright a future for a Caravaggist. In Naples, Ribera entered the open workshop of the Sicilian painter Gian Bernardino Azzolino, and that same year he married his daughter and established his own workshop.

The most important works of the early years in Naples are those painted about 1616–18 for the then viceroy, the Duke of Osuna, which were destined for the Colegiata that this nobleman patronized in the Spanish town of Osuna. In the *Martyrdom of Saint Sebastian* [72], Ribera demonstrates that his Roman education had not been exclusively in Caravaggio's school; he had also taken note of the art of the Bolognese, especially that of Guido Reni, with whose stay in Rome his had coincided. His study of Baroque Classicism and the art of the Renaissance, as well as of Greco-Roman Classical sculpture, is just as clear in the *Martyrdom*

72. *Jusepe de Ribera*: Martyrdom of Saint Sebastian, *Colegiata de Osuna, Museo Parroquial*

73. *Jusepe de Ribera*: Drunken Silenus, *Naples, Museo e Gallerie Nazionale di Capodimonte*

of Saint Sebastian as the stylistic elements drawn from realist sources. The pose of the saint, elegant and carefully designed, as well as his rhetorical gesture of devotion, are comparable to those we find in Guido Reni's work, while the minute description of anatomical detail and the shadows that engulf great portions of Sebastian's body are echoes of Caravaggio's. The strain of Classicism we see here (particularly evident in the composition of the figure) endures and grows in the coming years, and may be found throughout Ribera's oeuvre, even though, overlaid as it is by his striking realism, it is often overlooked.

The picture that until recently was held to be the earliest undisputable work by Ribera is his famous *Drunken Silenus* [73], signed in 1626. The mythological subject is treated with a naturalism that even today is somewhat shocking, and is in obvious contrast to that of any other seventeenth-century Italian or Flemish works of this type. Such artistic verism, however, has obvious precedents in Hellenistic art (abundantly represented in Roman collections), where it is not unusual to find images of equally crude realism. The *Drunken Silenus* is thought to have been painted for a wealthy Flemish merchant who resided in Naples, Gaspar Roomer, who was the most important art collector there after the viceroy, and evidently a sufficiently sophisticated connoisseur to appreciate the unusual picture.

Here we already find more of Ribera's "permanent" stylistic traits, among them the amazing economy of means in the handling of paint with which he achieves the appearance of nature, and the psychological acuity with which he characterizes his subjects. Several aspects of the composition are also very typical of the artist; the limited depth of the space depicted, and the use of multiple contrasting diagonal accents are distinctive features of his works throughout his career. Also characteristic of Ribera is the way that the lighted portions of the figures coalesce in a relieflike frontal plane, establishing a compositional scheme of almost geometric regularity.

Ribera's signature, written in Latin on a piece of paper that seems to have been accidentally dropped on the ground, advertises his Spanish nationality—even to his city of origin—besides his affiliation with the Roman Academy, all of which were evidently points of pride to the painter. The torn paper is held by a snake

in its mouth, an image whose symbolism has been interpreted in relation to the attributes of the central character, but may have a personal meaning instead, or as well. The anecdotes and rumors concerning Ribera's bitter rivalry with other painters in Naples suggest that he may have used the serpent as a symbol of envy, attempting to destroy his name.

The detail of Ribera's signature has an antecedent in El Greco's *Martyrdom of Saint Maurice* [15], where the artist's name also appears on a piece of paper in the mouth of a snake, but this is a painting that Ribera is not likely to have known. On the other hand, the device of placing a signature on a piece of paper lying casually on the ground or, as a trompe-l'oeil device, adhered or tacked to some spot in the picture, is probably related to El Greco's frequent use of it. Ribera would also use this type of signature repeatedly, but he is not the only Spanish painter to do so: Zurbarán and Velázquez also used it often. Given the frequency with which this feature occurs in the work of the three painters mentioned—while it is very rare to find it in seventeenth-century paintings outside of Spain—its presence cannot be dismissed as mere happenstance. Only in fifteenth- and sixteenth-century Venetian painting is this peculiarity also frequent (in the paintings of Giovanni Bellini, for example), and since this manner of signing first appears in Spain in El Greco's work, it seems likely that it was he who imported it from Venice, and that the later Spanish masters followed his example.

Also in 1626, Ribera signed two versions of *Saint Jerome and the Angel of Judgment*, the largest of which is one of his most beautiful works, and also in an excellent state of preservation [74]. Here, where the paint has not been rubbed, as is the case in the *Drunken Silenus*, one may enjoy fully the mastery of his brilliant and very personal technique. As in the *Silenus*, the strongly illuminated silhouettes that break out from the dark background are arranged in diagonal patterns that come together in the foreground plane of a shallow layer of space. This approach to composition has the effect of fixing the expansive gestures of the protagonists into a quasi-geometric pattern, which gives them an expressive authority similar to that found in Classical Greek sculpture.

In this painting, Ribera combines two episodes of the saint's life that were separated by a gap of many years. The appear-

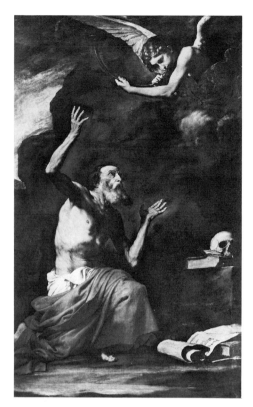

74. *Jusepe de Ribera:* Saint
Jerome and the Angel of Judg-
ment, *Naples, Museo e Gallerie
Nazionale di Capodimonte*

ance to Saint Jerome of the angel with the trumpet of the Last
Judgment, which had impelled him to withdraw to the desert to
live a hermitic existence, had taken place in Jerome's youth. Here,
the saint is depicted instead as a hoary penitent working on his
translation of the Bible from Hebrew into Latin, a work accom-
plished late in his life.

Another of Ribera's masterpieces of this decade, for which
he probably used the same model that inspired his Saint Jerome,
is the *Martyrdom of Saint Andrew* (Budapest, Szépmüvészeti Mu-
zeum), signed in 1628. Here, the saint is depicted at the moment
that he is being strapped to the cross for refusing to adore the
image of Zeus presented to him by the proconsul of Patras. Al-
though Andrew's face is seen in a lost profile, the emotion that
Ribera imparts to his features expresses very clearly his humble but
imperturbable rejection of apostasy. The composition of this pic-
ture brings to mind both Caravaggio's *Crucifixion of Saint Peter*
(Rome, Santa Maria del Popolo) and his *Deposition* (Rome,
Pinacoteca Vaticana) but, in contrast to these, it works essentially
in one plane, like the *Silenus* and the *Saint Jerome.*

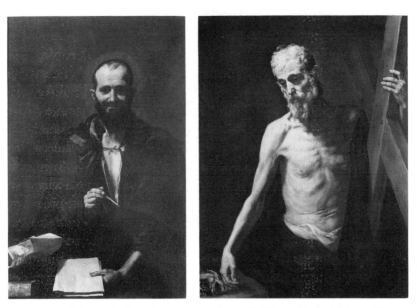

75. *Jusepe de Ribera:* Archimedes (Democritus?), *Madrid, Museo del Prado*

76. *Jusepe de Ribera:* Saint Andrew, Madrid, *Museo del Prado*

A category of pictures that was very much in vogue among the intellectuals and collectors of Ribera's day was that of imaginary portraits of the philosophers of antiquity, which Ribera started to paint in the 1630s. Many of his subjects are not easily identifiable, but as characterizations of individual men they are unforgettable images. The so-called *Archimedes* (Democritus?), of 1630 [75], is an excellent example of this genre. Poorly dressed, with his compass and folios in hand, the philosopher smiles at us with an ironic look radiating from his eyes. Ribera's interpretation of the subject, of the crudest realism, wholly departs from the idealized portraits of philosophers painted in the Renaissance, but it yields here and elsewhere vivid images of the personalities of the thinkers so portrayed.

To the 1630s belongs as well *The Blind Man from Gambazo* (Madrid, Museo del Prado), of 1632, so called on account of the erroneous identification of the sitter with the blind sculptor Giovanni Gonnelli, born in Gambassi. This picture, instead, probably formed part of another series of the five senses, of which this *Sense of Touch* is the only remnant. Ribera portrays here a blind man

who, unable to see the painted image of an antique marble head, feels with his fingers the head itself, which he holds in his hands. Many years earlier, he had represented the sense of touch in a similar fashion, but his characterization of blindness is more convincing and pathetic in this later version.

The saints Ribera painted throughout his life are fully individualized human beings, with physiognomies described in lifelike detail and characters that are equally well defined. His ascetic *Saint Andrew* [76] of c. 1630–32, whose gaunt body and hands deformed by labor spell out his condition as a poor fisherman, displays an expression of melancholy meditation in which sorrow is tempered by stoic restraint. His spiritual presence is no less powerful than his physical reality, and it makes the viewer respond to the painted image as he would to a living man.

Ribera's *Saint Matthew,* of 1632 (Fort Worth, Kimbell Art Museum), may have belonged to a series depicting the six apostles whose writings make up the New Testament (pictures of Saint Peter and of Saint Paul with books in their hands, which are likely companions of the *Saint Matthew,* are still extant). Here, in a totally different but no less impressive register, Ribera captures the sensitivity and visionary side of the evangelist's personality, expressed by the intense glance he fixes on a distant point, and the delicacy with which he holds his Gospel. The nobility and spiritual depth of the apostle (as was also the case with the *Saint Andrew*) are both imposing and moving, but he is also presented with the physical realism of a portrait from life, bringing the saint's humanity close to the viewer's heart. It is in portrayals of aging or grizzled men such as these that Ribera's style and painterly technique find their most effective outlet.

The religious paintings of the 1630s include a large number of Ribera's most famous works, beginning with the *Holy Trinity,* of 1632 [77]. The subject is the same that El Greco had painted in Toledo half a century earlier, and the comparison between the earlier canvas, which reflects the Michelangelesque Mannerism of El Greco's first works in Spain, and Ribera's, whose approach to the image is as naturalistic as the subject allows, brings out vividly the qualities and character of the latter painting. In contrast to the idealization and monumentality of El Greco's figures of God and Christ, which place them in a suprahuman and inaccessible

sphere, Ribera offers us instead two characters whose real existence is as convincing as that of his philosophers and saints. His Christ is a young man with a slight and vulnerable body, whose narrow chest sinks into his Father's lap. God is a venerable and frail old man, who cradles his Son's head in his hands, holding the crown of thorns with tender gentleness. The blend of sorrow and love conveyed by God's expression, and the pathos of Christ's figure, which accent the human tragedy inherent in the image, translate the abstract and essentially mysterious concept of the Trinity into a language that reaches the viewer directly through his feelings. To reinforce the creation of an emotional and quasi-sensorial bond between the divinity and the faithful, Ribera brings the figures of the Trinity so near the picture plane (in a dense and again relieflike composition) that they seem to be literally within hand's reach.

The goal of bringing the faithful closer to the religious message of an image by appealing to their hearts is not unique to the work of Ribera; it is already present in Caravaggio's art earlier

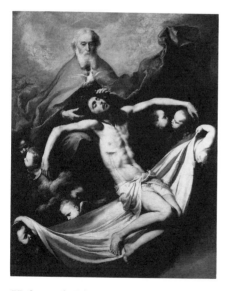

77. *Jusepe de Ribera:* Holy Trinity, *Madrid, Museo del Prado*

78. *Jusepe de Ribera:* Immaculate Conception, *Salamanca, Agustinas de Monterrey*

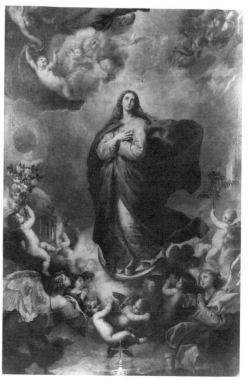

in the century, and is an artistic doctrine also shared by Zurbarán and the young Velázquez. During the first half of the seventeenth century, this approach to religious art, which was viewed as an effective means of stimulating popular devotion, had the whole-hearted support of the Spanish Church. It also relates to the ideas elaborated by Saint Ignatius of Loyola in his *Spiritual Exercises*, which were aimed at intensifying the spiritual experience with the aid of the senses.

At the same time that Ribera presents all the elements that make up the *Holy Trinity* with the greatest physical and emotional realism, he also sets up a structural scheme of geometric clarity to regulate them. Their arrangement in crisscrossing diagonals on the picture plane results in a formal balance of classical stability, but it also imparts a Baroque movement to the composition.

At the end of 1633 or beginning of 1634, the Count of Monterrey, then viceroy of Naples, commissioned from Ribera two pictures for the church of the convent of Discalzed Augustinian nuns in Salamanca as centerpieces for its high altar. These paint-ings, a monumental *Immaculate Conception* (1635) [78] and a smaller *Pietà* (1634), would be set in place in 1637, after the completion of the church, where they still remain.

In the seventeenth century, the image of the Immaculate Conception became the most popular representation of the Virgin in Spain, for although the belief that Mary was free of the taint of original sin from the moment of her conception did not become dogma until the nineteenth century, this doctrine was accepted and upheld by the Spanish Church and people with particular fervor from the beginning of the seventeenth. Pacheco had codi-fied the prescriptions for its pictorial formulation in his *Arte de la pintura*, but its typology had already been established since the middle of the sixteenth century. Ribera accepted that tradition and showed the Virgin surrounded by a glory ("dressed in the sun") and standing on a half moon, with angels around her carry-ing Marian attributes, more of which appear floating among the clouds or set down on the landscape. In the upper left-hand cor-ner, however, God and the Holy Spirit loom over the Virgin, an unusual feature in Immaculate Conceptions of this period. The pose and garments of the Virgin impart to her figure both monu-mentality and grace, and introduce a powerful movement into a

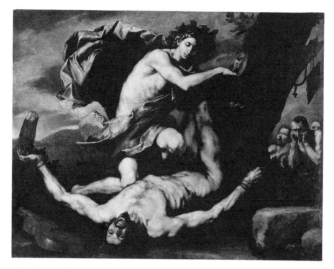

79. *Jusepe de Ribera:* Apollo and Marsyas, Naples, *Museo Nazionale di San Martino*

composition that is, nevertheless, again an example of classical balance.

Among the small number of pictures of mythological sub-jects painted by Ribera during his entire artistic career, two paint-ings executed in 1637 stand out for their dramatic intensity and pictorial beauty: the *Apollo and Marsyas* still in Naples [79] and the *Venus and Adonis* now in Rome (Galleria Corsini). In both he adopted compositions with strong foreshortenings and spatial dia-gonals, otherwise infrequent in his work, and gave the characters a physical and emotional agitation that also goes beyond his cus-tomary parameters. Nonetheless, in spite of the whirlwind that sweeps through these compositions, Ribera imposes on the forms in motion a controlling order that results in his characteristic structural clarity.

In the *Apollo and Marsyas* the painter stressed the cruelty of the scene, which he manifested not only in the dreadful contrast between the satyr's expression of unbearable agony and the half smile and elegant gestures of the god, but also in the horrified and frightened faces of Marsyas' companions, who witness his suffering in helpless anguish. The brilliant reddish golds of the clouds that fill the sky also echo the bloodiness of the divine punishment.

Suffering also permeates Ribera's vision of the Adonis

myth, from which he chose the moment in which Venus discovers the body of her dead lover. He also used the light of sunset here, which seems to turn to flames Venus' red hair and scarf, and adds sheen to the blood-colored mantle on which Adonis lies. Venus' gestures and facial expression as she hurtles through the air to reach her beloved express both passion and pain as intensely as the grimaces of the satyrs in the *Apollo and Marsyas* express their fear and distress.

Ribera's unusual representation of Venus, dressed in garments that reveal only her arms and throat, differs radically from the sumptuous nudes which appear in Italian or Flemish examples of similar mythological subjects. It is possible that this modesty was due to the wishes of the patron (perhaps the Count of Monterrey) rather than to the artist's, since many other female figures in his work (be they a Magdalen or a Saint Agnes) appear much less chastely covered.

To the same year of 1637 belongs one of Ribera's more majestic and moving religious pictures, the *Pietà* for the church of the Certosa di San Martino in Naples, first of the various works he was to execute for this monastery [80]. The large canvas was

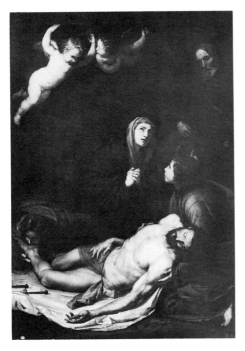

80. *Jusepe de Ribera:* Pietà, *Naples, Church of the Certosa di San Martino*

painted to be placed over the altar of the New Sacristy, where it still remains.

The focal point of the *Pietà*'s composition is the Virgin's hands, clasped in a gesture of anguished prayer, above which rises her face, where self-restraint controls deeply felt sorrow; everything else seems to revolve around this axis of grief. The sad but serene face of Nicodemus looks out toward the observer, inviting him to meditate on the significance of the divine sacrifice.

The handling of the dead Christ's body, its pathos and beauty, admirably exemplifies Ribera's artistic position at this moment in relation to Caravaggesque realism and Bolognese classicism. The comparison of this *Pietà* with Caravaggio's *Entombment* of 1603–4 (Rome, Pinacoteca Vaticana) and with Annibale Carracci's *Pietà* of c. 1606 (London, National Gallery) brings out clearly the Spanish painter's aesthetic objectives, and the degree to which he was able to realize them. Ribera's Christ, and his *Pietà* altogether, illustrate the perfect balance in his art between the illusion of living reality that he imparted to his characters and the idealization with which he raised them above the worldly plane. This achievement separates his religious painting from Zurbarán's and from the religious scenes painted by the young Velázquez in Seville; neglect of the classical tradition in the case of the first meant that his idealized figures lacked both credibility and grandeur, and the total commitment to observed reality in the early work of the latter kept his divine figures always earthbound.

The *Pietà* is impressive not only for its emotional impact but also for its brilliant technique and extraordinary color. The prostrate Magdalen at Christ's feet—seen in such extreme foreshortening that her form is pared down to the mass of her golden-red hair juxtaposed to a dark pink mantle—is a stunning demonstration of Ribera's gifts as a colorist even while chiaroscuro remained the dominant ingredient of his art.

In 1638, Ribera received again an important commission from the prior of the Certosa di San Martino: fourteen canvases with images of prophets to decorate the nave of its church. Of these, twelve were full-length reclining figures for the spandrels of the nave arcade, designed so their poses would integrate them into their architectural setting, and two were half-length figures for the entrance wall. The work was completed five years later, in 1643.

The first pictures to be finished were the two half-length portrayals of Moses [81] and Elijah, both signed in 1638, whose unusual format also points to their integration into the architecture of the nave. The broad brushwork with which Ribera defines these figures, achieving realistic effects with great economy of means, also relates to their placement in the church, where they are seen from a considerable distance. The blue skies against which the simple silhouettes of the two prophets are outlined, and the special brilliance of the whites and other light colors in these paintings suggest an open, daylight environment for the figures, unusual for the master until then.

81. *Jusepe de Ribera:* Moses, *Naples, Church of the Certosa di San Martino*

The *Moses* and *Elijah* are among Ribera's most powerful characterizations and, like all of his half-length figures of saints, they look like portraits. But although these prophets, with their highly individualized physiognomies, are seen as men of flesh and blood, they are also presented as men who have been touched by God; their spiritual grandeur raises them above ordinary mortals. Ribera's genius lies in the creation of such characters: majestic and inspired, but also endowed with an unmistakable humanity and an almost palpable physical presence.

Apart from the few pictures of mythological or allegorical content, most of Ribera's paintings deal with religious subjects, but his oeuvre also contains a handful of portraits of the highest quality. Four of those that have come down to us date from the 1630s; a fifth, the *Equestrian Portrait of Don Juan de Austria* (Madrid, Palacio Real), is datable to 1647/8.

This large equestrian portrait was most probably painted to commemorate the important role played by the bastard son of Philip IV in putting down Masianello's popular uprising in Naples, which broke out in 1647. As a picture and as a likeness, it is perhaps the least interesting of the five. Its composition, in which the rider holds the horse in a difficult curvet, follows the model established by Velázquez in 1628–29 in his equestrian portrait of Philip III (Madrid, Museo del Prado), or Rubens's allegorical portrait of Philip IV of those same years, now known through a copy in the Uffizi. Rider and mount stand out against a distant landscape background, viewed from the heights of a promontory that overlooks the rocky shore.

The portrait titled *Magdalena Ventura with Her Husband and Child* [82], executed in 1631, on the other hand, is surely one of the most uncommon pictures ever painted. It was commissioned by the then viceroy of Naples, the Duke of Alcalá, as a visual document of one of nature's aberrations (the pedestal provides a long explanatory account of the fifty-two-year-old bearded woman's life), but the painter also conveyed the human tragedy inherent in his subject. The psychic content of pain, dejection, and resignation that is reflected in the faces of husband and wife transcends the representation of the bizarre physical anomaly that was its source; once the initial shock that the portrait of this couple produces subsides, the feelings of revulsion and curiosity it elicits at first give way to compassion for their plight.

In spite of the merciless realism of the portrayal of Magdalena Ventura, Ribera's image is not a direct transcription of the models set before him. The infant that the bearded woman has at her breast is not a portrait of an actual infant, newly born in 1631, but a figure that serves a symbolic function, like the spindle and the head of the distaff that rest on the pedestal next to her. As those objects symbolize Magdalena's wifely status, so the breast-feeding of a child symbolizes her maternity—that is, her female

82. *Jusepe de Ribera:* Magdalena Ventura with Her Husband and Child, *Toledo, Museo Fundación Duque de Lerma*

83. *Jusepe de Ribera:* Knight of Santiago, *Dallas, Meadows Museum*

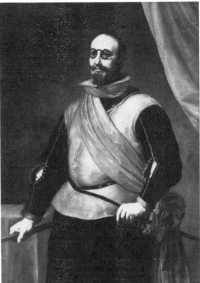

nature (she had borne three children before she began to grow a heavy beard at the age of thirty-seven).

The three portraits that Ribera painted at the end of the 1630s all have different formats: bust, three-quarter length, and full length. The model for the bust portrait (Toledo [Ohio] Museum of Art), signed in 1638, has not been identified with certainty, but it is clear that the picture represents a music master, as he holds in his right hand a roll of sheet music and in his left a conductor's baton, now almost invisible. The straight and open look with which the model engages the observer and the manner in which he holds (or rather wields) the musical score bring out his professional pride and complement the expression of intelligence and sensitivity captured by Ribera.

The specific identity of the *Knight of Santiago* [83], which stylistically also belongs to this period, has yet to be ascertained, but as in the previous work, the sitter can be generically identified

by his dress and attributes as a captain general in the Spanish army and as a knight of the exclusive Order of Santiago. It is quite possible, therefore, that the man portrayed is the Count of Monterrey, who held both of these titles and was a patron of the artist as well.

Coloristically, this painting has the impact appropriate to the image of power presented by the subject. The deep, rich reds used by Ribera in the sash that crosses the sitter's chest, the drapery, and the tablecloth stand out among the blacks and tans of his costume and of the background, but without diminishing the attraction exerted by his face. Ribera's prodigious technique is particularly evident in the depiction of the eyes, which look benevolently at us from behind the eyeglasses.

Very few seventeenth-century portraits show the sitter wearing glasses (although presumably some of the men portrayed may have used them), and therefore they call attention to themselves. Eyeglasses appear in El Greco's *Portrait of a Cardinal* [34], where they bring out the scholarly facet of the model, and in a

84. *Jusepe de Ribera:* Portrait of a Jesuit, *Milan, Museo Poldi-Pezzoli*

portrait by Velázquez of the poet Quevedo, of c. 1635–39, now known through workshop replicas. In the *Knight of Santiago,* where the contrast they make with the overall military character of the portrait makes them still more conspicuous, they undoubtedly place stress as well on the intellectual side of the sitter.

The *Portrait of a Jesuit* [84], also signed in 1638, is an endearing characterization of a slight clergyman of kind and somewhat melancholic mien. The presence of the lion that accompanies him, and which the Jesuit seems to subdue just by the gentle touch of his hand, has been interpreted in various ways, but what is beyond doubt is that it is a symbolic beast. In all likelihood, it alludes to the evangelic mission of the order, whose members had by then taken the Christian Gospel to Africa and Asia.

The *Martyrdom of Saint Philip* [85], dated in 1639, is exemplary of Ribera's mastery in combining the most convincing physical and psychological realism in his characters with a compositional order regulated by a lucid geometry and classical balance. Saint Philip's body, powerful yet gaunt, is described in all its details with astonishing facility; the artist's brush seems to literally recreate the hair, the skin, and every muscle and sinew that modulate the saint's epidermis. The rude features of the saint, also rendered with incomparable pictorial skill, are those of a fisherman or stevedore, but they are transfigured by his expression of passionate surrender to God's will. The saint is at once Everyman and an admirable example of the best that a Christian can give for his faith. The various attitudes of the spectators are also beautifully rendered, suggesting melancholy resignation, compassion, curiosity, and indifference, the whole gamut of feelings with which man responds to the sight of a stranger's suffering.

In the execution of the figures in the background, Ribera attains effects of extraordinary modernity. Throughout the entire painting, his light and vivacious brushwork now manipulates a medium thinner than what he employed in his early work, reserving impasto only for the stronger highlights. This looser technique is accompanied by a daylight illumination, which the artist would continue to use for many of his canvases from this moment on, even though he did not abandon his dark, neutral backgrounds altogether; these he continued to employ for certain types of pictures, especially his half-length figures.

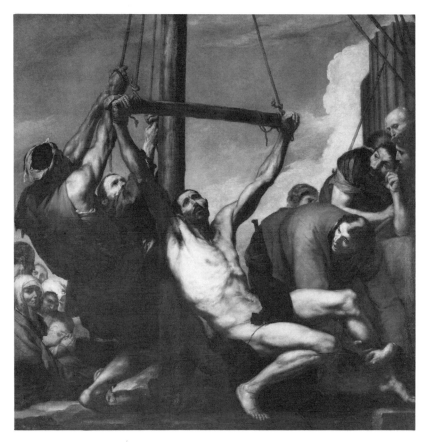

85. Jusepe de Ribera: Martyrdom of Saint Philip, *Madrid, Museo del Prado*

Another large work of the same year is *Jacob's Dream* (Madrid, Museo del Prado), one of the few pictures in which Ribera deals with an Old Testament subject. Here as well, the event takes place outdoors, and the scene is set against a luminous blue sky, which in this instance is traversed by the radiant glow of the dreamed stairs and the angels that ascend them. The portrayal of Jacob's sleep in this picture is yet another demonstration of Ribera's mastery in capturing with total realism any aspect of the human experience. In a work in which the subject matter is depicted with the sparest of means, and the expressive content is limited to the representation of sleep, the artist is able, nonetheless, to lend monumentality to the sleeper's figure and mystery to his dream.

One of the Christian themes most successfully treated by Ribera is that of the ascetic and penitent saint, which he depicts throughout his career. *Saint Paul the Hermit* [86], of 1642, stands

out among the several paintings of similar subject matter executed during the 1640s as perhaps Ribera's most deeply felt image of spiritual meditation on death and the transience of all worldly things. The gnarled hands that the saint presses to his breast are the affective center of the scene, the link between Saint Paul's bald head and the skull, its mirror image, on which he fixes his glance.

Although in this picture the environment of earth and rocks in which Saint Paul is set is perforce somber, Ribera plays up the luminosity of the saint's flesh and of the opening to the sky, saturating the painting with light.

The theme of rejection of the worldly vanities as a means to salvation, suggested by the image of Saint Paul the Hermit, recurs constantly in Baroque iconography, both in Northern and Southern painting, but that of the exercise of charity as a path to salvation, on the other hand, is exclusively popular (and particularly so) in Spain, and it already appears in some of El Greco's works. In Ribera, the incitement to practice that most important Christian virtue takes a very unusual form, that of the famous *Clubfooted Boy* [87], a painting signed in 1642.

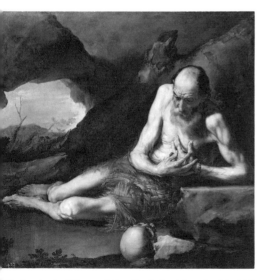

36. *Jusepe de Ribera:* Saint Paul the Hermit, *Madrid, Museo del Prado*

37. *Jusepe de Ribera:* The Clubfooted Boy, *Paris, Musée du Louvre*

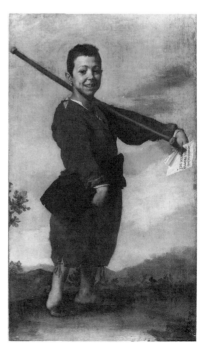

The boy, who marches gallantly with his crutch to his shoulder through an open and sun-drenched landscape, has stopped for a moment to greet the passerby with a cheerful smile. His demeanor presents a surprising contrast to his ragged clothing and physical deformity, and the very low vantage point from which he is sighted, so that his entire figure is silhouetted against the sky, lends him an also unexpected grandeur. In the same hand that holds his crutch, the boy carries a piece of paper on which can be read the Latin inscription GIVE ME ALMS FOR THE LOVE OF GOD, the message that gives us the clue to the meaning and purpose of the painting. The crippled beggar is not painted in order to leave record of one of nature's cruel jests, as was the bearded woman Magdalena Ventura [82], or as a portrait of a specific local character, as are those painted by Velázquez of the dwarfs and fools of Philip IV's court [132], nor yet as a genre character, as Murillo's ragged children would be [191, 193]. Instead, this child is a statement of the function served by the needy in the salvation of the Christian soul, as instruments of God that provide man the opportunity to practice the virtue of charity. The *Clubfooted Boy* is also a reminder of the value of poverty itself as one of the paths leading to redemption. The indifference toward the trials of life on this earth, expressed by the child's bearing and smile, completes this triumphant and proud image of a character who elicits affection and commands respect.

One of the masterpieces of Ribera's last ten years of life is the *Baptism of Christ* (Nancy, Musée des Beaux-Arts), signed in 1643, a picture in which the trend toward a neo-Venetian colorism and luminosity, apparent in his painting since the second half of the 1630s, has become dominant. This stylistic turnabout is even more evident in a small picture dated the same year, *Saint Bruno in Prayer* [88], a work of clear, brilliant tints, and full of light. From this point on, Ribera's use of daylight and open landscape backgrounds is very frequent, particularly in multifigure compositions, in contrast to the strong chiaroscuro and opaque backgrounds of the first two decades of his artistic activity. What remains constant in the *Baptism* and other late paintings is Ribera's manner of structuring his compositions with contrasting diagonals on the picture plane, and the placement of figures in a shallow layer of space, brought as close as possible to the observer. The physical

88. *Jusepe de Ribera:* Saint Bruno in Prayer, *Naples, Museo e Gallerie Nazionale di Capodimonte*

realism that defines these figures' humanity, and makes them directly accessible to the faithful, is also a constant feature of his art. The subject is treated very simply here, but it is also charged with emotion, which we are asked to share by the look with which Christ engages us.

Until only a few years ago, one facet of Ribera's work was totally unknown. The two large landscapes that belong to the House of Alba, probably painted between 1640 and 1652, apprise us of his remarkable artistry in that genre. Although they come as a surprise, these landscapes conform in all respects to the character of his narrative and religious works of those years. The composition of the *Landscape with Shepherds* is designed in the same classical vein that regulates the rest of his oeuvre, and its luminosity and clear colors are present as well in the background landscapes of his history paintings. Here, however, these features are applied to majestic, open views of nature, painted with great sensitivity. Landscape painting as an independent genre was very rare in Spain, and these pictures are unprecedented in the context of Spanish art. In Naples, they invite comparison only with the landscapes of Salvator Rosa (1615–1673), although the latter are examples of Baroque composition and a proto-Romantic approach to nature.

The *Mystic Marriage of Saint Catherine* (New York, Metro-

89. *Jusepe de Ribera:* Adoration of the Shepherds, *Paris,*
Musée du Louvre

politan Museum of Art), of 1648, is one of the very small number
of representations of the Virgin and Child, with or without accom-
panying saints, painted by Ribera. Here, he highlights the group
of the Virgin and Child with Saint Catherine, set against an
undefined background whose dark shadows veil the more distant
figures of Saint Joseph and Saint Anne. These are painted in warm
and earthy colors, which contrast with the pink whites of the flesh
tones of the principal group, and with the brilliant colors of their
garments. The majestic composure of the figures and the classical
balance of the group are counterbalanced by the protagonists'
lifelike gestures and physical presence, so that the formal artifice
of the composition in no way diminishes the illusion of community
between them and the onlooker. The Virgin and Saint Joseph fix
their glances on him, acknowledging his presence and welcoming
him as witness to the mystic marriage.

The *Adoration of the Shepherds* [89], the only signed work of 1650 that has come down to us, introduces again an open landscape as background, with only a dark strip on the left, where the indistinct figures of a shepherd and a donkey may be glimpsed in the shadows of the manger. The gestures and glances of the men that surround the Christ Child express with subtlety their awe and their love, while the Virgin raises her eyes as if in communion with the Father. Only the old shepherdess standing on the right looks out at the viewer; the touch of reproach in her sadness suggests her intuition that it is for the viewer's sake that the divine Child will be sacrificed.

Ribera's manipulation of the density of pigment and the movement of his brush here produce some striking effects of mime-

90. Jusepe de Ribera: Communion of the Apostles, *Naples, Certosa di San Martino*

sis, from the tender flesh of the Child to the dirty pelisse of the shepherd in the foreground. In these last years of Ribera's artistic activity, his technique attains a totally convincing replication of nature, but such effects are always subservient to the spiritual content of the image, never calling attention to themselves.

The last of Ribera's most important works, the enormous canvas of the *Communion of the Apostles* [90], finished and signed in 1651, is still in its original location in the choir of the church of the Certosa di San Martino in Naples, together with a large *Christ Washing the Apostles' Feet* by Giovanni Battista Caracciolo, a tenebrist picture painted in 1622. The *Communion* had been commissioned in 1638, together with the paintings done for the nave of the Carthusian church, but although its invention and the beginning of its execution go back to that date, the picture had remained unfinished until 1651, when Ribera undertook at last to complete it.

Some of the figures on the left of the canvas suggest parallels with others done before 1638—that is, the apostle in the foreground, who repeats with only slight modifications the pose of the *Saint Jerome* of 1626 [74]—but the totality of the painting has the luminosity and lively technique of the artist's last works. The composition adapts itself, probably deliberately, to that of Caracciolo's painting, of which it was to be a pendant; both consist of a relieflike frieze of interlocking figures, with a background of Classical architecture. The level of the heads in the *Communion*, however, is much lower in relation to the total height of the picture, and it is quite possible that the upper portion of Ribera's canvas and the group of cherubs it contains may have been a later revision of the original composition. Also unlike the predominantly closed and dark backdrop of *Christ Washing the Apostles' Feet*, Ribera's *Communion* has an open and luminous setting.

The last years of the artist's life were plagued by poor health and economic difficulties, but his painting always remained at the highest level of accomplishment, both in invention and execution. The half-length *Saint Jerome*, signed the year of his death, 1652, presents a new and final vision, of almost savage intensity, of the saint that he had painted so many times. The brilliant technique Ribera had developed over the years makes no small contribution to the expressive force of this image; with

greater succinctness than ever, he gives to each brushstroke the power of counterfeiting the matter and the spirit of reality itself.

Although in geographic terms Ribera spent his entire artistic life out of Spain, Naples had been a Spanish territory since the fifteenth century, and the leading and moneyed classes, from the viceroy down, consisted primarily of Spaniards, attracted by the administrative positions available in that kingdom and by its mercantile and financial opportunities. Many of Ribera's paintings, therefore, originally commissioned or acquired in Naples, were later taken to Spain when their owners returned there, and many others were destined from the start for its churches and chapels. His position in relation to the art of his native land, however, was very different from that of another great artist who flourished abroad, the French painter Nicolas Poussin (1594–1665), who worked in Rome most of his life. Poussin, who was more literally an expatriate than Ribera, also found in Paris the patronage of connoisseurs who understood and prized his art. But while Poussin's art was to define the course that French painting would follow in his own century, and had an immeasurable impact in that of the eighteenth and nineteenth, Ribera's did not leave a similar mark in Spain. The Caravaggist tenebrism and naturalism of his painting were very well received in his country until late in the 1640s, since those stylistic traits coincided with the taste then prevalent in Spain, but after the mid-century, Spanish painting would take on a very different complexion from Ribera's, and he had no artistic succession.

🏵 *Francisco de Zurbarán* (1598-1664)

Ever since the nineteenth century, when the painting of Zurbarán was retrieved for the history of art as a worthy object of study and admiration, few painters have epitomized in the public's mind the art and essence of their native country more than he has. His religious images have been regarded as the perfect visual expression of the piety of Spanish society in his day, and of the severe asceticism of its religious institutions.

This image is certainly not inaccurate, but its validity is less absolute than one may suppose; the vicissitudes of Zurbarán's artistic career, his fame in his own time, and its subsequent eclipse reveal that his identification with the spirit of an age and a nation was of brief duration. That the view about the essential "Spanishness" of his art has continued to prevail in modern times is primarily due to the endurance of the Romantic idea of Spain that had been forged in France precisely at the time that Zurbarán was rediscovered, in the mid-nineteenth century. In his own day, his paintings were greatly admired and coveted, but the esteem in which he was held as an artist was at its peak only in the third and fourth decades of the seventeenth century; by the 1640s Zurbarán's style had ceased to satisfy the aesthetic ideas and the general temper of Spanish society; by the time of his death in 1664, his reputation had sharply declined, and after his death his name fell into total oblivion.

Zurbarán was born in the small village of Fuente de Cantos (Extremadura) in 1598, into a shopkeeper's family. Nothing is known about his beginnings as a student of painting, but they must have been inconsequential, given the artistic level that could be expected in his hometown. It was only in 1614, when he was already fifteen, that Zurbarán's artistic training began in earnest, by his removal to the metropolis of Seville, where he was apprenticed to an obscure painter of religious images about whom practically nothing else is known. After finishing his apprenticeship, in 1617, Zurbarán established himself in the Extremaduran town of Llerena, not too far from Seville. In Llerena the artist could count on an almost complete lack of competition, and he remained there for the following twelve years.

The earliest works of Zurbarán are not known, and the first commission he executed for Seville, three paintings for the Carthusian Monastery of Santa María de las Cuevas, can be dated only tentatively to 1624/26, before the first documented commission he received, early in 1626, for a large series of paintings for the Dominican Monastery of San Pablo el Real, also in Seville. Both the hapless compositions of the two narrative pictures for the Carthusians, with their more than evident absence of an understanding of perspective, as well as the rigidity of the figures seem to suggest an early date for this work; it is only in the luminous whites of the monks' habits in the *Virgin of the Carthusians*, and in the naturalistic detail of the food and dinnerware in *Saint Hugh in the Carthusian's Refectory*, that one can already appreciate some of the special qualities of Zurbarán's work. The paintings belonging to the cycle in San Pablo el Real that have survived (albeit scattered throughout the world) are the first to provide us with a secure point of reference from which to gauge the development of Zurbarán's art. In these, his style is already well defined, and has assumed the traits that were going to be permanent characteristics of his work.

The splendid *Crucified Christ* [91] painted for the Dominicans, signed in 1627, is one of the artist's most distinguished works, and so it was valued by his contemporaries. There, and in the full-length figures of the Fathers of the Church in this cycle, which were approached as portraits, we see for the first time his sharp chiaroscuro, in which a brilliant light pulls the human form

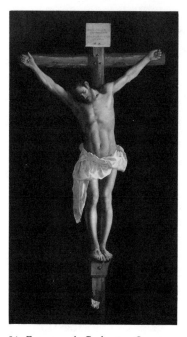

91. *Francisco de Zurbarán:* Cruci-
fied Christ, *Art Institute of Chicago*

92. *Francisco de Zurbarán:* Saint Serapion, Hartford,
Wadsworth Atheneum

out of total darkness, revealing the smallest details of its anatomy
and garments. This tenebrist approach, Caravaggesque in origin,
would be used by Zurbarán on every possible occasion; it is only
in subjects such as the *Immaculate Conception* [102] that his paint-
ing admits a more generalized lighting. Even in those cases, how-
ever, the shadows are still radically contrasted to the lighted areas,
so that his forms possess the same sculptural qualities as in the
tenebrist paintings.

The intense realism of the *Crucified Christ* is another char-
acteristic aspect of Zurbarán's art, and a very distinctive note in
this painting. What gives this image its power, however, is not
simply that we see Christ with the body of a strong and lean
peasant, or a cross that is rudely carved, but rather the contrast
between that veristic view of the subject and the abstract isolation
of the figure within its spatial context. Its realism brings it close
to the daily experience of the observer, but the chiaroscuro that
so vividly manifests its form also removes it from the real world.

The striking *Saint Serapion* [92], signed in 1628, also be-

longs to a group of paintings sent by Zurbarán to Seville, this time to the Convent of the Merced Calzada. The young Mercedarian saint appears tied to a tree and already lifeless, his head, like that of Christ in the previous work, collapsed on his shoulder. The physical and human realism of the saint's image—his face could be that of any Spanish peasant—contribute to his function as a model of faith and sacrifice. But the light that bathes his white habit, allowing for only the smallest hint of the tree in the impenetrable darkness of the setting, gives to the event and its protagonist their transcendental character.

The full range of Zurbarán's style and technique in these years can be observed well in the narrative scenes painted for the Merced Calzada in 1629–30, most of them of very high quality. The *Vision of Saint Peter Nolasco* [93], perhaps the finest picture of the cycle, is an extraordinary image in which color, light, and expression all share a high intensity. The simultaneously real and unearthly figure of the Apostle Peter, nailed to his upside-down cross and floating in a vivid orange cloud, is unforgettable, and so is the kneeling figure of his namesake; no other artist has known how to depict the heavy folds of white habits as subtly and richly as Zurbarán. The picture is simple in composition and almost completely filled by the two saints, and their close proximity to the observer, characteristic of many of Zurbarán's works, also contributes in no small measure to its impact.

Zurbarán's reputation as an artist rose rapidly in the last

93. *Francisco de Zurbarán:* Vision of Saint Peter Nolasco, Madrid, *Museo del Prado*

years of the 1620s, and the first noteworthy consequence of this ascent was the invitation made by the City Council of Seville in June of 1629 to change his residence from Llerena to the Andalusian capital. Zurbarán established himself in Seville that very summer, and proceeded to execute a new series of paintings for another religious order, this time the Franciscan. It may have been this commission from the Franciscan College of Seville, probably received the previous year, that was responsible for the City Council's invitation.

This cycle, dedicated to Saint Bonaventure, had been started earlier by Francisco de Herrera the Elder, who completed four pictures, and Zurbarán was asked to do another four canvases. The *Funeral of Saint Bonaventure* (Paris, Musée du Louvre), a mixture of contemporary and imaginary portraits, presents an extreme example of one distinctive aspect of Zurbarán's style: his adherence to Mannerist compositional formulas in which the spatial relationships of the figures are unclear or downright impossible. The scene seems to take place on a narrow and very tilted floor plane (viewed from above) on which the tightly packed figures (viewed at eye level) are not allowed enough space to accommodate the volume of their bodies. This shallow stage is defined exclusively by the figures that inhabit it; beyond them there is only a black void, as in the *Crucified Christ.*

The most imposing canvas of this period—and the largest of Zurbarán's entire artistic career—is the *Apotheosis of Saint Thomas Aquinas* altarpiece [94], painted in 1631 for the Colegio Mayor de Santo Tomás in Seville, where it was to ornament the high altar of its chapel. The picture's iconography was dictated by the rector of the college, and its composition was inspired by the two- or three-tiered type used throughout the Rennaissance for countless Assumptions and Coronations of the Virgin and, more to the point, for other glorifications of saints, such as the *Triumph of Saint Hermenegild* [40], which Herrera the Elder had painted about 1620. As in that work, the principal figures occupy a spatial band very close to the picture plane.

In the *Apotheosis of Saint Thomas Aquinas,* the heavenly level is inhabited primarily by the monumental figures of the four Latin Fathers of the Church with Saint Thomas in their midst, who receives his inspiration directly from the Holy Spirit; looking

94. Francisco de Zurbarán:
Apotheosis of Saint
Thomas Aquinas, Seville,
Museo Provincial de Bellas
Artes

upon them, in a more distant bank of clouds, sit Christ and the
Virgin, Saint Paul, and Saint Dominick. Kneeling in the lower
level are the founder of the college and other Dominican friars,
and its patron, Emperor Charles V with his retinue. This simple
arrangement serves very lucidly the picture's didactic function:
honoring the Dominican saint and commemorating the founda-
tion of the college. The static regularity that such a composition
imposes on the work, however, is animated by the power of Zurba-
rán's chiaroscuro, and by the brilliant coloring and richness of
pattern that he gives to the figures' garments, so that the *Apotheosis*
attains both formal grandeur and visual excitement.

One of the most beautiful pictures of this period, painted
about 1630, is *Christ and the Virgin in the House at Nazareth* [95],
an unusual subject, in which Christ pricks a finger while weaving
a crown of thorns, a presage of his Passion. This painting's blend
of commonplace domesticity and transcendental meaning is a very
personal feature of Zurbarán's art, and it produces an image of
reality that is touched by mystery and transformed by its spiritual
content.

Again the scene is set on an undefined and relatively shal-
low stage. The darkness of the environment is pierced by an

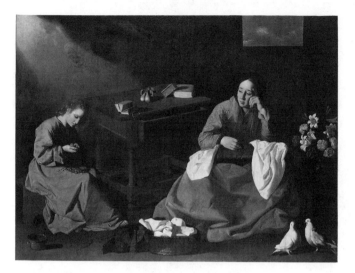

95. *Francisco de Zurbarán:* Christ and the Virgin in the House at Nazareth, *Cleveland Museum of Art*

intense light of divine origin, which illuminates the figures, the meager furnishings, and the scattered objects around them; it is only this paraphernalia that defines the space that mother and son occupy. As occurs in other paintings by Zurbarán, but here to an extreme degree, each of the elements that make up the composition appears isolated from all the others. In the context of this picture's subject, the separateness of each form makes the Virgin's sadness more poignant, for the distance that separates her from the Christ Child seems unbridgeable.

In this painting, where still-life elements abound, another characteristic aspect of Zurbarán's work is highlighted: the figures are as objectified as the lovingly observed books, flowers, or earthenware pots that surround them; their actions seem to be stilled forever. This manner of presenting reality alters it essentially; it is another way of removing from the sphere of the quotidian things which are otherwise described with total fidelity to nature, and raising them to the realm of the spirit.

When the subject of Zurbarán's painting is simply a still life, this way of composing and describing also imparts an almost sacramental flavor to paintable objects which need not have particular significance. Such is the case in the only picture in this genre signed by Zurbarán, the *Still Life with Cidras, Basket of Oranges,*

Cup, and Rose, dated 1633 [96]. In this crystalline, mesmerizing picture, the isolation of the painted receptacles and their contents, intensified by the sharp light that bathes them, and the frontality and symmetry with which they are arranged, lend such an aura of mystery to those mundane objects that it is almost impossible to perceive them simply as such.

In 1634, Zurbarán received an invitation from the king to participate in the decoration of the great Hall of Realms in the newly built Buen Retiro palace in Madrid, the only such invitation to a painter who was not a resident of the court. Of the twelve engagements recently won by the Spanish armies that were to be commemorated there, Zurbarán was chosen to paint *The Defense of Cádiz* (Madrid, Museo del Prado), successfully commanded by Don Fernando de Girón, who, old and gouty, appears seated on the chair from which he led this campaign.

Zurbarán had not worked until then at such a large scale, and the only major works painted by him prior to this date to which the *Defense* could refer in its compositional scheme were two of the stories of Saint Peter Nolasco painted for the Merced Calzada in 1629–30. The figures there were also deployed in a horizontal band, but they filled the greatest part of the canvas, while those in the new picture inhabit a vast, open space. The general lines of this composition conform to the scheme followed by the majority of the other battle pictures in the Salón de Reinos, and the painting fits perfectly into the series. Only Velázquez's *Surrender of Breda* [131] and Mayno's *Recovery of Bahia* [60] stand out among all of them by their compositional inventiveness and artistic quality, but Zurbarán's canvas is more than a match for most of the others.

Zurbarán was also commissioned to paint ten pictures of

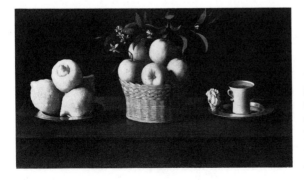

96. *Francisco de Zurbarán:* Still Life with Cidras, Basket of Oranges, Cup, and Rose, *Pasadena, Norton Simon Museum of Art*

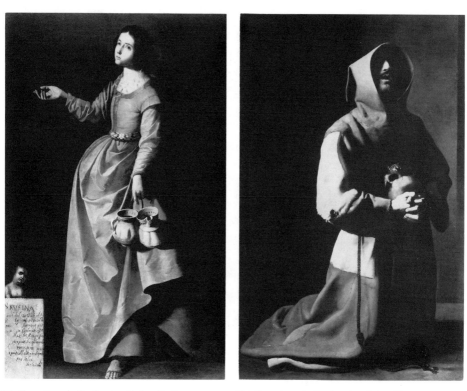

97. *Francisco de Zurbarán:* Saint Rufina, *Dublin, National Gallery of Ireland*

98. *Francisco de Zurbarán:* Saint Francis in Meditation, *London, National Gallery*

the Labors of Hercules—the mythological hero who had become a symbol of the Hapsburg dynasty—to go over the windows in the Hall of Realms in alternation with the battle paintings. The choice of Zurbarán for this undertaking is somewhat puzzling, since he had never before painted a nude in action. The artist made up for his lack of experience by using prints (primarily by Flemish Mannerists) as models for the dramatic nudes. The Hercules paintings combine with surprisingly happy results the exaggerated action poses of his sources and his own realistic description of faces and bodies, as well as his striking chiaroscuro.

Once his part in the execution of the paintings for the Buen Retiro was finished, Zurbarán returned to Seville. In spite of having fulfilled his task more than adequately, he never again received another royal commission.

The pictures of martyred virgins with their attributes, painted as single figures but often forming part of a series, occupy

a prime place among the most characteristic and beloved of Zurbarán's works. These young saints, usually presented in full length, are depicted in often rich and always colorful costumes, which are brilliantly set off by the paintings' black backgrounds. Two examples from the years 1634–40, *Saint Margaret* (London, National Gallery), clad as a shepherdess in a fine local costume, and *Saint Rufina* [97], stylishly attired in garments close to contemporary fashion, are very representative of the elegance and charm of these figures, which give the artist the opportunity to work with a less austere subject than those that make up the majority of his religious work.

The caliber of Zurbarán's art is most consistent both in invention and quality when dealing with an isolated figure, strongly lit against an opaque background. Beyond their success as visual images, the saints portrayed in prayer or meditation which fit into this category are also powerful evocations of religious emotion. Perhaps the most effective in both respects is *Saint Francis in Meditation* [98], of c. 1635–40. His features are barely discernible in the shadow cast by his hood, but the intense devotion expressed by the saint's face through this penumbra, and by the force with which he presses against his chest the skull in his hands, is vividly suggested. The viewer's empathetic experience of Saint Francis's emotion, which is the principal religious objective of such an image, is perfectly achieved.

Saint Francis in Meditation and, like it, other versions of the same subject follow the type of ascetic and penitent image of this saint that El Greco had established the previous century, but now interpreted by Zurbarán in a realist vein.

The same degree of naturalism used to give to his images of saints their particularized look of men and women of flesh and blood is employed by Zurbarán to give form to his representations of heavenly visions, endowing them with a concrete existence. In *Christ Crowning Saint Joseph* (Seville, Museo Provincial de Bellas Artes), of c. 1636, he presents two voluminous and solid figures—measured and solemn in their gestures—firmly planted on a substantial floor of clouds, but he expresses the mystery and transcendence of the scene equally strongly by means of the luminous and intensely colored setting against which they are sharply silhouetted.

The last important commission received by Zurbarán at the end of this decade is also the only one that is preserved complete and in situ, in the new sacristy of the Monastery of San Jerónimo in Guadalupe. The cycle, painted to honor the memory of the founder of the monastery and the piety and achievement of various members of the community in past centuries, was to be the pictorial ornament to the richly decorated sacristy and adjoining chapel, built in 1638–40.

Of the eight pictures that adorn the walls of the sacristy (the majority dated in 1639), the most beautiful is undoubtedly the imaginary portrait of Fray Gonzalo de Illescas [99], one of the most eminent personalities in Spain in the fifteenth century. The prototype for this image can be found in El Greco's *Saint Ildefonso Writing*, in Illescas [27], but while the saint there pauses to gather his inspiration from the image of a Virgin within the painting, Zurbarán's Fray Gonzalo, pen poised in midair over a letter, turns to scowl at the viewer, on the other side of the picture plane, as if in response to the interruption of his work. This device, in which the sitter appears to be caught off guard, and the painter seemingly captures his spontaneous reaction to an external stimulus, was introduced in sixteenth-century portraiture, and it had become quite common in Baroque art. The draped red hanging suspended over the friar's head, which serves to aggrandize the sitter, is also a characteristic prop of seventeenth-century portraiture.

The composition of this portrait, which stresses the intellectual work of the friar, also includes, however, a splendid memento mori still life on his worktable, and a city view where an instance of his charity is depicted, balancing Fray Gonzalo's portrayal as a scholar with references to his religious thought and Christian works. It should be noted that Zurbarán seems to remain ignorant of (or perhaps simply ignores) the rules of linear perspective in his architectural view, and the result is very similar to the background settings in many paintings by sixteenth-century central Italian Mannerists.

For the chapel, Zurbarán executed the *Apotheosis of Saint Jerome* that crowns the retable, and *Saint Jerome Flagellated by the Angels* and the *Temptation of Saint Jerome* [100] for the side walls. In the *Temptation,* where the artist used a particularly dramatic chiaroscuro, the sharp light serves to enhance the exaggerated

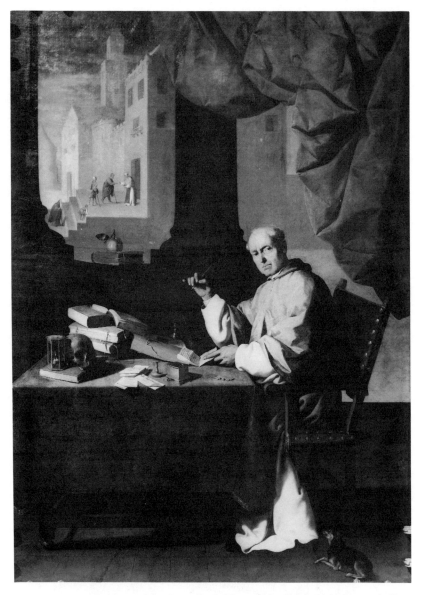

99. *Francisco de Zurbarán:* Fray Gonzalo de Illescas, *Guadalupe, Monasterio de San Jerónimo*

gesture of rejection with which Saint Jerome fends off his vision of young women, a visible representation of the temptation of the flesh.

Zurbarán depicts Jerome's vision in terms as concrete as

those used for the saint itself; the young women are dressed in quasi-contemporary costumes similar to those worn by his martyred virgin saints and play on solid, heavy musical instruments. In characteristic fashion, Zurbarán does not represent the Roman girls dancing, as the saint described them in one of his letters, but rather singing and playing their music with gravity and composure, with no other movement than that of their fingers and lips; were it not for Saint Jerome's gesture, one might believe them to be angelic figures come to comfort the penitent saint. Having avoided the movement of the dance and dressed the young women with propriety, Zurbarán made use of a traditional means to convey that they stood for Lascivia: their musical instruments, which since the Middle Ages had been a frequent pictorial symbol of lust.

After 1640, Zurbarán received no more commissions for important cycles of paintings such as had come to him at the apogee of his career, and from 1650 on, no commission of any sort is documented. In 1658, riddled by debts and with no prospect of financial improvement, the painter moved to Madrid, where he was to die in poverty six years later. This change of fortunes in Zurbarán's artistic career in the last fifteen years of his life may be attributed, and it has, to general economic factors (since the 1640s the Spanish economy had entered a phase of clear decadence), to

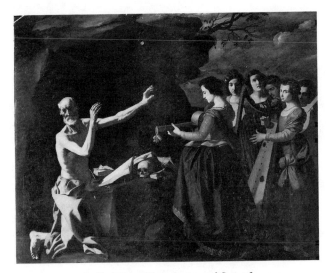

100. *Francisco de Zurbarán*: Temptation of Saint Jerome, Guadalupe, Monasterio de San Jerónimo

the effects in Seville itself of the devastating episode of bubonic plague in 1648, and, finally, to the emergence in the artistic scene of the younger Murillo, who supplanted Zurbarán as the favorite painter of the religious communities of Seville. Although there is no question that all these factors contributed to the decline in Zurbarán's output, the idea that Murillo's rise as a painter c. 1650, per se, had a fatal effect on his older contemporary's popularity should be given closer scrutiny.

The naturalism of Spanish religious art during the first half of the seventeenth century was addressed to the instruction and edification of the faithful by means of images of an almost tangible reality; for this purpose, artists strove to make the protagonists, content, and spiritual message of those images as vivid as possible. In sculpture and in painting, the holy figures were presented as human beings of flesh and blood in both physical and emotional terms, and the narrative they enacted was conveyed in clear and direct terms. In conjunction with this naturalistic style, certain aspects of religious life were frequently touched upon: asceticism was presented as an exemplary way of life, worthy of reverence and emulation, and the efficacy of an intense and firm faith was emphasized as a means to salvation.

During the second half of the century, the dominant temper of religious art became less austere, and its subjects, now enacted by more idealized characters, were presented in sensuous, more eye-flattering images, aimed at creating a mellower mood and eliciting a more sentimental response from the viewer. If Zurbarán had been the most outstanding exponent of the earlier, severe naturalism, and interpreted best the ascetic religious ideals of his time, it was Murillo's sensual and emotively tender art that best represented the idealizing and sentimental approach to sacred art of his own day.

Zurbarán's work, however, was not unaffected by the change in outlook apparent in religious art. His life spanned the transition from one artistic mode to the next, and the paintings he executed in his later years reflect that general shift of temper. This modification begins to be noticeable in his work as early as 1650—in pictures whose very subjects set a tender, emotional tone—and his style became mellower, less formally austere than that of his maturity. Although he continued to describe the

101. Francisco de Zurbarán: Virgin and Child with Saint John the Baptist, *San Diego Museum of Art*

102. Francisco de Zurbarán: Immaculate Conception, *Madrid, Museo del Prado*

painted subjects with the same insistence on their tactile values that had always characterized his art, he now moderated the earlier crispness of contour in figures and objects, and softened the harsh illumination that previously divided so trenchantly light from darkness. The transition from the solid forms to their surrounding space is less abrupt, less categorical, and the shadows dissolve, become less opaque. Together with this softening of his technique, there comes a sweetening of his color, earlier more vivid and brilliant.

The *Virgin and Child with Saint John the Baptist* [101], signed in 1658, is an excellent example of this final phase of Zurbarán's painting. The subject of the Virgin and Child, appropriate to move the pious observer with its sweet persuasion, is in itself characteristic of it. Absent from Zurbarán's work until the decade of the 1650s, the image of the Virgin and Child appears several times in those years, and is the subject of his last documented picture, dated 1662 (Bilbao, Museo de Bellas Artes). The production of these works answered a new demand for devotional images in which the elements of femininity and maternal love of the

Virgin were highlighted, and Zurbarán created in his own versions a tone of intimacy that was new in his art.

The change in Zurbarán's painting is revealed even in subjects of identical content to earlier pictures, such as the Immaculate Conception. In the *Immaculate Conception* painted about 1630/35 [102], the youthful figure is grave and monumental, traits achieved by the seriousness of her expression, the simple outline of her heavy mantle, and the axiality and immobility of her pose. The Virgin in the *Immaculate Conception* dated 1661 (Langon [Bordeaux], Parish Church), whose features and body are daintier, is also a more ornamental figure. She floats lightly with an oblique movement, and her pose follows a curve that is repeated by her blue mantle, dramatically blown by a heavenly wind. In contrast to the clarity of features and incisive definition of forms in the earlier *Immaculate Conception*, the face of the Virgin in the later work is painted with a delicate sfumato that dissolves its contours.

Other paintings of the same period—such as *Christ Bearing the Cross* (1653; Orleans, Cathedral), *Saint Francis in Prayer* of 1658 [103], and *Christ After the Flagellation* (1661; Jadraque [Guadalupe], Nuestra Señora del Carmen)—reveal stylistic and expressive

103. *Francisco de Zurbarán:* Saint Francis in Prayer, *Madrid, Arango Collection*

similarities to the devotional images of the Virgin. These works are very different from the pictures painted in the 1630s, to which they might be compared thematically, but neither in invention or facture are they of lesser quality than those. The fineness of execution and subtlety of expression of the late Christ figures and the Saint Francis are the equal of Murillo's in his best pictures of those dates.

Zurbarán responded to the change in the temper of religious feeling that took place in the second half of the century at the same time as Murillo, and even though his own style had been formed within a naturalist and austere mold, he was also able to give expression to the new ideals in the works of his last years, albeit in a more sober fashion. But if the transformation that took place in his painting was significant in relation to his earlier work, it was not enough to preserve his position of eminence in Seville, or to gain it in Madrid. The field had been taken by a younger generation of artists, who began to work in a Spanish version of the High Baroque, against which even Zurbarán's late style must have seemed hopelessly outmoded.

🔲 *Alonso Cano (1601-1667)*

Alonso Cano, painter, sculptor, and architect, was born in Granada in 1601. His father, the architect and retable maker Miguel Cano, moved with his family to Seville in 1614, and it was there that Alonso received his artistic education as a painter. In 1616, he entered the workshop of Francisco Pacheco, where Velázquez, two years his senior, was still undergoing his apprenticeship with his future father-in-law, and there he remained for the next four or five years. This close contact with Velázquez lasted only four months, but it would prove to be significant for his art both in the short and in the long run. His first known work, dated 1624, the full-length *Saint Francis Borgia* (Seville, Museo Provincial de Bellas Artes), was executed in a tenebrist and naturalistic style of strongly modeled forms painted with self-concealing brushwork, traits that it shares with Velázquez's Sevillian paintings.

In the early 1620s, Cano probably went from Pacheco's household to the workshop of Juan Martínez Montañés (1568–1649), the most important Sevillian sculptor of the seventeenth century, whose refined style had a decisive influence on Cano's sculpture, particularly evident in his early pieces. Although Cano passed the examinations necessary to enter the painters' guild in 1626, the works that occupied his youthful years, and that established his reputation as an artist, were primarily sculptural. The most conspicuous commission of the years spent in Seville was the

design of the great retable of the church of Santa María de la Oliva, in Lebrija, and the execution of its polychromed figures, done in 1629–31.

In spite of the prominence that Cano had gained as an artist in the 1630s, and of the sizable dowry that had come to him with his marriage to his second wife in 1631, in 1636 Cano was put in debtors' prison, the first of the many troubles he brought upon himself throughout his life. Two years later, in 1638, he entered the service of the Count-Duke of Olivares as his painter and *ayudante de cámara,* and left Seville for good to establish himself in Madrid. Olivares would be his protector at the court from that date until 1643, when the prime minister fell in disgrace.

The works painted by Cano about 1635–37, in the years immediately before his departure for Madrid, already display some of the features that would be constants of his mature style, and begin to move away from the pronounced tenebrism that characterized *Saint Francis Borgia.* A good example of the change that takes place in his painting during these years is the *Vision of Saint John the Evangelist* [104], a picture that was originally part of a large retable dedicated to the saint, executed c. 1635–37 for the church of Santa Paula in Seville. Cano had been responsible for the design of the retable itself, as well as for the execution of its sculpted decorative figures and its paintings. The central image of the altarpiece was a polychromed statue of Saint John by Martínez Montañés, and is still in situ; six of Cano's paintings are now preserved in various museums around the world.

In the *Vision of Saint John the Evangelist,* the figures are idealized and their movements elegant, and the lines created by their contours weave them into a cruciform pattern that realizes fully the ornamental value of their forms. This design is not merely decorative, however; its central point is also the focus of the spiritual communication between the angel and the saint. In this work, Cano also abandons the pronounced tenebrism that characterizes his *Saint Francis Borgia;* the colors of the *Vision* are clear and subtle, and a luminous atmosphere permeates the whole painting and renders the shadows transparent.

At the court, Cano renewed contact with his ex–fellow apprentice, Velázquez, and through him gained access to the royal collections, rich in Venetian and Flemish pictures; both contact

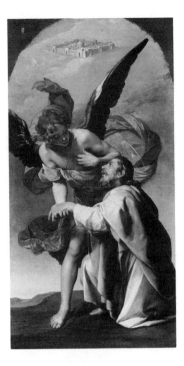

104. *Alonso Cano:* Vision of Saint John the Evangelist, *London, Wallace Collection*

with Velázquez and exposure to the paintings in the royal sites would play an important role in his development as a painter. The work of restoration of the pictures that had survived a disastrous fire in the Buen Retiro palace in 1640 would also be a significant factor in the change in style that can be noticed in Cano's work about 1645. From that point on, his figures become noticeably less sculpturesque, his definition of contours less linear, his brushwork looser, and his lighting more diffused.

In 1643 and 1644, Cano's career at court was severely set back, if only temporarily. Olivares's fall from power in 1643 left Cano without his most important supporter, and his personal life took a serious blow the following year: his second wife, aged twenty-five, was stabbed to death in bed by an unidentified workshop assistant, who fled the scene and was never seen again. Cano was imprisoned under suspicion of having paid the young man to do the murder, put to torture for a confession, but finally released as innocent. After these events, the painter left Madrid for a brief stay in Valencia, but soon returned to pick up his brushes again.

There are no known sculptures by Cano that date from the years spent in Madrid between 1645 and 1652, but this is his most productive period as a painter, and to it belong some of his finest works. One of them is the *Miracle of the Well,* of c. 1646–48 [105],

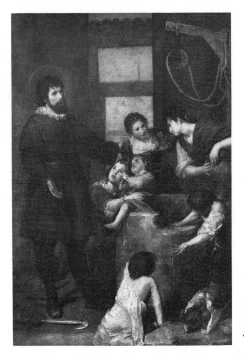

105. *Alonso Cano:* Miracle of the Well, *Madrid, Museo del Prado*

which represents a miracle performed by the patron saint of Madrid, Saint Isidro Labrador. This extraordinary picture was part of the high altar retable of the church of Santa María de la Almudena, and is mentioned in contemporary accounts as the most admired of his paintings in the city. Even in its present pitiful state of conservation, and with the canvas cropped on both sides, it is still possible to appreciate its quality and originality.

In the *Miracle,* Saint Isidore is shown thanking God for the miraculous rescue of a child that had fallen into a well, whom he had saved by hoisting him up with a fragile rosary. Although the rosary he holds in his hand still unites him to the infant, the saint appears isolated; his dark silhouette belongs to a different world from that of the women and children who surround the well. This group, painted with vivid and luminous colors, is interpreted as a genre scene, and the movement and spontaneity of its figures contrast with the saint's hieratic and entranced attitude. In its technique, this is the painting by Cano that most closely approximates those of the Venetian school, particularly Titian's pictures of c. 1560–70, many of which had been painted for Philip II and were then the ornament of the Alcázar.

The *Virgin and Child in a Landscape* [106], very close to the *Miracle of the Well* in its facture, must also date to c. 1646–48. Its composition is directly based on an engraving by Dürer of 1520 (B. 38), with some small changes in the landscape and more important ones in the description of the Child, who is shown nude and with his blue eyes half open in the painting. Literary sources report that Cano made frequent use of prints in his work, but in this practice, as has been already pointed out, he does not differ from many other Spanish painters of this period, including Velázquez and Murillo. In this instance, in which his engraved source is known and available for comparison, we can see precisely what Cano retained from it. The general scheme of the print is almost unchanged, but the transformation undergone by the model in his painting is nonetheless significant; Cano translates the severe and linear language of the German print into his own tender and painterly manner, without undermining the classical structure of Dürer's image or betraying the values of his own medium and technique.

One of the most interesting pictures of these years, for its compositional originality and its expressive subtlety, is *Christ in Calvary* [107], still in the church of San Ginés in Madrid, for which it was commissioned. The subject of this painting, errone-

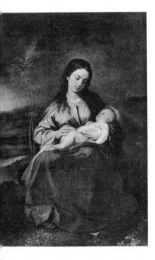

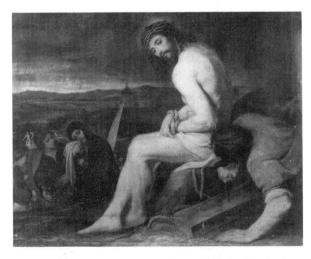

106. *Alonso Cano:* Virgin and Child in a Landscape, *Madrid, Museo del Prado*

107. *Alonso Cano:* Christ in Calvary, *Madrid, Church of San Ginés*

ously identified as an Ecce Homo, is a moment of the Via Crucis: Christ resting before he is nailed to the Cross, a rare scene in the iconography of the Passion. As in the *Virgin and Child in a Landscape*, the figures here too appear in a dark landscape, whose horizon begins to be touched by dawn; against it stands out the white body of Christ, seated on a rock. In a distant middle ground, Saint John and the Magdalen are shown consoling the Virgin, isolated from Christ at this moment. With his head sharply turned back, Christ looks at the executioner drilling the wood of the Cross with a turning pin, and he, in turn, raises his head to look at Christ. The Savior's expression in this silent dialogue of glances is rich in emotional nuances; it suggests fatigue, sadness, and a feeling almost of concern for his tormentor.

Various features of this painting can be related to earlier works possibly known by Cano: Christ's pose is comparable, although not identical, to that of the *Man of Sorrows* that serves as the cover leaf of Dürer's *Great Passion*, of 1518 (B. 4); and the executioner and the small group of the Virgin and Saints John and Magdalen may be related to those in El Greco's *Disrobing of Christ* [12]. The conception of the subject, however, is completely personal, and the refined beauty of the Christ figure and the subtlety of his expression are distinctively Cano's.

To the same period, between 1645 and 1652, belongs his *Christ Supported by an Angel*, in which the body and head of Christ have been raised to a high level of idealization and given an aristocratic elegance. The handling of the paint is similar in both works: the brushwork is light and the contours of the forms are soft. In style as well as in execution, Cano's painting here is reminiscent of Van Dyck's, whose sensibility he shares. The works of the Flemish master were known to him—those in the royal collection firsthand, and others through engravings—and they were obviously admired; in this proclivity, he was a forerunner of the later painters of the school of Madrid.

In Cano's paintings of the crucified Christ, a subject that he repeated many times, Christ's body is again treated with a similar elegance and smoothness, although its modeling is much more sculpturesque. This last quality is perhaps the result of the proximity of this type of image to the polychromed sculptures of Christ carved by Martínez Montañés and Cano himself. In fact,

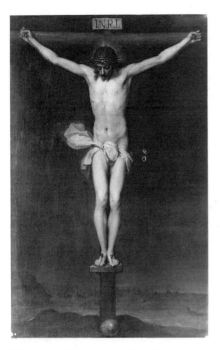

108. *Alonso Cano:* Crucified Christ, Madrid, Academia de San Fernando

109. *Alonso Cano:* Immaculate Conception, *Vitoria, Museo Provincial de Alava*

in most of his renderings of Christ on the Cross (including a sculpted one), the structure of the body, the inclination of the head, and the *contrapposto* pose that the use of three nails brings about are very similar to what we see in one of Montañés's most admired works, the *Christ of Clemency* in the cathedral of Seville.

In the *Crucified Christ* illustrated here [108], on the other hand, Cano followed Pacheco's dictum and painted the Crucifix with four nails, so that the vertical axis of the figure is less sinuous, and the pose more frontal than in his other renderings of the subject. Cano's Christ is set in a tauter posture than Pacheco's, however, and is both a more realistic and more sensual portrayal of the male nude. Also unlike Pacheco's, the crucified Christ is set against a dark landscape tinted with red—particularly intense in the distant horizon, a feature that gives the picture a highly dramatic quality.

The signed *Immaculate Conception* now in Vitoria [109], executed by Cano c. 1650–52, belongs to the type developed

during the second half of the seventeenth century, in which the representation of the multiple Marian symbols that characterized the Immaculate Conceptions painted in the sixteenth century and the first half of the seventeenth is abandoned. Only the lilies and irises that two small angels carry in their hands refer symbolically to the Virgin's purity.

The physical beauty of this Immaculate Conception is comparable to that of Murillo's young Virgins, but her expression is more mature and proud, suggesting her identity as Queen of Heaven as well as her spotlessness. The silhouette formed by her ample mantle as it is blown by the wind lends her a grandeur that is rare in this type of image; among those painted by Murillo, only the Virgin of the Franciscans [173], of these same years, can be compared to it, and before both, that of the Salesas of Salamanca, painted by Ribera [78].

Images of mystical encounters between the saints and the divinity abound in seventeenth-century painting; direct contact with Christ or the Virgin, as experienced in a vision, was regarded at this time as the most precious sign of grace that could be bestowed upon a mortal. This meant that in the depiction of the lives of saints, pride of place was given to such miraculous appearances, over any other sort of miracle. In the paintings that honor Saint Anthony of Padua, for example, the miracles of the saint that had been commonly depicted in Italian fifteenth- and six-teenth-century art were now only rarely retold. In Baroque painting, instead, the visionary moment in which the saint receives in his arms the Christ Child is tirelessly repeated, particularly during the second half of the seventeenth century. At that moment, the preference for this type of subject is reinforced in Spain by the new taste in religious art for events and situations in which tenderness is the dominant emotion. The vision of Saint Anthony suited perfectly both desiderata.

Cano's *Vision of Saint Anthony of Padua* [110], of c. 1646–52, illustrates this subject in a picture of great formal and spiritual delicacy. The degree of idealization and stylization of the Virgin is very marked, as is the elegance of her form and movement, her head and trunk turning on the figure's axis in a fluid spiral. Saint Anthony's face, seen in *profil perdu* (a view much favored by the artist), expresses innocence and wonder, and his total absorption

in the Virgin's presence. She, on her part, looks sweetly at the saint, almost touching him with her hand. The physical proximity of the two figures could not be greater, nor the intensity of their eye contact stressed further.

During the eleven or twelve years spent in Madrid, Cano had been in Philip IV's employ and served as Prince Baltasar Carlos's drawing master, and in 1651, the artist requested as a grace from the king a prebend in the cathedral of Granada. His request was granted, and the painter took possession of this sine-cure early the following year, leaving Madrid with the intention of never returning.

From the beginning, his relations with the canons of the cathedral were strained, and in 1656 the latter declared his pre-bend vacant by reason of his not having fulfilled the established precondition necessary to retain it: his ordination as a priest a year after taking possession. Sometime in 1657, then, Cano returned to the court to protest before the king for the loss of his post, and early the following year he received holy orders, and his prebend was returned. Two years later, in 1660, he returned to Granada, this time for good.

During the first years spent in Granada, between 1652 and 1657, Cano deployed a prodigious activity on behalf of the cathe-

110. Alonso Cano: Vision of Saint Anthony of Padua, *Munich, Alte Pinakothek*

111. Alonso Cano: Presentation of the Virgin *and* Annunciation, Granada, *Cathedral*

dral, beginning with the design of its great lectern and two large altar lamps. He then started on the execution of a series of seven monumental canvases (c. 15½ feet high) with scenes of the life of the Virgin, planned for the rotunda of the sanctuary, high above the ground. The paintings that belong to this moment of activity are the *Presentation of the Virgin,* the *Annunciation,* the *Visitation,* and the *Purification,* although some of them were retouched by him after 1660. These large canvases were conceived with their assigned placement in mind, and since they were painted for a very long view from the ground, their compositions were kept particularly simple and clear. The *Presentation of the Virgin* [111 left] was probably the first of the subjects to be executed, since its figures are at a smaller scale than those of the other six pictures (even the similarly multifigured composition of the *Birth of the Virgin*), suggesting that Cano learned from that experience to increase significantly the size of the rest. In the *Annunciation* [111 right], organized on the basis of two contrasting diagonals and a strong chiaroscuro breakdown of the painted surface, the brilliance of the space filled by the glory and the white tunic of the angel make easy the reading of the distant scene. The figures' poses and gestures,

and the pattern of the light that falls on them, indicate that this is the precise moment of conception: the descent of the Holy Spirit has the force of an electrical discharge that moves the Virgin and awes the angel.

During these years, Cano also devoted some of his time to works of architecture, sculpture, and painting for various religious orders. His most important commission, although now little remains of it, was the design of the church of the Franciscan Nuns of the Angel Custodio, as well as the sculptures and paintings that decorated it. Of the latter, only two have survived, the best known being the *Holy Family* [112], one of Cano's most attractive pictures.

The subject of the *Holy Family* is not interpreted in its traditional form, in which the Virgin holds the Child in her arms and Saint Joseph stands beside her, but instead with an emphasis on the person of the patriarch that is typical of Spanish religious art of the seventeenth century and already present in that of the late sixteenth century. Here the scene illustrates the transfer of the Child from the arms of his mother to those of Saint Joseph, who receives him as his appointed protector during his infancy. The

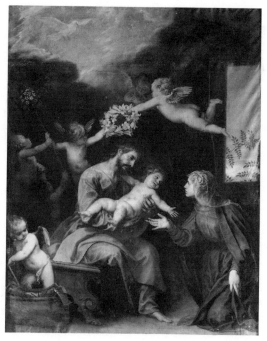

112. Alonso Cano: Holy Family, *Granada*, Convent of the Angel Custodio

cherubs that surround the group hold in their hands Saint Joseph's attributes: his carpenter's tools, the flowering rod, and a wreath of lilies; sanctifying the moment, the Holy Spirit sheds its light on the Holy Family. The glances and gestures exchanged by the three protagonists of the scene are both expressive and subtle, as is always the case in Cano's best works.

Of the series of pictures painted by Cano for the Franciscan Convent of San Antonio y San Diego, also only a few are left, and those few in poor condition. One of the better preserved is the *Saint Bernard and Saint John Capistrano* [113], which belonged to the predella of the high altar of that church, and is a work of great originality and pictorial beauty. The two saints appear absorbed in conversation and walking at a good clip, for although they appear only *en buste,* the forward tilt of their bodies and the white banderole that the first holds suggest quite vividly their rapid motion. The highly individualized and expressive heads are painted in a manner that brings Velázquez to mind in the simplicity with which the forms are defined.

Although it is not documented, the large *Christ in Limbo* [114] probably belongs to this period as well. In spite of its poor state of preservation, it is one of Cano's most impressive works,

113. *Alonso Cano:* Saint Bernard and Saint John Capistrano, *Granada, Museo de Carlos V*

114. *Alonso Cano:* Christ in Limbo, *Los Angeles County Museum of Art*

also notable because it contains one of the few female nudes in Spanish seventeenth-century painting.

The event is presented in an unusual way, since a minimum number of characters is included, and their surroundings are also reduced to the barest essentials, in contrast to the crowds and complexity of most representations of this subject. The amount of empty space in this picture, however, is not unusual in Cano's compositions, particularly those of his later years, such as the *Vision of Saint Bernard* (Madrid, Museo del Prado), of c. 1658–60.

The male nude is fairly frequent in Cano's painting, and this Christ is a superb demonstration of the artist's understanding of human anatomy. It is also a testimony to the lessons learned in Madrid from Velázquez's art and technique. Eve's figure, which like Velázquez's *Venus* [139] discreetly turns her back toward us, is nonetheless a memorable representation of feminine sensuality. The shape of her body, in its specificity, seems drawn directly from the model, but her pose, also like that of Velázquez's *Venus,* reveals a Classical origin. The modesty expressed by her posture is that of the *Venus pudica* type established in Greek sculpture in the fourth century B.C. and known from ancient copies, such as the *Capitoline Venus* and the *Medici Venus,* on which it is indubitably based.

The image of the Immaculate Conception appears repeatedly in Cano's oeuvre, most frequently in the last fifteen years of his life. Among the late pictures of this subject, the *Immaculate Conception* of the oratory of the sacristy in Granada's cathedral [115], painted c. 1660–67, presents in its most distinctive form the characteristic format Cano gives to his Immaculate Conceptions. The Virgin's pose, with her head turned to the left and the hands held in prayer pointing to the right, is based on the identical *contrapposto* of the Immaculate Virgin in Vitoria [109], but here it is markedly restrained, with strikingly different results. The inclination of the head, torque of the body, and bend of the left leg that make up the pose are not only much more emphatic in the Vitoria Immaculate Virgin than in Granada's, but are also reinforced there by the strong spiraling motion of her mantle. The figure of Granada's Immaculate Virgin, attenuated and elegant, is less sinuous and less movemented, and its outlines are more symmetrical with respect to its vertical axis. The rhombuslike silhou-

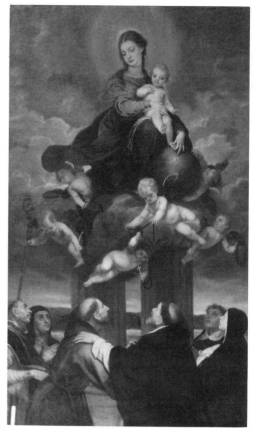

115. *Alonso Cano:* Immaculate Conception, *Granada, Cathedral, Oratory of the Sacristy*

116. *Alonso Cano:* Virgin of the Rosary, *Málaga, Cathedral*

ette formed here by the arrangement of her mantle gives the figure stability and monumentality without diminishing its gracefulness. In this Immaculate Conception, Cano was able to create an ideal vision of Mary, a majestic but also feminine image of great beauty and sensuality.

During his last years in Granada, Cano left the city for a period of considerable duration, sometime in 1665 or 1666, which he spent in Málaga. Most of the pictures that he executed during that time have been lost, but his major work there, the large *Virgin of the Rosary* altarpiece in the cathedral [116], is still in situ.

This picture was commissioned by the recently appointed bishop, the Dominican Alonso de Santo Tomás, and honors the Dominican legend concerning the origins of the rosary. The Virgin appears seated on a throne of clouds on which the orb of the world also rests, hovering in front of two fluted Classical columns that rise symmetrically in the center of the painting. She looks benevolently on the six saints standing below her, who in turn

look up to her in awe. Saint Ildefonso and Saint Teresa, identifiable by their attributes, appear on the left; in the center are Saint Francis and Saint Dominic, who is about to receive the rosary from the cherubs that support the Virgin, and on the right are Saint Catherine of Siena and Saint Thomas Aquinas, all seen in half length.

The poise and symmetry of the composition of the *Virgin of the Rosary,* as is also the case in the *Immaculate Conception* of Granada, clearly show Cano's classical bent, but the realism and emotiveness of the saints belong fully to the Spanish version of the Baroque style.

Although Alonso Cano had considerable talent for portraiture, very few examples of that facet of his work are known today, and only one of them is signed, the *Portrait of an Ecclesiastic* [117], an early picture. Among the others, one that clearly falls well within the parameters of Cano's style, although it is not documented, is the *Portrait of a Dominican Friar* [118], a late work. Chance provides us with a telling contrast between the likenesses of a gaunt, ascetic-looking, and severe individual, painted c. 1625–30, and a well-nourished, earthy cleric, done c. 1660–67, who seem to embody in their own persons the change of character that takes

117. *Alonso Cano:* Portrait of an Ecclesiastic, *New York, Hispanic Society of America*

118. *Alonso Cano:* Portrait of a Dominican Friar, *Kassel, Staatliche Gemäldegalerie*

place in religious painting between the first and the second half of the century.

The format of the *Portrait of an Ecclesiastic,* in which the figure shares the picture space with a table and some objects, is one established in the sixteenth century, first in the Netherlands and Italy, and later in Spain. The ecclesiastic holds in one hand a prayer book, which he appears to have been reading, and his other hand rests on an hourglass, a frequent symbol of the transience of man's life. His melancholy and stern expression, in combination with those objects and the predominant blacks and grays of the painting's color scheme, give the portrait a somber and austere character, which would be hard to find in portraiture at this time elsewhere other than in Spain. The rigidity and reserve of the sitter keep him at a distance from the observer, as is the case with many other Spanish seventeenth-century portraits.

In the *Portrait of a Dominican Friar,* the sitter also holds in his hand a prayer book, marking his place with the index finger inserted between its pages, as does the ecclesiastic, but the two portraits otherwise differ in every respect. Apart from what the physique of the rotund friar itself contributes to the more light-hearted tone of his portrait, his good-natured, almost amused expression makes a strong contrast to the hardness exhibited by the ecclesiastic's mien. The friar also differs from the earlier sitter in his closer and more open relationship to the onlooker; the half-length figure occupies most of the picture plane, so that he is physically nearer the observer, whose glance he engages directly. The ecclesiastic, instead, is literally and psychologically more distant; his melancholic glance seems to go past the observer, with whom it makes no contact.

Alonso Cano's last work was the design for the facade of the cathedral of Granada, of which he had been appointed chief architect in May of 1667. He would not be able, however, to supervise its construction, for in September of that same year, he died after a short illness.

In spite of his extensive production in the arts of painting, sculpture, and architecture, and of his high artistic reputation throughout his life, Cano died in poverty, leaving behind numerous debts, a fate he shared with many other major and minor Spanish painters of the seventeenth century.

🎨 *Diego de Silva y Velázquez*
(1599-1660)

Velázquez is not only the most important of the Spanish painters of the Golden Age, but also the one about whom we are best informed; various published literary sources—the most exhaustive concerning any Spanish seventeenth-century painter—and a good quantity of available archival documentation have provided us with a large number of more or less trustworthy facts about the man and his work.

Velázquez was born in Seville in 1599, first child in a family of modest means but some claims to nobility. His father was of Portuguese origin, and his mother, whose maiden name he would adopt for common use, was Sevillian.* His artistic education began at the end of 1610, when his father placed him under Francisco Pacheco's tutelage as an apprentice. Pacheco was a painter of meager talent, but with humanistic and theoretical interests that set him apart from the rest of the Sevillian artists of his day and were of great importance for the development of Velázquez's art. The contact with scholars and poets in Pacheco's circle not only gave Velázquez from the start a familiarity with the humanistic traditions of the Renaissance—in itself unusual among the Spanish painters of this period—but also equipped him with intellectual habits that would shape his ideas about painting in later years.

*The practice of using the mother's surname was current in Andalusia still in Palomino's day, and Juan de Valdés Leal is another example of this.

119. Diego Velázquez: Old Woman Cooking Eggs, Edinburgh, National Gallery of Scotland

After six years of apprenticeship in Pacheco's workshop, Velázquez was admitted into the painters' guild in 1617, and a year later he married his master's daughter, Juana Pacheco. Between 1617 and 1623, the year in which Velázquez left Seville to establish himself at the court, his painting evolved in a direction that took more from Pacheco's doctrine than from his example. The realism and tenebrism of Velázquez's early work parallel the innovative tendencies in Italian painting at the turn of the sixteenth century, best represented by the art of Caravaggio, as well as the striking naturalism and tenebrism practiced by some Spanish painters working in Castile in the first quarter of the seventeenth century, such as Sánchez Cotán, Tristán, and Mayno.

All of Velázquez's first works are genre scenes, a fact that in itself is evidence of his particular genius, since they are among the earliest genre paintings to be done in Spain.* The first masterpiece in this group of youthful pictures is the Old Woman Cooking Eggs [119], painted in 1618, which already reveals Velázquez's incomparable skill in the imitation of nature.

In this picture, each object is captured in all its particulars of texture and color, and the figures are defined with the same almost obsessive precision, which objectifies and immobilizes them. As in his earlier efforts, which it surpasses in descriptive

*Velázquez's genre scenes are often called bodegones, which is the term used in Spanish for genre scenes with still lifes as well as for pure still lifes, without figures.

power, such concentration on each object has the effect of breaking down the overall composition into a pattern of separate units. This visual parity of importance of all the elements that make up the picture is further increased by Velázquez's use of an intense chiaroscuro, which creates a series of isolated luminary accents on the picture plane. The figures of the old woman and the boy are also psychologically disassociated from each other, for although formally they are connected by the bottle of wine, their actions are unrelated, and their glances do not focus on each other. In his passion to describe, Velázquez also falsifies the perspective of the scene; the old woman is shown as if on the same level with the viewer, but the table and the cooking utensils that rest on it are seen from a higher vantage point, so as to give a more complete view of them. This device, of course, had been used by countless artists throughout the history of art, but it is somewhat surprising here because of Velázquez's otherwise veristic approach to the subject.

Among the genre scenes of his early years, the *Water Carrier of Seville* [120], painted in 1619, is the first one in which descriptive virtuosity takes its proper place in the conception of

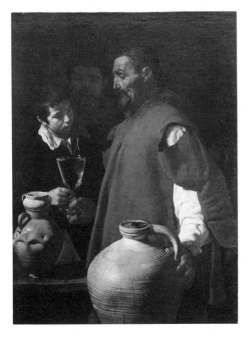

120. Diego Velázquez: Water Carrier of Seville, *London, Wellington Museum*

the picture. Although the qualities of each object are equally detailed—in fact, Velázquez's pictorial effects reach here an even higher level of illusionism—the figures and their actions are now dominant, and each element of the picture is integrated into a coherent and well-knit composition. Chiaroscuro is also handled so as to unify the constituent parts of the painting, and the composition is focused on the transfer of the glass of water from hand to hand, the central subject of the scene. Gestures in the *Water Carrier* are part of a fluid movement that not only unites the figures physically but also bonds them in a common action. As before, however, they remain psychologically isolated; the water seller and the boy seem wrapped up in their own thoughts.

Christ in the House of Martha and Mary [121], painted in the same year as the *Old Woman Cooking Eggs,* is a picture that at first glance also seems to be a simple genre scene, in which two women busy themselves with the preparation of a meal. As in the former work, the various elements that make up the picture are observed and recorded with minute attention, but now the figures play a more important role, and they also have an emotive charge that was absent from the becalmed characters of the cooking scene. The subject of this painting, however, is not limited to the activity represented in the foreground; in the background there is another scene, in which a seated man appears in dialogue with two women, one of whom is seated at his feet.

Although the spatial relation of this background scene to the foreground is somewhat ambiguous (are we looking at the reflection on a mirror or at an opening between two rooms?), the action it represents, crucial to the reading of Velázquez's painting other than as a simple genre picture, is sufficiently clear. The two scenes, in fact, correspond to the passage in Saint Luke's Gospel (10:38–42) describing Christ's visit to the house of Martha and Mary, in which Martha is troubled by Mary's listening to Christ while she works alone to lavish attentions on the visitor.

The compositional format of Velázquez's picture, which equivocates with the nature of the painting's subject, is the same that we find in many Flemish pseudo-genre scenes of the second half of the sixteenth century—several of them by Pieter Aertsen— in which a kitchen scene in the foreground overlaps a religious scene depicted in the distant background, most frequently the

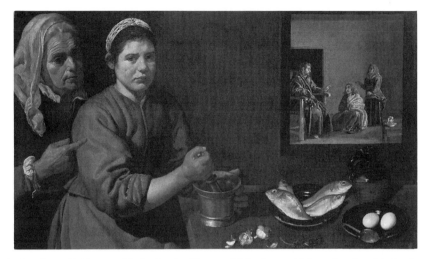

121. Diego Velázquez: Christ in the House of Martha and Mary, *London, National Gallery*

Supper at Emmaus or the event represented here by Velázquez. Locating the principal subject in the background, and thus transposing the expected visual emphasis to a secondary scene, is a typically Mannerist device that initially disorients the viewer; as used by Velázquez, it may also have a special meaning. The old woman in the foreground pointing to Martha also appears to be present in the background scene, where she points to Mary. Her presence and actions suggest that Velázquez did not envision his painting simply as a pictorial counterpart of Luke's text, but also as a commentary on its meaning, presenting the options of an active or a contemplative life that are available to a Christian.

The realism and intense chiaroscuro of Velázquez's early works are most commonly associated in seventeenth-century art with the paintings of Caravaggio and his followers, and one might well ask if the artist arrived at these stylistic features through the influence of Caravaggism. The answer is, most probably, no. Italian, French, and Dutch painters, contemporaries of Velázquez, had absorbed the Caravaggist idiom in Rome or in Naples, but Velázquez's contact with Caravaggio's style in his youth could have been only of the most peripheral sort. It is worth remembering that Sánchez Cotán's still lifes, which share those same features, had been executed at the turn of the century, at a time in which Caravaggism did not exist in Spain as yet.

In the *Adoration of the Magi* (Madrid, Museo del Prado), of 1619, Velázquez approaches the religious subject in a more conventional manner, but gives the presentation of the scene the same qualities that appear in the genre pieces that came before. The physical types of the protagonists are comparable to those that people the genre pictures—in fact, the head of the youth who accompanies the Magi duplicates exactly that of the boy in the *Water Carrier* in pose and illumination—and, as in those works, the figures occupy a shallow stage close to the picture plane, defined almost exclusively by their own overlapping bodies. These volumes are compressed into a compact, relieflike mass, and space exists primarily as the intervals between objects and figures; only the upper left-hand corner of the picture opens up to a distant landscape, dimly illuminated by the light of dawn. The painting's subject demanded that Velázquez paint an outdoor scene, but the change in environment does not really modify the relationship between figures and space, so that the landscape is as disconnected from the figure-filled foreground as is the scene of Christ and Mary in *Christ in the House of Martha and Mary*. What has increased here in relation to the earlier works is the level of psychological contact among the characters, with the Christ Child as the focus of most glances.

In 1622, Velázquez traveled to Madrid to try his luck at professional success in the Spanish court. The time seemed propi-

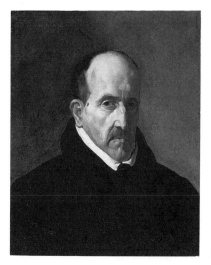

122. *Diego Velázquez:* Don Luis de Góngora, *Boston, Museum of Fine Arts*

tious, since Philip IV (1605–1665) had just acceded to the throne the year before, and Velázquez had reason to hope for protection from the Count-Duke of Olivares, mentor and favorite of the seventeen-year-old king; Olivares, who belonged to the Sevillian nobility, had close ties with the elder Pacheco's circle in Seville, within which Velázquez had matured. Giving the young and talented Velázquez an added stimulus to undertake this trip was the fact that at this time most of the painters to the king belonged to an older generation, whose art had remained attached to already outmoded conventions.

Velázquez's expectations were to be frustrated this time; the primary purpose of his trip to Madrid, to come to the king's attention, was not accomplished. One of the positive upshots of the trip, however, was a memorable portrait of the poet Luis de Góngora [122], which Velázquez painted at Pacheco's request for a book of likenesses of great literary figures that he was preparing.

Among Velázquez's early portraits, that of Góngora (1622) is the one where his great gifts for this genre are most clearly manifested. Going beyond the faithful representation of the poet's physiognomy, it penetrates the surface to give us an incisive characterization of this great poet and intellect, but also bitter man. Velázquez's technique here already shows the simplification of detail that will characterize his mature work. The brushstrokes create a series of planes that are seen as such at close range, but which also create the illusion of truth in the painted image.

In spite of the success attained at the court by his portrait of Góngora, Velázquez was not given the opportunity to portray Philip IV or any member of the royal family, so before the beginning of the new year, the painter returned to Seville. In August of 1623, however, he was back in Madrid, for the death of one of the painters to the king had opened up a vacancy which he hoped to fill. By October he had been officially appointed to that post.

The first picture to be painted by Velázquez in the king's service was a full-length portrait of Philip, the beginning of a long line of likenesses that would span the next thirty-six years of the king's life. This picture is known nowadays only through copies by the workshop; the original was completely overpainted by the artist himself a few years later (Madrid, Museo del Prado), in order to bring up to date the physical appearance of the young king and

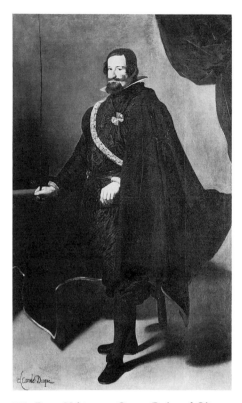

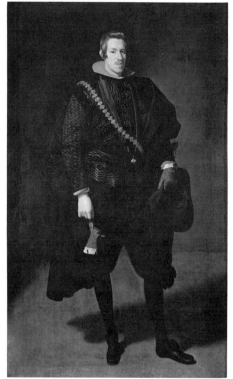

123. *Diego Velázquez:* Count-Duke of Oli-
vares, *New York, Hispanic Society of America*

124. *Diego Velázquez:* Infante Carlos, *Madrid,
Museo del Prado*

modernize the format of the pose, now more compact and elegant
than in the earlier version. The setting, the colors, and the king's
stance in the 1623 portrait could not be simpler, but in that
simplicity there is a great deal of artistic ingenuity. The use of a
bold and complex shadow, cast by the figure to define the other-
wise undifferentiated floor plane, is just one instance of it.

On two occasions during those early years, Velázquez por-
trayed his benefactor, the Count-Duke of Olivares, also at full
length, and the portraits of the minister and those of his king
present an interesting contrast. The second *Count-Duke of Olivares*
[123], of c. 1626/7, presents him in a pose and in a setting that
lend him an ostentatious aura of power that we do not find in the
king's portraits, always sober and reticent. To give form to the
image of the arrogant favorite, Velázquez employed a dramatic
Baroque design that is totally absent from his royal portraits.

The portrait of Infante Carlos [124], which belongs to these same years, reflects in its pose that of his brother Philip's earliest likeness, and is even simpler in the figure's surroundings. Here, Velázquez eliminated all the usual accessories that appeared in the previous works; the figure is alone in an environment defined exclusively by the meeting lines of the wall and floor planes, and the shadow cast by the prince on the floor. The *Infante Carlos* shows particularly clearly a characteristic of Velázquez's perspective, present in the previous portraits as well: the floor plane appears to have a noticeable slope, as if we were seeing it from above, while the figure seems sighted as if it stood on the same horizontal plane as the observer. This dual viewpoint had been used earlier by the artist in his *bodegones*, but for a different purpose: to give a more complete view of the objects depicted; here, it enhances the illusion of space. The isolation of the standing figure of Infante Carlos within a minimally defined environment has precedents in the courtly portraits by Sánchez Coello [3], but in Velázquez's work it exists in a space vividly endowed with the third dimension by the long shadow cast by the prince on the floor, and by the atmospheric treatment of color and light in the wall and floor planes.

In the portrait of Infante Carlos Velázquez begins to use a looser technique—to suggest, rather than to describe. This is particularly evident in the heavy gold chain, painted with touches of impasto overlaying quite irregular yellow brushstrokes that create the illusion of being finely detailed when seen from the proper distance.

Apart from several portraits, Velázquez painted relatively few pictures during his early years at the court. The most noteworthy among them is the so-called *The Topers*, more appropriately named the *Feast of Bacchus* [125], painted in 1628. In this work, the nude youth crowned with a wreath of grape leaves can be easily identified as the mythical Bacchus, but his features and body are far from godly; they are those of a coarse and overfed young man, with thick, sensual lips and narrow shoulders, without a trace of idealization. Velázquez sets the scene outdoors, with Bacchus seated on a wine barrel and crowning a kneeling man with an ivy wreath, while some already tipsy peasants drink wine, the god's gift to humanity. In the background to the left, a satyr

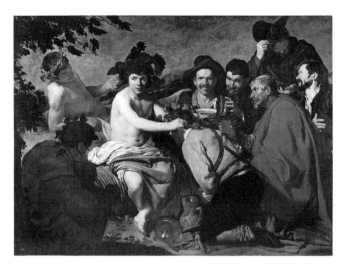

125. Diego Velázquez: Feast of Bacchus (The Topers), *Madrid, Museo del Prado*

reclines behind Bacchus, and to the right, a beggar approaches to ask for alms. The portrayal of the drinkers here not only surpasses in optical realism the figures in Velázquez's Sevillian genre pieces, but their faces have a vivacity and expressiveness that is new and totally convincing.

The composition of the *Feast* is conceived in similar terms to that of the *Adoration of the Magi:* as a sculptural high relief with a minimum of space between figures, and a landscape background that is disconnected from the foreground. The illumination, however, although still clearly studio light, is more generalized, and the shadows are more transparent.

Apart from the elements of this picture that continue Velázquez's earlier pictorial ideas or develop new ones, the *Feast of Bacchus* also gives some indications that he had studied with profit the paintings in the royal collection. Although in tone and composition Velázquez's painting seems to have little to do with Titian's *Bacchanale,* then in the Alcázar, the foreshortened pose of the satyr behind Bacchus is quite close to that of a young woman in the center of Titian's composition, and is most probably inspired by it.

The same year that Velázquez painted the *Feast of Bacchus,* 1628, Peter Paul Rubens (1577–1640), then at the peak of his fame, spent seven months in Spain as the representative of the Archduchess Isabella Clara Eugenia, Philip IV's aunt, who was then governor of the Netherlands. During this stay, Rubens pursued his

own artistic endeavors as well, and was therefore in close contact with Velázquez, whose studio he shared. Among the works painted by Rubens in those months were several portraits of Philip IV, the only ones not to issue from Velázquez's brush after 1623, but he also made copies (primarily for his own instruction) of some of Titian's paintings in the Alcázar, among them the *Bacchanale* mentioned above.

The presence of the Flemish master in Madrid had an effect on Velázquez's painting that would become evident soon after his departure. Rubens's painterly technique and use of color, inspired originally by the works of the Venetian school, which he had studied in Italy early in his career, were developed throughout its course toward an ever looser brushwork and greater luminosity. This development would be reinforced during his Spanish sojourn by his close contact with Titian's paintings in the collection of the Spanish king. The example of Rubens's transparent color, optical technique, and airy, spacious compositions would steer Velázquez's interest toward contemporary Flemish and Italian Baroque painting, where tenebrism had for the most part already disappeared.

Apart from the direct influence exerted by Rubens's painting on the subsequent evolution of Velázquez's work, Rubens's visit also inspired Velázquez to travel to Italy, center of Baroque art. Shortly after Rubens's departure from Madrid, in August of 1629, Velázquez set out for Italy with his king's permission, and remained there for a year and a half, traveling around the country and settling in Rome for a stay of long duration. From his port of entry at Genoa, Velázquez had first directed his steps to Venice by way of Milan, and from there he set out for Rome, stopping in various cities along the way. On his return trip to Spain he went by way of Naples, completing his acquaintance with the various schools of painting, both past and present, that had flourished in the peninsula.

The most relevant works of this Italian period are *The Forge of Vulcan* [126] and *Joseph's Many-Colored Robe* (El Escorial, Nuevos Museos). The distance that separates *The Forge of Vulcan* from the *Triumph of Bacchus* in terms of style and technique clearly demonstrates the importance that Rubens's visit and this Italian journey had had for Velázquez. Apart from the obvious idealiza-

tion of the bodies—even that of the malformed Vulcan—what strikes the observer immediately is the different conception of volume and space in relation to the artist's earlier work. Even though here the scene is also made up of figures arranged in a group parallel to the picture plane, the intervals between them are as important—one is tempted to say as palpable—as the figures themselves. The elements that serve as repoussoirs—anvil, cudgels, pieces of armor—are used to define the distance between the actors and the picture plane, and the space behind them also seems measurable; the fireplace and the figure beyond it push farther back, in turn, the limits of the room where the scene takes place. The change in Velázquez's representation of light is no less remarkable. Although in this instance the scene is set indoors, a clear daylight not only illuminates the shining flesh of the bare-chested gods and cyclops, but it also permeates the space they inhabit.

The illusion of reality created by Velázquez in this work is even more convincing than in the earlier pictures, for he now describes the visual world consistently in terms of the impression it makes on the eye of the beholder, rather than of its tactile substance. Vulcan's physiognomy and expression are achieved with very little detail, and the transitions between features are blurred, without defined contours or breaks. In the figure beyond the fireplace, the economy of the brushwork without loss of definition or expression is extraordinary. This technique, of course, does not appear all at once in Velázquez's work; we find it already to a smaller degree in the *Triumph of Bacchus,* where the contours of bodies and faces do not have the sharpness that we see in the royal portraits of c. 1623–27.

On his return from Italy at the end of 1630, Velázquez had the satisfaction of seeing that Philip IV had not sat for a portrait during his absence, and had also waited for his return to have Prince Baltasar Carlos portrayed. Baltasar Carlos had been born shortly after Velázquez's departure in 1629, and the first portrait of the prince we have (Boston, Museum of Fine Arts), which shows the infant together with his dwarf, must date of 1631.

Prince Baltasar Carlos and His Dwarf presents the heir to the most powerful monarch in Europe in a hieratic stance, dressed and bedecked with the symbols of his rank. The dwarf, who appears

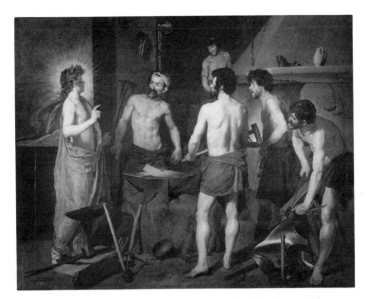

126. Diego Velázquez: The Forge of Vulcan, *Madrid, Museo del Prado*

to be moving away with a melancholy glance backward, holds in his hands a rattle and an apple, objects that belong to the world of childhood but are also reminiscent of the scepter and the orb, symbols of royal power.

The inclusion of a dwarf in a royal portrait continues a tradition that was established the previous century, and of which Villandrando's *Prince Philip and His Dwarf Soplillo* (Madrid, Museo del Prado) is a good example. In Velázquez's moving juxtaposition of the two small figures, the affliction of the jester, as in Villandrando's picture, serves to enhance the perfection of the prince, but it also allows the painter to introduce into his portrait symbolic elements that enrich the meaning of the image.

From the time Velázquez settled at the court in 1623 until the end of his days, he executed only a handful of religious paintings, of which at least one was done for the Alcázar. Of the commissions that lay outside his activities as Painter to the King, the most important are the large *Christ on the Cross* (Madrid, Museo del Prado), painted c. 1631/35 for the convent of the nuns of San Plácido in Madrid, and another sizable canvas, the *Saint Anthony Abbot and Saint Paul the Hermit* [127] painted for the Hermitage of San Pablo in the Buen Retiro c. 1634/35.

The general disposition of the Christ figure in the first of these follows both the design of a painting of the same subject

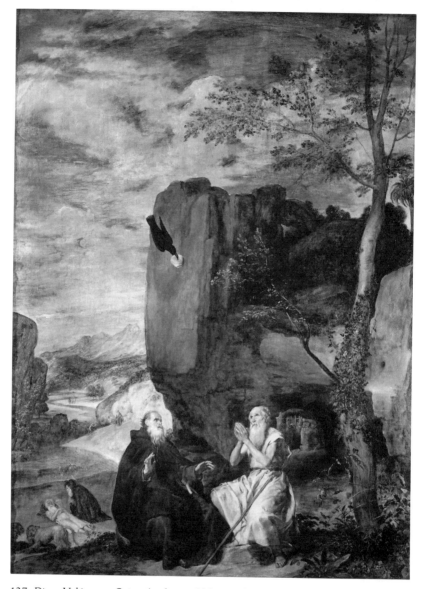

127. *Diego Velázquez*: Saint Anthony Abbot and Saint Paul the Hermit, *Madrid, Museo del Prado*

done by Pacheco, and the iconographic prescriptions put forth in his *Arte de la pintura*, according to which Christ was crucified with four nails. But although the composition of the *Christ* of San Plácido does not differ essentially from that of Pacheco (or of Zurbarán's for the *Crucified Christ* in San Pablo el Real, [91]), the

painting is unique in how Christ's body is imagined and in the expression Velázquez achieved through the unusual handling of the head. The elegant classical proportions of Christ's figure bring to mind the male nudes of the great Greek sculptors of the fourth century B.C., Praxiteles and Lysippus, but its ideal beauty is informed by the spiritual content of the image. The pathos of this Christ figure is given special poignancy by a most unusual feature, the hair that falls forward under the crown of thorns to hide half of Christ's face. The disarray suggested by this detail disrupts the otherwise perfect composure of the dead Christ, recalling the cruelty and mockery suffered by the Savior throughout his Passion.

Saint Anthony Abbot and Saint Paul the Hermit is an exceptional picture in every respect. Perhaps its most noticeable point of difference with earlier works is that the landscape is given a great deal of space in relation to the figures, an altogether unprecedented feature in Velázquez. Here, the human drama and the grandeur of the landscape have equal visual importance; the pure and radiant faith of the hermit has a counterpart in the freshness and luminosity of the landscape and sky.

If one considers only the principal episode in this picture— the two saints receiving a double ration of bread brought by the crow that regularly fed Saint Paul—the vastness of this landscape is obviously unnecessary, as the Dürer woodcut (B. 107) that served Velázquez as inspiration for his figural composition clearly demonstrates. But even taking into account that the painting presents the story of the two saints in a series of consecutive episodes dispersed throughout the landscape, the top third of the picture is gratuitous as far as providing a setting for the narrative. It is evident that Velázquez is interested at this point in the depiction of the landscape per se, and the great vistas of mountains and valleys that he uses as backdrops for many of his portraits of the royal family executed in the period 1633–40 [129, 135] confirm this.

If the figures of the two saints were suggested by Dürer, the character of the landscape seems inspired by different Northern sources: the paintings of Joachim Patinir (c. 1475–1524) and Joos de Momper (1564–1635) that were in the royal collection. In its transparency and atmospheric quality, however, the landscape of *Saint Anthony Abbot and Saint Paul the Hermit* also recalls Vero-

nese's frescoes in the Villa Barbaro, in the Veneto, and those of Domenichino in Rome, both of which Velázquez is most likely to have studied.

The color, luminosity, and handling of the landscape in the picture for the Hermitage of San Pablo point up vividly the remarkable evolution undergone by Velázquez's painting in the five or six years after his first trip to Italy. Stylistically and techni- cally, the comparison between the *Adoration of the Magi* of 1619 (Madrid, Museo del Prado), the *Feast of Bacchus* of 1628 [125], and this painting, of c. 1634–35, gives a striking demonstration of the painter's extraordinary capacity for artistic growth.

One of the most splendid portraits of Philip IV, also painted c. 1634–35, is the *Philip IV in Brown and Silver* [128], in which the king appears dressed in a brown and white costume covered with silver-thread embroidery. This dazzling suit sets this portrait apart from earlier ones, in which the king was dressed in black from head to foot, but the impression of brilliance the picture gives is also due to Velázquez's use of a red drapery behind the figure, repeating the color of the table's cover by the king's

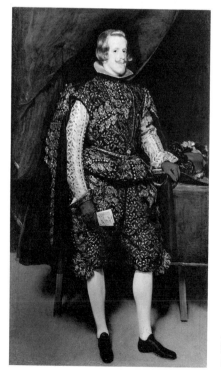

128. *Diego Velázquez:* Philip IV in Brown and Silver, *London, National Gallery*

side. Velázquez's *Philip IV in Brown and Silver* differs from prior royal portraits also in the manner in which the king's lavish suit is painted; the embroidery is suggested by a web of what appear to be casual brushstrokes and touches of impasto. These brushstrokes, which from a near view dissolve into formless separate touches, seen from the appropriate distance blend in the retina and are perceived as a regular pattern. By not describing the embroidery in detail, Velázquez takes the emphasis away from the clothes and concentrates it on the king's appearance and on his royal station. If we look back to Pantoja's portraits [8, 9], the advantage of Velázquez's technique, based on optical observations, becomes very clear: it gives even greater play to the lavishness of the embroidery without making it the most important visual element in the picture.

The greatest part of Velázquez's artistic activity in the decade of the 1630s was related to the decoration of the Buen Retiro palace, and to that of the Torre de la Parada, a royal hunting lodge in the Pardo, both of them recently built. Apart from determining and supervising their overall decorative programs, his own contribution as a painter was considerable; among the pictures he executed for these buildings are some of the most impressive and original paintings in his oeuvre.

The most important project in the Buen Retiro was the decoration of the Hall of Realms, a room of the otherwise vanished palace which is still preserved as part of the Museo del Ejercito. This hall, of enormous dimensions, was the one most frequently used for state ceremonials, and its décor consisted of twelve large battle pictures celebrating as many Spanish victories; five equestrian portraits of the royal family; and a series of ten pictures of the Labors of Hercules, the mythical hero associated with the Hapsburg dynasty. This type of program, devised for the glorification of the reigning house, continued a tradition established in Spain by Charles V and carried on by Philip II in El Escorial.

The execution of most of the battle pictures (a visual catalogue of Spain's military victories won during the reign of Philip IV) was apportioned among the painters to the king; Vicencio Carducho was commissioned three; Félix Castelo, his disciple, one; Eugenio Cajés two; Jusepe Leonardo, his assistant, another two; and Juan Bautista Mayno, one more. The remaining three

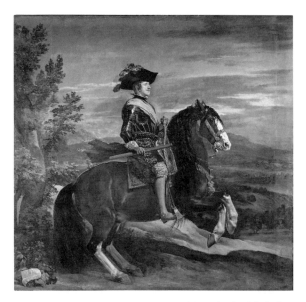

129. Diego Velázquez: Philip IV on Horseback, *Madrid, Museo del Prado*

were given to Antonio Pereda, Velázquez, and Zurbarán. The Labors of Hercules were also commissioned from Zurbarán, and the equestrian portraits of the royal family were entrusted to Velázquez and his workshop. Among the equestrian portraits, those of Philip IV and of Prince Baltasar Carlos were the only ones executed in their totality by Velázquez himself.

The closest prototypes for *Philip IV on Horseback* [129] were Titian's equestrian *Charles V at Mülberg* (Madrid, Museo del Prado) and the lost equestrian portrait of Philip IV painted by Rubens, known today through a copy (Florence, Uffizi), and both were in the Alcázar, right under Velázquez's nose. Although *Philip IV on Horseback* is related to these two pictures in general terms, it departs from both in important ways. While Charles V appears riding at a good pace through a wooded landscape, Velázquez presents Philip IV and his mount in a static pose high over a vast mountain landscape that removes the king's image from time and action. Velázquez's equestrian portrait of Philip IV, while closer in pose and setting to Rubens's, departs from it by the absence of allegorical figures, so that whatever symbolism the image contains is projected exclusively by a strictly realistic representation. In his portrait, Velázquez suggests the king's capacity to command by means of a pose that attests to his consummate horsemanship: he maintains his massive steed still in a difficult equestrian maneuver

with only his free left hand. By presenting Philip in an almost complete profile and with his glance fixed in the far distance ahead, the painter also isolates the king, distancing him from the beholder. Velázquez's image of Philip IV is more than a superb equestrian portrait; it is also an icon of the royal office.

Philip IV on Horseback allows us to observe Velázquez's working methods particularly well, for extensive corrections and changes in various parts of the horse and rider can be detected with the naked eye. The artist's practice in most cases was to determine the final form of his compositions while he was painting them, which meant that their design underwent more or less important alterations to arrive at the desired perfection. In contrast to his Italian and Flemish contemporaries, it appears that Velázquez did not make exhaustive preparatory drawings, or *bozzetti* in oils to study the composition, poses, and other details of a work before setting brush to canvas. This is not to say that he never made use of such preliminary studies but, like Caravaggio, he worked more *alla prima* than other Baroque painters. The result of this practice is that the process of elaboration of the image can often be studied not only with the aid of X-rays but by the *pentimenti* that now show through the final layers of paint.

In *Prince Baltasar Carlos on Horseback* (Madrid, Museo del Prado), Velázquez employed again a symbolic realism to bring forth an ideal image of the prince—a child only five years old at the time—as heir to the throne. This portrait was meant to be placed over a door in the Hall of Realms, therefore in a higher position with respect to the observer than that of Philip. Velázquez took advantage of this circumstance to forge a dramatic and monumental image. The horse (actually a pony), placed diagonally in space, seems to rush toward us, but the small, upright figure of the prince conveys the perfect control he has over his mount. The composition of the horse and rider in this picture is reminiscent of Rubens's portrait of Marchese Giacommo Massimiliano Doria, Knight of Santiago, painted in Genoa in 1606/07, which Velázquez may have known, but it greatly resembles also the view from that particular vantage point of the equestrian monument to Emperor Marcus Aurelius in the Campidoglio, a work that Velázquez had undoubtedly studied while in Rome.

In the portraits of both king and prince, but especially in

that of Baltasar Carlos, Velázquez adapted his technique to the viewing conditions, with the pictures situated over the observer's head. The impressionistic brushwork that conveys the form and texture of costumes and trappings in these paintings moves further away still from detailed description than *Philip IV in Brown and Silver*. The prince's face, where Velázquez does not use the impasto that animates all the other surfaces, is painted with a minimum of detail, and his features seem to dissolve behind an atmospheric veil.

From this same period, and related to the Buen Retiro equestrian portraits in its content, format, and size, is the large canvas the *Count-Duke of Olivares on Horseback*, of c. 1635–38 [130]. The strongly foreshortened view from the back of horse and rider is thoroughly novel for a major portrait, particularly at such a scale, but it had been employed earlier for an imaginary portrait of Julius Caesar engraved by Tempesta, a print that Velázquez probably knew. The formal ties between the *Olivares* and the image of the great Roman general surely are not coincidental, since in this painting Velázquez glorifies the virtue of courage and the ability to command of his first protector. There is one important feature in which the poses of the count-duke and Julius Caesar do not agree: Olivares turns his head back sharply, as if encouraging

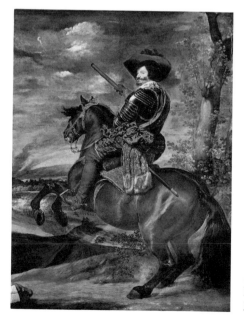

130. *Diego Velázquez:* Count-Duke of Olivares on Horseback, *Madrid, Museo del Prado*

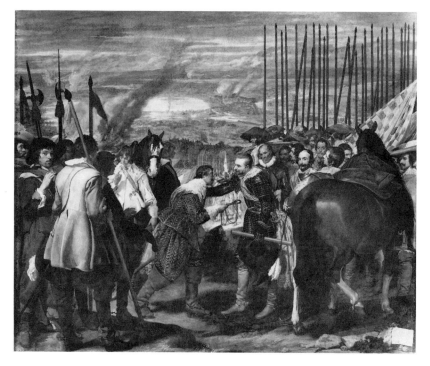

131. Diego Velázquez: Surrender of Breda, *Madrid, Museo del Prado*

his troops to follow him into the fray that can be discerned in the valley below. This gesture stresses the spontaneity and transitory nature of the pose and also serves to connect the count-duke to the observer, the opposite effects to those sought in the king's portrait for the Hall of Realms.

The most famous of the pictures that decorated the Hall of Realms is Velázquez's *Surrender of Breda* [131], painted in 1634. Of the other victory scenes, only Mayno's *Recovery of Bahia* [60] comes near it in invention and pictorial quality.

In the *Surrender,* Velázquez interpreted the subject so as to highlight the chivalry and magnanimity of the victor, the Genoese general Ambrogio Spinola, and of the Spanish troops he commanded. The placement and poses of the principal figures do not follow the traditional treatment of images of surrender, which we see in some of the battle pictures for the Salón de Reinos—such as Vicencio Carducho's *Relief of Constance* or Jusepe Leonardo's *Surrender of Jülich* (both Madrid, Museo del Prado), where the same Ambrogio Spinola is depicted on horseback and the defeated

general on his knees. The vanquished Justin of Nassau is shown in Velázquez's picture on the same level as Spinola, and he is not alone in front of the victorious general, but rather accompanied by his soldiers, still bearing their arms. The expressiveness of the gestures of all the participants in this episode, particularly the attitudes of the two commanders; the lighting of the two figures, Spinola's face in full light, Justin's in shadow; and the contrast between the disarray in the group of Dutch soldiers and the compact mass of the Spaniards and their lances convey with subtlety and apparent naturalness the military and human situation portrayed.

In this painting, Velázquez made use of a compositional scheme which may be termed classical and which reflects the study of the Roman works of Raphael and Annibale Carracci. At either side of the fulcrum of the extended arms of Justin of Nassau and Ambrogio Spinola, the masses of the two armies and the disposition of the various elements that make up the composition are in perfect *contrapposto*. Velázquez's naturalistic style and classical pictorial structure are both at the service of the symbolic expression of a moral and political idea.

The private apartments of the Buen Retiro housed several series of portraits of the jesters and dwarfs resident at the Spanish court. These pictures, executed by Velázquez in the 1630s and 1640s, are of special interest not only as a social document but as early examples of the psychological portrait. They are splendid demonstrations of Velázquez's ability to express spiritual content through formal means.

The portrait of Juan de Calabazas [132], painted c. 1637–39, shows the cockeyed fool looking up at the viewer with a smile and crouching on his cushion in a corner of the floor as if he wanted to make himself smaller. His pose, with arms and legs retracted close to his body, and hands tightly clasped in an awkward and pathetic gesture, conveys vividly the isolation and helplessness of Velázquez's subject. The idiot's face is described with extraordinary virtuosity in the transitions from light to shade, and his traits emerge purely by virtue of color, without a single precise contour. This vagueness in the definition of his features, the blurred look it gives to the face, translates into pictorial terms the dimness of the fool's mind. "Calabazas" ("gourds" in Spanish) is

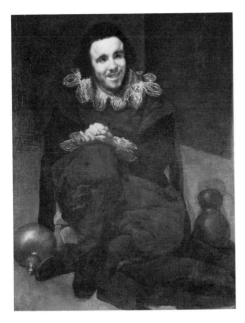

132. Diego Velázquez: Juan de
Calabazas, Madrid, *Museo del
Prado*

not represented as a curious or comic figure, but as an imperfect
human being unconscious of his condition and capable of eliciting
affection.

Of the other portraits in this group, that of *Sebastián de
Morra* (Madrid, Museo del Prado), of c. 1644, is the most powerful
as a psychological likeness. The simplicity of the composition and
the closeness of Morra's figure to the painting's edges give his
portrait a special directness and impact, but it also focuses the
picture's emotional center on the accusatory look addressed to the
viewer by the dwarf, physically misshapen but mentally lucid. His
frontal and symmetrical pose is another master stroke, for al-
though it accents the shortness of his legs, it also monumentalizes
the figure. Frontality in portraiture was a feature usually reserved
for royal personages (most of the imaginary portraits of the kings
of Spain in the Salón Dorado of the Buen Retiro were depicted
in seated frontal poses), and it therefore lends an unexpected
grandeur to Morra's figure.

Fools, dwarfs, and jesters had long been a ubiquitous pres-
ence in all the courts of Europe, and were particularly plentiful in
the seventeenth century. Some of these men and women had been
portrayed, alone or with their masters, at least since the fifteenth
century, but the numerous portraits of court entertainers painted

by Velázquez (at least eight independent likenesses are now extant, and we know from contemporary sources that he painted still others) constitute an unparalleled collection of paintings of this genre, and one may well wonder what might have been the reason for this abundance. The answer has usually been that such creatures were unusually numerous at the Hapsburg court, suggesting by implication that this was yet another sign of the dynasty's decadence. It is more likely that the quantity of portraits of fools in Philip IV's household was not directly related to the absolute numbers of fools dwelling in it, but had to do primarily with artistic reasons. As court painter in residence at the palace, and in the fulfillment of his functions as Aposentador (Palace Chamberlain), Velázquez was in daily contact with these denizens, whom he must have come across continually in corridors and halls. It is not surprising that he may have wanted to portray them, since they not only presented a varied gamut of physical and psychological types, but their depiction was also totally free from the constraints imposed by decorum on royal portraiture. In these works Velázquez could allow himself to experiment, and to push to the limit his illusionistic technique. That Philip IV may have encouraged his painter in this pursuit would not be surprising either; the characters portrayed were an unexceptional part of palace life (as the *Maids of Honor* itself illustrates), and the king, as much as today's museum goer, must have admired the brilliant characterizations of these men created by Velázquez's brush, with the added pleasure that knowing the subjects themselves must have provided him.

Portraits of a different sort, but also free from social restrictions, are those of *Aesop* (Madrid, Museo del Prado) and *Menippus* [133], probably painted as a pair for the Torre de la Parada between 1638 and 1640. Imaginary portraits of ancient philosophers belonged to a tradition current in the seventeenth century (also illustrated by Ribera's *Archimedes [Democritus?]* [75]), and in this instance, Rubens's full-length *Democritus* and *Heraclitus,* also in the hunting lodge and of similar dimensions, may have provided the specific incentive to tackle this type of subject in a similar format. Velázquez's imaginary portrait of the Cynic philosopher Menippus (fl. 270 B.C.) forms a logical pair with that of Aesop, the semilegendary fabulist who used stories about animals to ridicule human behavior. Both are individualized to the same degree as the

portraits of jesters, and their characters and the ideological con-
tent of their writings are expressed by their garb and demeanor.
Menippus' ironic expression, his ragged attire, and the books and
papers strewn about the floor reflect risually the nature of his
satirical works and their humorous skepticism. The two pictures
are thoroughly realistic portrayals but, as is the case in other works
by Velázquez, this naturalism serves to convey an intellectual con-
tent.

Another extraordinary painting executed by Velázquez in
these years for the decoration of the Torre de la Parada is the
canvas that depicts the god Mars in repose [134]. As an interpreta-
tion of the god of war, Velázquez's *Mars* is not related to any other
image of this mythological figure, for although he wears his helmet
and other parts of his armor are spread on the floor at his feet,
the god is almost naked and in a thoroughly unmilitary attitude

133. Diego Velázquez: Menippus,
Madrid, Museo del Prado

134. Diego Velázquez: Mars, *Madrid,
Museo del Prado*

of reflection. A recent interpretation of Mars's pensiveness, of his nudity, and of all the elements that surround him is undoubtedly correct: Velázquez has imagined him after the undignified outcome of his amorous adventure with Venus, seated on the bed that was the stage of his recent humiliation at the hands of Vulcan. The helmet's visor veils the god's face with shadow, but through it, his perplexed expression can still be guessed. The artist conceived the mythological subject in the same vein as the imaginary portraits of the philosophers from antiquity, with originality and wit.

Also for the Torre de la Parada and about 1634/35, Velázquez painted three full-length portraits of the royal family: those of Philip IV, his brother the Cardinal Infante Don Fernando, and Prince Baltasar Carlos. The three pictures show their subjects dressed for the hunt, the quintessential "sport of kings," but otherwise without any of the external trappings of royalty. Compared with Van Dyck's *Charles I at the Hunt* (Paris, Musée du Louvre), painted about the same years, these portraits surprise us by their modest and private character, from which Baroque rhetoric is completely absent.

135. *Diego Velázquez:* Prince Baltasar Carlos as a Hunter, *Madrid, Museo del Prado*

136. *Diego Velázquez:* Lady with a Fan, *London, Wallace Collection*

Prince Baltasar Carlos as a Hunter [135] is set against a splendid view of the Guadarrama Mountains painted in the blues and grayish greens characteristic of Velázquez's landscape backgrounds. The six-year-old Baltasar Carlos, dressed exactly like his father, is endowed with equal measures of childish charm and royal aplomb. The two dogs—a small, nervous hound and a dozing mastiff—are painted with the love with which Velázquez always painted the dogs in the royal household, and are a perfect complement to the diminutive hunter.

The recently restored *Philip IV as a Hunter* (Madrid, Museo del Prado) is another instance of the extensive reworking of a portrait of the king after its completion. It has already been noted that Velázquez brought some of Philip's portraits up to date by overpainting them—the fact that the works he executed for the king often remained in the various royal seats allowed him to modify his pictures even years after they were finished. In this instance, however, the reworking of the image appears to have taken place shortly after its completion, since it does not involve the king's likeness itself. Several major revisions to the figure's outline can now be seen with the naked eye, and are confirmed by an extant studio replica of its original state. They included placing the hunting cap on Philip's head, rather than in his hand, and all seem to have been dictated by a desire to perfect the design of the figure, which in fact they do.

There are few portraits of women by Velázquez that do not represent members of the royal family; among these, perhaps the most beautiful is that of an unidentified woman, known as the *Lady with a Fan,* of c. 1638–39 [136]. The picture probably represents the painter's daughter, Francisca, born in 1619 and already a mother at the time the painting was done. It is impossible to corroborate this supposition, but the undeniable physical resemblance of the lady to Velázquez and the existence of an unfinished genre piece, *Lady Sewing* (Washington, D.C., National Gallery of Art), where the same model is depicted at a domestic task, militate for this identification. Whatever her identity, the woman portrayed here has a sensuous beauty combined with an air of modesty and dignity that endow her with a potent allure.

Like many of Velázquez's portraits, this one is notably sober coloristically, and only the lady's lips and the blue bow with

a touch of red that adorns her gold rosary introduce some notes of color among the blacks, browns, and whites of the painting. The portrait follows the Baroque conventions of this genre: it shows the woman in motion—her fan open in one hand, the other pulling her veil over her breast—as if caught unawares by the painter on her way to church.

In the period between the end of the 1630s and Velázquez's second journey to Italy, in November of 1648, his artistic production started to diminish, and this decrease became even greater after his return from Italy in 1651. Primarily responsible for the paucity of works in the last two decades of Velázquez's life was the progressive elevation in rank of the painter as a courtier and servant of the royal household. In 1643, Philip IV had named Velázquez Ayuda de Cámara (Gentleman of the Bedchamber), and in 1652 he was accorded the distinction of the office of Aposentador Mayor de Palacio (Chief Chamberlain of the Palace), titles that entailed numerous responsibilities and left him ever less time to paint. For one, Velázquez's personal attendance to the king meant that he accompanied him in his frequent journeys, spending long stretches of time away from Madrid. As Aposentador, Velázquez's functions included the decoration of the royal seats, something that he had begun to do even before he was named to the post, and he was in charge of the purchase and arrangement of the works of art that Philip IV, great lover and connoisseur of painting, amassed in prodigious quantities.

In the decade of 1640 to 1650, Velázquez's artistic production was for the most part limited to painting portraits of the royal family, something which, as Painter to the King, was always his principal activity. The most outstanding of these portraits, and perhaps the only one of Philip IV executed during this period, is the picture painted at Fraga in 1644 (New York, Frick Collection). Velázquez had accompanied the king on his visit to the Catalan front, where the city of Lérida, held by the French, was under siege by the Spanish armies. Some time during the three months spent by Philip IV at nearby Fraga (Huesca), the king posed three times for Velázquez in the clothes he would eventually wear in his triumphal entry into the liberated city.

Philip IV at Fraga is patterned compositionally on the portrait of the Cardinal Infante Don Fernando painted by Van Dyck

in 1636 (Madrid, Museo del Prado), but it is simplified in that the figure stands against a neutral background, rather than a rich drapery. Like its prototype, it shows Philip IV facing left, the only instance of this pose among his portraits, as the king favored his right side. As usual, Velázquez painted the head with more meticulous, smoother brushwork than that used for the hands and costume. The comparison between Philip's head and that of the dwarf Sebastián de Morra, painted about the same time, points up the contrast between the technique used by Velázquez for an informal, private portrait such as the latter and that used for the likeness of the king, whose royal image was subject to the strictures of decorum. The red jacket with silver embroidery and the white sleeves, on the other hand, attain brilliant illusionistic effects with what appears at close range to be totally erratic brushstrokes.

In November of 1648, Velázquez left the court for a second journey to Italy, with the purpose of searching for and buying paintings and sculptures—both ancient and modern—for Philip IV's art collection. Velázquez's stay in Italy, where he would remain two and a half years, was also a great personal triumph, and he was even more warmly received by artists and patrons—now as an acknowledged master—than in 1629. In Rome, where he resided from mid-1649 to late 1650, he was honored with membership both in the Academia di San Luca and in the Congregazione dei Virtuosi al Pantheon.

During his stay in that city, Velázquez painted numerous portraits of the clergy and aristocracy, most of which are lost; the most important of the Roman portraits, however, that of Pope Innocent X [137], is still in the Pamphili palace in Rome. The format of this work continues the tradition established by Raphael in his portrait of Julius II (London, National Gallery), in which the seated pope, in half length, is turned in a three-quarter pose, but it is given greater monumentality than in any of its prototypes. The Pamphili pope's characterization is one of Velázquez's most penetrating, suggesting the difficult and suspicious nature of his model but also the vigor of the aged pontiff. Within the boundaries of papal portraiture, Velázquez achieved an extraordinary re-creation of the physical and psychological reality of Innocent X. Only Bernini's best busts of the previous pope, Urban VIII, reach an equivalent artistic and expressive level.

The superb portrait of the painter Juan de Pareja [138], Velázquez's assistant and slave, was probably painted in 1649 or early 1650, close in date to the portrait of Innocent X. According to tradition, it was done in preparation for the papal likeness, but more than a practice piece, this portrait seems a challenge issued by Velázquez to his Italian colleagues, for it was exhibited in the Pantheon's portico on the nineteenth of May of 1650, together with paintings by other artists residing in Rome, at the annual show that was held there for the feast of Saint Joseph. The public exhibition of this piece may have been preceded by some private ones if, as Palomino asserts in his *Lives*, the artist sent his assistant's portrait about to the houses of Rome's social elite by means of Pareja himself, as a sample of his abilities as a portrait painter. This picture is, indeed, an incomparable demonstration of his genius as a portraitist; with apparently simple means, the artist created an image of great dignity and vitality, replicating the sitter in a likeness that is as "alive" as the man himself.

An important painting which may have been executed during Velázquez's stay in Rome is the famous *Venus at the Mirror* [139], recorded in the collection of the Marqués de Eliche in

137. Diego Velázquez: Innocent X, *Rome, Galleria Doria-Pamphili*

138. Diego Velázquez: Juan de Pareja, *New York, Metropolitan Museum of Art*

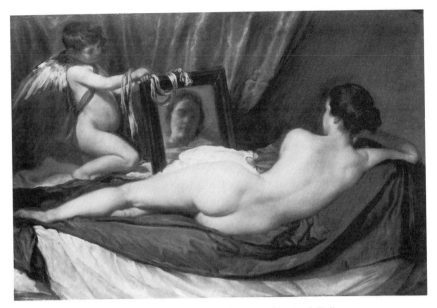

139. Diego Velázquez: Venus at the Mirror, *London, National Gallery*

Madrid the following year, 1651. It is an extraordinary picture in several ways; it is the only surviving female nude painted by Velázquez, as well as one of the rare ones in Spanish seventeenth-century painting altogether.

The subject of the painting, an undraped female figure looking at herself in a mirror, goes back to the early sixteenth century, when it was first painted by Giovanni Bellini in 1515 *(Nude with a Mirror)*; subsequently, and more explicitly as a Toilet of Venus, with a figure of Cupid by her side, it would be repeatedly taken up by Titian and by Rubens. In all of these thematic precedents for Velázquez's picture Venus is shown seated, but there were also many compositions of Venus reclining on her couch with which Velázquez was familiar, and he may have even known examples of the view of a reclining Venus seen from the back. The image is, nonetheless, startlingly novel, and has a more erotic effect than most of its possible prototypes. The formal precedent that comes closest to the sensuality of Velázquez's nude is not a Venus figure, in fact, but the Hellenistic sculpture of a sleeping hermaphrodite. Although the slim, graceful body of Velázquez's Venus appears to be directly observed from nature, both her delicate figure and her pose may have been inspired by the Hellenistic

piece, a version of which Velázquez had dispatched to Madrid together with many other acquisitions made in Rome of Classical statuary and casts of famous works.

Whatever its thematic or formal sources, Velázquez's *Venus* has an appeal beyond that provided by the beauty of the model, of the painting's color, and of its brilliant execution. In contrast to its *Toilet of Venus* antecedents, it alone reveals nothing of the goddess's face directly; we see her features in a frontal view only, as reflected on her mirror. The reflection of Venus' face, although complete, is undefined; shadow obscures most of it, and the same technique that so convincingly re-creates the sheen of the glass also cheats us of a clear view of what it reflects. The tantalizing vision of the features that seem to gratify the goddess's self-appraisal (Venus' expression suggests a smile of contentment), remains forever beyond our reach. In the context of the picture's subtext, *Venus at the Mirror* as an allegory of vanity, the elusive appearance of her face may be seen as a metaphor for the beauty of the flesh, as insubstantial and fugitive as a reflection on a mirror.

On his return from Italy, Velázquez devoted himself intensively to the decoration of the Alcázar and El Escorial, but the demands on him as court painter also increased; there are more extant court portraits from the last decade of his life than from the previous one. This was in part due to the increase in the royal family when Philip IV married his niece Mariana of Austria, since the new queen and the children born of this union had to be portrayed. To this was added the need for portraits of the now marriageable Infanta María Teresa, Philip's eldest daughter, to be sent to her suitors. The production of workshop replicas and variants of these portraits also increased considerably in these years, among them some for which the originals have vanished.

The first portrait of Queen Mariana painted by Velázquez, of 1652 [140], shows her standing in full length; the rest are either bust or half-length pictures, as are also those of the Infanta María Teresa. In spite of the homeliness of both the Queen and the Infanta, Velázquez's dazzling technical virtuosity places their portraits among the most beautiful official likenesses executed by the painter.

The portraits of Infanta Margarita (1651–1673), first child of Mariana, document the changes in appearance of the beautiful

140. *Diego Velázquez:* Queen
Mariana, *Madrid, Museo del
Prado*

child at various stages of her development, the most famous being,
of course, *Las Meninas.* The earliest of these portraits (Vienna,
Kunsthistorisches Museum), of c. 1653–54, shows Princess Mar-
garita in a pose similar to her mother's in her full-length portrait,
and with a seriousness appropriate to her station. But although
there is a minimum of animation in her expression, the execution
of her dress and of the accessory features of the portrait (particu-
larly the vase of flowers on the table) is of such liveliness and
spontaneity that these characteristics are transmitted to the sub-
ject without the artist's departing from the conventional impas-
siveness required by her rank.

The most exhaustively studied painting in all of Ve-
lázquez's oeuvre is the picture now known as *Las Meninas* or *The
Maids of Honor* [141], executed in 1656 and regarded ever since as
his most important work. The unusual subject itself, a hybrid of
genre painting and group portraiture (in the seventeenth-century

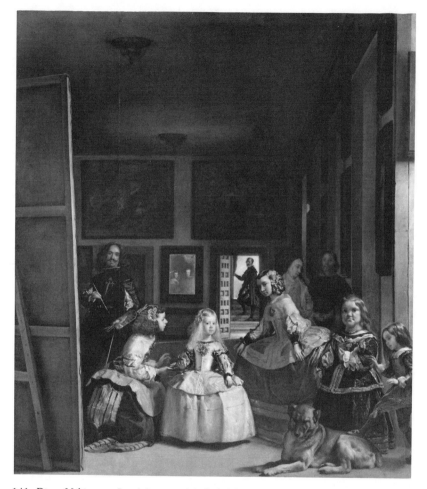

141. *Diego Velázquez:* Las Meninas, *Madrid, Museo del Prado*

palace inventories it was referred to as "the picture of the Family," and Palomino calls it a portrait of the princess), is an inspired and novel feature of this altogether remarkable work. The Infanta Margarita is here the center of a scene of domestic intimacy, peopled by recognizable individuals and taking place in an identifiable room of the Alcázar.

Velázquez's picture, in which almost every gesture suggests movement, seems to record a specific moment, whose fugacity is permanently captured on canvas by the artist. But what moment does it represent and what is the picture about? Although the Infanta's central position and brilliant illumination make her the

focus of our attention, as well as of the two *meninas* tending her, there is also a different, implied center of interest, on which the looks of most of the characters who populate the picture are fixed. This center is occupied nowadays by the viewer, but at the time of its creation it was occupied by Philip IV himself. In Velázquez's invention, it is the presence of the king, who is reflected in the mirror at the back of the room together with his wife, Mariana, that provokes the various reactions of the actors in the scene. That the reflection in the mirror is that of the royal pair itself, rather than of a double portrait on which Velázquez is at work, is made clear by the enormous size of the canvas, incompatible with any possible portrait. Such a portrait, in fact, was never painted; what is more, there are no royal double portraits of this size in all of seventeenth-century painting. The image that confronts the modern viewer is what Philip IV would have seen had he stood at the entrance to Velázquez's studio on some given occasion. Since the painting was destined to decorate the king's study in the private quarters of the palace, it not only recorded what Philip IV may have once looked upon, but it replayed that image for him for as long as he lived.

If the canvas that turns its back to us is something other than a portrait of Philip and Mariana, we are left wondering about its possible subject. Its dimensions are matched only by those of *Las Meninas* itself among all of Velázquez's known paintings, and it is tempting to imagine that the artist represented himself painting precisely the picture we behold, a typically Baroque conceit concerning the relationship of art and nature.

In order to create the illusion of reality that has amazed generations of viewers confronting *Las Meninas*, Velázquez utilized the full resources of his art; the picture is a tour de force of painterly virtuosity. It would seem that in *Las Meninas* Velázquez had undertaken the task of bringing together in a single painting all that his knowledge of this art encompassed; Luca Giordano had correctly understood the picture as a *summa* when he referred to it as "the Theology of Painting" upon first seeing it.

In the foreground, the figures and their garments seem to have the solidity and texture of their models, but they are depicted with different degrees of clarity, those in the center appearing more sharply defined than those in the periphery. This variation in the

definition of the figures also functions in depth: the foreground group, which receives directly the light from the windows on the right, is the most distinct; farther back, in a half light, Velázquez's figure appears less firmly modeled and with less detail, and farther back still, the widow Marcela Ulloa and the Guardadamas who accompanies her, their forms barely suggested, are almost engulfed by shadow. At the end of the hall, the silhouette of the Aposentador José Nieto is seen against the light of an open door, and a mirror on that far wall reflects dimly the forms of Philip IV and Mariana. On the upper part of the same wall, in the darkest area of the painting, two large copies of mythological pictures painted for the Torre de la Parada after Rubens's sketches, *Apollo and Marsyas*, and the *Fable of Arachne*, are only barely recognizable. This variety of effects in the representation of figures and objects is accompanied by equally subtle variations of light in the representation of space, and it is through them, more than from linear perspective, that Velázquez achieves the extraordinary illusion of distance and atmosphere that make this picture so astonishing.

The very size of *Las Meninas*, and the display Velázquez makes of his artistry in that picture, cannot but suggest that this work was of major significance for the artist, and so it has been interpreted in modern critical writings. The elements that compose its complex iconography point to a carefully elaborated meaning, which expresses metaphorically Velázquez's vision of himself and his art.

At the time the picture was painted, Velázquez was not merely the most highly placed Painter to the King; throughout the course of his career he had attained increasingly more important positions of service at the court, and by 1652 had reached the rank of Aposentador Mayor, a highly prized distinction for any gentleman, since it involved a close association with the king himself. At this time, Velázquez was also trying to establish his right to be admitted into the Order of Santiago, one of Spain's most exclusive knightly orders, as an *hidalgo* (gentleman) and son of an *hidalgo*, but also by refuting the taint of exercising a mechanical art, which was the way painting was still viewed in Spain in the seventeenth century. *Las Meninas* makes a strong case for the nobility of his art.

In *The Maids of Honor*, Velázquez postulates the concept of the intrinsic nobility of the art of painting by two means:

through the presence in his workshop, actual and implied, of three members of the royal family, and through the images of artist-gods that appear in the pictures in the background. According to the first, the closeness that existed between Velázquez and his king— who, as a modern Alexander, visited his workshop regularly for the pleasure of seeing the painter at work—stamped on the art of painting an indisputable seal of approval (Philip IV himself painted for his own amusement). According to the second, the thematic content of the mythological paintings on the back wall, and of still two others below them, *Prometheus* and *Vulcan* (de-signed by Rubens as well), also argued for the status of painting. Rubens, the artist who had conceived them, had been knighted by Charles I of England and by Philip IV, but more importantly, the subjects of the pictures themselves were also proof of the nobility of painting, since the arts, including that of painting, were prac-ticed by the gods themselves. *Las Meninas,* besides being an ex-traordinary artistic performance, is also a painted manifesto af-firming the nobility of the artist and of his art.

Although Velázquez's production was small during the last decades of his life, it is to this period that many of his most important and complex pictures belong. The most outstanding of these is the *Fable of Arachne,* more commonly known as *The Spin-ners* [142], painted for Pedro de Arce, a courtier who was also a great connoisseur of art.*

At a distance of forty years, the *Fable of Arachne* (c. 1658) reprises an approach to subject matter that Velázquez had ex-plored in his Sevillian years, in *Christ in the House of Martha and Mary* [121]. As in that painting, the most significant part of the narrative, that which reveals its meaning, takes place in a small space in the background, more brightly illuminated than the fore-ground. This inversion of emphasis, which in the early painting makes the viewer think at first that he is looking at a genre scene, has much the same effect here. Although the subject comes

*The canvas has suffered extensive damage, particularly in the darker areas, but what distorted most its modern appearance was the considerable alteration to its original form that the painting had undergone in the eighteenth century, when large strips of canvas were added to its original dimensions, most conspicuously on top. During the recent restoration of this work it was clearly established that these additions were later modifications to Velázquez's painting. The *Fable of Arachne* is illustrated here in its original format, as it is also currently exhibited in the Prado.

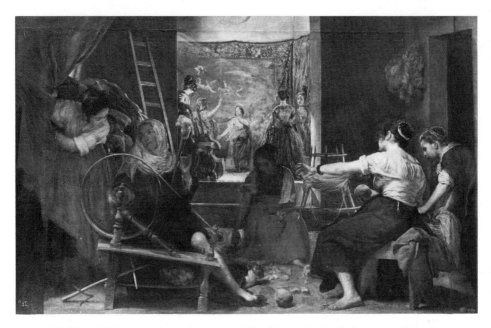

142. *Diego Velázquez:* Fable of Arachne (The Spinners), *Madrid, Museo del Prado*

straight from Ovid's *Metamorphoses,* this reversal accounts for its having been misinterpreted as a portrayal of the royal tapestry works of Santa Isabel, and given the nickname of *The Spinners.*

The scene in the background represents the passage of the myth in which Minerva has to admit (if only to herself) that the tapestry woven by Arachne in competition with her surpasses her own in beauty. Moments later, the goddess will give vent to her rage by destroying Arachne's work and transforming her into a spider.

According to Ovid, the tapestry woven by the unfortunate girl illustrated Jupiter's many dalliances with mortal women (thereby further angering his daughter), the first of which was the Rape of Europa. The subject of Arachne's work is easily recognizable in Velázquez's painting because he represents it as it appears in Titian's picture of the *Rape of Europa* (Boston, Gardner Museum), executed for Philip II a century earlier and still in the royal palace at the time. The use of this model not only served to identify readily the subject of Velázquez's picture, but also paid homage to Titian, upon whose example Velázquez had elaborated his own

pictorial technique, so brilliantly deployed here. In the *Fable of Arachne* more than in any other painting, Velázquez exploits to the hilt the possibilities of his optical method for describing the visual world, attaining such effects of breathtaking realism as the impression of movement given by the spinning wheel in the foreground.

As in *Las Meninas*, the subject of the *Fable of Arachne* as it is interpreted by Velázquez is also an apologia for the nobility of the artist and of his art. The scene in the background demonstrates not only that the gods themselves took pride in their art but that a mortal may also aspire to equal with his work that of a deity. Velázquez, therefore, does not place emphasis on the goddess's revenge, as does Rubens in the picture mentioned in connection with *Las Meninas*, but on the result of the contest.

Among the pictures painted by Velázquez shortly before his death, his *Mercury and Argus* [143], of 1659, is another highly original interpretation of a subject that had been dealt with earlier by Rubens for the Torre de la Parada. *Mercury and Argus*, together with three other mythological scenes that were destroyed in the 1734 fire in the Alcázar, originally formed part of the decoration of its Salón de Espejos, where Velázquez had placed, among others, paintings by Titian, Veronese, Tintoretto, and Rubens. Velázquez's pictures were set between the windows of the hall, which meant that they were seen against the light, so Velázquez pared

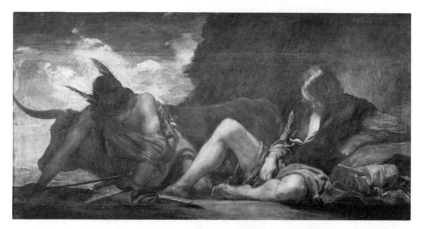

143. *Diego Velázquez:* Mercury and Argus, *Madrid, Museo del Prado*

down his descriptive technique even further than usual. *Mercury and Argus* is painted with extraordinary boldness (at close range, his manipulation of the brush is unbelievably summary), but the illusion of volume and of space is nonetheless totally convincing.

The difficult format of this picture, a low and broad rectangle, is ingeniously used by Velázquez to give emphasis to the cunning and stealth employed by Mercury to triumph over the many-eyed guardian of Io, who had been metamorphosed into a cow. The tension and suspense that the artist creates in this scene are as real as his description of the figure of Argus sunk into a profound sleep. It is worth noting that Argus' pose, in spite of its naturalism, is clearly derived from that of the famous Hellenistic *Dying Gaul*, then in one of the collections that Velázquez had been able to study during his stay in Rome.

Also from 1659 are Velázquez's last portraits of the youngest children of Philip IV, Infanta Margarita (Vienna, Kunsthistorisches Museum) and Prince Don Felipe Próspero (1657–1661), both sent to Emperor Leopold I in Vienna. In the Infanta's face at the age of eight the characteristic traits of the Hapsburgs begin to be perceptible, but if her beauty is somewhat diminished, her dark blue velvet dress with white and silver trimming is one of the

144. Diego Velázquez: Prince Don Felipe Próspero, *Vienna, Kunsthistorisches Museum*

most beautiful costumes ever painted by Velázquez. This portrait is also interesting because of its background (unfortunately in poor condition), which is more elaborate in its furnishings than those of previous portraits by Velázquez, and suggests a specific and spacious room.

This more detailed description of the environment occupied by the sitter is taken further in the portrait of *Prince Don Felipe Próspero* [144]. Here, the dim space of the room where the child stands opens up in the back, where a door and the opening into another room beyond can be discerned. The arrangement of the furnishings surrounding the prince and the distance between the picture plane and his figure fix precisely his position in space, and the space itself fulfills a more important visual function than it had in Velázquez's portraits of the 1620s and 1630s. In this respect, the portrait of Prince Felipe Próspero ties in to other late works of Velázquez, especially to *Las Meninas,* rather than to the earlier portraits. The visual weight of this space contributes to emphasize the fragility of the minuscule figure of the prince, who was to die before reaching his fourth birthday. The lack of vitality of the child, however, is compensated by the lively expression of the small lap dog that sits by him, and by the warm coloration of most of the picture.

In June of 1660, in accordance with his duties as Aposentador Mayor, Velázquez accompanied Philip IV on his trip to Fuenterrabía for the ceremonial handing over of Infanta María Teresa as a bride to King Louis XIV of France. A little over a month after his return to Madrid, the sixty-one-year-old painter became ill and a few days later, on August 6 of 1660, he died.

Velázquez was without question the most outstanding figure in Spanish seventeenth-century painting, but his influence on the art and artists of Spain in his own day, and in what remained of the century, was surprisingly small. While Rembrandt and Rubens had numerous disciples, followers, and imitators throughout their careers, Velázquez had practically no immediate artistic descendants to continue or develop his pictorial style. The most salient feature of his art—his extraordinary technique—was inimitable, and his only true disciple, Juan Bautista Martínez del Mazo (c. 1612–1667), who came closest to approximating it, died only a few years after his master. The artists who started to gain promi-

nence toward the mid-century, the now-called School of Madrid, overlapped Velázquez's life span but developed independently from him. They drank at the same sources that he had—Venetian sixteenth-century painting, and Flemish painting of the seventeenth—but these sources were assimilated directly, not through the filter of Velázquez's art. Velázquez's influence on this new generation of painters was indirect and only partial, restricted almost completely to portraiture.

In addition to his singular style, the objectivity of Velázquez's vision and the touch of irony in his interpretation of characters and stories were also unique among the Spanish painters who came after him. Only when Goya appeared on the scene, more than a century later, did his artistic legacy find a true heir.

🕮 The School of Madrid, I

Juan Bautista Martínez del Mazo, Antonio Pereda, Francisco Rizi, Juan Carreño, Francisco de Herrera the Younger

JUAN BAUTISTA MARTÍNEZ DEL MAZO (C. 1612–1667)

Very little is known about Juan Bautista Martínez del Mazo before 1633, the year he married Velázquez's eldest daughter, Francisca. He was born in the province of Cuenca sometime about 1612, but the whereabouts of his training remain a mystery. He must have been in Velázquez's workshop sometime before his marriage to Francisca, so it is quite possible that, like Velázquez himself, he had been his future father-in-law's apprentice. After 1633, he became Velázquez's chief assistant, and in the years that followed he also went up the social ladder in the court's hierarchy. In 1643, he was named Pintor de Cámara (Painter to the Bedchamber) of Prince Baltasar Carlos, then Usher to the King's Privy Chamber, and in 1661, after Velázquez's death, he succeeded him as Pintor de Cámara of Philip IV.

The artistic relevance of Martínez del Mazo is difficult to gauge, since a great portion of his extant work consists of repetitions of portraits of the royal family painted by Velázquez. Although he often attains in these such a high level of quality that they have been frequently attributed to Velázquez, these are pictures in which his own artistic personality is submerged in that of the author of the originals. Mazo's adaptability to another painter's style and technique was not limited to the replication of Velázquez's portraits; a good number of his copies of pictures by

Titian, Rubens, and Jordaens have also been preserved, and they are all remarkably successful.

Only a handful of his own works is documented, and they are of widely disparate types and dates, but we also know a sufficient number of pictures that can be attributed to him with reasonable certainty, so it is possible to make some generalizations about his work.

In regard to technique, he was unquestionably the only painter at court who approached Velázquez's manner, but even in his most faithful copies of the latter's portraits (a good many of Queen Mariana, some of the Infanta Margarita), his brushwork does not have the illusionistic efficacy of Velázquez's; in the costumes, hair, and ornaments, Mazo's brushstrokes are denser and more erratic, and the features of the sitters are not described with as much subtlety. In the portraits he painted independently of Velázquez, those differences in technique are more marked, and they impart to those paintings a personal character.

For his independent portraits [145], Mazo adopted the expanded surroundings that Velázquez had introduced into his late ones, but he gave them an individual twist: the floor plane rises and extends back in a more exaggerated perspective, which often

145. *Juan Bautista Martínez del Mazo*: Empress Margarita of Austria, *Madrid, Museo del Prado*

146. *Juan Bautista Martínez del Mazo*: The Family of the Painter, *Vienna, Kunsthistorisches Museum*

ends in a distant scene with small figures or a view of the outdoors.

In *The Family of the Painter* [146], executed c. 1665, the inspiration provided by *Las Meninas* is evident, but it is limited to the idea of representing a group of identifiable characters gathered in the painter's studio in the Alcázar (clearly not the same one painted by Velázquez). Here there is neither a suggestion of spontaneity in the arrangement and movements of the figures, who are represented posing rather than in action, nor an ideological program to give a special meaning to the picture. But this canvas, of relatively modest dimensions, is nonetheless an interesting and original work, as an almost unique example of group portraiture in Spain at this time. The *Portrait of the Danish Ambassador Cornelius Pedersen Lerche and His Friends*, by Antolínez [220], signed in 1662, is the other known instance of this genre in seventeenth-century Spanish painting, but this latter picture is almost certainly dependent on the Dutch tradition of group portraiture.

This portion of Mazo's work, although worthy of study, is of relatively more limited interest, since it is essentially an elaboration of Velázquez's style and technique, which he keeps alive for a few more years after the master's death. It is in the field of landscape and view painting, a genre seldom practiced in Spain, where Mazo makes an important personal contribution to Spanish art.

One of the very few documented works by Mazo that has come down to us is the large *View of Zaragoza* [147], dated 1647. In 1646, Mazo had accompanied Prince Baltasar Carlos to Zaragoza on the unfortunate journey in which the heir to the Spanish throne would die, and while they were there he had started to paint this view of the city upon the prince's request.

This type of city view, with a relatively low vantage point and a frieze of figures in the foreground, had been common in Flemish and Dutch prints since the sixteenth century, and by the seventeenth century similar prints and drawings illustrating Spanish towns had become current. Views of this sort on canvas, however, were totally foreign to Spanish painting; they appear in the Netherlands only in the seventeenth century, in paintings such as Vermeer's *View of Delft* (The Hague, Mauritshuis), of 1662. Mazo's picture, therefore, apart from its merits as a work of art, is unique in Spanish painting of this period.

Because of its high quality, the *View of Zaragoza* has been

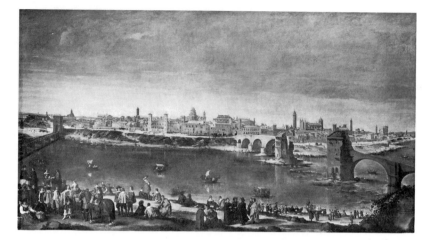

147. *Juan Bautista Martínez del Mazo:* View of Zaragoza, *Madrid, Museo del Prado*

persistently attributed to Velázquez, at least partially, even though it is signed by Mazo; according to some, Velázquez would be the author of the landscape, and according to others, that of the figures. Nevertheless, there is no reason to doubt the veracity of the inscription the picture bears, in which Mazo is named unequivocally as the sole author, and both the figures and the landscape are completely consistent with his style and technique in works that are accepted as his.

The landscapes generally attributed to Mazo can be divided into three types: views of cities and identifiable localities, pictures of hunting and other outdoor entertainments, and imaginary views with Classical ruins and mythological figures. The *View of Zaragoza* and a view of the fortress of Pamplona fall within the first category, but so do two large pictures with views of the gardens of Aranjuez (*The Queen's Avenue* and *The Fountain of the Tritons* [148], the latter one painted in 1657), and another with a view of the large lake in the Buen Retiro (the last three now also in the Prado).

For such views of gardens it is possible that Mazo was inspired by the two small canvases with views of the Villa Medici that Velázquez had painted in Rome in 1649/50 (Madrid, Museo del Prado), but as court painter he also had easy access to the numerous landscapes that decorated the Buen Retiro palace, the

Torre de la Parada, and other royal seats, painted for the most part by Flemish and Dutch artists who were specialists in the genre. The size of these pictures, and the distant and high viewpoint taken by Mazo, are features that also relate them to landscapes by Claude Lorrain, which then were in Madrid, but Mazo's manner of representing nature is more closely tied to Rubens's landscape painting and to that of Velázquez than it is to Claude's.

Mazo knew Rubens's work more intimately than any other Spanish painter, since he had made copies of a large number of his pictures for the Torre de la Parada, to serve as decoration for various apartments in the royal palace (his are the copies of the Torre de la Parada paintings that hang on the back wall in *Las Meninas*). In *The Fountain of the Tritons*, the trees and foliage are very similar to those in Rubens's landscapes of the 1630s (and to those of Rubens's followers, such as Peter Snayers), but here, as well as in the *View of Zaragoza*, the colors and general tonality of the painting, with its silvery greens and grayish tans, are close to Velázquez's.

Mazo's pictures of mythological subjects, such as the *Landscape with Mercury and Herse*, in which a partially ruined temple

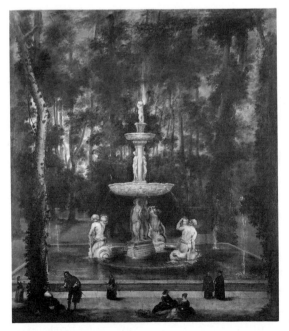

148. *Juan Bautista Martínez del Mazo:* Fountain of the Tritons at Aranjuez, Ma- drid, Museo del Prado

appears, or the *Death of Adonis* (both in Madrid, Museo del Prado), present a superficial resemblance to Claude's compositions, but they differ in important respects. Mazo's landscapes do not have the fine atmospheric quality and the slow movement toward a far horizon that characterize Claude's; they are done in a sketchy and quick technique, and have a Baroque dynamism that is very far from the classical serenity of Claude's pictures.

Without being a specialist in the genre, Mazo is the most interesting Spanish landscape painter of the seventeenth century. His views of actual sites are the only modern landscapes painted in Spain at that time apart from those done by Velázquez, and his mythological landscapes established a dramatic Baroque genre, also new, which would be continued by his disciple Benito Miguel de Agüero (c. 1626–1670). Besides Mazo and Agüero, the only independent landscape painters whose work is still known are Francisco Collantes (c. 1599–1656), who worked at the court, and Ignacio de Iriarte (c. 1620/21–1685), who painted in Seville. A fair number of landscapes by Collantes are extant, many of them painted for the Buen Retiro, but of Iriarte's landscapes hardly any have survived. The landscape style of both is frankly old-fashioned; their works are still noticeably dependent on Flemish models of the late-sixteenth and early-seventeenth centuries, such as the works of Gillis van Coninxloo and Joos de Momper.

The reasons for such paucity of painters engaged in this specialty in Spain can be only surmised. The royal inventories inform us that in the time of Philip IV literally hundreds of landscapes by painters of all nationalities were purchased for the decoration of the Buen Retiro and the Torre de la Parada, and such pictures were also abundant in the great private collections. Although this demonstrates that an appreciation of landscape painting existed in the upper tiers of the social scale, the general demand for such a specialty must not have been enough for a painter to make a living from it alone. In Spain, artistic patronage was more concentrated in the church's hands than was the case in other countries of Europe, and although the king and some noble families were great consumers of art, it was the church that fed the majority of Spanish painters. That the art market in Spain did not allow for the kind of specialization that existed in other countries is clearly stated by Palomino in his *Lives* in relation to Enrique de

las Marinas, a Spanish painter of seascapes who worked in Rome all his life: "And if he had come here without knowing how to paint other things, he would have perished; for on top of not being paid as well as over there, he would have been idle most of the year."

ANTONIO PEREDA (1611-1678)

Antonio Pereda, born in Valladolid in 1611, belonged to a family of painters, and his first apprenticeship must have been with his father, a modest local artist. At his father's death in 1622, Pereda entered the workshop of another local painter, but soon moved to Madrid, where he already resided by 1627/8. There, he entered the school of Pedro de las Cuevas, an important painting teacher from whom we have, however, not a single work left. Pereda's precocious talent was recognized by Giovanni Battista Crescenzi, an Italian nobleman, architect, painter, and connoisseur of art—as well as an influential man in the court of Philip IV—who met him in 1629 and would be his protector to the day of his death, in 1635.

The first important dated work by Pereda is the *Relief of Genoa by the Marqués of Santa Cruz* (Madrid, Museo del Prado), painted in 1634 as part of the decoration of the Hall of Realms of the Buen Retiro palace, a commission undoubtedly obtained through the good offices of Crescenzi. Pereda took good advantage of this opportunity to demonstrate his artistic caliber in competition with the most outstanding court painters, and this work, located as it was in such a prominent place, did much to establish his reputation. But what might have been a brilliant career as Painter to the King was frustrated by the death of Crescenzi in 1635. Be it on account of the enmity that existed between Crescenzi and the Count-Duke of Olivares, be it for lack of support at the court after the death of the marquis, Pereda never received another royal commission. From 1635 on, he would paint primarily for churches or religious institutions, although his oeuvre includes a considerable number of still lifes, today perhaps the most admired part of his production.

The *Relief of Genoa by the Marqués of Santa Cruz* is one of the best battle paintings in the Hall of Realms and, apart from

Velázquez's *Surrender of Breda* and Zurbarán's *Defense of Cádiz*, the only one whose classical, friezelike composition departs from the diagonal division between the foreground and the background that characterizes the rest. Its strong points are its color, the richness of details, the naturalistic description of characters and garments, and the use of a dramatic backlighting to emphasize the Duce of Genoa and his gesture of thanks.

In what may be his most beautiful work, the great *Vanitas* painted about 1634 [149], Pereda shows off the perfection of his technique in the depiction of a welter of objects of the most varied sort. These are organized in three parallel planes connected by diagonal lines, a type of composition that is reminiscent of Dutch still lifes of the same period by Claesz or Heda. In both the profusion and the arrangement of objects represented, Pereda's picture has little to do with the Spanish still-life tradition represented by Sánchez Cotán's and Van der Hamen's compositions. Only the precise description of the contents of this *Vanitas* and the black background against which they are set associate it to earlier Spanish works of this genre.

The name given to this work in Pereda's day was *The Illusion of Worldly Things,* and it was meant to act as a reminder of man's mortality and the futility of all earthly endeavor not related to the salvation of his soul. Although this type of moralizing work

149. *Antonio Pereda:* Vanitas, *Vienna, Kunsthistorisches Museum*

150. *Antonio Pereda:* Saint Jerome and the Trumpet of the Last Judgment, *Madrid, Museo del Prado*

appears in Spain for the first time here, the genre had become popular in Dutch painting in the 1620s, and the symbolism of the various objects that made up a *vanitas* image was common knowledge at the time Pereda painted his picture. Gun, armor and baton of command, the imperial cameo (Charles V) atop the globe of the world, and the medal of Julius Caesar represent the illusion of military triumphs and worldly power; the books, the illusion of human science and knowledge; the gold chain and the gold and silver coins, that of riches; the playing cards, that of fortune; and the portraits and flasks of perfume, that of the pleasures of love. Next to them Pereda presents the symbols of the brevity and fragility of life (clock, hourglass, and spent candle), and of the inevitability of death (skulls).

A skull is the most frequent memento mori in religious images of penitent saints, but its multiplication in the pile of skulls seen from various angles in Pereda's *Vanitas* gives special emphasis to the concept of the vanity of life itself, of the perishability of the flesh. In a small undated *Vanitas* (Zaragoza, Museo Provincial de Bellas Artes), probably painted in the 1640s, Pereda concentrates on that memento mori image; three skulls and a watch on a red tablecloth, also seen against a dark ground, point up man's mortality with shocking conciseness.

The most personal and attractive of Pereda's religious paintings are those where he can fully deploy the analytic vision that he developed in his still lifes. The two paintings of 1643 which portray aged saints, *Saint Jerome and the Trumpet of the Last Judgment* [150] and *Saint Peter Liberated by an Angel* (Madrid, Museo del Prado), especially the first, have a great expressive force, achieved through the intense realism of the artist's description of the bodies and faces of the saints. Pereda paints the wrinkled flesh and white beard of Saint Jerome with the same minute attention that he bestows on the objects in the foreground, and this realism involves also the spiritual content of the character, making the contrite expression of the saint as convincing as his outward appearance. In the composition of the two works, he also uses the same type of organization employed in the earlier *Vanitas,* in which the various planes are interconnected by repeated diagonals.

In these two pictures of 1643, Pereda uses a broader, more loaded brushstroke than in his paintings of 1634/35, and his

151. *Antonio Pereda:* Still Life with Fruits, *Lisbon, Museu Nacional d'Arte Antiga*

152. *Antonio Pereda:* Sacrifice of Isaac, *Dallas Museum of Fine Arts, Hoblitzelle Foundation*

brushwork is even more vigorous in the magnificent *Still Life with Fruits,* painted in 1651 [151]. Here, the rich facture increases the lustiness of a composition that departs radically from the Spartan canons of Spanish painting of this genre. The abundance of foods and the density of the grouping of objects bring Pereda's still life closer to contemporary Italian and Flemish ones than to those of Zurbarán, Sánchez Cotán, or Van der Hamen [96, 53, 71]. Fruits, vegetables, and kitchen paraphernalia are seen against the black background common to Spanish still lifes, but Pereda forsakes the characteristic isolation of their component elements. The emphasis is placed instead on their grouping, and objects in different planes interlock in an artful and dynamic composition that binds them together. This is not to say that the compositions of the earlier painters mentioned above were any less artful, but their artifice was geared to imparting to those objects an iconic presence.

Very different from this robust still life are the two canvases signed in 1652, one with an ebony chest, coffee service, and sweets (Leningrad, Hermitage), and the other with an ornamental clock, fine china, and seashells (Moscow, Pushkin Museum), in which the elegance of the objects is complemented by a delicate and smooth technique. They are also different in the backgrounds used—a dark wall against which the shadows of the neighboring objects are cast in the first, and a silken drape in the second—which replace the black, opaque backgrounds of his earlier still

lifes. In these elegant and ostentatious still lifes the influence of Dutch painting, especially that of Heda, is particularly evident.

In the *Sacrifice of Isaac* [152], a large religious work which can be dated to c. 1645/50, Pereda uses a similar type of composition to those of his religious paintings of smaller format done in 1643. His figures are set in a plane parallel to that of the picture, and the composition is animated by the diagonals created by their poses. He also makes use of a strong chiaroscuro—even though the scene takes place in a landscape—to impart volume to the figures and project them toward the viewer. As in those earlier paintings, the figures fill up most of the picture plane.

The episode of Abraham's sacrifice of Isaac, a traditional Old Testament prefiguration of the sacrifice of Christ, receives an original treatment in Pereda's picture. Instead of illustrating the usual biblical passage, in which the angel stops Abraham's hand just before the sacrifice is consummated, Pereda chooses an earlier moment in the story. Here, Abraham appears to explain to his son that the obedience owed to God makes his sacrifice necessary, and the child, in turn, seems to offer himself to it wholeheartedly and without fear, with an expression of stoic surrender comparable to that of a Christian martyr facing his ordeal. The choice of this moment in the narrative, and of such an account of the feelings of Isaac, places stress on the strength of the faith of both characters rather than on the story's dramatic climax of divine deliverance, most frequently represented.

One of Pereda's latest works is the half-length *Saint William of Aquitaine* (Madrid, Academia de San Fernado), dated 1672. The mood and style of this beautiful picture are very Venetian, even Giorgionesque, but its contents show the same stress on the penitent and meditative devotion of his earliest pictures. Saint William, dressed in a suit of armor, is depicted with his hands to his chest in front of a crucifix, a Bible open to an image of the Virgin and child, and a skull, painted with the same attention to detail as the memento mori of *Saint Jerome and the Trumpet of the Last Judgment* of 1643.

In his religious paintings of the 1650s through to his death in 1678, Pereda approached the ideals of grace in the figures, and of movement and spatial openness in the compositions, that characterize the works of Francisco Rizi and Juan Carreño, his almost

exact contemporaries. But Pereda's forms remain always more substantial, and his work never shows the same degree of assimilation of Rubensian style, looseness of brushwork, and luminosity as the paintings of those two artists; it mantains to the end a stronger link than theirs to the conventions and aesthetics of Spanish painting of the first half of the seventeenth century.

FRANCISCO RIZI (1614–1685)

Francisco Rizi was the son of Antonio Rizi, an Italian painter who had settled in Spain in 1585, invited by Philip II to take part in the decoration of El Escorial. His older brother, Fray Juan Rizi (1600–1681), was also a painter of some distinction who remained, however, attached to his tenebrist beginnings throughout his artistic career.

Francisco was born in 1614 in Madrid, where he would spend the greatest part of his life. His apprenticeship was done in the workshop of Vicencio Carducho, who was then Painter to the King, and after his master's death in 1638, he also entered the service of the royal household. Rizi's first documented works, in fact, are two double portraits of medieval kings of Spain, now lost, painted for the Salón Dorado of the Alcázar in 1639.

The *Adoration of the Magi* [153] in the cathedral of Toledo, signed in 1645, already exhibits a fully developed personal style, independent from Carducho's school. The bright and clear colors, and the quick and free manipulation of the brush, which are from this point on trademarks of his style, reveal his study and thorough assimilation of Venetian sixteenth-century painting. This neo-Venetianism will be a constant in Spanish art of the second half of the seventeenth century, and Rizi is the painter in whom it is first and most strikingly evidenced. The movement of the figures and the type of composition Rizi uses in the *Adoration,* typical of Baroque art, indicate on their part his study of Rubens, whose work, besides being very well represented in the royal collection, was also known through the engravings of his pictures that were available all over Europe.

In the works that followed, Rizi's technique and color became livelier and his compositions more movemented, so that the great altarpieces painted from 1650 on exemplify an exuberant

Baroque style that is almost completely unrelated to that of Spanish religious painting of the first half of the century. In the works of the School of Madrid from c. 1650 to c. 1700, Spanish painting merged with the mainstream of Baroque art, turning its back on the tradition of realism and tenebrism that had characterized Spain's art before the mid-century.

Rizi's first major work, *The Virgin with Saint Francis and Saint Philip* [154], painted in 1650, is still in the Capuchin convent of El Pardo for which it was executed. Although the planar and static composition of this altarpiece follows a classicizing pattern, its colorism and light effects, the movement of the draperies, and the impressionistic technique used by Rizi connect it to the High Baroque style that he would develop in the following years. This grand manner would prove very effective in Rizi's role as decorator and set designer. Since 1649, when he worked on the ephemeral decorations erected in the streets of Madrid for the solemn entry

53. *Francisco Rizi:* Adoration of the Magi, *Toledo, Cathedral*

54. *Francisco Rizi:* The Virgin with Saint Francis and Saint Philip, *El Pardo (Madrid), Capuchin Convent*

of Mariana of Austria as new Queen of Spain, he had worked in that capacity for Philip IV, as he would subsequently for Charles II. For many years, he was also the man in charge of the scenography for the comedies represented in the theater of the Buen Retiro palace, the Teatro del Coliseo. Some drawings for his stage sets have fortunately survived, as a record of that facet of his work.

In the large canvases painted by Rizi for monumental retables in the decade of 1650–60, his dynamic and theatrical style is deployed at full strength. In these pictures, Venetian inspiration—particularly Veronese's at this moment—is mingled with the energy and grandeur of Rubens's art, whose compositional schemes, poses, and foreshortenings Rizi emulates with remarkable effect. This was the style that would stimulate the younger painters, active in the last quarter of the century, to proceed upon similar paths.

In that decade and in the first years of the following one, Rizi was at the apogee of his career, and received a large number of important commissions to adorn the altars and retables of the churches of Madrid and its environs. A beautiful example of his work from the years 1660–65 is the *Annunciation* [155], probably painted as the attic of a now dismembered retable. In this picture,

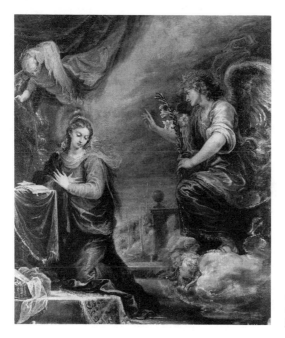

155. *Francisco Rizi:*
Annunciation, *Madrid,*
Museo del Prado

style, technique, and composition are perfectly matched; the design of the figures, full of movement and life, is complemented by his impressionistic brushwork and brilliant color, which lend the image an extraordinary visual richness and animation.

Although from 1656, when he was named Painter to the King, to 1670, when his professional decline began, Rizi continued producing important oil paintings, his artistic activity during this period centered primarily on the execution of frescoes for the Alcázar and for the churches of Madrid and Toledo. That facet of his art is very poorly represented in our day due to the destruction of the Alcázar and the disappearance or alteration of many of the churches of Madrid in the following centuries. Among the few remaining examples are the paintings commissioned by the cathedral of Toledo in 1666 to decorate the walls and vaults of the Camarín of the Virgen del Sagrario, which, if not in perfect condition, give some account of Rizi's approach to fresco decoration in those years. Its main feature, here and in his other frescoes, is the use of the *quadratura* technique, which involves a special understanding of perspective, at which Rizi was most adept.

In *quadratura*, the simulated architecture that ornaments and appears to extend the actual surfaces that delimit the frescoed space is combined with painted open skies and figures seen *di sotto in sù*, so as to create an illusionistic and often spectacular vision. The use of this type of fresco decoration had been introduced in Spain by the Bolognese painters Agostino Mitelli and Michelangelo Colonna, specialists in the art of *quadratura* (of long-standing tradition in Bologna), whom Velázquez had imported to Spain in 1658 for the frescoing of some important rooms in various royal palaces. The two artists had remained in Madrid until 1662, the year in which Mitelli died and Colonna returned to Italy.

The art of fresco painting had never taken root again in Spain after the passing of the Middle Ages; in the sixteenth century and the first half of the seventeenth, the frescoes that were painted there—most of them executed for royal seats such as the palace of El Pardo or the monastery of El Escorial—were done by Italian painters or by Spaniards educated in Italy. After the middle of the seventeenth century, on the other hand, mural painting had a great flowering, and although initially the sources for both the technique and style of fresco decoration were Italian, its practice

was taken up and developed independently by a good number of Spanish artists.

The frescoes for the dome of the church of San Antonio de los Alemanes (now called "de los Portugueses"), in Madrid, also date from the 1660s [156]. The architectural elements of the *quadratura* had been sketched out by Colonna before his departure for Italy, but were later reelaborated by Rizi in conjunction with the glorification of Saint Anthony that they surround. In this commission, as on many other occasions, Rizi worked in collaboration with Juan Carreño, who actually executed the frescoes, and to whom those of the walls below also belong. In spite of the retouchings undergone by the San Antonio frescoes from the hand of Luca Giordano at the end of the century, most of the dome's composition is of Rizi's invention, and it is as up to date in its design as the most important contemporary ceiling frescoes painted in Italy.

In its use of *quadratura* and figures seen *di sotto in sù*, the dome of San Antonio continues in general terms the scheme used by Pietro da Cortona in the vault of the Barberini Palace in Rome (1633–39). This illusionistic conception of decoration culminates in Rome in the vaults of Il Gesù (1674–79), by G. B. Gaulli, and of San Ignazio (1691–94), by Padre Pozzo; the dome of San Antonio, which predates them, has a similar treatment of figures, space, and light. As in the Italian vaults, the figures in San Antonio's rise or descend in the open sky above the simulated architecture in groupings that absorb their individual forms; they are also arranged in a freer and more irregular composition than that of Cortona's Barberini frescoes, as is also the case of the Gesù's and San Ignazio's. The intense light that permeates the scene, also similar to that of the two Late Baroque frescoes, effaces the contours of clouds and figures, and contributes in great measure to create the illusion that what the viewer beholds is in truth a celestial vision.

The frescoes painted by Rizi in 1678 for the Capilla del Milagro, in the convent of the Descalzas Reales in Madrid, where he employed the same illusionistic technique, are also preserved in fair condition. In the dome's *Coronation of the Virgin* [157], the overall luminosity and airiness of the composition, and the diaphanous colors and delicate hues employed, are again as "modern" as

156. Francisco Rizi and Juan Carreño: Dome of the Church of San Antonio de los Alemanes, Madrid

157. Francisco Rizi: Coronation of the Virgin, Madrid, Descalzas Reales, Capilla del Milagro

their Italian counterparts of the late-seventeenth and early-eighteenth centuries.

During the last fifteen years of his life, Rizi worked primarily for churches and convents outside Madrid—in Toledo, Avila, Plasencia, Alba de Tormes—but at the end he renewed his relationship with the court. From those years, however, the only work that has survived is the curious *Auto de Fe de 1680* (Madrid, Museo del Prado), more interesting as a social and historic document than as a work of art.

His last work was to have been the altarpiece for the sacristy of El Escorial, but the project never went past the design stages during his lifetime. At his death in 1685, the commission was transferred to Claudio Coello, his former student, who executed it according to a design that modified Rizi's composition.

Francisco Rizi is not only one of the most important figures in Spanish art of the second half of the seventeenth century for the outstanding works he produced throughout his career, but also for having been the example and master of the following generation of painters. Among these were Juan Antonio Escalante (1633–1669), José Antolínez (1635–1675), and Claudio Coello (1642–1693), painters whose artistic personalities were shaped by direct contact with Rizi, but who then followed their own independent paths.

JUAN CARREÑO DE MIRANDA (1614–1685)

Juan Carreño de Miranda was born in Avilés (Asturias) or its environs in 1614. His father, a gentleman of the same name, took the boy to Madrid with him when he was eleven years old, and there it was decided that Carreño would stay at the court in order to pursue an artistic career. In Madrid he attended the school of Pedro de las Cuevas—where Antonio Pereda was also a student— and later entered the workshop of Bartolomé Román, also a little-known painter.

No youthful picture by Carreño has been identified; the first signed work that we know dates to 1646, when he was already thirty-two years old. This may be due to his having matured late as an artist, as is suggested by an anecdote related by Palomino in his life of Carreño in praise of this artist's modesty. In this anecdote, Carreño points at one of his own youthful pictures, which was being derided at a gathering of artists who did not know it was his work, as an example of why a painter should not despair of becoming proficient no matter how inept in his beginnings. Even in the picture dated 1646, *Saint Anthony Preaching to the Fish* (Madrid, Museo del Prado), painted for the Convent of Caballero de Gracia, his style is not fully developed; his artistic personality is manifested only in the painterly brushwork and, to a lesser extent, in the luminous color.

In a picture signed three years later, the *Holy Family* painted for the parish church of San Martín, in Madrid, the strong influence of Rubens, which will dominate Carreño's painting for many years, is very marked; to it would soon be added that of the other great Fleming, Van Dyck, and by way of the latter, of Venetian sixteenth-century technique, especially that of the mature and late Titian. His paintings for the Venerable Tercera Order in Madrid, still in situ, but particularly the *Annunciation*, signed in 1653, already display a more personal style, into which Flemish and Venetian influences have been fully assimilated. It should be noted, however, that Carreño still uses at this point—and will continue to do so in future paintings—prints after the works of other artists as the basis for compositions or poses. In the pendant to the *Annunciation*, the *Mystic Marriage of Saint Catherine*, he based its composition on an engraving after Van Dyck's *Virgin and*

Child with Saint Rosalie (now in Vienna, Kunsthistorisches Museum).

One of Carreño's most beautiful paintings is the monumental *Penitent Magdalen* [158], done in 1654 for the Convento de Recogidas of Madrid. Although in general terms the *Penitent Magdalen*'s composition is comparable to those of penitent saints painted by Ribera, Carreño gives a greater openness and visual weight to the figure's surroundings, which complement it and enhance its grandeur. The Magdalen's splendid forms and the sensuality of her beauty are very far from the standards of modesty that governed the representations of the repentant sinner in earlier Spanish works; she is at home, instead, with Titian's, Rubens's, and Van Dyck's versions of the saint.

Another picture in which the voluptuousness and elegance of the saint's physical type are stressed is his *Saint Sebastian,* signed in 1656 [159]. Although the saint's pose was probably inspired by Guido Reni's *Samson* (Bologna, Pinacoteca), painted c. 1615–20—an artist whom he also admired and of whose works he occasion-

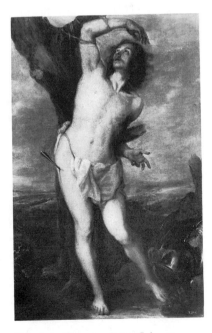

158. *Juan Carreño:* Penitent Magdalen, Madrid, Real Academia de San Fernando

159. *Juan Carreño:* Saint Sebastian, Madrid, Museo del Prado

ally made copies—Saint Sebastian has nothing of *Samson*'s cool perfection. The softness and luster of the saint's flesh make the physical appeal of the young martyr no less strong than that of the penitent Magdalen, but in both paintings, the exalted devotion that animates the saints' expressions balances the sensuality of the body with the spirituality of the soul. It is fair to say that in these pictures Carreño reached the pinnacle of his art as far as religious images are concerned, even though in the 1660s he would execute more ambitious canvases, in which the subject matter allowed him to work on more complex compositions.

In December of 1661, Pope Alexander VII published the bull *Sollicitudo,* in which he recommended devotion to the Immaculate Conception, a doctrine that was vigorously supported in Spain. The following year, Carreño painted his two first-known canvases of the Immaculate Conception, and from this time on the format of this image remained fixed in the painter's oeuvre; the many versions of this subject that exist, up to the one dated 1683, twenty-one years later, repeat it with only minor variations in the figure of the Virgin. In the 1662 *Immaculate Conception* illustrated here [160], the ample but compact, rhombuslike silhouette of the

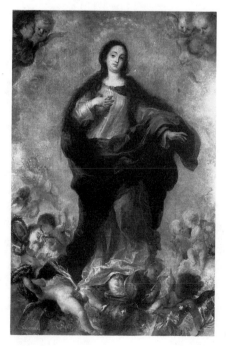

160. *Juan Carreño:* Immaculate Conception, *Madrid, Adanero Collection*

Virgin achieves both monumentality and elegance. Her image is still and frontal, majestically serene, but the playful cherubs who are concentrated at her feet to support her and the play of light around the figure give liveliness and visual excitement to the picture. It is not surprising that this image of the Immaculate Conception became one of Carreño's most popular subjects.

The largest extant canvas by Carreño, and one of the most important Spanish altarpieces of the second half of the seventeenth century, is the *Foundation of the Trinitarian Order,* painted for the Trinitarians of Pamplona and signed by Carreño in 1666 [161]. In this picture the painter worked in collaboration with Francisco Rizi, something he had done before on other occasions, but the collaboration in this instance appears to have been limited to making use of a drawing by Rizi for the general layout of the composition. That design itself was directly inspired by a painting by Van Thulden, a student of Rubens, which provided the scheme for the lower part of the picture.

Carreño's composition of the *Foundation* varies from Rizi's design and its prototype in the greater openness of the space where the scene is staged, which swells above the heads of the foreground figures, and beyond the acolytes and the faithful who witness the apparition, but also in introducing space between the figures themselves, which previously were arranged in a compact mass. The canal that Carreño opens between the middle ground and the landscape seen beyond a terrace and portico also helps to attract the viewer's attention to the two additional episodes of the story that are included in the background.

The facture of this splendid altarpiece and of its preparatory oil sketch (still extant) is the most brilliant in Carreño's entire career; the enormous canvas is painted with the same liveliness as the preparatory oil sketch and loses none of the *bozzetto's* freshness. The picture's resplendent color and light, and Carreño's masterly manipulation of paint, attain their highest point in the rendering of the kneeling priest's dalmatic, and in the glory and vision of Saint John of Mata in the upper portion of the picture.

The *Foundation of the Trinitarian Order* is an apotheosis of Venetian and Flemish painterly bravura and colorism, and of High Baroque dynamism in the movement of figures and composition; in brief, it is the quintessence of the style of the school of Madrid,

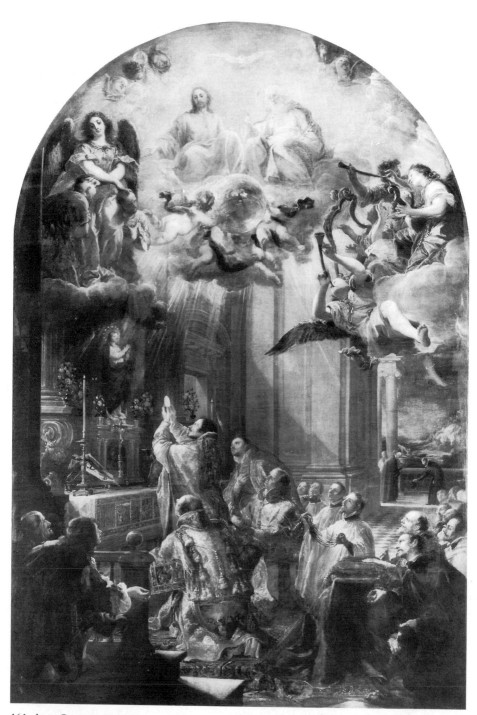

161. *Juan Carreño:* Foundation of the Trinitarian Order, *Paris, Musée du Louvre*

and, as such, an excellent example of the distance that separates the painting of this period from that of the first half of the century. The emphasis on the tactile qualities of the objects and figures represented in a painting, which characterizes Spanish art of the first half of the century, is replaced in the second half by an optical approach, in which form and surface are suggested by the touch of the brush and the combination of colors that make up the pictorial field. It is only natural that in paintings in which the artist intends to represent the palpable and essentially unalterable existence of whatever figures and objects are presented to the viewer, he should attend to conveying, as convincingly as possible, their solidity, weight, and surface texture, and to do so in stable, stationary images. This holds true for the painting of Sánchez Cotán, Mayno, Zurbarán, and the young Velázquez. On the other hand, an emphasis on the depiction of space and light, such as we see in Carreño's picture, presupposes a different, perhaps intrinsically more pictorial goal: to capture the changing appearance of forms and surfaces in movement or touched by a fluctuating light. The tactile mode of representing reality is usually better served by a smooth application of paint, in which the brushstrokes are self-effacing, or at least do not manifest themselves as separable from that which they represent; the optical mode (with some notable exceptions) usually avails itself of a technique in which the brushstrokes are irregular, apparent, and independent of the volumes and surfaces they re-create.

By 1659, Carreño's ability for mural painting had already been recognized, and he was entrusted, together with Francisco Rizi, with the decoration of the soffit of the Salón de Espejos in the Alcázar with paintings of mythological subjects. These frescoes disappeared with the demolition of the Alcázar after the fire of 1734, but fortunately those that he painted for the dome of the church of San Antonio de los Alemanes, not much later, are still in existence [156]. For these frescoes, painted between 1660 and 1668, he also worked in collaboration with Francisco Rizi, who provided in this instance as well the composition from which Carreño would execute the *Vision of Saint Anthony*. From what we can gather from Rizi's preliminary drawings of the *Vision of Saint Anthony*, the finished version of the dome painting stood in a similar relationship to Rizi's design as the *Foundation of the*

Trinitarian Order had to his preparatory drawing, Carreño's paint-
ing being somewhat more spacious and open.

The best-known facet of Carreño's art is his portrait paint-
ing, of which we still have some magnificent examples. In this field,
his identifiable oeuvre belongs to the latter half of his career, when
he was already more than forty-five years old. Even in the portrait
that is considered his earliest signed and dated work in that genre,
the *Bernabé de Ochoa* (New York, Hispanic Society), the reading
of its date as 1660 is questionable. Another signed and dated
portrait, the *Marquesa de Santa Cruz*, still in the Santa Cruz Palace
in Madrid, also carries a date that has been read both as 1665 and
1670. The first more securely datable portrait, and one of the most
beautiful of this period, is the *Duke of Pastrana* [162], whose cape
bears the emblem of the Cross of Santiago, which the duke re-
ceived in 1666. The painting, therefore, is not earlier than that
date, and it does not seem to be much later either, as Don Gre-
gorio de Silva Mendoza (1648–1693) looks about the twenty-six
years of age that he was when he entered the order.

In the field of portraiture, the *Duke of Pastrana* shows the
same assimilation of the Venetian and Flemish traditions that
molded Carreño's style in his religious works, but also that he can
transcend those sources to create a work that is unmistakably
personal. In this likeness, he emphasizes a romantic mood—pres-
ent sometimes in Van Dyck's portraits—by means of a softness of
forms and colors that wraps the man and his horse in an atmo-
spheric veil.

Another identifiable and datable portrait is the beautiful
and decidedly Van Dyckian likeness of the Russian ambassador
Peter Ivanovich Potemkin (Madrid, Museo del Prado). The ambas-
sador was in Madrid on two occasions, in 1668 and in 1681–82,
and it is on this latter date that the portrait must have been
painted. Potemkin's majestic figure is silhouetted against a black
background that shows off his luxurious and exotic attire, colored
in an intense red. The brilliant execution of the ambassador's
clothes and adornments, and the expression of authority and
energy that Carreño captures in his model, make this portrait his
most impressive likeness.

Among the portraits of the ladies of the court, only the
Marquesa de Santa Cruz mentioned above is signed, but unfortu-

nately it is in poor condition. The best-known one is the so-called *Marquesa de Monterrey* [163], of similar size and format, in which the charm of the young woman and beautiful coloring of the picture make up for an unusually wooden depiction of the curtain and the lower half of her garments, which do not seem by Car-reño's hand. The handsomest and most convincingly attributed portrait is the *Unknown Lady* from the house of Medinaceli (Se-ville, Casa de Pilatos, Fundación Medinaceli). It dates certainly no earlier than 1665, when the fashion of the exaggerated hoop skirts worn by the high-born ladies (seen in Velázquez's portraits and in the *Marquesa de Monterrey*) begins to alternate with the type worn by this young woman, of more moderate breadth.

Although Carreño had worked for Philip IV since 1659, it was only in 1669 that he was given the post of Painter to the King, requested in 1667 from the already widowed Queen Mariana of Austria. A year and a half later, in 1671, he rose to the rank of Pintor de Cámara, and his activity as a portrait painter became more important; it is in his portraits of Queen Mariana and of

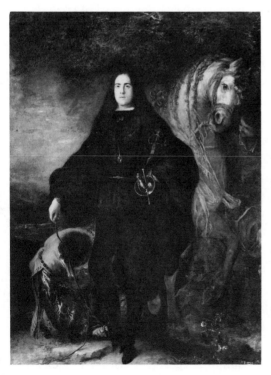

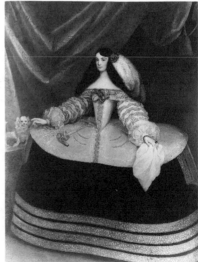

162. *Juan Carreño:* Duke of Pastrana, *Madrid, Museo del Prado*

163. *Juan Carreño:* Marquesa de Mon-terrey, *Madrid, Museo Lázaro Galdiano*

Charles II (1661–1700) that he attains the greatest originality in this field.

The first likeness of Charles II executed by Carreño is dated 1671 (Oviedo, Museo de Bellas Artes de Asturias), and it fixed the pattern for the portrayal of the king for the next decade; Carreño and his workshop would repeat its composition in a long series of portraits in which the physical development of the unfortunate king was periodically brought up to date [164]. In this picture, the young Charles appears standing by the side of a table in the Alcázar's Hall of Mirrors, dressed in a black outfit much like those worn by his father almost fifty years earlier, with the badge of the Order of the Golden Fleece hanging on his chest and a sword by his side.

In Charles II's pose and in the detail of having him hold a letter or petition in his hand, Carreño obviously refers to the portraits of Philip IV painted by Velázquez, but placing the king in a recognizable and complex setting is an important new development. The expanse of space in which the figure is placed develops an aspect of royal portraiture that Velázquez had begun to explore in his 1659 likeness *Prince Don Felipe Próspero* [144], and which Martínez del Mazo had expanded in his *Empress Margarita of Austria* [145], of c. 1665–66, and *Mariana of Austria in Widow's Weeds*, dated 1666. In Velázquez's *Felipe Próspero*, the space is not sufficiently particularized to be recognizable, but in Mazo's portrait of Mariana, the queen is shown sitting in an armchair in a large hall, beyond which can be seen the Pieza Ochavada in the Alcázar. But Carreño's most important source of inspiration, in a broader sense, was *Las Meninas* [141], in which Velázquez exploits the allegorical potential of the room occupied by the subjects portrayed. It is this allegorical function of the environment in Velázquez's great painting that Carreño introduces into his first likeness of Charles II.

The setting of this portrait of the young king provided the artist with a means of expressing a symbolic content that alluded explicitly to the regal authority of the heir to the Spanish crown, soon to be head of a state which until recently had been the most powerful kingdom in Europe. The Hall of Mirrors had been the room used by Philip IV to receive the most important visiting dignitaries to his court and, as such, it suggests Charles II's official

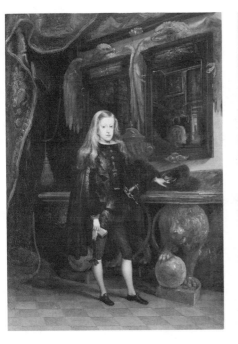

164. *Juan Carreño:* Charles II, *Madrid,*
Museo del Prado

165. *Juan Carreño:* Queen Mariana of Austria,
Madrid, Real Academia de San Fernando

duties and position as his father's successor. This room had been
lavishly decorated under Velázquez's direction in 1659 and, apart
from the set of tables supported by gilded bronze lions and the
handsome mirrors framed by imperial eagles that give the room its
name, its decoration consisted of an outstanding gallery of paint-
ings by the great masters of the sixteenth and seventeenth centu-
ries, including Velázquez himself. Carreño, in fact, had par-
ticipated in that decorative campaign by executing some of the
vault's frescoes, and he was well aware of the political message
conveyed by its program. The imperial eagles and the paintings
reflected in the mirrors they frame—most importantly Rubens's
allegorical equestrian portrait of Philip IV as the defender of the
faith—stress again Charles II's position as his father's heir.

The first dated portrait of Queen Mariana that has come
down to us is dated 1673, but it is likely that Carreño, as Pintor
de Cámara, may have already portrayed her in 1671, the year in
which he first painted Charles II, or even earlier, when he obtained
the post of Painter to the King in 1669. The portrait illustrated
here [165], of c. 1670–75, shows Queen Mariana in widow's weeds,
seated at her desk in the Hall of Mirrors, which also served as the

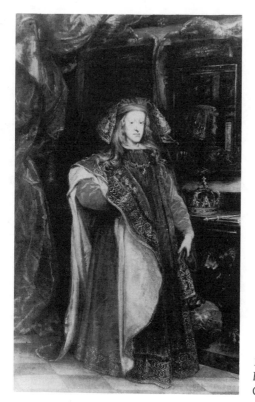

166. *Juan Carreño:* Charles II, *Rohrau, Austria, Harrach Collection*

queen mother's office during Charles II's minority. Like her son's, this portrait was repeated in numerous versions, in which more or less space is given to the description of the architectural environment. The version illustrated is of high enough quality to suggest that it was painted by the master himself; it is also the one that gives greatest prominence to the space in which the regent sits.

As in Charles's portrait, the room serves as a vehicle for a political message: the regent is represented at work, fulfilling her functions as governor and also as the defender of the faith. The painter locates his subject in a different part of the room and farther away from the wall seen behind the prince; this means that a different painting can be seen above two other mirrors framed by imperial eagles: Tintoretto's *Judith and Holofernes* (Madrid, Museo del Prado), a biblical example of a valorous woman who destroys the enemies of her people.

After Charles II's coming of age, in 1675, Carreño portrayed Mariana by following the format established by Velázquez in his first portrait of the queen, of 1652 [140], but although he

uses the same environment, he gives greater breadth to the space. The companion of a likeness of Queen Mariana of this type, painted in 1677 (Rohrau, Harrach Collection), is the most splendid portrayal of Charles II painted by the artist [166]. Here, the king is already in full possession of his royal functions and is shown dressed in the habit of Grand Master of the Order of the Golden Fleece, established in the fifteenth century by his Burgundian ancestors. The rich costume, the royal crown that rests on the table, and the curtain that frames the figure, on which Carreño poured all his art, have a startling beauty which, ironically, over-powers the weak and sickly monarch; the gorgeous trappings bring out the devastating contrast between the royal effigy and its sub-stance.

The pair of likenesses of Eugenia Martínez Vallejo, a five-year-old, grossly obese child, both dressed and nude (Madrid, Museo del Prado), were painted by Carreño in 1680 by order of the king. In the nude portrait, La Monstrua, as she was referred to, is adorned by grape leaves, so that the picture appears to represent a mythological subject: a child Silenus. The portrait in which she is dressed in a formal costume of the period, however, continues the tradition of recording on canvas the sorry creatures who arrived at the court for protection or for display as freaks of nature, such as Sánchez Cotán's *Bearded Woman*. In this painting, Carreño makes an effective display of his brilliant technique, coun-teracting the monstrous obesity of his model by the beauty of his picture's coloring and brushwork.

Juan Carreño died in Madrid in 1685. He and Francisco Rizi, exactly contemporary and closely linked by professional ties for a great part of their careers, were the principal movers in the change of direction taken by painting in Madrid in the second half of the seventeenth century. Only Francisco de Herrera the Younger, thirteen years their junior, surpassed these two masters in the daring of his stylistic revolution.

FRANCISCO DE HERRERA THE YOUNGER (1627–1685)

Francisco de Herrera, called the Younger to distinguish him from his father, was born in Seville in 1627. According to Palomino, who knew him personally and must have been well informed, he

was apprenticed first to the elder Herrera, and then went to Italy to perfect his art, probably between 1647, the year he married in Seville, and 1653, when he is documented in Madrid. This is the period in which Herrera the Elder moved to Madrid (1650), where he would remain until his death, about 1656. The trip of Herrera the Younger to Italy is not documented, but the degree of Venetian influence apparent in his first known datable work, the *Triumph of Saint Hermenegild* [167], of 1654, also lends credibility to Palomino's assertion. The foreshortening of the figures here suggests a ceiling painting; it seems directly inspired by Tintoretto's and Veronese's *di sotto in sù*. Brilliant in light and coloring, the painting also presages Tiepolo's ceiling frescoes.

The *Triumph of Saint Hermenegild* places Herrera in the forefront of the Late Baroque style that was being forged in these years by Rizi and Carreño, and lends itself to a very instructive comparison with the picture of the same subject painted by Herrera the Elder c. 1620 [40]. The younger Herrera's asymmetric, zigzagging composition, in which the figures move in all directions and the saint seems irresistibly propelled upward, as if caught in a whirlwind, is the antithesis of his father's static, two-level composition, in which Saint Hermenegild appears firmly planted on a platform of clouds and is the fulcrum of a group of classically balanced figures at either side.

The astonished and terrified king and Arrian bishop in the foreground of Herrera's exuberant picture offer a vivid contrast of color, form, and light to the saint. Their angular contours, silhouetted against the light, serve as a striking repoussoir for Saint Hermenegild, whose graceful body rises, impelled by the force of his faith, with a vigorous but elegant motion. Still in a brighter key, the flurry of cherubs and musical angels that surround the saint seems to dematerialize in the intense light.

At this date, Herrera's style expresses more ostensibly than that of Rizi or Carreño in Madrid, or that of Murillo in Seville, the new approach to religious art that was to prevail in Spain during the second half of the century. Realism falls outside its concerns; figures are idealized and their poses studied to endow them with elegance and the greatest possible amount of movement. Here, the drawing of the fluttering red cloak of Saint Hermenegild sets the tone of lightness and dynamism that rules the

entire composition. Its kinetic effect is achieved not just by the variety and liveliness of the poses given to all figures, but also by the distribution of light and shadow in the picture, which stimulates the eye of the observer to move from one point of the canvas to another, without remaining fixed in any.

At the end of 1655, Herrera is documented in Seville, where he simultaneously requested admission into the Brotherhood of the Holy Sacrament and painted for that confraternity the most extraordinary surviving picture of his career: the *Triumph of the Holy Sacrament* [168], still in the cathedral of Seville. The canvas is signed and dated in 1656, when it was set in place.

The subject of this picture indicates that Counter-Reformatory passion was still alive in Spain at this late date, for the exaltation of the Sacrament and its place in the writings of the Doctors of the Church, as well as the devotion to the Immaculate Virgin, who appears here venerating the Sacrament, were themes dear to Spanish religious art since the end of the sixteenth century.

The novel approach evident in the *Saint Hermenegild* is here taken to its final consequences. The spiritual center of Herrera's image, the luminous monstrance held aloft by energetic

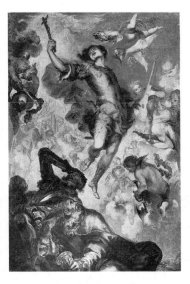

167. *Francisco de Herrera the Younger:* Triumph of Saint Hermenegild, *Madrid, Museo del Prado*

168. *Francisco de Herrera the Younger:* Triumph of the Holy Sacrament, *Seville, Hermandad Sacramental del Sagrario, Cathedral*

cherubs, is noticeably off center visually, in spite of the compulsion toward symmetry exerted by the shape of the canvas on which it is painted, and the picture's composition is no less movemented than that of the earlier altarpiece, with every object and figure seemingly set into motion by the magnetic force of the Sacrament. The use of a strong *contre-jour* for the figures in the foreground is more extreme here, as is the transparency and vagueness of contour of those that are near the luminous center of the picture.

When Herrera's *Triumph of the Holy Sacrament* was first seen, its dramatic composition and light effects, its brilliant coloring, and its extraordinarily free painterly technique must have astonished both the Sevillian public and his fellow painters, among whom were Murillo and Zurbarán. There is little doubt that this picture, and that of Saint Francis painted for the cathedral immediately after, in 1656–57, had great impact on the development of Murillo's art, and they may have contributed to Zurbarán's decision to leave Seville in 1658.

That second commission, from the cathedral itself this time, was for a large altar painting dedicated to Saint Francis, still in situ, in which Herrera represented an apotheosis of the saint in ecstasy. Of the three paintings considered here, this is the less innovative, probably because it was destined for the cathedral and Herrera may not have felt as free to experiment with new ideas. Its composition resembles that of *Saint Hermenegild,* but it is more symmetric and centralized, and the poses of Saint Francis and Brother Leo are derived from a print after Rubens's *Stigmatization* (Cologne, Wallraf-Richartz Museum). Nonetheless, it is the first painting with a wide public exposure to introduce in Seville the pictorial ideas of the Late Baroque style that were being elaborated at the court, and it must have helped accredit the similar artistic vision of Valdés Leal, who had returned to Seville from Córdoba in 1656.

Herrera remained in Seville several more years, founding at the beginning of 1660, together with Murillo, a drawing academy over which both artists presided jointly. Later that same year, however, Herrera's name no longer appears in the academy's roster, so we may suppose that it was then that he returned to Madrid, where he would reside until his death, twenty-five years later.

The large *Dream of Saint Joseph* [169], painted c. 1660–65,

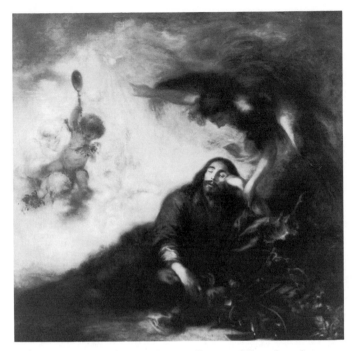

169. *Francisco de Herrera the Younger:* Dream of Saint Joseph,
private collection

after Herrera's return to the court, is again a painting of great
originality. Even in a picture whose subject is essentially static,
Herrera imparted to its interpretation a dynamic character compa-
rable to that of the *Triumph of Saint Hermenegild.* The figures'
attitudes, the strong contrasts of light, and the brilliant pictorial
technique give an extraordinary intensity to the scene. The sleep-
ing saint is almost the only stable element in the composition; the
angel who awakens him, pointing toward the Holy Spirit, seems
to gyrate in space, its body and mantle moving in a spiraling twist.
The dove of the Holy Spirit radiates an almost blinding light,
which alternately sets off and dissolves the lightly colored forms of
the cherubs, who carry the emblems of the Virgin's purity. As in
the *Triumph of the Sacrament,* the principal figures here are silhou-
etted against the luminous background, but their contours are still
softer and less defined.

The idealization of the saint, the sensuous beauty of the
work, and the ostentatious dramatism of the composition are
characteristic aspects of the new type of religious painting that

triumphs at this time both in the court and in Seville, and which Herrera takes to its most extreme position. Neither his contemporaries nor the younger artists who continued to paint until the end of the century would push the limits of this intensely Baroque style beyond the point where Herrera had taken it soon after the mid-century.

Upon his return to Madrid, Herrera received some important commissions for fresco paintings, none of which has survived, and in 1672, he was named Painter to the King. From that year on, he was involved, as was Rizi too, in the creation of sets and costumes for the comedies represented in the Salón Dorado of the Alcázar, for which some drawings are still extant.

During these years, Herrera also worked on architectural projects, and in 1677, he was named Architect of the Royal Works. From 1680 to 1682, he was in Zaragoza to oversee the execution of his plans for the church of El Pilar, later drastically altered. This concentration on architecture during the last ten years of his life is probably responsible for the paucity of his pictorial production during that decade. Diminishing it still further is the loss of a great portion of his paintings, which are now known only through literary references. The few that have been preserved are all the more precious.

In little over two months in 1685, from August to October, the three most talented masters of the generation that succeeded Velázquez in Madrid—Rizi, Carreño, and Herrera—all died, but the course that would be followed by Spanish religious art until the end of the seventeenth century was already firmly set.

✾ Baroque Painting in Seville

Bartolomé Esteban Murillo and Juan de Valdés Leal

BARTOLOMÉ ESTEBAN MURILLO (1617–1682)

Bartolomé Esteban Murillo was born in Seville in the last days of 1617, to a numerous family of modest but sufficient means. Having been orphaned of both parents at the age of ten, he was placed in the custody of his brother-in-law, who raised him at home until he began his apprenticeship as a painter. That apprenticeship probably began in 1633, under the tutelage of a relation, the painter Juan del Castillo (1584–1640), in whose house he would remain until 1638.

Although Castillo is a second-rate painter in relation to some of his Sevillian contemporaries, his workshop at the time was a prestigious one, and during the period that Murillo was apprenticed there, it counted besides the presence of Alonso Cano as a collaborator. Even though during these years Cano devoted himself primarily to sculpture, his refined and serene art and its ideal forms must have reinforced Murillo's similar inclinations.

In spite of his formation in Castillo's workshop, the most evident influences in the works painted by Murillo between 1639 and 1646, such as *The Virgin Giving the Rosary to Saint Dominic* (Seville, Archepiscopal Palace), come primarily from the works of the more important painters working in Seville during the first four decades of the century: Roelas, Herrera the Elder, Zurbarán, and the young Velázquez. These paintings show bright, clear colors and an even illumination with just enough chiaroscuro to model the forms.

The commission that marks the beginning of Murillo's brilliant career, and in which his own style begins to define itself, was a great cycle of large canvases with Franciscan stories, which he painted for the small cloister of the Convent of San Francisco in Seville between 1645 and 1646. That same year of 1645 he married, a union that would give him nine children.

For the cycle at San Francisco, whose paintings are now dispersed and in an uneven state of conservation, Murillo painted thirteen large canvases, eleven of them narrative scenes. Two that depicted the coats of arms of the Franciscan order and an Immaculate Conception, both apparently of lesser quality, and one of the narrative scenes have been lost. The narrative pictures deal with episodes of charity or exaltation (miraculous apparitions, visions, levitation) in the lives of various members of the order, some of them already canonized; one of the two largest ones carries Murillo's signature and the date 1646. All these pictures included on the bottom long inscriptions alluding to the events represented, but some have been removed and lost.

In many of the canvases that make up this cycle, Murillo used a strong chiaroscuro, and in all of them he gave a naturalistic interpretation of the characters and stories depicted, features that reflect his attraction to the style of Zurbarán, who was then a much-sought-after painter, and to Velázquez's early work. In the smooth and thick application of paint, and in the way he describes the simple and heavy folds of the monks' habits, Murillo emulates the first artist's aesthetic, and in the physical types of his characters he refers, sometimes directly, to those of the second.

The picture that bears the date of 1646, the so-called *Angel Kitchen* [170], must have been one of the latest to be painted for the series, to judge by its technique and composition, which are here more mature than in several of the other paintings. The protagonist of the episode illustrated has not been identified with certainty, but the legend of the miraculous assistance that the ecstatic monk receives from the angels can be connected to at least two revered Spanish Franciscans. As in his other canvases, the principal sources of Murillo's inspiration here were the pictures by the most important painters that had worked or were still working in Seville—Velázquez, Zurbarán, and the elder Herrera—but some reflect a new awareness of Italian and Flemish art. This new

170. Bartolomé Esteban Murillo: Angel Kitchen, *Paris, Musée du Louvre*

aspect of his style may have been the result of a trip made by Murillo to Madrid before his marriage, which Palomino asserts took place, or simply of an internal evolution promoted by his study of prints of Italian and Flemish works and an occasional canvas that he may have seen in Seville itself. Be it as it may, at this point an interest in Titian's and Van Dyck's painting, nonexistent before, manifests itself in Murillo's work.

The complex treatment of space in the *Angel Kitchen,* with figures in several planes and a skilled use of perspective, is not to be found in other (presumably earlier) pictures of the series, and is evidence that Murillo's artistic expertise had progressed notably during the execution of the project. It is here as well that a new and personal manner of painting begins to emerge.

Between the years 1639 and 1642, to which his early known paintings belong, and the time that he executed this painting, Murillo had fully absorbed whatever was most modern in Herrera's and Zurbarán's painting and in Velázquez's Sevillian works, and acquired a visible knowledge of Titian's and Van Dyck's pictures, together with a taste for their art. He had also elaborated a personal pictorial technique, in which a firm modeling of volumes is combined with a free and vigorous brushwork that animates their surfaces. His technique in 1646 not only differs from his own earlier facture, which was smooth and meticulous, but no longer emulates those of his models. By the end of the 1640s, his mature style had already been formed.

The large *Flight into Egypt,* painted by Murillo about 1648

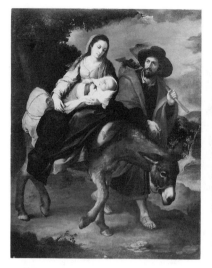

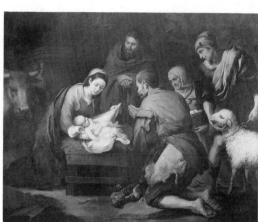

171. Bartolomé Esteban Murillo: Flight into Egypt, *Detroit Institute of Arts*

172. Bartolomé Esteban Murillo: Adoration of the Shepherds, *Madrid, Museo del Prado*

[171], is a typical example of the naturalistic mode that character-izes his religious painting at this moment. The Holy Family and their donkey are strongly modeled and brought close to the picture plane, filling it almost to capacity, so that their seemingly tangible presence appears to be at arm's length. Joseph and Mary are also portrayed as humble people, and their human feelings are clearly suggested. The Virgin's glance, full of love and a twinge of sadness, the perfect peace of the sleeping Child, Saint Joseph's mixture of worry and determination all attract the observer's sympathies; the physical and human reality of the characters brings him close to them. In this respect, Murillo's picture is much like Ribera's works, but unlike the latter artist, by this date Murillo had begun to illustrate religious themes of a more homely and tender character.

The *Holy Family with the Bird* (Madrid, Museo del Prado), of c. 1650, shows very clearly how the painter approached the rendering of religious subjects at this point. The ordinary and familiar feelings of childish mischief and paternal love and pride depicted here, together with the warm domestic atmosphere that Murillo creates in his picture, lend to the scene a look similar to that of genre painting, but the artist also manages to elevate it above that apparent ordinariness. The garments of the sacred

figures and the environment they inhabit are modest, but they manifest their innate refinement in their bearing and gestures, and the delicacy of their feelings in their expressions.

More consistently than any other Spanish artist, Murillo is the painter of Saint Joseph in the fullness of his physical vigor, and as an example of parental fortitude and devotion. In this picture, the physiognomy of the handsome patriarch radiates intelligence, patience, and tenderness; he is the ideal father—as Mary had been for so long the ideal mother—and here he takes on the dominant role as protector of the Christ Child.

Murillo depicted the Adoration of the Shepherds at several points in his career, and one of his earliest essays on the subject [172] dates from c. 1650–52, a period when the tenebrist and naturalist style of many of his works brings them close to Ribera's painting. The textures of the sheep's fleece and of the hen's feathers, the roughness of the dirty soles of the kneeling shepherd, and the softness and translucency of the Child's flesh are achieved with the utmost realism. The strong chiaroscuro combines with the coloration—in which the intense red and blue of the Virgin's garments and the luminous white of the swaddling cloth are in vivid contrast to the earthy colors of everything that surrounds them—to attract the eye of the beholder to the focal point of the image. The *Adoration of the Shepherds* also resembles Ribera's works in its composition—rerielieflike, limited in depth, and with only a moderate amount of diagonal movement, traits that characterize all of Murillo's paintings in this early phase of his artistic development.

Throughout his career, Murillo would also paint numerous times the Virgin and Child as a devotional image, a subject that, in spite of the devotion to Mary that distinguishes Spanish art of the seventeenth century, was not very frequent before he started to paint it; there are relatively few pictures of this image painted in the first half of the century, and it is Murillo who establishes its popularity in Seville during the 1650s. Examples of this subject are more numerous in this earlier part of the artist's career; the *Virgin of the Rosary* (Madrid, Museo del Prado), one of the earliest, must have been painted shortly after the Franciscan cycle, c. 1648–50, and many more would follow it in the next decade.

The format for the image of the Virgin and Child estab-

lished by Murillo in the *Virgin of the Rosary*—a full-length seated Virgin with the Child sitting or standing on her lap—would be repeated by the artist in many variations in later versions of the theme. Here, as in most of them, the Virgin appears seated on a simple stone bench against a dark, neutral background, but this is the only instance in which the Virgin's clothes, usually atemporal red and blue garments, suggest that she is dressed in a regional costume. The impression created by the stripes, embroidery, and tassels that ornament her shawl and head coif is reinforced by the very Spanish cast of her face.

The name of Murillo, particularly in Spain, immediately conjures up the numerous images of the Immaculate Conception that he painted throughout his career. This connection is justified in great measure by the sheer number of such images that came from his hand and from his workshop, but also because Murillo gave perfect form to the belief in Mary's exemption from original sin.

The first important version of the Immaculate Conception painted by Murillo is that known as *La Grande*, an enormous canvas executed shortly after 1650 for the triumphal arch of the church of the Franciscan friars of Seville. The *Immaculate Conception of the Franciscans* [173] is the most monumental presentation of the theme ever given by the artist, not only because of its large scale but for the grandeur of the figure itself. Mary's garments are more voluminous and heavier than in his later treatments of the subject, and they create a simpler silhouette against the clouds. The dramatic effect of the whirling blue mantle and the streaming hair is unique among all of Murillo's Immaculate Conceptions. The figure of the Virgin herself is fuller and more robust than those in his other versions, with more classical features and a graver expression.

In his interpretation of the subject, Murillo deviated from the precedents established in Seville by Pacheco and Velázquez years earlier, and later reaffirmed by Zurbarán. None of the Marian symbols which, distributed over the sky and landscape, populated earlier Spanish Immaculate Conceptions is to be found in Murillo's.

The simplicity and force of the *Conception of the Franciscans* are to a large extent determined by what the artist judged most

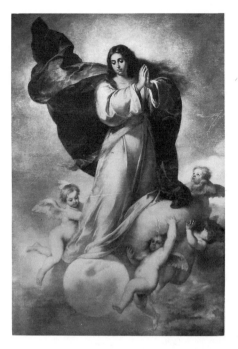

173. Bartolomé Esteban Murillo:
Immaculate Conception of the
Franciscans, *Seville, Museo Provincial
de Bellas Artes*

appropriate for the place where the painting was destined to hang.
Even the downward direction of the Virgin's glance, rare in his
Immaculate Conceptions, seems adjusted to the placement of the
image in the nave, high above the heads of the faithful. The vigor
and grandeur of this Immaculate Conception separate it from
Murillo's later ones, in which youth and grace are more stressed
than monumentality, but all those that follow it—the Immaculate
Conceptions known as *de El Escorial* [176], *de Aranjuez* (Madrid,
Museo del Prado), *de los Venerables* [189], and many others—are
variations of the compositional format established by *La Grande*,
notwithstanding the sweeter and more delicate tone that charac-
terizes them.

Another canvas of large dimensions, *Saint Ildenfonso Receiv-
ing the Chasuble* (Madrid, Museo del Prado), has been variously
dated by students of Murillo, but its strong chiaroscuro and im-
pasted brushwork, as well as the physical types of the figures, seem
to fit best in the first half of the 1650s. The subject of the picture
is the miracle of the Virgin's appearance to the saint who had so
steadfastly defended the doctrine of her perpetual virginity, to
present him with a chasuble for use in her feast days. The scene

is treated with a mixture of realism and idealization in which the first is reserved for the two human participants and the depiction of the gift, and the second for the forms and physiognomies of the Virgin and angels.

The formal organization of the *Saint Ildefonso* is based on crossed diagonals that divide the picture plane from corner to corner, in a composition in which the light and the arrangement of the figures both link and separate the Virgin and the archbishop. This play of contrasted diagonals, here as well as in most of Murillo's works, functions more on the surface than in space, where it is only moderate. The sedate movement of the figures and the measured equilibrium of the composition lend this painting a classical sobriety, but within the classical tone that rules the organization of the whole, the Baroque light effects accent the picture's emotiveness and bring out the spiritual character of the event.

In 1656, Murillo painted the monumental *Vision of Saint*

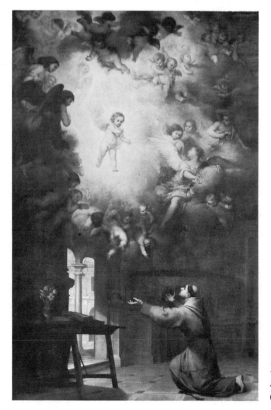

174. *Bartolomé Esteban Murillo:* Vision of Saint Anthony of Padua, *Seville, Cathedral*

Anthony of Padua [174] for the baptismal chapel of the cathedral of Seville, where it has remained. It was the largest work that the artist had undertaken until then, and it was undoubtedly prepared with great care (at least two drawings for Saint Anthony and some angels have survived). As on other occasions throughout his career, Murillo found his inspiration for the composition in a print—in this instance an Italian engraving of 1640—but on the outlines it provided him, he built a grand and dramatic vision in a fully Baroque vein. The contrast between Saint Anthony's tangible world (which includes a table in *contre-jour* with an exquisite still life of flowers) and his celestial vision of the Christ Child is perfectly realized by means of strong light effects and a dazzling technique. Light and brushwork differentiate the two spheres, and lend them their disparate yet compatible realities.

In the seventeenth century, the vision experienced by Saint Anthony would be illustrated more often than any of his miraculous deeds, which had been popular subjects during the Renaissance. Contact with the divinity was now regarded as the highest demonstration of sanctity, and Murillo, who painted many other visionary experiences, would repeat this specific subject several times, albeit in less grand versions.

The *Vision of Saint Anthony,* with its painterliness and drama, opens a new phase in Murillo's art, and it is tempting to suppose that it was the *Triumph of the Holy Sacrament* [177] by Herrera the Younger—which was already in place in the cathedral in the first days of 1656—that opened Murillo's eyes to the style of painting that was evolving in Madrid, whose modernity was unmatched among the artists of Seville. Two years later, in 1658, Murillo would travel to the court in a journey of undetermined length, and the contact with the Flemish, Italian, and Spanish works that could be seen there was to have an important influence on his own.

The large *Jacob Laying the Peeled Rods Before Laban's Flock* [175], probably painted about 1660 for the Marquis of Villamanrique, was part of a series of five compositions illustrating various episodes of the story of Jacob, of which only four have survived. Apart from their size and beauty, what lends special interest to these works in the context of Murillo's oeuvre is the unusually important role that landscape plays in them. The settings in this

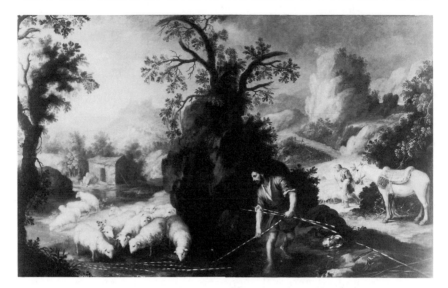

175. Bartolomé Esteban Murillo: Jacob Laying the Peeled Rods Before Laban's Flock, *Dallas, Meadows Museum*

series follow the Netherlandish landscape tradition (with which Murillo was certainly familiar), and reflect most particularly the style of Joos de Momper (1564–1635) and Gillis d'Hondecoeter (d. 1638), who painted in the late-sixteenth and early-seventeenth centuries. The landscapes of the Jacob paintings are romantic inventions that offer an ideal view of nature; in this particular picture, the fantastic character of the hills, rocks, and foliage is very marked. The stress is not on naturalism here, but on dramatic light-and-dark contrasts; Murillo silhouettes the darker elements of the landscape's foreground against a rocky background so vaporous and light that it seems to have no more substance than the cloudy sky above.

The *Immaculate Conception of El Escorial* [176] is perhaps Murillo's most popular representation of the Immaculate Virgin, and its popularity is very understandable; the picture is a feast for the eyes, not only because of Mary's beauty but also thanks to Murillo's brilliant technique throughout the painting. The *Immaculate Conception of El Escorial* offers an ideal representation of the essence of the point of doctrine it illustrates. Here, the cherubs that surround the Virgin do not serve to carry her heavenward, as they do in *La Grande,* but play instead at her feet with some

of the emblems of the Marian litanies: lilies, roses, olive branch, and palm frond. But the figure itself is foremost in suggesting Mary's freedom from original sin; the perfect beauty of this adolescent girl and the innocence of her expression are the visual equivalent of what was then still a contested doctrine. This Immaculate Conception is the spiritual prototype from which all the later variations on this theme painted by Murillo would evolve.

The *Saint Justa* (Dallas, Meadows Museum) and the *Saint Rufina* [177], painted as a pair, show the two patron saints of Seville in half length, set against an open sky. Both carry in their hands earthenware pots and a palm frond, symbols of their profession and martyrdom. Murillo painted these popular saints at least twice, the most important version being the large canvas for the Capuchins of Seville (Seville, Museo Provincial de Bellas Artes). These half-length pictures, probably painted shortly before 1660, are conceived in a more intimate vein, and reflect the type of Hernando Sturm's 1555 composition in the Chapel of the Evangelists in the cathedral, where the two saints, however, appear together in the same picture.

The beauty Murillo gives the two saints, Rufina in particu-

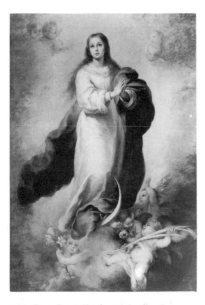

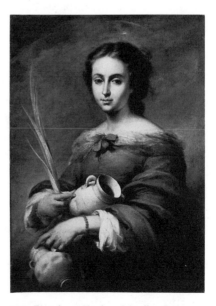

176. Bartolomé Esteban Murillo: Immaculate Conception of El Escorial, *Madrid, Museo del Prado*

177. Bartolomé Esteban Murillo: Saint Rufina, *Dallas, Meadows Museum*

lar, seems so concrete that one can imagine the paintings to be portraits of two young Sevillian women. The specificity that Murillo confers on ideal characters from a remote past gives them an appearance of contemporaneity that brings them closer to the faithful. The physical beauty and youthful freshness of the two saints are powerful inducements for the beholder to regard them with affection; the religious emotion of the devout viewer is awakened primarily by means of the image's sensuous and aesthetic impact. Murillo's qualities as interpreter of religious themes in his day are perfectly clear in his *Saint Justa* and *Saint Rufina*. The convincing mixture of realism and idealization in his rendering of the saints, and their power to elicit a spiritual emotion from the viewer, are eloquent reasons for the great attraction his works exercised on his contemporaries and their success as religious images.

The *Birth of the Virgin* [178], the only known version of this subject painted by Murillo, is an important milestone in the evolution of his style, concretely in regard to his ever-subtler control of light. This work, painted in 1660 for the entrance archway of the sacristy of the Chapel of the Immaculate Conception in the cathedral of Seville, anticipates by a few years his most ambitious essays in the handling of chiaroscuro, the pictures for Santa María la Blanca [179], painted in 1665. Chronologically, the *Birth of the Virgin* is closer to the *Vision of Saint Anthony of Padua* [174] than it is to those paintings, but stylistically it belongs with them for the subtlety and richness of its modulation of light.

The *Birth of the Virgin*'s chiaroscuro has sometimes been characterized as Rembrandtesque, but the picture is more closely related to Rubens in coloring and to Velázquez in its treatment of light and shade than it is to Rembrandt's painting. Murillo applied here the lessons learned from *Las Meninas* and the *Fable of Arachne* in the subtlety and richness of the half shadows, lessons that he had the opportunity to assimilate during his visit to the court two years earlier.

In his interpretation of the subject in the *Birth of the Virgin*, Murillo skillfully blended the human and the divine to give a naturalistic setting of domestic warmth to the divine event. In the play between the cherub and the lap dog, and in the feminine discussion held over the infant's clothing, he appeals to the

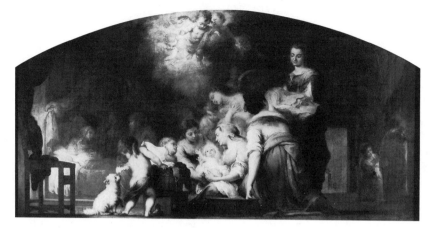

178. *Bartolomé Esteban Murillo:* Birth of the Virgin, *Paris, Musée du Louvre*

viewer's daily experience to make him a participant in the sacred story, but he does it without losing in the process the atmosphere of spiritual mystery required by the subject.

In January of 1660, Murillo had participated in the foundation of an academy of drawing, under the joint presidency of Herrera the Younger and himself. Unlike Italian academies of art, such as that of San Luca in Rome, this one did not aspire to provide young painters with a structured and complete education, but to establish a meeting place for artists—reputable masters as well as beginners—where they might come regularly for the purpose of drawing from the model. Murillo remained in its ranks until 1674, when the financial difficulties of the institution forced it to close its doors.

The decade that followed the death of his wife in 1663 was probably Murillo's most prolific one. Between 1665 and 1672 he received and completed three important commissions: for Santa María la Blanca, for the Capuchins of Seville, and for the hospital of La Caridad.

The commission for the four paintings Murillo executed for the Sevillian church of Santa María la Blanca originated from Don Justino de Neve y Yébenes, canon of the cathedral, and it involved two large lunettes for the arches of the crossing and two smaller lunettes for the ends of the side aisles. The story of the foundation of the church of Santa Maria Maggiore in Rome was depicted in the first two, and the other two were the *Triumph of*

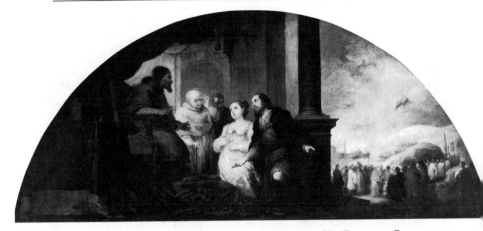

179. *Bartolomé Esteban Murillo:* The Patrician Relating His Dream to Pope Liberius, *Madrid, Museo del Prado*

the Immaculate Conception (Paris, Musée du Louvre) and the *Triumph of Faith* (Buscot Park, Lord Faringdon collection). The four canvases were finished in 1665.

In the *Dream of the Patrician* (Madrid, Museo del Prado), the penumbra in which the couple sleeps, sitting in their bedchamber, is contrasted with a light-filled distant view of the Esquiline, toward which the Virgin points to indicate the spot covered by snow on which her church should be built. The characterization of the patrician and of his wife, which makes us recognize their noble refinement even in an unguarded moment of repose, is one of the most appealing of the master. In the other lunette of the crossing, *The Patrician Relating His Dream to Pope Liberius* [179], the composition is also divided into two uneven sections of light and dark, with an abrupt juxtaposition of the near and far spaces similar to that used in the other canvas. Within the segment showing the procession toward the Esquiline (miraculously covered by snow in summer), everything is painted in light, scintillating colors, and with a very summary, spontaneous touch, which dissolves the forms and creates the illusion of distance. This impressionistic approach is not reserved just for the distant view, however, but is also very much in evidence in the figures of Pope Liberius, a prelate with eyeglasses, and the patrician's wife, which are extraordinary examples of a pictorial freedom that surpasses anything Murillo had attempted until then. In his handling of the brush and of light, Murillo was indebted to the paintings executed

for the cathedral by Herrera the Younger, but here he not only equals him in audacity but also manages to retain, as Herrera does not, the illusion of corporeality of the forms described. The painterliness of Murillo's technique in the pictures of Santa María la Blanca, with their broken colors, undefined contours, and atmospheric effects, would be characteristic of his work from this point on.

The *Saint John the Baptist as a Child* [180], which dates to c. 1665–75, is yet another good demonstration of Murillo's gifts for religious painting; thanks to a perfectly balanced blend of naturalistic observation of the physical aspects of the subject and an imaginative suggestion of his spiritual state, he succeeds in expressing the intense faith of the child saint in a totally convincing image. To understand better his modus operandi, it may be profitable to compare the similarly posed child eating grapes in one of Murillo's genre pictures, *Boys Eating Grapes and Melon* [191], with the young Baptist, who is wrapped up in mystical contemplation. The degree of fidelity to the model appears to be more or less the same in the religious work and in the genre piece, but the effect of the two figures is totally different. In the religious image, Murillo gives a less than veristic description of the young saint; his arms and legs have softer contours and are fleshier than the firm, thin members of the street urchin, and the naturalistic touch of the decidedly dirty sole of the foot of the latter is softened in the former. The questioning look that the boy eating grapes gives his

180. Bartolomé Esteban Murillo: Saint John the Baptist as a Child, *Madrid, Museo del Prado*

friend is replaced in the John the Baptist by a rapt expression and a rhetorical gesture of devotion. The spiritual content of the two figures could not be less alike, but the creation of the physical and psychological reality of these children achieved by Murillo persuades us equally of the ecstatic communion of Saint John with God, and of the poor child's skepticism.

The *Baptism of Christ* of the cathedral of Seville (in situ) was commissioned from Murillo in 1667 to go above the *Vision of Saint Anthony of Padua* in the baptismal chapel. Christ appears kneeling at the edge of the River Jordan, bowed before Saint John, with his arms crossed on his chest in a gesture of devotion. The emotion that overcomes Christ and his humility as he receives the sacrament are very clearly projected—an important consideration, given the placement of the painting high above the viewer's head. The *Baptism*'s sketchy execution imparts a softness to the picture that complements the devotional, tender tone of the scene. The juxtaposition of the two paintings in the baptismal chapel, separated by eleven years, provides the viewer with a good measure of the distance traveled by Murillo's work in the direction taken by the earlier picture. In Murillo's art, technique and expression

181. Bartolomé Esteban Murillo: Saint Thomas of Villanueva Dividing His Clothes Among Beggar Boys, *Cincinnati Art Museum*

evolve simultaneously toward a more painterly, softer style, and a gentler modality in the expression of feeling.

Saint Thomas of Villanueva Dividing His Clothes Among Beggar Boys [181] was painted as part of a retable for the chapel dedicated to that saint in the church of the convent of San Agustín in Seville, no longer extant. Murillo had also been in charge of the lateral paintings of the high altar, executed c. 1665–75, and Saint Thomas seems datable to the same years, c. 1670. The canvas represents the saint as a child, distributing his fine garments among a group of beggar children, pointing out that the virtue of charity, by which this saint was best known, had been practiced by him since childhood.

The subject demanded the depiction of a group of children absorbed in some common activity, such as he was painting then in his genre pictures. But here, instead of recording the pastimes and mischief of the children, he depicts an edifying scene with a moral content. His description of the children's attitudes, expressions, and feelings reveals the same close observation of nature apparent in his genre pieces and imparts to the scene the same verisimilitude. In this work, however, it serves not only to delight the viewer with the charm and lifelikeness of Murillo's world of urchins but also to foment the devotion to the saint who is the main protagonist of the scene as a model of the Christian life. Ultimately, this picture is another exhortation to the faithful to practice the virtue of charity, by presenting it in terms of an emotionally touching human experience.

In 1665, Murillo received the commission to decorate the Capuchin church of Seville with an extensive cycle of paintings. The work, which comprised twenty-one canvases of various sizes and several small crucifixes, was probably finished by 1669, with an interruption in 1667.

Among the nine canvases that made up the high-altar retable, whose central piece was the Jubilee of the Portiuncula (Cologne, Wallraf-Richartz Museum), was Saint Joseph and the Christ Child (Seville, Museo Provincial de Bellas Artes), one of the most attractive images of the saint of all those painted by Murillo. The patriarch's paternal affection and his role as protector of the Christ Child are always stressed in Murillo's pictures when he appears within a narrative context; here, they are highlighted

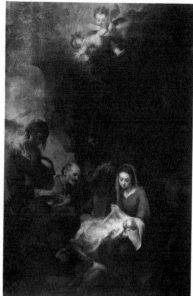

182. *Bartolomé Esteban Murillo:* Saint
Francis Embracing the Crucified
Christ, *Seville, Museo Provincial de
Bellas Artes*

183. *Bartolomé Esteban Murillo:* Adora-
tion of the Shepherds, *Seville, Museo
Provincial de Bellas Artes*

solely by the attitudes and expressions of the two figures. In its
evocation of the intensity and warmth of the familial bond, this
picture surpasses the most successful representations of the Virgin
and Child in the seventeenth century.

Saint Francis Embracing the Crucified Christ [182], also part
of the Capuchin cycle but done for one of the church's side
chapels, must date to the last years of the project's execution. The
subject is an unusual one within Franciscan iconography, but it
had been represented earlier in the century by Ribalta [69], for the
Capuchins of Valencia. It is most unlikely that Murillo knew this
work, and in any case his own does not reflect Ribalta's painting
beyond its general compositional scheme, dictated by the subject
itself. The spiritual content of the work is pointed out by the
inscription in the book held aloft by two cherubs: "Whosoever he
be of you that forsaketh not all that he hath, he cannot be my
disciple" (Luke 14:33). Saint Francis's renunciation of his earthly
possessions to devote himself to the service of Christ is rewarded
by the embrace of the crucified Savior.

In *Saint Francis Embracing the Crucified Christ*, the two

protagonists move with the elegance that characterizes all of Murillo's figures, and their embrace is tender and delicate, full of mutual love. Christ's body and face have a classical perfection that contrasts with the more naturalistic description of Saint Francis, and a similar contrast can be seen in their expressions: noble composure in that of Christ and simple, childlike devotion in that of Saint Francis. In Murillo's hands, the representation of a transcendental and symbolic event—the saint's renunciation of the world for Christ—turns into a moving scene of human affection.

The *Adoration of the Shepherds* [183], also painted as an altarpiece for one of the side chapels, is one of the last versions of a theme that Murillo had treated frequently throughout his career. Although its vertical proportions separate it from most of his other Adorations as regards format, the figural composition does not differ much from that used in the first canvases of the subject that can be ascribed with certainty to Murillo. But even though the arrangement of the figures is similar to that in his early works, the definition of forms and space is totally different, and the atmosphere, which was absent from them, is now almost palpable. In the *Adoration of the Shepherds* of c. 1650–52 [172], the figures are painted with a rich impasto and in large planes of color that model their forms emphatically. They make up a compact group in the manner of a sculptural relief, in which the solid bodies completely dominate the composition; space is fundamentally the empty areas that surround this mass. In the *Adoration* for the Capuchins, on the other hand, the composition is more open, and air circulates between the figures, which are here grouped in a clearly spatial arrangement. Murillo's strong chiaroscuro in this work does not have the opaque shadows of his earlier one, either; even the darkest zones are diaphanous, and reflected light bounces off the figures seen in *contre-jour*. In the shepherdess on the left, the painter explores a light effect of great daring and subtlety: her form is silhouetted against the natural light behind her, but her features are defined solely by the distant and opposite illumination that emanates from the Christ Child. Murillo would utilize again this device in a more dramatic fashion in *Saint Thomas of Villanueva Distributing Alms* [184] in this same series, and most subtly in the contemporary *Boys Playing Dice* [193].

Besides the differences in execution and spatial organiza-

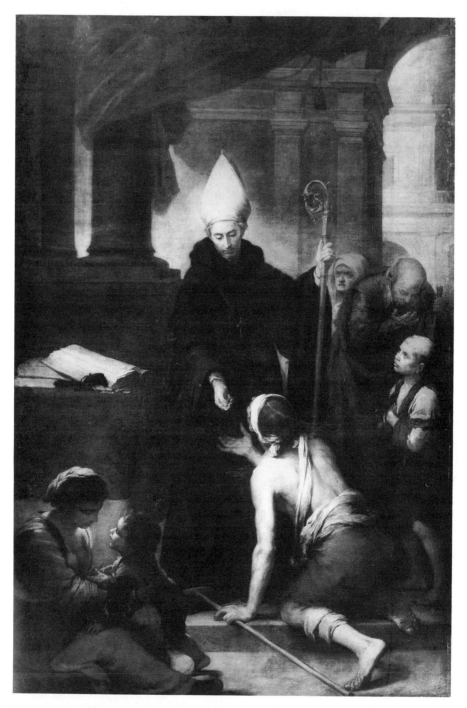

184. Bartolomé Esteban Murillo: Saint Thomas of Villanueva Distributing Alms, *Seville, Museo Provincial de Bellas Artes*

tion that separate the canvas for the Capuchins from that of c. 1650–52, there is also a greater movement and animation in the characters; the composition is no longer static, as in the earlier work. The liveliness of the brushwork and the variety and inventiveness of the light effects harmonize with the more active conception of the scene, in a perfect accord between form and expression.

The *Saint Thomas of Villanueva Distributing Alms* [184] that forms part of this same cycle was probably one of the last works completed for the side chapels of the church. The presence of an Augustinian saint in a church of the Franciscan order, and in a place of honor—the chapel facing the one dedicated to Saint Francis himself—may be explained by the special devotion felt for the sainted archbishop of Valencia by the Valencian friars in the Capuchin community of Seville, who had participated in the foundation of its convent in 1627. The choice of this subject also introduces an example of the active life and the exercise of the cardinal virtue of charity among the scenes of visionary contact with the divinity that predominate in this series.

During these years, Murillo represented the subject of this picture on two other occasions, but the Capuchin canvas is his final statement on the theme of Saint Thomas as a model of compassion and charity, both as a work of art and as a religious image. The archbishop is shown as an elegant and refined man, on whose countenance one may read the sorrow he feels in face of so much penury and human misery, which he can alleviate only partially. The appearance and expressions of the poor, the weak, the sick are portrayed with vivid naturalism, but the crippled beggar who kneels before the saint shares with him a beauty and dignity that goes beyond realism. We enter again a world that is raised from vulgarity to an ideal plane by Murillo's understanding of nature and his ability to transform it.

One of the most beautiful aspects of this altarpiece is the rich handling of the light, very varied here, and its use as an effective tool to organize the space of the narrative. The most striking passage in this respect is that of the mother and child in the lower left-hand corner, who act as *repoussoirs* but are also a demonstration of Murillo's inventiveness and of the brilliance of his technique. They would not be out of place in one of Goya's mature works.

Murillo had joined the Confraternity of the Santa Caridad in 1665, and it is possible that his admission was influenced in part by the hope for his potential services in the decoration of the Confraternity's newly rebuilt church. This enterprise had been directed by Don Miguel Mañara, a noble and wealthy Sevillian gentleman who, as a consequence of a remarkable spiritual about-face, had entered the Confraternity in 1662, and had presided over it as Hermano Mayor since 1663. It was thanks to his initiative that a hospice to give shelter and food to the needy, and a hospital for the care of the elderly and incurable, had been established, and that the work of rebuilding the Confraternity's church, which had been protracted over twenty years, was again taken up and brought to completion. The iconographic program for its decoration was to follow closely Mañara's ideas and directives.

Although the paintings most frequently associated with the church of the Hospital de la Caridad are Valdés Leal's *Hieroglyphs of Death and Salvation* [205, 206]—perhaps because of their terrifying subject matter, which makes them unforgettable—the principal share of the pictures commissioned for the decoration of the church had gone to Murillo. He may have received the commission for the paintings he was to execute as early as 1667, and had finished the six large pictures for the upper part of the church's nave by mid-1670; the two pictures destined for the side altars of the nave were paid for in 1672, although they were possibly finished earlier.

All the subjects with which Murillo dealt in the eight canvases that constituted his part of the commission are related to the Seven Works of Mercy (Matthew 25:34–40), with special emphasis on the caring for the sick, and reflect Mañara's ideas on the purposes of the Confraternity. This mandate is illustrated not just in the *Healing of the Paralytic* [186] but also in the pictures of the two side altars, *Saint Elizabeth of Hungary Caring for the Sick* and the *Charity of Saint John of God* (both in situ), where the protagonists are depicted as models of personal participation in the exercise of charity.

Moses Before the Rock of Horeb [185], which illustrates "giving drink to the thirsty," is one of the two large horizontal canvases that were placed on the upper portion of the walls; it has remained in situ, as has its pendant, the *Miracle of the Bread and*

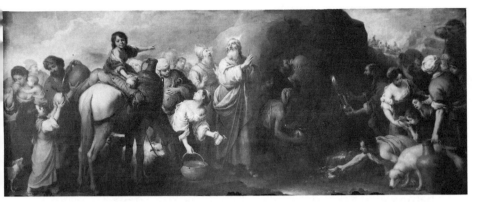

185. *Bartolomé Esteban Murillo:* Moses Before the Rock of Horeb, *Seville, Hospital de la Caridad*

the *Fishes*. Although the composition involves a large number of characters, the action develops on a stage that is no more than six figures deep. Its organization, typical of Murillo, is basically planar and avoids sharp movements into or out of the picture. The various planes are marked primarily by changes in the illumination of the figures, which separate the different groups.

In adopting a wide format, Murillo undoubtedly meant to take advantage of the possibilities it offered for the display of a narrative rich in anecdotal incident, which the subject itself provided. Through gesture, he describes in this canvas a diversity of behavior that communicates dramatically the reaction of the Israelites to the miraculous relief from their thirst. Moses and Aaron (the calm center of a crowd in motion) are depicted in attitudes of thanksgiving, but all the other characters are busy obtaining, drinking, or giving to others the miraculous water. The only exception is the boy on horseback, who, with a broad smile, points to the source and turns around to look at the viewer.

The *Return of the Prodigal Son* (Washington, D.C., National Gallery of Art), which illustrates the act of "clothing the naked," was one of the four canvases of square format that also occupied the upper portion of the nave walls, and which are now dispersed around the world. In his interpretation of the subject, Murillo stresses the element of the biblical narrative that is most pertinent to the work of mercy the picture aims to illustrate, the action of providing the Prodigal Son with new garments. He does not forget, however, the primary sense of Christ's parable: the importance of

repentance and the infinite mercy of God. Through his gestures, the Prodigal Son manifests shame and heartfelt contriteness, and his father compassion and forgiveness, expressed with a degree of emotion that only the aged Rembrandt surpasses in his own late *Return of the Prodigal Son* (Leningrad, Hermitage), of similar date.

The *Healing of the Paralytic* [186], which illustrates "visiting the sick," is one of Murillo's most beautiful paintings and the high point of the Caridad series. Its composition, uncharacteristically, is strongly asymmetrical, with a pronounced break between the mass of figures on the left and the open space with the pool of Bethesda on the right. This luminous architectural backdrop, lightly painted, seems a reminiscence of the Veronese pictures seen by Murillo in Madrid.

The figure of Christ is a memorable image of the Savior, and a measure of its strength is that the masterful characterization of the paralytic does not rob it of our attention altogether. The two figures are in vivid physical and psychological counterpoint; the elegant proportions and youthful beauty of Christ are set off by the gnarled limbs of the old cripple, the serenity of the former by the despair of the latter. The simplicity in the arrangement of the figures in the foreground and their eloquent but restrained play of gestures are in the best classical tradition, and manifest the con-

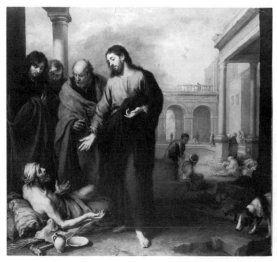

186. *Bartolomé Esteban Murillo:* Healing of the Paralytic, *London, National Gallery*

187. *Bartolomé Esteban Murillo:* Christ After the Flagellation, *Champaign, Illinois, Krannert Art Museum*

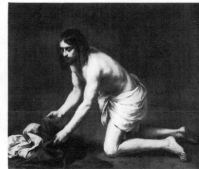

trast between Murillo's style and the exuberant Late Baroque manner of most of Murillo's contemporaries, both in Seville and at the court.

Throughout his long career, Murillo used compositional schemes derived from older works that he knew firsthand or through prints, a frequent occurrence among the Spanish painters of the seventeenth century. For the compositions of the Caridad he had recourse to the most disparate sources of inspiration but, as in Velázquez's case, those schematic underpinnings were only springboards for the creation of images that are characteristic of his own pictorial approach and sensibility.

Although the subject of *Christ After the Flagellation* [187] is very infrequent among representations of the Passion of Christ, there are several examples of this scene in Spanish seventeenth-century painting; Alonso Cano painted one version c. 1646/52 (Madrid, Academia de San Fernando); Zurbarán another in 1661 (parish church of Jadraque), and Murillo at least two—the one illustrated here, of c. 1670, and an earlier one (Boston, Museum of Fine Arts). The scene illustrates one of the many literary elaborations of the episodes of the Passion which emerged after the Counter-Reformation and became sources of new paintable matter. The inspiration for these pictures, Murillo's in particular, is a passage in the mystic Alvarez de Paz's *Meditations*, published in the early years of the seventeenth century.

Murillo's painting depicts the moment in which Christ, untied from the column of the flagellation and fallen to his knees, picks up his garments from the ground. In this image, his figure suggests humility, resignation, and sorrow, rather than the physical surrender to the weakness of the flesh expressed by Murillo's first version of the theme. The response that the artist wants to elicit from the "pious souls [that] look upon you" addressed by the Alvarez de Paz text is of reverence for the patience and longanimity of the tormented God-become-man, as much as of pity for his human destiny.

Although not as numerous, the paintings of the last ten years of Murillo's life have the same quality and show a comparable creative vigor as those of the peak decade of the 1660s, both in their expressive force and in their brilliant technique.

The *Martyrdom of Saint Andrew* [188] is one of Murillo's

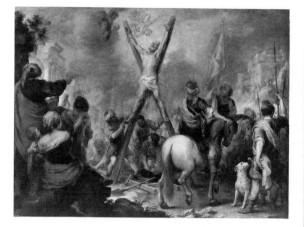

188. *Bartolomé Esteban Murillo:* Martyrdom of Saint
Andrew, *Madrid, Museo del Prado*

189. *Bartolomé Esteban Murillo:* Immaculate Conception
of Los Venerables, *Madrid, Museo del Prado*

few religious works that represent tragic subjects, but even here,
the crucifixion of the saint is conceived as an ecstatic union with
God, rather than as an episode of suffering. The picture's mood
is expansive and radiant; the element of grief that is introduced
by the weeping woman on the left, being cast in shadow, is effec-
tively subordinated to the sense of the saint's spiritual triumph.

This *Martyrdom of Saint Andrew* is a magnificent example
of the vitality of Murillo's technique in his last years. Here it is
displayed in all its brilliance, and the bold liveliness of the canvas
gives it the quality of spontaneity and immediacy of a preparatory
sketch. The entire picture seems to vibrate with a light that dis-
solves forms without robbing them of their reality. The term "va-
porous," with which the critic Ceán Bermúdez designated
Murillo's late style in his *Diccionario* (Madrid, 1800), describes very
effectively the character of this painting, with its soft brushwork,
light colors, and the almost phantasmagorical vagueness of the
more distant forms.

One of Murillo's final essays on the theme of the Immacu-
late Conception—perhaps his last and certainly his most famous
one—was painted for the hospital of Los Venerables Sacerdotes
in Seville about 1678 [189]. In this work, Mary's graceful forms

and slender proportions are combined with a poise and gravity that make her, together with the very differently conceived *La Grande* [173], one of Murillo's most majestic depictions of the Immaculate Conception. A profuse escort of cherubs, more numerous here than in any other of his earlier Immaculate Conceptions, fills the golden space around the Virgin, accompanying her in her gentle ascent. The stronger than usual chiaroscuro employed here by Murillo not only helps to define the direction of Mary's upward motion but also makes this picture the most visually dramatic and Baroque of his Immaculate Conceptions.

In Murillo's production, genre pictures represent a relatively small proportion of the total of his works, but they constitute the only field in that oeuvre that has always retained its public appeal and critical standing. Within this genre, the most numerous are the pictures of children, a type of subject that had been very infrequent until the middle of the seventeenth century.

Murillo's activity in this field is paralleled only by the work of one of Rembrandt's disciples, Monsú Bernardo, the Danish painter Bernard Keil (1624–1687). Monsú Bernardo had gone to Italy in 1652, and settled in Rome in 1656. Shortly after that date, he started to specialize in paintings of children engaged in various activities, alone or in groups. It is doubtful that Murillo knew Keil's work before he painted his own genre scenes of children, although some of this artist's canvases arrived in Spain during Murillo's lifetime. In any case, and apart from the fact that his earliest genre scenes are almost certainly earlier than Keil's, the latter's are totally unrelated to Murillo's in either style or content.

The *Boy Killing Fleas* [190], which was probably painted shortly after the Franciscan cycle for the Claustro Chico, between 1646 and 1650, is Murillo's first known essay in pure genre; it is also unique among his pictures of poor children for its melancholic tone. The child's isolation, the bareness of the cell where he sits, and the serious and unhappy expression with which he applies himself to his task contribute to the impression of desolation that permeates the scene.

The unadorned naturalism of the presentation of the subject and the picture's dramatic chiaroscuro are also features of the *Boy Killing Fleas* that separate it from Murillo's other genre paintings. The bright sunlight that shines upon the child, cutting the

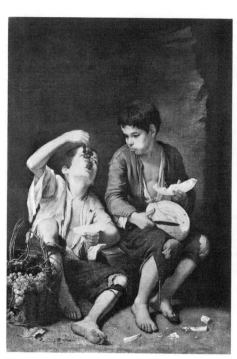

190. *Bartolomé Esteban Murillo:* Boy Killing Fleas, *Paris, Musée du Louvre*

191. *Bartolomé Esteban Murillo:* Boys Eating Grapes and Melon, *Munich, Alte Pinakothek*

darkness of the interior like a knife, defines very effectively the three-dimensionality of the boy and the jug; the volume and spatial projection of every object are modeled with a plasticity comparable to that achieved by Velázquez in his youthful genre scenes. Unlike Velázquez in his early works, however, Murillo uses natural light rather than an abstract chiaroscuro to illuminate the scene; the spotlight on the boy is the warm sunshine that enters through the rough masonry opening on the left.

Like the *Boy Killing Fleas,* which is an isolated instance of genre among the religious pictures of the 1640s, the *Boys Eating Grapes and Melon* [191], a work painted probably between 1650 and 1655, is a lone example of genre in the following decade. In this scene, the dim background is less defined, and a softer light falls on the two children and on the basket of fruit by their side. This light models their forms less emphatically than the trenchant beam of the earlier piece, and there are few hard outlines in the figures' contours. Murillo attains in this picture an illusion of the

reality of material objects, of their solidity and substance, that is both painterly and plastic at once; the brushwork that so expertly defines all surface textures is quite visible throughout the canvas, yet it does not destroy the illusion of the solid volume of what it depicts. This physical naturalism is complemented by the acuity of his observation of gesture and expression, so that the scene seems to capture an actual slice of life.

In spite of the beauty and originality of these two works, which might be expected to have gained popular success for this type of picture, Murillo did not take up children's genre again until the 1670s, which is when most of his genre scenes were painted. One can only conjecture that there were not enough patrons for children's genre in Seville (or in Spain) before that time.

Murillo's *Two Women at a Window* [192], an isolated example of genre painting of a different sort, has generally been dated late within his oeuvre, but its style and technique (with a heavy impasto, and vigorous flat brushstrokes in some areas) suggest rather a date between 1655 and 1660.

The type of scene represented in Murillo's picture, in which figures at a window actively solicit the attention of the viewer, is altogether unusual in Spanish art but is very frequent, instead, in Dutch seventeenth-century painting (examples by Honthorst, Rembrandt, and Gerard Dou come readily to mind). Its use may be an indication that at least some of Murillo's genre works

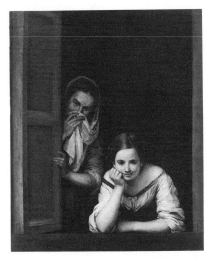

192. Bartolomé Esteban Murillo: Two Women at a Window, *Washington, D.C., National Gallery of Art*

were painted for the Netherlandish community in Seville or for Northern patrons outside of Spain, who were familiar with such pictures. Also pointing to a connection with Dutch genre is the strong likelihood that this painting may hold a moralizing message, even though it is not as evident at first sight as that of most Dutch works. The attitudes of the two women, seen at an open window looking out onto the street, make clear that we are witnessing an overt flirtation with a passerby. This conspicuous lack of decorum in the behavior of the women portrayed could only allude, for the seventeenth-century viewer, to their moral relaxation. We are, in brief, dealing with a scene of love for sale, such as were popular in contemporary Dutch genre. We should note, however, that the subject here is more subtly formulated than in the latter, for the music-making or drinking figures that usually form part of Dutch depictions of seduction or prostitution, the exchange of money, and even the male participant are all absent. The object of the flirtation is only implied, and it is the viewer who plays this role.

All of Murillo's numerous genre scenes of the 1670s (c. 1670–75) have poor children—many of them clearly beggars—as their principal actors, but only exceptionally do they strike a pathetic note. Eating, playing, or engaged in any other activity, most of these urchins—extroverted and brimming with vitality—are depicted enjoying whatever life has to offer. The tone of these late works is in general lighter than that of the early ones; the most distinctive trait of these children is not their poverty but their charm. In contrast to the objectivity of the early genre pictures, Murillo presents now a poetic and lighthearted vision of childhood.

In these late paintings, children are as idealized in their physical appearance as they had been realistic in the earlier ones. Although they continue to be poorly dressed and shod, their ragged attire is less naturalistically portrayed than in the Boy Killing Fleas or the Boys Eating Grapes and Melon, and their features are decidedly attractive. Nonetheless, the depiction of the psychological content of the characters is so acute, and the painting of the objects that surround them so true to life, that the viewer accepts the possible reality of the whole. In the Little Fruit Vendors (Munich, Alte Pinakothek), where Murillo shows us two children totally wrapped up in the pleasant task of toting up their earnings,

the degree of idealization is very high, but the image is still con-
vincing as a portrayal of believable characters in a real situation.

In comparison with the earlier genre pictures, Murillo
places in the late ones a greater emphasis on the anecdotal content
of the scenes. While the earlier pictures have a minimal amount
of action, the late ones play up their narrative elements, brilliantly
capturing the psychology and behavior of young children. These,
unlike their early counterparts, now elicit from the viewer an
emotive involvement with their proceedings. The *Boys Playing Dice*
[193] illustrates these features particularly well. Although the na-
ture of the subject might place it in the tradition of gambling
scenes derived from Caravaggio, the element of trickery and cheat-
ing, essential to those, is absent in this picture. The urchins play
at dice with the concentration and innocent passion that children
put into all their games; the expressions of the two players—
delight at a lucky throw and disappointment at a loss—are per-
fectly rendered. A younger child eating bread, plainly bored, turns
away from the players and their game, from which he is excluded.
A dog, the frequent companion of the children in Murillo's late
genre pictures, raises his eyes toward the child, with the hope of
being thrown a morsel.

The composition of the *Boys Playing Dice* is similar to that
of several of the other children's pieces painted in this period. The
characters, who form a diagonally arranged block, are shown out-
doors, with a fragment of wall with sprays of ivy behind them and
a distant view of hills in the background; a corner of the fore-
ground is occupied by a fruit still life. The picture also shares with
the other genre paintings of these years (and with the artist's
religious painting as well) a fresh and clear coloration in which
grays and delicate greens abound; a light, thin brushwork; and
transparent shadows. The masterly handling of light is both subtle
and striking: the head of the child in the center is in this respect
one of the most beautiful passages in all of Murillo's painting.

Portraits play a relatively small role within Murillo's pro-
duction and, besides one signed and two indirectly documented
ones, only a few are known which can be attributed to him with
certainty; of these, two are self-portraits. One of the latter, now in
the Frick Collection, must date from about 1650, to judge by the
apparent age of the artist, and, if so, it is one of Murillo's earliest

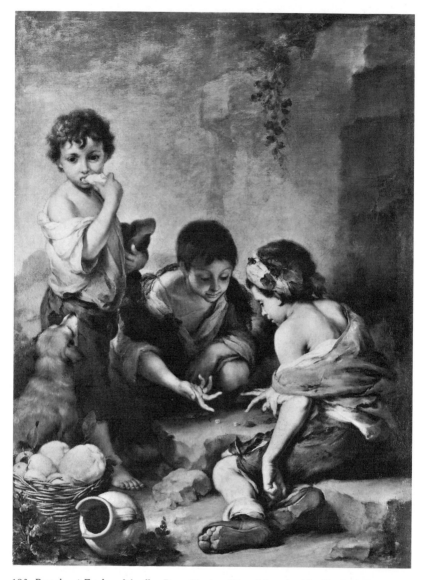

193. *Bartolomé Esteban Murillo:* Boys Playing Dice, Munich, Alte Pinakothek

known portraits (the oldest dated one is of 1650). The other self-portrait is the famous canvas painted c. 1670–75 at the request of his children, as the Latin inscription in the cartouche explains [194].

In both of these pictures, Murillo made use of an unusual device, inserting a painted likeness in a simulated sculptural con-

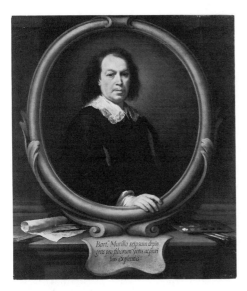

Bart. Murillo seipsum depin
gens pro filiorum votis acpreci
bus explendis

194. *Bartolomé Esteban Murillo:*
Self-Portrait, *London, National*
Gallery

text. For the second, Murillo devised a complex and disconcerting juxtaposition of elements whose spatial relationships are thoroughly ambiguous. In this work, the half-length figure appears as a painting set into an oval stone frame, which rests on a parapet between two Classical pilasters. On the plinth, at either side of the frame, the professional tools of the painter are laid out: palette and brushes, a bar of sanguine in its holder, a ruler and dividers, and a rolled-up sepia drawing. What makes this arrangement of the figure and its surroundings disconcerting is that the artist's right hand emerges from the supposedly painted canvas to hold the frame that encircles it, thus endowing Murillo's half-length figure with the same three-dimensional "reality" that the painter's paraphernalia and the frame itself have. That figure is no longer a "picture within a picture" but an actual person truncated at the waist. Given the naturalism of the portrait, this game of equivocation set up by Murillo would seem to indicate that the artist meant to express by means of it something specific, rather than to confuse the viewer. The *Self-Portrait* may be intended both as a definition of the art of painting, which by means of color, drawing, and measurement can counterfeit reality in a convincing manner, and as a demonstration of his own mastery of that art.

Almost all of Murillo's portraits present the figure either as a bust or in half length within an oval stone frame, or in the

traditional Spanish full-length format first established by Antho-
nis Mor a century earlier. To this second type belongs *Don Andrés
de Andrade y la Col* (New York, Metropolitan Museum of Art),
whose style and facture suggest a date between 1650 and 1660.

The composition of this picture is characteristic of
Murillo's full-length portraits, with the figure placed on a terrace
that opens onto a landscape, and a piece of Classical architecture
on one side. Also typical is that Andrade is posed almost frontally
with respect to the picture plane, with his head turned in the same
direction as his torso, and looking straight at the viewer. This pose,
together with Andrade's stiff bearing and his severe and impasive
countenance (features shared by other portraits of Sevillian noble-
men painted by Murillo), endows the effigy with a formal and
reticent character that maintains the viewer at a respectful dis-
tance. Murillo's subjects, in fact, are highly uncommunicative by
the standards of Baroque portraiture outside of Spain. If one
considers the great stress placed by the artist on expression, and
on the description of emotional states in his religious and genre
pictures, it may seem surprising that in his portraits he should
abstain almost completely from interpreting or giving shape to the
personality of his sitters. That his models take shelter behind an
icy reserve must be attributed more to a traditional allegiance to
conventions formulated early on in Spanish courtly portraiture
than to Murillo's personal preferences.

The *Portrait of Don Justino de Neve* [195] is the only one we
have of a seated figure, but it coincides in many other respects with
the standing portraits. Although Don Justino is seated in a space
that appears to be a study, the background is similar to those of
the standing figures: an open terrace with a Classical pier and a
balustrade. The upper portion of the figure is also turned almost
frontally, even though his chair is at a right angle to the picture
plane, and the head is turned even farther toward the viewer,
giving him a virtually frontal view of the sitter's face.

Don Justino de Neve, who posed for Murillo in 1665 (ac-
cording to the inscription below his coat of arms), was a canon of
the cathedral of Seville and the person primarily responsible for
the work of embellishment of the church of Santa María la Blanca.
He was also the founder and patron of the hospital of Los Venera-
bles Sacerdotes, to which he would bequeath this portrait. Murillo

195. *Bartolomé Esteban Murillo:* Portrait of Don Justino de Neve, *London, National Gallery*

196. *Bartolomé Esteban Murillo:* Portrait of Nicolas Omazur, *Madrid, Museo del Prado*

must have known him well, at least since he was commissioned to execute the lunettes for Santa María la Blanca, and it is likely that he painted this portrait upon the termination of that work. But even with the degree of acquaintance that existed between the painter and his model, and in spite of the torque of Neve's bust and of the suggestion of a momentary action given by his placing a finger between the pages of his book, the picture has the same effect of rigid formality that is common to all of Murillo's full-length portraits. The artist paid lip service to the convention of spontaneity that was part of Baroque portraiture, but without renouncing the tradition of solemnity and reticence of Spanish portraiture in which he had been formed.

At least two of Murillo's male portraits can be identified as being of members of the Netherlandish merchant community that resided in Seville. One is of the Dutchman Josua van Belle (Dublin, National Gallery of Ireland), painted in 1670, and the other of the Fleming Nicolas de Omazur [196], painted in 1672.

Nicolas de Omazur was part of a pair with a portrait of Omazur's wife, Isabel Malcampo, painted in 1674, in which both

sitters held in their hands symbols of mortality: Isabel Malcampo a rose (also symbolic of connubial love), and Omazur a skull. Although *vanitas* imagery was very popular at this time both in and out of Spain, its conjunction with portraiture was quite unusual, and there are no other known examples of husband and wife portraits with such symbolism. Omazur, who had adopted the Spanish fashion of the stiff linen collar known as *golilla*, in electing to include this memento mori in his portrait, also seems to have absorbed the spirit prevalent then in Murillo's circle. The year his portrait was executed, 1672, was also the year in which Valdés Leal painted his *Hieroglyphs of Death and Salvation* for La Caridad [205, 206], and in which Mañara's *Discourse on Truth* was published. Omazur was a highly educated man and a great art collector, and both images and text may have influenced this unusual choice of iconography.

The last commission of importance that Murillo would receive was for the paintings of the high-altar retable in the church of Santa Catalina in Cádiz, which he started in 1681. The preparatory sketch for the central piece, the *Mystic Marriage of Saint Catherine* (Los Angeles County Museum of Art), has the same high quality and verve of his finest works; the pedestrian execution of the picture now in the retable, however, must be attributed to his pupil and assistant Francisco Meneses Osorio (c. 1630–c. 1705). While working on this large canvas, which he was never to complete, Murillo fell from the scaffolding; a few months later, in April of 1682, he died, perhaps as a result of that fall.

Murillo left behind an extensive trail of followers and imitators in Seville, but no outstanding pupil. The balance between realism and idealization struck by his art, the subtlety of his expressive language, and the descriptive power of his technique were never again attained in Sevillian painting.

JUAN DE VALDÉS LEAL (1622–1690)

Juan de Valdés Leal was born in Seville in 1622, from a Portuguese father and a Sevillian mother. Nothing is known about his early youth: neither where, when, or with whom he did his apprenticeship; he is first recorded in 1647, when he was married and already established in Córdoba as a master. Although it has been repeat-

edly asserted, without any documentary proof, that Valdés went through his apprenticeship in Córdoba with Antonio del Castillo (1616–1668), it is more likely that it took place in Seville, before his moving to Córdoba.

Valdés's first signed and dated picture, the *Saint Andrew* painted for the church of San Francisco, where it has remained, also belongs to 1647. It is a work in which the most distinctive aspect of his art already manifests itself: its emphatic expressiveness. Valdés Leal did not seek in his figures either regularity of features or physical beauty (the hands of the saint here look indeed like those of a fisherman), but rather emotiveness and expressive force, abundantly achieved in this picture. His skill and imagination as a painter of still lifes (symbolic rather than purely descriptive) is also apparent here, in the depiction of the fish and the book. The latter (perhaps meant to represent the apocryphal *Acts of Andrew*) looks as if it had been inadvertently dropped on the floor at Saint Andrew's feet, and its dog-eared pages and well-worn cover suggest its frequent use.

197. Juan de Valdés Leal: Defeat of the Saracens at Assisi, *Seville, Museo Provincial de Bellas Artes*

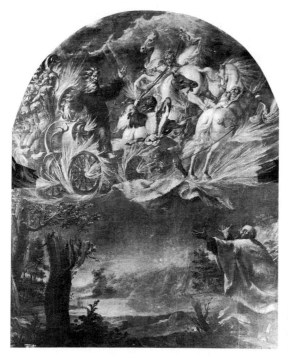

198. *Juan de Valdés Leal*: Elijah in the Chariot of Fire, *Córdoba, Church of the Carmelites*

The artist's first important commission, the cycle of paintings about the history of the order of Saint Clare, executed in 1652–53 for the Convent of Santa Clara in Carmona, reveals his personal style already fully developed. In the *Defeat of the Saracens at Assisi* [197] we can already see the unrestrained movement of the figures (here quite appropriate to the subject), the brilliant coloring, and the flashes of light that are so frequent in his work from this point on. The agitated mass of Saracens that pours out toward the viewer is composed in terms of contrasting diagonals both in space and on the picture plane; the violence of the action is registered not only in the gestures and expressions of the characters but also compositionally. It is in pictures like this that one can see, even at a distance of almost fifty years, the strength of the heritage of Roelas's work [38] in Sevillian painting.

Valdés is thought to have taken a trip to Madrid in 1655, and if that is the case, contact with the painters of the School of Madrid, and with Venetian and Flemish painting in the royal collection, must have reinforced his inclination toward colorism and an ever-looser painterly technique.

Between 1655 and 1658, Valdés painted the multipicture retable of the church of the Carmelite convent in Córdoba, still

in situ, whose central painting is *Elijah in the Chariot of Fire* [198]. In these canvases, especially in that of Elijah's ascension, Valdés Leal's very personal style appears at full strength; the lively brush-work and a drawing that is almost out of control, the feverish agitation of all forms, animate or inanimate, reveal here the most emotive and passionate side of his art. It is worth noting, however, that he does not apply the same handling of paint or work with such freedom in the design of his forms in all cases. In the two canvases of the predella, Valdés depicts portraitlike pairs of female saints in half length in a thoroughly realist vein and with a care-fully controlled design [199].

Among the various pictures that make up the retable of the Carmelites, there are two paintings that depict the severed heads of Saint John the Baptist (a subject of long standing) and of Saint Paul. The apostle's noble head, with long gray hair and beard, seems to rise from the ground above the sword used for his decapi-tation, a potent but not macabre image of martyrdom as a triumph of the spirit over death.

Valdés remained in Córdoba until 1656, but that year he returned to work in his native city, where he would stay until his death. His encounter with Murillo's and Herrera the Younger's latest works [183 and 177] in Seville can have only reaffirmed his own pictorial vision.

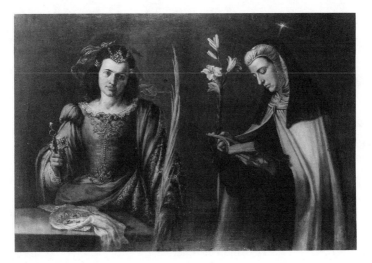

199. *Juan de Valdés Leal:* Saint Apollonia and a Carmelite Saint, *Córdoba, Church of the Carmelites*

The commission that probably induced him to move to Seville that year was the project for the decoration of the Monastery of San Jerónimo de Buenavista, which consists of a series of six episodes in the life of Saint Jerome and twelve portraits of former distinguished friars of the order, including its founder. The dynamic quality of Valdés's painting is clearly demonstrated in the *Temptation of Saint Jerome* [200], in spite of the fact that its composition was inspired by Zurbarán's static representation of the subject in Guadalupe [100]. The young temptresses here dance to the sounds of their own music, and the contrasting diagonals in the pose of the saint, together with the shapes of the rocks and the landscape in the background, contribute to impart a strong movement to the entire scene. The brilliant coloring and the luminosity of the space endow this image with a sensuous tone that is altogether absent from Zurbarán's picture.

The *Temptation of Saint Jerome* and one of its companions, the *Flagellation of Saint Jerome* (Seville, Museo de Bellas Artes), which is also comparable to Zurbarán's canvas of the same subject

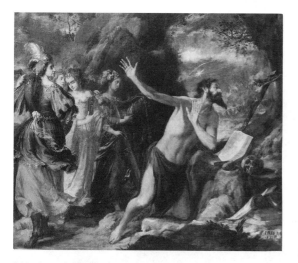

200. *Juan de Valdés Leal:* Temptation of Saint Jerome, *Seville, Museo Provincial de Bellas Artes*

201. *Juan de Valdés Leal:* Fray Hernando de Talavera, *Seville, Museo Provincial de Bellas Artes*

painted for Guadalupe, throw into relief not only the individual differences between the two artists but also the radical changes in aesthetic sensibility and in the interpretation of religious subjects that had taken place in the second half of the century with respect to its first half. Zurbarán's austere conception of the subject matter, and the conciseness and moderation of gestures and movements in the pictures painted in 1638, stand in marked contrast to the sensuous coloring, the liveliness of the action, and the emotiveness in the expression of feelings in Valdés Leal's canvases of 1657. The smooth technique and the plasticity of form in Zurbarán's painting, typical of the realism of the first decades of the century, are replaced in Valdés Leal's by the impressionism and colorism, ultimately traceable to Venetian painting, that dominate Spanish art after the mid-century in both Madrid and Seville. In the space of twenty years, the tenor of Spanish painting had gone through a major change, and Valdés Leal represents one of its alternatives, shared with the painters of the School of Madrid.

The series of imaginary portraits for the Hieronymites of Buenavista included several individuals who had also been painted by Zurbarán for Guadalupe. Among the best are that of the patron saint (Madrid, Museo del Prado) and the *Fray Hernando de Talavera* [201], which seem to have been conceived as a pair. In this series, the figures in the foreground are generally inserted in an architectural setting open to the outdoors, where a relevant episode in the life of the friar portrayed is depicted. If one compares these portraits of Buenavista to the imaginary portraits of Mercedarian doctors painted by Zurbarán for that community in Seville about 1630–35 (Madrid, Academia de San Fernando), in which static, sculpturesque figures are presented against black backgrounds, the same contrasts can be drawn as for the narrative pictures. It should also be pointed out that Zurbarán's *Saint Jacob of the Marches* (Madrid, Museo del Prado), painted in Madrid in 1658, is much closer stylistically to Valdés's *Fray Hernando de Talavera* of 1657 than to his own earlier Mercedarian friars of the 1630s.

From the period about 1657–59 is the impressive *Liberation of Saint Peter*, probably painted for the cathedral of Seville, where it is at present. Although most of Valdés's painting is light and brilliant in coloring, when he uses the strong chiaroscuro sug-

202. *Juan de Valdés Leal:* Allegory of Vanity, *Hartford, Wadsworth Atheneum*

203. *Juan de Valdés Leal:* Annunciation, *Ann Arbor, University of Michigan Museum of Art*

gested by a specific subject (here the nocturnal appearance of an angel in Saint Peter's prison cell), he knows how to take advantage of it to achieve the intense drama that he always seeks in his paintings. The angel is depicted as a solid adolescent, painted in clear colors and with bold brushstrokes, but his radiant figure and the agitation of his garments, hair, and wings transmute him into an ethereal and spiritual being.

Valdés's standing as an artist during these years is revealed not only by the commissions he received but also by his repeated election as examiner for painting and as steward of the painters' guild. In 1660, he also participated in the foundation of the drawing academy, of which he would be president three years later.

To 1660 also belong a signed and dated pair of curious allegorical paintings, which approach the theme of salvation through the contrast between the worldly vanities that can damn the soul and the virtuous path that opens for it the way to salvation. The *Allegory of Vanity* [202] presents a variegated pile of objects on a table, all identifiable symbols of the vanity of worldly

things, and an angel behind them who unveils and points to a picture of the Last Judgment. All the objects shown in this composition were in current use in *vanitas* pictures of this time, and they symbolize the transitory and fragile nature of life (skull, watch, putto blowing soap bubbles), the temptations of pleasure, riches, and power (cards, jewels, crown), and even the vanity of nobler ambitions: the artistic and intellectual triumphs that bring fame (laurel wreath, books, dividers). Above this chaotic compendium of worldly temptations and reminders of mortality, the picture of the Last Judgment revealed by the angel is an exemplary image of divine order. Enumerating the obstacles that humanity finds on its road to salvation, and reminding the viewer of the final and eternal punishment for man's sins, Valdés expresses very clearly the moral lesson to be drawn from his work.

In contrast to the exuberant display of objects and the richness of color of its companion, the *Allegory of the Crown of Life* (York, City Art Gallery) is an austere composition in form and color, which alludes symbolically to the promise of eternal life and the arduous road by which it is reached, through faith, devotion, and sacrifice.

With its lavish color and delicate technique, the *Allegory of Vanity* is one of Valdés's most beautiful pictures, and it reminds us that the artist could—when he wanted to—paint his pictures with nicety. The "furia del penello" with which he executed the *Elijah in the Chariot of Fire* and the *Temptation of Saint Jerome* is reserved for pictures which gain in dramatic impact from forceful brushwork and expressive drawing.

Such is the case of the *Annunciation* signed in 1661 [203], a picture even smaller in size than the *Allegory of Vanity*, which nonetheless exemplifies vividly Valdés's expressive style. The agitation of the forms is not limited to the figures and their garments but touches also inanimate objects such as the prie-dieu, whose shape and ornamentation echo the torsions of the poses of the Virgin and Gabriel. The explosive energy of this composition is also due to the dramatic handling of the blinding light which breaks into the Virgin's room and dances over figures and objects and to the artist's brilliant and lively technique, which animates the entire pictorial surface.

In Valdés Leal's oeuvre, the subject of the Immaculate

204. *Juan de Valdés Leal:* Immaculate Conception, *London,
National Gallery*

Conception does not appear as frequently as in that of other
contemporary painters but, in compensation, his interpretations
are quite varied and of greater iconographic complexity than
theirs, including Murillo's. The most beautiful of those preserved
is the *Immaculate Conception* signed in 1661 [204], a large picture
of great refinement and delicate and clear colors. Besides the little
angels bearing the Marian symbols, God the Father and the Holy
Spirit are also present—incandescent, almost transparent figures
toward which the Virgin ascends.

The half-length likenesses of two donors which fill the
lower corners of the picture, both strong and realistic portrayals,
allow us to gauge Valdés's gifts as a portrait painter, a genre that
he seems to have practiced scantily, nonetheless; until now, very
few portraits from his hand have been identified. One of them is
the recently attributed *Portrait of an Ecclesiastic* (Amherst College,
Mead Art Museum), which has been dated to Leal's late period,
c. 1682–84, on the basis of an identification of the sitter as the
Archbishop of Seville Ambrogio Spinola. This identification is far
from certain, and the painting's facture would seem to place it
instead close to the execution of the *Allegory of Vanity* (1660) and

of this very *Immaculate Conception*, with which it shares its light colors and luminosity. This portrait, however, seems more idealized than those of the donors in the *Immaculate Conception*, and it may well be an imaginary or posthumous portrait of a past archbishop of Seville.

Another of the portraits that has come down to us, even though darkened and repainted, records the fiercely intense physiognomy of Don Miguel Mañara (1627–1679), for whom the painter had executed in 1672 the pictures that would bring him greatest posthumous fame: *In ictu oculi* and *Finis gloriae mundi*. This portrait of Mañara seems to date to the last years of his life, and was the one that served as model for the engraving in the frontispiece of the 1679 edition of his *Discurso de la Verdad*. It is worth noting that its format and iconography—half-length figure framed by a simulated oval stone frame, with one hand resting on a skull—are very similar to those of the *Portrait of Nicolas Omazur* [196] painted by Murillo in 1672, the year in which the first edition of the *Discurso* was published.

Something has been said already about Don Miguel Mañara in regard to the canvases of the Seven Works of Mercy painted by Murillo between 1667 and 1672 for the church of the Confraternity of La Santa Caridad. The images presented by the *Hieroglyphs of Death and Salvation*: *In ictu oculi* [205] and *Finis gloriae mundi* [206], which flank the low vestibule under the choir of this church, have their origin in the thinking and obsessive vision of death of this strange personage, but they are not literal illustrations of the text of his *Discurso de la verdad*; rather, they are transcriptions into a pictorial medium of the essence of its contents. Valdés, like Murillo before him, had joined the Confraternity in 1667, and was well acquainted with the author and his work.

The painting of the Triumph of Death—an animated skeleton that puts out the flame of life "in the batting of an eye"—is a sinister version of the *Allegory of Vanity* of 1660, and also depicts a similarly confused profusion of objects. But here, the allegorical catalogue is restricted to those things which symbolize the vanity of power and glory. Crowns, scepters, arms—whatever object signals the political or social preeminence of man—and the books that immortalize his glorious deeds are represented at a monumen-

205. Juan de Valdés Leal: In ictu oculi, *Seville, Hospital de la Caridad*

tal scale, and without the sensuous appeal of the 1660 *vanitas*. Among the books that have been identified in this pile are two theological tomes, with which the vision of what constitutes worldly glory is amplified to include even that gained through pious erudition.

In the *Finis gloriae mundi,* Valdés presents the most terrifying image ever painted of the corruption of the flesh: in the foreground, next to a still intact cadaver of a knight of the Order of Calatrava (to which Mañara belonged), appears that of a bishop in the last stages of putrefaction, gnawed by worms and covered with vermin. Above the mortal remains that fill the mausoleum, Valdés paints a balance in perfect equilibrium held by Christ's stigmatized hand; in its scales rest symbolic figures of the seven deadly sins on one side ("ni más," neither more), and of prayer and penitence on the other ("ni menos," nor less).

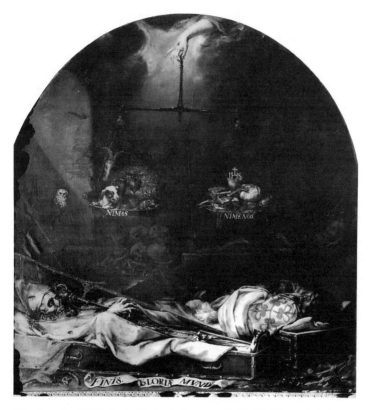

206. *Juan de Valdés Leal:* Finis gloriae mundi, *Seville, Hospital de la Caridad*

Although the *Hieroglyphs of Death and Salvation* are ostensibly grim sermons on the impermanence of life and the ephemeral nature of all worldly glories, the judgment of the soul expressed by the scales in the *Finis gloriae mundi* and the inscription from Matthew 25:34–36, also in the vestibule (wherein Christ promises the kingdom of heaven to those who have practiced the Seven Works of Mercy), tie them thematically to the doctrinal intent of the entire decoration of the church. All Seven Works of Mercy are extolled, but foremost among them as a means to salvation is the virtue of charity; the weight of this virtue is what may tip the scales and save a Christian soul.

Valdés Leal's works from the end of the 1650s through the first years of the 1670s represent his artistry at its apex, and in them one may appreciate the qualities and idiosyncrasies of his style at its most accomplished. His strongly expressive art, of

unusual dramatism in the context of Sevillian painting, is characterized by a nervous brushstroke, brilliant color that sometimes becomes almost strident, light that flickers over the surfaces of figures and objects, and a lack of attention to correct drawing and classical beauty, which are always sacrificed to emotive intensity in both figures and composition.

Valdés's production throughout his career, but especially from the mid-1670s on, is manifestly uneven in pictorial quality and composition. As well as pictures that testify to his mastery and genius, Valdés's enormous oeuvre includes many others that seem to belie them. This unevenness may be due in part to the use of studio assistants, to the careless or hurried execution of poorly remunerated work, and—in the last ten or fifteen years of his life—to a physical decline that finally rendered him incapable of painting works already contracted (beginning in 1680 or a little later, his son and disciple Lucas Valdés, born in 1661, had to participate in ever-increasing measure in his father's commissions). Even so, the variation in quality among Valdés's pictures is greater than we find in most artists who produced their paintings under similar studio circumstances. His best pictures are, nonetheless, beautiful and fascinating works of great originality.

CHAPTER 11

The School of Madrid, II

Mateo Cerezo, José Antolínez, Juan de Arellano, Bartolomé
Pérez, Claudio Coello

The generation of painters born in the 1630s produced a consider-
able number of artists of distinction who would work at the court
during the third quarter of the seventeenth century. Many of them
were students of the most important figures of the previous genera-
tion, Juan Carreño (1614–1685) and Francisco Rizi (1614–1685),
and continued developing their Late Baroque style and looking
toward the Venetian and Flemish schools for inspiration. Most of
them had short careers, either dying before their masters or surviv-
ing them by little. The most outstanding among them were Juan
Martín Cabezalero (1633–1673), Carreño's disciple, a painter of
great refinement and strongly influenced by Rubens and Van Dyck
[207]; Juan Antonio de Frías y Escalante (1633–1669), Rizi's disci-
ple, also a painter of great sensibility whose style is directly rooted
in sixteenth-century Venetian painting, although it also refers to
Van Dyck [208]; José Jiménez Donoso (c. 1628/32–1690), trained
in Rome and later Carreño's assistant in Madrid, a remarkable
painter of whose work, unfortunately, little remains [209]; Mateo
Cerezo (1637–1666), also Carreño's student; and José Antolínez
(1635–1675), Rizi's disciple. Another of Rizi's students, Claudio
Coello (1642–1692), a younger contemporary of the painters men-
tioned and collaborator of several of them, is the brilliant last
flower of the School of Madrid before Spanish painting entered
into its long eclipse.

207. *Juan Martín Cabezalero:* Assumption of the Virgin, *Madrid, Museo del Prado*

209. *José Jiménez Donoso:* Foundation of the Basilica of San Giovanni in Laterano, *Valencia, Museo de Bellas Artes*

208. *Juan Antonio de Frías y Escalante:* Dead Christ, *Madrid, Museo del Prado*

MATEO CEREZO (1637–1666)

Mateo Cerezo was born in Burgos in 1637 to a painter of the same name, from whom he must have received his earliest instruction. The teachings that determined Cerezo's style, however, were received in Carreño's workshop in Madrid. His most youthful works are not known (his earliest already date to 1659), but those of the

1660s, painted in the six years before his early death at the age of twenty-nine, show by their luminosity, lively coloration, and loose facture not only his master's influence but also that of Carreño's principal sources, Van Dyck and Venetian painting. These ingredients are mixed in different doses in his various works, with a greater emphasis on the Venetian inheritance in some and on the emulation of the Flemish painter in others. He shares with the latter his figures' refinement of physical type and the elegance of their movements, distinctive characteristics of his entire oeuvre.

The arrangement of the figures and other elements in the *Mystic Marriage of Saint Catherine* [210], of 1660, and the way in which its characters interrelate, follow a characteristic Baroque pattern. The composition is based on a scheme of surface and spatial diagonals that join and cross, which lends it great movement but also creates a strong focal point in the head of the Christ Child; the gestures and glances of the various figures also contribute to interconnect them, and to attract toward the Child the observer's attention.

Pictures representing the Magdalen were quite frequent in religious painting from the latter part of the sixteenth century on,

210. *Mateo Cerezo:* Mystic Marriage of Saint Catherine, *Madrid, Museo del Prado*

since her repentance and asceticism were subjects favored by religious art after the Counter-Reformation. In Spain, the devotion for the repentant sinner resulted in a great surge of images of the saint, either in full or in half length. Cerezo's *Penitent Magdalen* [211], signed and dated in 1661, is of the more popular half-length format, in which the figure is shown in fervent prayer addressed to a crucifix, with a book and a skull as sole company. This *Magdalen* is one of the most beautiful examples of the pictorial quality and expressive force of Cerezo's work; it is a painting that can be regarded as outstanding not only in the context of Spanish art of this period but of Spanish seventeenth-century painting altogether.

In his biography of the artist, Palomino mentions that Cerezo also painted small still lifes, but of this facet of his production very little remains. Two signed still lifes are known, a meat and a fish still life (the latter dated 1664), and two more are reasonably attributed to him, one of them, the *Kitchen Still Life* [212], unanimously so. The signed ones and this painting are works of extraordinary quality, and they are all very close to each other stylistically.

The strong chiaroscuro and deep colors of these still lifes separate them from Cerezo's large religious paintings, which are

211. *Mateo Cerezo:* Penitent Magdalen, *The Hague, Mauritshuis*

212. *Mateo Cerezo:* Kitchen Still Life, *Madrid, Museo del Prado*

usually diaphanous and bright. This handling of the light relates them instead to the tradition of still-life painting of the first half of the century (especially to Antonio Pereda's works in this genre [151]), and in the use of stepped ledges, we also see an echo of Van der Hamen's still lifes [66]. Cerezo's compositions, however, are denser and more complex than those painted in the first half of the century; the *Kitchen Still Life* is composed on a pattern similar to that of the *Mystic Marriage of Saint Catherine* and shares its structural cohesiveness.

The *Kitchen Still Life* is also unlike earlier Spanish pictures of this genre in the bloodiness of its subject, particularly unsettling because of the richness of Cerezo's reds and his mastery of realistic description in the painting of the eviscerated kid and the skinned lamb's head.

JOSÉ ANTOLÍNEZ (1635–1675)

José Antolínez, born in Madrid in 1635, was trained in Francisco Rizi's workshop, but his painting also reflects the influence of Herrera the Younger, who was eight years his senior. As in Herrera, Antolínez's broad technique and swift execution are perfectly adapted to the lively and light motions of his figures, but his paintings lack the dramatic contrasts of light and dark favored by the Sevillian artist; his palette, like that of his contemporaries, has cooler hues, and he uses a more generalized illumination.

Antolínez was a prolific painter, so although he was also short-lived (he died at the age of thirty-nine), there are many signed and dated works by him still extant, to which should be added many others that are known to be lost. Of his surviving works, a large proportion is made up of images of the Immaculate Conception, a subject he repeated in countless variations.

The *Immaculate Conception* of c. 1663, now in the Prado [213], is very representative of his treatment of the subject, and the Virgin's type, with large eyes and small chin and mouth, also exemplifies his personal canon of feminine beauty. The broken pose of the Virgin is complemented by the movement of her mantle, which the wind seems to blow and causes to swirl around her, and by the pointed terminations of its borders, very typical of Antolínez. All these features contribute to give the figure of the

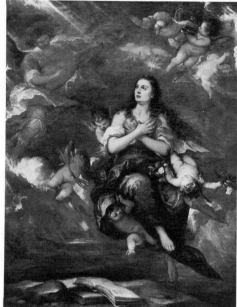

213. *José Antolínez:* Immaculate Concep-
tion, *Madrid, Museo del Prado*

214. *José Antolínez:* Transit of the Magdalen,
Madrid, Museo del Prado

Virgin a very open and irregular silhouette and an active pose. The
angularity of the silhouette is a personal trait, but the movemented
pose and turbulent mantle of Antolínez's Virgin are shared with
many of the Immaculate Conceptions painted by his contempo-
raries. Also characteristic of Antolínez is the prominence given to
the cherubs who fly around the Virgin carrying Marian emblems,
whose varied foreshortenings add to the movement that seems to
agitate the entire image.

One of Antolínez's most beautiful works is the *Transit of
the Magdalen* [214], a relatively infrequent subject that has its
origins in the *Golden Legend.* In this image, in which the Magdalen
in ecstasy is transported to heaven by angels and hears celestial
music, the painter was able to give full play to his love of move-
ment, since its narrative content fully justifies it, as it does not in
depictions of the Immaculate Conception.

For the pose of the Magdalen, Antolínez must have found
inspiration (through prints) in Rubens's Assumptions, particularly
that in the cathedral of Antwerp, of 1626, in which the ascensional

motion is very marked. In the *Transit,* the angularity of the forms, already mentioned in relation to the *Immaculate Conception,* extends even to the configuration of the heavenly light and of the clouds—in fact, of the entire composition—intensifying the effect of rapid ascent suggested by the pose itself. In her physical type, the Magdalen is close to those of Van Dyck and, through them, to Titian's. Her countenance has a more classical but also more earthy beauty than the dainty faces of his Virgins. Both the coloring, in which light and intense blues and silvery whites predominate, as well as the luminosity that permeates this picture, are very characteristic of Antolínez, but they also coincide with the stylistic tendencies current in Madrid at this time.

The *Transit of the Magdalen,* so polished stylistically and technically, must date from the period of the artist's full maturity, the years about 1670 to 1675 (his earliest preserved work dates from 1658).

Although Antolínez's output is primarily religious, a couple of small mythological scenes, some portraits, and a genre picture by him are also known. The portraits of two little girls, now housed in the Prado, represent unidentified sisters and were once attributed to Velázquez [215]. Their inclusion in Antolínez's oeuvre is unquestionably correct, but they are indeed related to Velázquez's pictorial vision, and their high quality and subtlety

215. *José Antolínez:* Portrait of a Girl, *Madrid, Museo del Prado*

of color propitiated that old attribution. Antolínez's rendering of the two girls is thoroughly charming, and ties them to the delightful infants that appear in his religious work.

The *Portrait of the Danish Ambassador Cornelius Pedersen Lerche and His Friends* [216], signed in 1662, is a completely unexpected work in the context of Spanish painting, where group portraiture is a rarity; the two outstanding exceptions are Velázquez's *Las Meninas* [141] and Mazo's *The Family of the Painter* [146], both of which are unrelated in their format to Antolínez's picture. Its conception must be due to the Danish ambassador, as the picture obviously conforms to the Dutch tradition of group portraiture. This genre had been developed in Holland in the late sixteenth century and had become very popular in the seventeenth, reaching its apogee in Rembrandt's and Hals's great corporation portraits. The composition of Antolínez's picture, however, probably owes its specific design to a different source, since Dutch portraits of this type must not have been known firsthand in Spain. The disposition of the figures—even the detail of the child and his dog in the foreground—is very similar to that of Veronese's *Supper at Emmaus* (Paris, Musée du Louvre), a painting in which the portraits of the donor and his family are incorporated into the religious subject, and which Antolínez may have known through a print. Whatever the sources, Antolínez succeeds in conveying in this work a liveliness and a sense of spontaneity that is the quintessence of Baroque portraiture.

216. *José Antolínez:* Portrait of the Danish Ambassador Cornelius Pedersen Lerche and His Friends, *Copenhagen, Royal Museum of Fine Arts*

217. José Antolínez: The Itinerant
Painter, *Munich, Alte Pinakothek*

The *Danish Ambassador* also has anecdotal interest, since
it may include a self-portrait of the artist. If, as is most likely, the
dark-haired young man on the left wearing an earring represents
Antolínez himself, his mien and bearing agree with the description
of the artist given by Palomino in the *Lives,* where he reports that
the painter was very haughty and vain, and also had a very caustic
temper.

 Genre painting is very rare in Spain and, apart from those
by Murillo and the youthful works of Velázquez in Seville, only
another small group of low genre pictures by a Spanish artist is
known. These pictures seem stylistically related to Velázquez's
painting, and are attributed at present to Antonio Puga (1602–
1648), although there is no conclusive proof of his authorship. *The
Itinerant Painter* [217], the only genre picture known by Antolínez,
is therefore of special interest on account of its subject, but it is
also a work of great pictorial beauty.

 This canvas, more Velázquean than any other of Anto-
línez's works (even in the coloring, dominated by light tans), fits
into the vein of Puga's pictures, but in a form into which Dutch
elements and his personal idiosyncracies enter as well. The picture
is large, and the principal figure life size, so in this respect it comes

closer to Velázquez's portraits of court jesters, such as *Don Juan de Austria* (Madrid, Museo del Prado), or his imaginary portraits [131] than it does to Dutch genre pictures. In its setting, however—an interior space that opens into a succession of other spaces beyond—Antolínez's painting comes much closer to Dutch or Flemish genre scenes by Pieter de Hooch (1629–c. 1684), Adriaen Brouwer (c. 1605–1638), and David Teniers the Younger (1610–1690) (artists whose works, particularly the latter's, were certainly well represented in the Alcázar) than to any Spanish prototype, including *Las Meninas* [141], to which it has been likened.

Antolínez's picture is variously known as *The Itinerant Painter* or *The Picture Seller*, and the interpretation of its subject is still open to discussion, since the identity of the two figures and the meaning of their gestures have not been completely elucidated. The most likely identification of the ragged character that addresses the viewer, proffering to him a picture of the Virgin and Child (copy of an identifiable Italian painting), is that he is one of those "traveling and tattered painters" or "vagabond painters" to whom Palomino refers on several occasions in his *Lives*. These peripatetic painters arrived in Madrid—sometimes from as far away as Italy—and solicited temporary work at the public workshops, or painting shops, set up for the production of devotional images for sale to the general public. If such is the case, the person addressed by the traveler is Antolínez himself, whose studio he has entered and from whom he is asking for work by presenting a sample of his competence. What is not completely clear, whatever the main character's identification may be, is the meaning of the gesture of the young man beyond the doorway, who seems to point toward the viewer with an amused expression.

JUAN DE ARELLANO (1614–1676)

Still-life painting had been practiced in Spain during the first half of the seventeenth century by such outstanding artists as Sánchez Cotán and Juan van der Hamen, and there are even isolated examples of flower pieces by these and other masters, but the painting of flowers as a specialty gained acceptance only in the second half of the century. Among the artists who specialized in

this genre then, the first and most distinguished one is Juan de Arellano. Although born in 1614, he began to devote himself to flower painting only at the already mature age of thirty-two, and his oeuvre therefore belongs with that of the following generation of painters, who worked during the third quarter of the seventeenth century.

Juan de Arellano, born in the village of Santorcaz, near Madrid, received his artistic training at the workshop of a modest landscape painter at the court, Juan de Solís, and the beginnings of his career must have promised little. It is known that he also painted landscapes and religious subjects (of which some examples still exist), but his fame would derive exclusively from his flower painting, where he developed a very personal style.

Given the artistic circumstances from which Arellano emerged, it is not surprising that his flower paintings have their sources primarily in the work of non-Spanish painters, both older and contemporary. The school which had first gained prominence in Spain in this genre was the Flemish one, and the influence of Jan Brueghel (1568–1625) endures in Arellano's flower pieces in such details as the introduction of insects and lizards to animate both the bouquets and the tables where they rest. The paintings of Daniel Seghers (1590–1661), closer to him in time and well represented in Spain, also served Arellano as an inspiration, and he devised his own versions of the rich garlands surrounding small religious subjects that were the Fleming's specialty. The more vibrant and casual bouquets of the Roman artist Mario Nuzzi, known as Mario dei Fiori (1603–1673), many of which were in Madrid and in the royal collection, also had great influence on Arellano's work.

Arellano's compositions are quite varied; simple bouquets of flowers in crystal vases [218], complex garlands, and even flowers still in a garden can be found in his oeuvre, but the type of flower piece that is most characteristic of the painter shows a basket resting on a stone ledge, filled with flowers and holding a luxuriant bouquet [219]. These flower baskets, painted between 1665 and 1676, gained great popularity, and many magnificent examples are still extant. They were frequently done as pairs, and were destined not only to decorate rooms in private houses or palaces but chapels and churches as well.

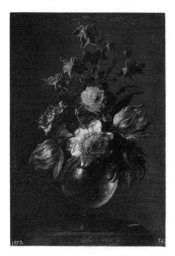

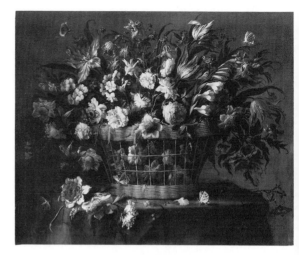

218. *Juan de Arellano:* Flower
Piece, *Madrid, Museo del Prado*

219. *Juan de Arellano:* Basket of Flowers, *Madrid, Museo del Prado*

The invention exemplified by the *Basket of Flowers* illustrated here allowed Arellano to increase the number of painted blossoms in the picture, since besides the abundant bouquet and the flowers that have fallen on the ledge, many others can be seen through the very open weave of the basket. The lively and richly colored flowers, nearly touching the borders of the canvas, take over the picture plane almost completely, to great effect. The flower pieces of this type—large in size, brilliant in color, and with bouquets of complex silhouette—are sumptuous paintings of great originality and Arellano's distinctive contribution to the genre.

BARTOLOMÉ PÉREZ (1634–1693)

Arellano's specialty and style of flower pieces were continued by his son-in-law, Bartolomé Pérez, but Pérez's looser and less detailed technique lends a greater softness to his blossoms. He also adopted a more pronounced chiaroscuro, in which the vivid color of the flowers contrasts more strikingly with the black background. The contours of the flowers are less defined as well, so the bouquet tends to merge into the surrounding darkness and to absorb the individual flowers, which in Arellano had been separate entities. Personal to Pérez are bouquets in urns of gilded bronze with reliefs

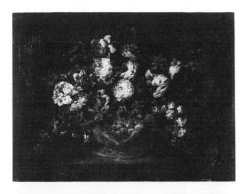

220. *Bartolomé Pérez:* Vase with Flowers, *Madrid, Museo del Prado*

221. *Bartolomé Pérez:* Flower Garland with Saint Anthony, *Madrid, Museo del Prado*

of figures and garlands [220], although he frequently employed glass vases as well. He also continued to paint garlands surrounding a religious subject, but in some of them he abandoned the frame or cartouche in which the figures are set, relying only in his strong chiaroscuro to separate them from the surrounding flowers [221].

CLAUDIO COELLO (1642–1693)

Claudio Coello, the youngest of the painters who worked in the court during the last third of the seventeenth century, is also the most distinguished one of that generation—a brilliant but final star of the Golden Age of Spanish painting.

Claudio Coello was born in Madrid into a family of Portuguese origin who had settled in Spain. His father, an artisan who worked in bronze and gold, placed him as an apprentice in Francisco Rizi's studio so that Claudio would learn drawing and assist him with designs for his metalwork. His talent as a painter was

soon recognized, however, and he remained with Rizi until 1660, when he started to work on his own.

Rizi's influence on Coello is evident in the grandeur and drama of his compositions, an aspect of his art that was reinforced by his study of the work of Rubens and Van Dyck, directly and through prints. It is possible, as has been pointed out, that the complexity of the settings in his religious paintings reflects his master's practice as a set designer—Rizi had been in charge of the stage sets in the Alcázar and the Buen Retiro since 1649—but such an explanation is unnecessary; red hangings, stepped platforms, and backgrounds with Classical architecture are features that abound in Baroque painting in general. In fact, the architectural backgrounds in several of Coello's paintings refer directly to six-teenth-century pictures by Veronese and Tintoretto that were in Madrid at the time.

Although there are two paintings by Coello signed and

222. *Claudio Coello:* Triumph of Saint Augustine, *Madrid, Museo del Prado*

223. *Claudio Coello:* Saint Joseph with the Christ Child, *Toledo (Ohio) Museum of Art*

dated in 1660 and 1661, it is only in the large *Triumph of Saint Augustine* [222], of 1664, that his distinctive personal style appears fully developed. The *Vision of Saint Anthony of Padua* (Chrysler Museum, Norfolk, Virginia), which supposedly bears the date 1663, is much closer stylistically to works dated after 1668.

The *Triumph of Saint Augustine* presents the image of the sainted Early Christian bishop (A.D. 354–430) as the defender of the Christian faith, triumphant over paganism and heresy. It is a work that, by itself, would qualify the young painter as a master of his art in every respect. Its cool, transparent hues, the luminosity of the whole, and the lively brushwork with which he defines the forms are features of his early works that build on the example of Rizi and Carreño. Its composition, in which the figures move in an ascending spiral that marks a powerful diagonal on the picture plane, is typically Baroque and in its dynamism also accords with most contemporary works of the School of Madrid. The monumentality and solidity of the saint's figure, on the other hand, are characteristic of Coello's individual style.

The beautiful *Saint Joseph with the Christ Child* [223], signed in 1666, is also a work in which Coello's early style and technique are perfectly exemplified. Even in a scene that does not require great movement, the artist animates Saint Joseph's pose; he advances resolutely toward us to deposit the Child in the cradle, and his spiraling motion is picked up and expanded in the arrangement of the cherubs. The very high quality of this splendid work is another demonstration of Coello's pictorial mastery; the subtle color and brilliant technique, the dynamic equilibrium of the composition, and the lively vigor of the figures make of these two pictures a true feast for the eyes.

The subject of the painting, in which Saint Joseph replaces the Virgin in her maternal role, is very frequent in Spanish art, and as in earlier or contemporary depictions of the saint, he is envisioned here as a handsome man in the flower of his maturity, endowed with both tenderness and grandeur, and tied to the Child by bonds of love and devotion. The Virgin, who is painted with a beautiful light touch, appears here only in a distant bower, interrupting her sewing to observe the scene.

Coello's large (229 by 249 cm) *Virgin and Child Venerated by Saint Louis* [224] was commissioned by an archer of the Royal

224. *Claudio Coello:* Virgin and Child Venerated by Saint Louis, *Madrid, Museo del Prado*

225. *Claudio Coello:* Annunciation, *Madrid, Church of San Plácido*

Guard named Luis Faure, and must also belong to the years between 1660 and 1666. In its composition and figure types, it is among Coello's pictures the one that most closely emulates Rubens's and Van Dyck's art, but its coloration and play of light are more directly inspired by Carreño's. Coello would have a close friendship with this painter in later years, but his work must have been familiar to him as far back as his days as an apprentice in Rizi's workshop, since his master and Carreño worked together in several instances from 1659 on.

The superb *Virgin of the Rosary with Saint Dominic* (Madrid, Real Academia de San Fernando), a huge picture that reveals similar traits to those of the *sacra conversazione* with Saint Louis, must also belong to the period before 1668, when Coello's style begins to undergo a noticeable change. The light, Van Dyckian figures, the Rubensian composition, and the color and luminosity of this picture are also reminiscent of Carreño's works of these same years [161].

In 1668 or shortly before, Claudio Coello received from the Benedictine nuns of San Plácido the most important commission he had been offered until then: the paintings for the high altar

and for the two side altars of their church, and the frescoes for the Chapel of the Holy Sepulcher attached to the latter. Francisco Rizi had worked earlier on the decoration of San Plácido, and it is possible that he recommended Coello for the execution of these pictures. The work was finished in 1668, the date that appears with Coello's signature on the high altar painting and on one of the lateral ones.

The picture in the high altar of San Plácido is ostensibly the *Annunciation* [225], but its iconography is more complex than is usual for that subject; it presents the Incarnation as the fulfillment of the prophecies of sibyls and prophets, who appear at the foot of the platform occupied by the Virgin. It is quite possible, since its resemblance is undeniable, that this painting was based on a Rubens sketch of an Annunciation of identical iconography, a preparatory design for the very same altar in San Plácido, which according to recent scholarship was first intended for Rubens. Coello did not follow faithfully Rubens's composition, but rather adapted it and simplified it, stressing further the glory with the Holy Spirit and the Virgin. His own composition is less asymmetrical and more spacious than Rubens's, and consolidates the various figure groupings into more massive blocks. The figures themselves

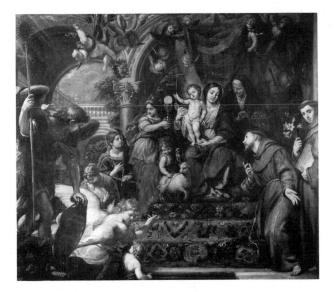

226. *Claudio Coello:* Virgin and Child with the Theological Virtues and Saints, *Madrid, Museo del Prado*

are more solidly modeled, with a greater chiaroscuro, than those of his possible model. These differences in the appearance and grouping of the figures in Coello's *Annunciation* also show a change of style in relation to his own earlier works.

The enormous *Annunciation,* seven and a half meters in height, is the clearest expression of the Late Baroque in Spain, altogether comparable to works painted in Rome during this same period. Coello's style here is very similar to that of the Italian painters of the Late Baroque, especially Giovanni Battista Gaulli's (1639–1709) and Luca Giordano's (1634–1705), with which it shares the same ideals of grandeur, drama, and visual richness.

The *Virgin and Child with the Theological Virtues and Saints* [226], signed and dated in 1669, is a good measuring stick with which to gauge Coello's artistic evolution by the end of the first decade of his career. The similarity of subject and size of this painting and those of the *Virgin and Child Venerated by Saint Louis* [224] allow us to see their stylistic differences very clearly.

In the picture of 1669, the figures are more massive, and the space that they inhabit is smaller in relation to them as well as less open than in the earlier work. All the figures are closer to the picture plane, and interconnected in a denser and more regular network than in the picture of Saint Louis. The light and spontaneous brushwork, the luminous color, and the animation of that picture have been replaced by more solid painting and a less brilliant coloration and illumination; the lightness of the forms and the movement of the whole composition in the *Virgin with Saint Louis* have given place to more sedate figures in a more static arrangement. In the earlier picture, Coello's style is still close to Carreño's or Antolínez's; by the time he painted the *Virgin with the Theological Virtues* he had forged a grander manner and a more classicizing Baroque than that of his contemporaries in Madrid.

The great *Virgin of the Pillar Appearing to Saint James the Major* [227], signed in 1677, is a monumental work that can be compared to the classicizing strain of Italian Late Baroque art, best exemplified in these same years by Carlo Maratta (1625–1713). But while in Maratta's painting the classical vein gains strength as the century reaches its close, Coello's always retains the more emotive tone and the emphasis on movement that characterize the Baroque style of the School of Madrid.

In the course of his career Coello painted several versions of the Immaculate Virgin; the *Immaculate Conception* of c. 1685 [228] illustrates vividly the vigor and monumentality of his late style. The marked contrapposto of the Virgin's pose is reinforced by the movement of her heavy mantle and by the strong contrasts of a dramatic chiaroscuro that was absent in his earlier works, always more saturated with light. The Virgin has the same classical facial type as the Virgin of the Pillar, but in a more youthful, sweeter version, appropriate to the Immaculate Conception's iconography.

Although Coello had been made Painter to the King in 1683, during the two following years he held the post without wages, and he must have spent the greatest portion of this time in Zaragoza, working on the frescoes for the Mantería. Upon his return to the court, Coello continued his practice as a fresco painter and undertook the decoration of several chapels in Madrid; these frescoes, unfortunately, are no longer extant. The most important late work by Coello is the large canvas known as *La Sagrada Forma* (the Holy Sacrament) [229], painted for the sacristy

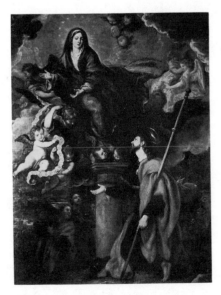

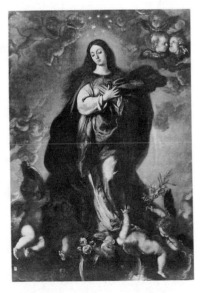

227. *Claudio Coello:* Virgin of the Pillar Appearing to Saint James the Major, *San Simeon, California, Hearst–San Simeon State Historical Monument*

228. *Claudio Coello:* Immaculate Conception, *Madrid, Church of San Jerónimo*

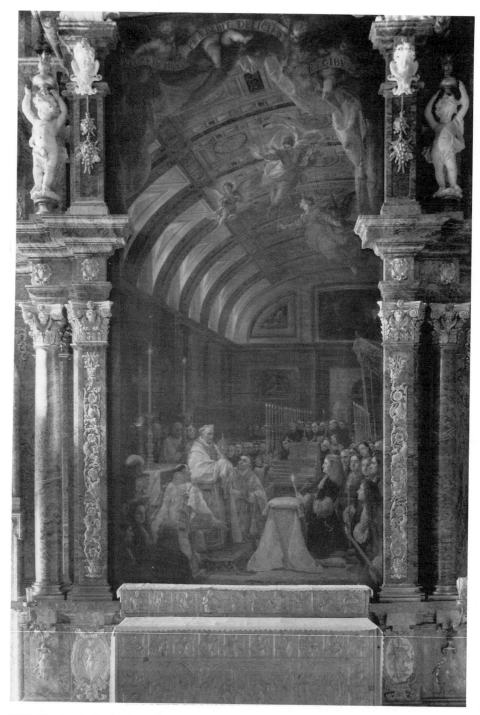

229. Claudio Coello: La Sagrada Forma, El Escorial, Sacristy of the Basilica

of the church of El Escorial between 1685 and 1690, the year in which it was signed and set in place.

This enormous altarpiece was commissioned by Charles II in commemoration of the placement of an important relic in the altar of the sacristy at El Escorial in 1684. It represents the exposition of the monstrance with the Holy Sacrament and the veneration of this miraculous relic by Charles II and his courtiers before its altar, culmination of the solemn event.

The execution of this picture had initially been entrusted to Francisco Rizi, but this artist died without having finished the project, and Coello was designated to replace him. It is quite possible that the overall design of the picture had already been settled before Rizi's death, but Coello modified the composition (according to Palomino's *Lives*) by lowering the vantage point of the perspective. The view of the figures and space in the *Sagrada Forma* shows precisely that point of difference in relation to another large picture whose design is also Rizi's, the *Foundation of the Trinitarian Order*, executed by Carreño in 1666 [161]. The compositional similarity between these two pictures also militates in favor of the idea that Coello retained the general outlines of his master's composition. The change of viewpoint, however, is of great importance for the viewer's perception of the scene, since the picture's linear perspective, aided by its masterfully achieved aerial perspective, places the observer in the position of actual witness to the solemn ceremony.

La Sagrada Forma has been frequently cited as the only example in Spanish painting that approximates the magic illusionism of *Las Meninas* [141] in its re-creation of an existing setting so that the observer may sense it as his own. There is also no doubt that the extraordinary portrait gallery, and the evocation of the light and atmosphere of the vast interior of the sacristy that houses the picture, have as a precedent only Velázquez's great painting, whose study must have been crucial for Coello's work.

The portraits of the participants in the ceremony (among whom his own is included, in the lower left-hand corner) demonstrate Coello's skill in this genre; the fidelity to their models is unverifiable, but all of them are imbued with life. The exception is the portrait of Charles II, which shows him in profile and perfectly still, separating the king from the rest of the congregation

by its hieratic character and its reference to imperial images. On the other hand, the view of the characteristic Hapsburg profile, very pronounced in Charles II, lends the last king of this dynasty a majesty and distinction that neither the many portraits of him by Carreño nor others by Coello ever manage to impart to him.

Of the independent portraits of Charles II by Coello only two are known, painted c. 1675/80, and one of them is now untraceable. The other [230] is an unfinished work, or perhaps a *bozzetto* or *modello*, remarkable for the vivacity of its impressionistic technique and for the also lively, almost smiling expression of the king, unique among his portraits. Instead of the traditional three-quarter pose of the formal half-length portraits, in which torso and head are turned in the same direction, Coello uses here a strong *contrapposto* in the bust that suggests a momentary action. This sort of *contrapposto* is frequent in Van Dyck's portraits, but in combination with the oval format of the work and the abbreviated bust of the sitter, it anticipates French and English eighteenth-century portraiture.

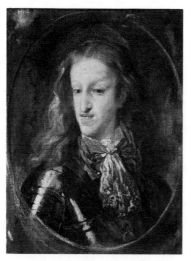

230. *Claudio Coello:* Charles II, *Madrid, Museo del Prado*

In his most important known portrait of Queen Mariana [231], Coello continued the type established by Martínez del Mazo in 1666 and developed by Carreño in the decade of 1670–80 [165], in which the queen appears in widow's weeds, seated, and in full length. Judging by the appearance of Mariana, who was born in 1634, this portrait must have been painted c. 1690–93, as she looks

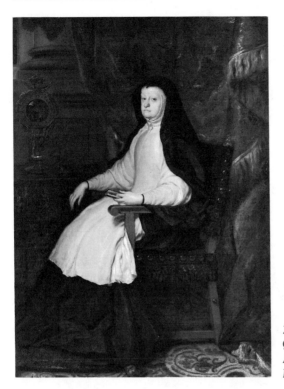

231. *Claudio Coello:*
Queen Mariana of
Austria, *Munich, Alte*
Pinakothek

older than in the last portraits painted by Carreño, and much
heavier. In Coello's picture, the figure is more monumental and
majestic than those of his models and, unlike them, the space it
occupies is simpler and less open.

The vitality of Coello's portraits seen in the *Sagrada Forma*,
in the oval portrait of Charles II, and even in that of Queen
Mariana with respect to those painted by Carreño is also present
in the so-called *Padre Cabanillas* (Madrid, Museo del Prado). The
simplicity of the composition and the habit's somber coloring
serve to concentrate on the head the observer's full attention, and
the model, whose coarse physiognomy is described in bold strokes
and with a light touch worthy of Velázquez, returns to him an
intent glance, filled with emotion.

As is the case for the majority of the frescoes painted by
his master and other contemporary artists in Madrid, only a small
fraction of Coello's output in this field can still be seen; nonethe-
less, he is among them the artist who is best represented as a mural
painter by what has survived.

The source of his approach to the decoration of walls and ceilings is the work of the Bolognese painters Michelangelo Colonna and Agostino Mitelli, imported by Velázquez to the Spanish court in 1658 for the decoration of the Alcázar. It is this illusionistic approach, of long standing in Bologna, that shaped Rizi's and Carreño's mural painting and, in turn, that of Coello and his collaborators. In the ceilings of the vestry of the cathedral of Toledo (1671–74) and of the Casa de la Panadería in Madrid (1672–73), for which he collaborated with José Jiménez Donoso, the allegories that occupy the center of the open skies painted on the vaults are surrounded by simulated architecture that frames them and extends visually the actual space of the room. This use of *quadratura*, Agostino Mitelli's legacy, was current throughout

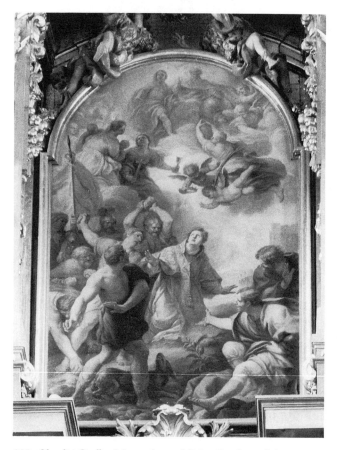

232. *Claudio Coello:* Martyrdom of Saint Stephen, *Salamanca, Church of San Esteban*

Italy by this date, and Coello's and Donoso's frescoes are very similar to those painted by Italian artists.

According to a rumor recorded by Palomino, after Coello's death in April of 1693, the gossips claimed that the demise of Charles II's painter had been caused by Luca Giordano's arrival to the Spanish court the previous year and his subsequent success. Coello's last major work, the large canvas that crowns the high-altar retable of the church of San Esteban in Salamanca (a work by Churriguera) indicates, in any case, that he had also succumbed to the exuberant style of the Italian painter. The dynamism of the composition and the light and brilliant coloring of the *Martyrdom of Saint Stephen* [232] echo the frescoes and canvases painted by Giordano at the court and in El Escorial. Its Baroqueness marks a notable deviation from the classicism and gravity of Coello's late religious works before Giordano's arrival in Madrid.

The death of Claudio Coello at the age of fifty-one cut short a career that was still in the process of evolution, bringing to an untimely end the life of the last great artist that would emerge in Spain for a long time.

The bibliography has been designed to provide the reader with a selected list of general or monographic texts on Spanish sixteenth- and seventeenth-century painting, chosen to include the most recent, important, and creditable studies in this area. Many of the books or exhibition catalogues included here contain very comprehensive bibliographies of earlier publications, which can refer the reader, in turn, to the more specialized literature on specific areas of interest.

Generally, only published books on any given topic or artist have been included, but an exception has been made for a few indispensable monographic articles, which are the only extensive studies to have appeared to date on the artists in question.

SOURCES

Agulló Cobo, M. *Más noticias sobre pintores madrileños de los siglos XVI al XVIII,* Madrid, 1981.

———. *Noticias sobre pintores madrileños de los siglos XVI y XVII,* Granada and Madrid, 1978.

Artists' Techniques in Golden Age Spain: Six Treatises in Translation, Cambridge and New York, 1986. Edited and translated by Zahira Veliz.

Calvo Serraller, F. *La teoría de la pintura en el Siglo de Oro,* Madrid, 1981.

Carducho, V. *Diálogos de la pintura,* Madrid, 1633. Edited by Francisco Calvo Serraller, Madrid, 1977.

Documentos para la historia del arte en Andalucía, 10 vols., Seville, 1927–46.

El manuscrito de la Academia de Murillo, Seville, 1982.

Engass, R., and J. Brown. *Italy and Spain 1600–1750: Sources and Documents,* Englewood Cliffs, N.J., 1970.

García Chico, E. *Documentos para el estudio del arte en Castilla*, 3 vols., Valladolid, 1940–46.

Martínez, J. *Discursos practicables del nobilísimo arte de la pintura* (1675?), Madrid, 1866. Modern edition, Barcelona, 1950.

Pacheco, F. *Arte de la pintura*, 2 vols. Edited by F. J. Sánchez Cantón, Madrid, 1956.

Palomino de Castro y Velasco, A. *El museo pictórico y escala óptica*, 3 vols., Madrid, 1715–24. Modern edition, Madrid, 1947.

———. *Lives of the Eminent Spanish Painters and Sculptors*, Cambridge and New York, 1987. Edited and translated by Nina Ayala Mallory.

Ponz, A. *Viaje de España*, 18 vols., Madrid, 1772–84. Ed. Aguilar, 1 vol., Madrid, 1947. Facsimile edition, Madrid, 1972.

Sánchez Cantón, J. F. *Fuentes literarias para la historia del arte español*, 5 vols., Madrid, 1923–41.

Zarco del Valle, M. *Documentos para la historia de las bellas artes en España*, Madrid, 1870.

GENERAL WORKS

Agapito y Revilla, J. *La pintura en Valladolid*, Valladolid, 1925–43.

Alcahalí, Barón de. *Diccionario biográfico de artistas valencianos*, Valencia, 1897.

Angulo Iñiguez, D. *Pintura del Renacimiento (Ars Hispaniae XII)*, Madrid, 1954.

———. *Pintura del siglo XVII (Ars Hispaniae XV)*, Madrid, 1971.

Angulo Iñiguez, D. and A. E. Pérez Sánchez. *A Corpus of Spanish Drawings. Spain: 1400–1600*, vol. 1, London, 1972.

———. *A Corpus of Spanish Drawings. Madrid: 1600–1650*, vol. 2, London, 1977.

———. *A Corpus of Spanish Drawings. Seville: 1600–1650*, vol. 3, Oxford, 1985.

———. *A Corpus of Spanish Drawings. Valencia: 1600–1700*, vol. 4, Oxford, 1988.

———. *Historia de la pintura española*, vol. I: *Escuela madrileña del primer tercio del siglo XVII*, Madrid, 1969.

———. *Historia de la pintura española*, vol. II: *Escuela toledana de la primera mitad del siglo XVII*, Madrid, 1972.

———. *Historia de la pintura española*, vol. III: *Escuela madrileña del segundo tercio del siglo XVII*, Madrid, 1983.

Baticle, J., and C. Marinas. *La Galerie Espagnole de Louis-Philippe au Louvre*, Paris, 1981.

Beltrán Martínez, A. *Catálogo del Museo Provincial de Bellas Artes de Zaragoza*, Zaragoza, 1964.

Bergström, I. *Maestros españoles de bodegones y floreros del siglo XVII*, Madrid, 1970.

Beruete y Moret, A. de. *The School of Madrid,* London, 1909.

Birmingham, Alabama. *The Art of Spain,* exhibition catalogue, Birmingham Museum of Art, 1971.

Braham, A. *El Greco to Goya: The Taste for Spanish Paintings in Britain and Ireland,* exhibition catalogue, London, National Gallery, 1981.

Brown, J. *Images and Ideas in Seventeenth-Century Spanish Painting,* Princeton, N.J., 1978.

Calvo Serraller, F. *La teoría de la pintura en el Siglo de Oro,* Madrid, 1981.

Camón Aznar, J. *La pintura española del siglo XVI (Summa Artis XXIV),* Madrid, 1970.

———. *La pintura española del siglo XVII (Summa Artis XXV),* Madrid, 1977.

Catalogue sommaire illustré des peintures du Musée du Louvre. II: Italie, Espagne, Allemagne, Grande-Bretagne et divers, Paris, 1981.

Ceán Bermúdez, J. A. *Diccionario histórico de los más ilustres profesores de las bellas artes en España,* 6 vols., Madrid, 1800. Facsimile edition, Madrid, 1965.

Díaz Padrón, M. *El arte en la época de Calderón,* exhibition catalogue, Madrid, Palacio de Velázquez, 1981.

Edinburgh. National Gallery of Scotland, 1951. *Spanish Paintings from El Greco to Goya,* exhibition catalogue by E. Waterhouse.

Gállego, J. *Visión y símbolos en la pintura española del siglo de oro,* Madrid, 1984.

———. *Peinture espagnole du siècle d'or,* Paris, 1964.

———. *La pintura española,* Barcelona, 1963.

Garín Ortiz de Taranco, F. M. *Catálogo-guía del Museo Provincial de Bellas Artes de San Carlos,* Valencia, 1955.

Gaya Nuño, J. A. *La pintura española fuera de España,* Madrid, 1958.

Gestoso y Pérez, J. *Ensayo de un diccionario de los artífices que florecieron en Sevilla desde el siglo XII al XVIII inclusive,* 3 vols., Seville, 1899–1900.

Gudiol, J. *The Toledo Museum of Art: Catalogue of Spanish Painting,* Toledo, Ohio, 1941.

Gudiol, J., S. Alcolea, and J. E. Cirlot. *Historia de la pintura en Cataluña,* Madrid, n.d.

Guinard, P. *Les peintres espagnols,* Paris, 1967.

Guinard, P., and J. Baticle. *Histoire de la peinture espagnole,* Paris, 1950.

Haraszti-Takáks, M. *Spanische Meister in Museum zu Budapest,* Budapest, 1966.

———. *Spanish Genre Painting in the Seventeenth Century,* Budapest, 1983.

Hernández Díaz, J. *Museo de Bellas Artes de Sevilla,* Madrid, 1967.

Indianapolis, John Herron Museum of Art. *El Greco to Goya, Spanish Painting of the 17th and 18th Centuries,* exhibition catalogue, 1963.

Jordan, W. B. *The Meadows Museum: A Visitor's Guide to the Collection,* Dallas, 1974.

———. *Spanish Still Life in the Golden Age, 1600–1650,* exhibition catalogue, Fort Worth, Texas, Kimbell Art Museum, 1985.

Kubler, G., and M. Soria. *Art and Architecture in Spain and Portugal and Their American Dominions: 1500 to 1800*, Baltimore, 1959.

Laclotte, M., J. Baticle, and R. Mesuret. *Trésors de la peinture espagnole: églises et musées de France*, exhibition catalogue, Paris, Musée des Arts Décoratifs, 1963.

Lafuente Ferrari, E. *Breve historia de la pintura española*, 4th ed., Madrid, 1953.

————. *Museo del Prado. Pintura española de los siglos XVII y XVIII*, Madrid, 1969.

Lassaigne, J. *La Peinture espagnole*, 2 vols., Geneva, 1952.

Loga, V. von. *Die Malerei in Spanien*, Berlin, 1923.

Longhi, R., and A. L. Mayer. *The Old Spanish Masters from the Contini-Bonacossi Collection*, exhibition catalogue, Rome, Galleria Nazionale d'Arte Moderna, 1930.

López Torrijos, R. *La mitología en la pintura española del siglo de oro*, Madrid, 1985.

Loyoza, Marqués de. *Historia del arte hispánico*, vols. III and IV, Barcelona, 1931–49.

MacLaren, N., and A. Braham. *National Gallery Catalogues. The Spanish School*, 2nd rev. ed., London, 1970.

Martín González, J. J. *El artista en la sociedad española del siglo XVII*, Madrid, 1984.

Martin-Méry, G. *L'age d'or espagnole*, exhibition catalogue, Bordeaux, Musée des Beaux-Arts, 1955.

Mayer, A. L. *Historia de la pintura española*, 3rd ed., Barcelona, 1947.

————. *Die Sevillaner Malerschule*, Leipzig, 1911.

Morales y Marín, J. L. *La pintura aragonesa en el siglo XVII*, Zaragoza, 1980.

Munich and Vienna, Alte Pinakothek. *Von Greco bis Goya; Vier Jahrhunderte Spanische Malerei*, exhibition catalogue, 1982.

Orellana, M. A. *Biografía pictórica valenciana o vida de los pintores, arquitectos, escultores y grabadores valencianos*, edited by X. de Salas, Valencia, 1967.

Orozco Díaz, E. *Guía del Museo Provincial de Bellas Artes, Granada*, Madrid, 1966.

————. *Temas del barroco*, Granada, 1947.

Pardo Canalís, E. *Pinturas de la corte de Carlos II*, Madrid, 1977.

Paris, Petit Palais. *La Peinture espagnole au siècle d'or: De Greco à Velázquez*, exhibition catalogue, 1976.

Pérez Sánchez, A. E. *Antonio de Pereda y la pintura madrileña de su tiempo*, exhibition catalogue, Madrid, Museo del Prado, 1978.

————. *Caravaggio y el naturalismo español*, exhibition catalogue, Sala de Armas de los Reales Alcázares, 1973.

————. *Carreño, Rizi, Herrera y la pintura madrileña de su tiempo*, exhibition catalogue, Madrid, Museo del Prado, 1986.

————. *Catálogo de dibujos de la Real Academia de San Fernando*, Madrid, 1967.

————. *El dibujo español de los siglos de oro*, exhibition catalogue, Madrid, Palacio de Bibliotecos y Museos, 1980.

————. *Dibujos españoles de los siglos XV–XVIII*, Madrid, Museo del Prado, catalogue of Spanish drawings, vol. I, 1972.

————. *The Golden Age of Spanish Painting*, exhibition catalogue, London, Royal Academy, 1976.

————. *Inventario de las pinturas. Real Academia de San Fernando*. Madrid, 1964.

————. *Pintura española de bodegones y floreros de 1600 a Goya*, exhibition catalogue, Palacio de Bibliotecas y Museos, 1983.

————. *Pintura española de los siglos XVI al XVIII en colecciones centroeuropeas*, exhibition catalogue, Palacio de Bibliotecas y Museos, 1982.

————. *Los Ribalta y la pintura valenciana de su tiempo*, exhibition catalogue, Madrid, Palacio de Villarhermosa, 1987–88.

Rafols, J. F. *Diccionario biográfico de artistas de Cataluña*, 3 vols., Barcelona, 1951–54.

Ramírez de Arellano, R. *Diccionario biográfico de artistas de la provincia de Córdoba*, Madrid, 1893.

Sanchez Cantón, F. J. *Dibujos españoles*, 5 vols., Madrid, 1930.

————. *Museo del Prado. Catálogo de los Cuadros*, Madrid, 1933. Revised ed., 1985.

————. *Los pintores de cámara de los reyes de España*, Madrid, 1916.

Soehner, H. *Spanische Meister*. *Alte Pinakothek*, Munich, 1962.

Stirling-Maxwell, W. *Annals of the Artists of Spain*, 5 vols., 2nd ed., London, 1891.

Sullivan, E. J. *Baroque Painting in Madrid: The Contribution of Claudio Coello, with a Catalogue Raisonné of His Works*, Columbia, Missouri, 1986.

Sullivan, E. J., and N. A. Mallory. *Painting in Spain 1650–1700*, Princeton, N.J., 1982.

Toledo, Hospital de Tavera. *El Toledo de El Greco*, exhibition catalogue, 1982.

Tormo, E., and M. E. Gómez Moreno. *Las iglesias de Madrid* (new edition of the two fascicles published in 1927), Madrid, 1972.

Torres Martín, R. *La naturaleza muerta en la pintura española*, Barcelona, 1971.

Trapier, E. du Gué. *Catalogue of Paintings in the Hispanic Society*, New York, 1929.

Valdivieso, E. *Historia de la pintura sevillana*, Seville, 1986.

————. *La pintura en Valladolid en el siglo XVII*, Valladolid, 1971.

Valdivieso, E., and J. M. Serrera. *La época de Murillo. Antecedentes y consecuentes de su pintura*, exhibition catalogue, Seville, Museo de Arte Contemporáneo, 1982.

Valdivieso, E., and J. M. Serrera. *Historia de la pintura española: Escuela sevillana del primer tercio del siglo XVII*, Madrid, 1985.

Viñaza, Conde de la. *Adiciones al Diccionario histórico de . . . D. Juan Agustín Ceán Bermúdez*, 4 vols., Madrid, 1889–94. Facsimile ed., Madrid, 1972.

Winnipeg Art Gallery. *El Greco to Goya*, exhibition catalogue, 1955.

Young, E. *Catalogue of Spanish and Italian Paintings*, Barnard Castle, Bowes Museum, County Durham, U.K., 1970.

———. *Four Centuries of Spanish Painting*, exhibition catalogue, County Durham, U.K., Bowes Museum, Barnard Castle, 1967.

Zarco Cuevas, E. J. *Pintores españoles en San Lorenzo el Real de El Escorial (1566–1613)*, Madrid, 1931.

ARTISTS

Antolínez

Angulo Iñiguez, D. *José Antolínez*, Madrid, 1957.

Cano

Granada, 1967. *Centenario de Alonso Cano en Granada*, exhibition catalogue. Published in 1970.

Wethey, H. E. *Alonso Cano: Painter, Sculptor, Architect*, Princeton, N.J., 1955. Revised ed. in Spanish, *Alonso Cano. Pintor, escultor y arquitecto*, Madrid, 1983.

Carducho, Vicente

Volk, M. C. *Vicencio Carducho and Castilian Painting*, New York and London, 1977.

Carreño

Barettini Fernández, J. *Juan Carreño, pintor de cámara de Carlos II*, Madrid, 1972.

Berjano Escobar, D. *El pintor don Juan Carreño de Miranda (1614–1685). Su vida y sus obras*, Madrid, n.d. [1925].

Pérez Sánchez, A. E. *Carreño, Rizi, Herrera y la pintura madrileña de su tiempo*, exhibition catalogue, Madrid, Museo del Prado, 1986.

———. *Juan Carreño de Miranda (1614–1685)*, Avilés, 1985.

Cerezo

Buendía, J.R. and I. Gutiérrez Pastor. *Vida y obra del pintor Mateo Cerezo (1637–1666)*, Burgos, 1986.

Coello

Gaya Nuño, J. A. *Claudio Coello,* Madrid, 1957.
Sullivan, E. J. *Baroque Painting in Madrid: The Contribution of Claudio Coello, with a Catalogue Raisonné of his Works,* Columbia, Missouri, 1986.

Donoso

Sánchez de Palacios, M. *Un pintor y arquitecto en la corte de Carlos II: José Ximénez Donoso,* Madrid, 1977.

El Greco

Brown, J., W. B. Jordan, R. L. Kagan, and A. E. Pérez Sánchez. *El Greco of Toledo,* exhibition catalogue, Toledo (Ohio) Museum of Art, 1982.
Brown, J., et al. *Figures of Thought: El Greco as Interpreter of History, Tradition and Ideas,* Washington, D.C., 1984.
Davies, D. *El Greco,* Oxford and New York, 1976.
Frati, T. *L'opera completa del Greco,* Milan, 1969.
Guinard, P. *El Greco,* Barcelona and New York, 1956.
Wethey, H. E. *El Greco and His School,* 2 vols., Princeton, N.J., 1962.

Herrera the Elder

Martínez Ripoll, A. *Francisco de Herrera "el Viejo,"* Seville, 1978.
Thatcher, J. S. "The Paintings of Francisco de Herrera, the Elder," *The Art Bulletin* XIX (1937): 325–80.

Herrera the Younger

Pérez Sánchez, A. E. *Carreño, Rizi, Herrera y la pintura madrileña de su tiempo,* exhibition catalogue, Madrid, Museo del Prado, 1986.

Leonardo

Mazón de la Torre, M. A. *Jusepe Leonardo y su tiempo,* Zaragoza, 1977.

Martínez del Mazo

Gaya Nuño, J. A. "Juan Bautista Martínez del Mazo, el gran discípulo de Velázquez," in *Varia Velazqueña,* vol. I, Madrid, 1960.

Murillo

Angulo Iñiguez, D. *Murillo,* 3 vols., Madrid, 1981.
Brown, J. *Murillo and His Drawings,* Princeton, N.J., 1976.
Ceán Bermúdez, J. A. *Carta de D. Juan Agustín Ceán Bermúdez a un amigo suyo sobre el estilo y gusto en la pintura de la escuela sevillana,* Cádiz, 1806. Facsimile ed., Seville, 1968.

Curtis, C. B. *Velázquez and Murillo*, London and New York, 1883.
Elliot, J. H., A. Domínguez Ortiz, D. Angulo Iñiguez, M. Mena Marqués, E. Valdivieso, and E. Waterhouse. *Bartolomé Esteban Murillo (1617–1682)*, exhibition catalogue, Madrid and London, Museo del Prado and Royal Academy, 1982.
Mallory, N. A. *Bartolomé Esteban Murillo*, Madrid, 1983.
Montoto de Sedas, S. *Bartolomé Esteban Murillo: Estudio bibliográfico-crítico*, Seville, 1923.

Pantoja de la Cruz

Kusche, M. *Juan Pantoja de la Cruz*, Madrid, 1964.

Pereda

Pérez Sánchez, A. E. *Don Antonio de Pereda (1611–1678) y la pintura madrileña de su tiempo*, exhibition catalogue, Madrid, Museo del Prado, 1978.
Tormo y Monzó, E. *Un gran pintor vallisoletano: Antonio de Pereda*, Valladolid, 1916.

The Ribaltas

Camón Aznar, J. *Los Ribaltas*, Madrid, 1958.
Fitz-Darby, D. *Francisco Ribalta and His School*, Cambridge, Mass., 1938.
Kowal, David M. *Francisco Ribalta and His Followers: A Catalogue Raisonné*, New York, 1985.
Pérez Sánchez, A. E. *Los Ribalta y la pintura valenciana de su tiempo*, exhibition catalogue, Madrid, Palacio de Villarhermosa, 1987–88.

Ribera

Brown, J. *Jusepe de Ribera: Prints and Drawings*, Princeton, N.J., 1973.
Felton, C. *Jusepe de Ribera, lo Spagnoletto (1591–1652)*, exhibition catalogue, Fort Worth, Texas, The Kimbell Art Museum, 1982.
Mayer, A. L. *Jusepe de Ribera, lo Spagnoletto*, Leipzig, 1923.
Spinosa, N. *L'opera completa di Ribera*, Milan, 1978.
Trapier, E. du Gué. *Ribera*, New York, 1952.

Rizi, Francisco

Angulo Iñiguez, D. "Francisco Rizi. Su vida, cuadros religiosos fechados anteriores a 1670," *Archivo Español de Arte* 122 (1958): 88–115; "Francisco Rizi. Cuadros religiosos posteriores a 1670 y sin fechar," ibid. 138 (1962): 95–122; "Francisco Rizi. Cuadros de tema profano," ibid. 176 (1971): 358–87; "Francisco Rizi. Pinturas murales," ibid. 188 (1974): 361–82.

Pérez Sánchez, A. E. *Carreño, Rizi, Herrera y la pintura madrileña de su tiempo,* exhibition catalogue, Madrid, Museo del Prado, 1986.

Roelas

Valdivieso, E. *Juan de Roelas,* Seville, 1978.

Sánchez Coello

San Román, F. de B. *Alonso Sánchez Coello,* Lisbon, 1938.

Valdés Leal

Kinkead, D. T. *Juan de Valdés Leal (1622–1690): His Life and Work,* New York and London, 1978.
Trapier, E. du Gué. *Valdés Leal, Spanish Baroque Painter,* New York, 1960.
Valdivieso, E. *Valdés Leal,* Seville, 1988.

Velázquez

Bardi, P. M. *L'opera completa di Velázquez,* Milan, 1969.
Brown, J. *Velázquez, Painter and Courtier,* New Haven and London, 1986.
Camón Aznar, J. *Velázquez,* 2 vols., Madrid, 1964.
Curtis, C. B. *Velázquez and Murillo,* London and New York, 1883.
Domínguez Ortiz, A., A.E. Pérez Sánchez, and J. Góllego. *Velázquez,* exhibition catalogue, New York, The Metropolitan Musuem of Art, 1989.
Gudiol, J. *Velázquez,* Barcelona, 1973.
Harris, E. *Velázquez,* Ithaca, N.Y., 1982.
Justi, C. *Velázquez y su siglo,* Spanish ed. by J. A. Gaya Nuño, Madrid, 1953.
López-Rey, J. *Velázquez: A Catalogue Raisonné of His Oeuvre,* London, 1963.
——. *Velázquez's Work and World,* London, 1968.
Trapier, E. du Gué. *Velázquez,* New York, 1948.
Varia Velazqueña: homenaje a Velázquez en el III centenario de su muerte, 1660–1960, 2 vols., Madrid, 1960.
Velázquez y lo velazqueño, exhibition catalogue, Buen Retiro, Madrid, 1960.
Wind, Barry. *Velázquez's Bodegones: A Study in Seventeenth-century Spanish Genre Painting,* Fairfax, Va., 1987.

Zurbarán

J. Baticle. *Zurbarán,* exhibition catalogue, New York, Metropolitan Museum of Art, 1987.
Brown, J. *Francisco de Zurbarán,* New York, 1973.
Frati, T. *L'opera completa di Zurbarán,* Milan, 1973.
Gállego, J., and J. Gudiol. *Zurbarán 1598–1664,* Barcelona, 1976.
Gaya Nuño, J. A. *Zurbarán,* Barcelona, 1948.

Guinard, P. *Zurbarán et les peintres espagnols de la vie monastique*, Paris, 1960.

Soria, M. *The Paintings of Zurbarán*, 2nd ed., London, 1955.

Zurbarán en el III Centenario, exhibition catalogue, Casón del Buen Retiro, Madrid, 1964.

INDEX